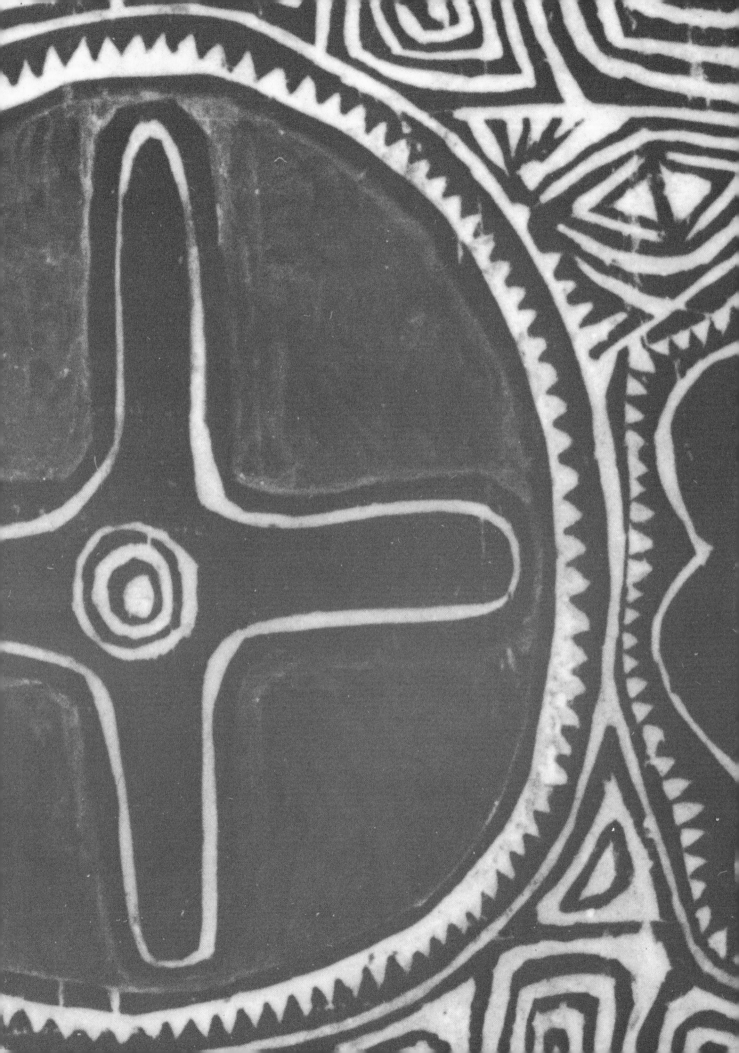

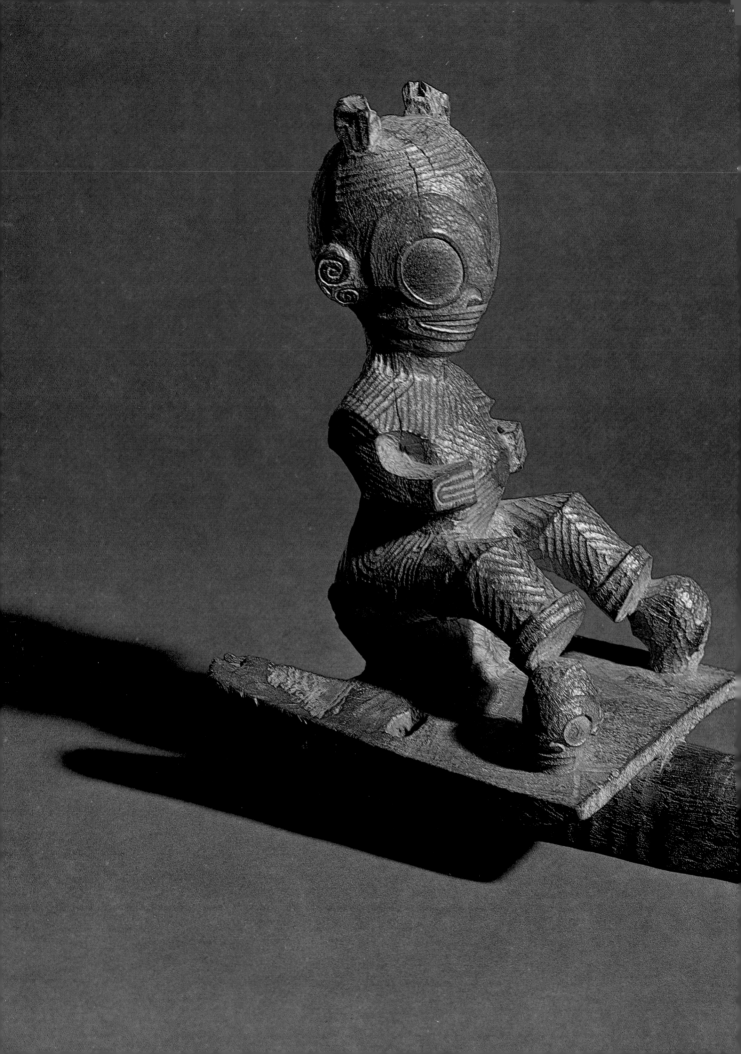

# The Art of the
# Pacific Islands

Peter Gathercole

Adrienne L. Kaeppler

Douglas Newton

National Gallery of Art, Washington   1979

This catalogue was produced by the Editor's Office, National Gallery of Art, Washington. Printed by Eastern Press, New Haven, Conn. The type is Bodoni book, set by Composition Systems Inc., Arlington, Va. The paper is eighty-pound LOE dull with matching cover.
Designed by Melanie B. Ness

The exhibition dates at the National Gallery of Art are July 1–October 14, 1979

Cover: *Cape* (detail), Hawaii, no. 1.7
Frontispiece: *Canoe Prow Ornament*, Marquesas Islands, no. 2.17

Library of Congress Cataloging in Publication Data:

The Art of the Pacific Islands.

Catalogue of an exhibition held at the National Gallery of Art, July 1-October 14, 1979.
Bibliography: p. 356
1. Art, Primitive—Islands of the Pacific—Exhibitions. 2. Art—Islands of the Pacific—Exhibitions. I. Newton, Douglas, 1920-
II. Kaeppler, Adrienne Lois. III. Gathercole, P. W. IV. United States. National Gallery of Art.
N7410.A74   730'.099'0740153   79-16114

# Contents

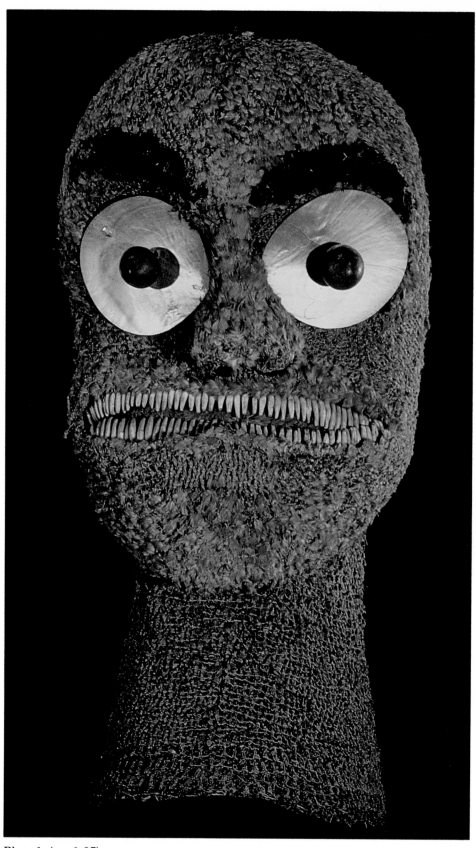

Plate 1  (no. 1.25)

# Foreword

The Pacific Islands—the phrase summons up images of an idyllic world composed of the most accessible kinds of physical beauty: a vast and tranquil ocean, a beneficent climate, tropical foliage, human charm; a scene which combines both innocence and pleasure, an exotic pastoral. It was fabricated in the eighteenth century, not by the sailors who actually ventured into those unknown seas, but by those who had stayed at home and heard their stories. It was a dream, but a lasting one: we know the fate of Gauguin, who pursued it to the bitter end; and to some extent it still endures in the aspirations of hopeful travelers. Like all powerful dreams, it has its nightmare side: the lagoons and *vahines* of Polynesia and Micronesia are balanced by the jungles and head-hunting cannibals of legendary Melanesia.

Where is the reality behind this to be found? We cannot recreate the islands in our own place and time, but, as with all cultures and periods, we can discover much about them through their art. The installation of this exhibition, occupying the full reaches of the temporary exhibition area on the concourse level of the Gallery's new East Building, has been organized as a voyage across the Pacific, beginning with the Polynesian culture of Hawaii. To explore the art of the Pacific Islands is, for most of us, a genuine voyage of discovery. In a period when the arts of much of the past and the non-Western world are increasingly familiar, from Lascaux, ancient China, the Egyptian Pharoahs, Benin, and ancient America, those of the Pacific are still largely a closed book.

In spite of the wealth it has to offer, the art of the Pacific Islands remains perhaps the least known of the world's art to the modern audience. Although there have been many small exhibitions of aspects of it, there has been no general survey since *Arts of the South Seas* held at the Museum of Modern Art in 1946—a time before many new discoveries and studies were made. This contrasts with survey exhibitions that have been more recently held of African, pre-Columbian, and American Indian art—other major areas of so-called "primitive art."

Throughout this mass of islands, in some cases until recently, there existed hundreds of cultures, many of them sustained by only a few hundred people. By way of interaction and exchange among many of the people from the large islands, and conversely through the isolation of those in the more remote island groups, the cultures developed into richly disparate modes with elaborated social systems and highly refined systems of intellectual and religious life. Most striking of all, however, is that these cultures created an extraordinary range of art styles to express and to serve their beliefs.

Even the simplest of the cultures demonstrated creativity, and the more complex were immensely productive of sculpture, painting, and the minor visual arts.

It has been customary to speak of the art of Polynesia as tranquil and classic; of Melanesia as expressive and romantic; and of Micronesia as decorative. In fact, these arts are infinitely diversified, any one culture working in a number of differing and often contrasting styles. Their rich variety is an extraordinary phenomenon which it is now timely to celebrate, especially in an era when many of the countries where they originated are now gaining independence and a revived consciousness of their ancient traditions and values.

This exhibition has been rigorously selected from the private and public collections of Europe, the United States, and some of the Pacific countries themselves. The aim has been to choose those objects which were made before or collected at the earliest contact by Westerners, and which therefore reflect the most pristine state of the cultures. There have been few exceptions to this rule. No object displayed has not been used for the religious or domestic purposes for which it was intended; and each work stands to be judged as an individual achievement of its time and place. It is indicative of how much lies waiting to be discovered about these arts, and a measure of the genius that is yet unfound, that over a quarter of the objects exhibited have been been published, and in very many cases have never before been publicly exhibited. It is a world of the visual arts which is sometimes bizarre, sometimes exquisite, always instinct with human energy. It is rarely that one can say so positively of a group of works of art, not that it will reinforce already existing tastes and concepts, but that it will introduce whole areas of unfamiliar mastery.

The concept of the exhibition at the Gallery dates back many years, and owes much to the particular interest of a Gallery trustee, Dr. Franklin Murphy. From the beginning, we have been beholden to Douglas Newton, then the director of the Museum of Primitive Art in New York, and now the chairman of the Department of Primitive Art of the Metropolitan Museum of Art, New York, who has been in charge of the selection of objects and the preparation of the catalogue text, together with the very welcome collaboration of Peter Gathercole, the curator of the University Museum of Archaeology and Anthropology, Cambridge, England, and of the anthropologist Adrienne Kaeppler of the Bernice P. Bishop Museum, Honolulu. For the work of these learned scholars, together with all of those on the staff of the National Gallery who have helped produce this exhibition, we are enormously grateful.

We wish also to thank Continental Airlines, Inc., for their generous help in transporting both objects and people from the vast Pacific areas which they serve.

Above all, our thanks go to the many lenders from all over the

world who have made this exhibition possible. Much of this material is extremely fragile and awkward to transport. Their cooperation and generosity in lending have been enormously appreciated.

J. Carter Brown
*Director*

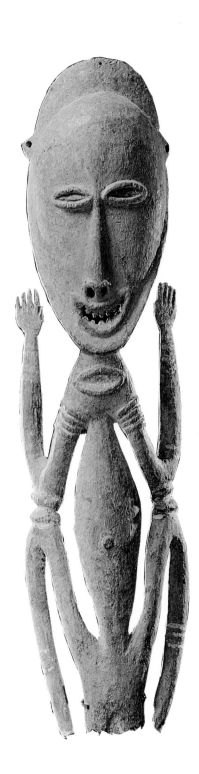

Plate 2  (no. 22.61)

# List of Lenders

Mr. and Mrs. Alvin Abrams, New York
American Museum of Natural History, New York
Auckland Museum, New Zealand
Australian Museum Trust, Sydney
Australian National Gallery, Canberra
Herbert Baker, Los Angeles
The Baltimore Museum of Art
Barbier-Müller Collection, Geneva
Bernice Pauahi Bishop Museum, Honolulu
Trustees of the British Museum, London
The Brooklyn Museum, New York
Dr. Robert M. Browne, Honolulu
Buffalo Museum of Science, New York
Canterbury Museum, Christchurch, New Zealand
Rhys Carpenter, Southampton, New York
The Historical Department, The Church of Jesus Christ of Latterday
   Saints, Salt Lake City
George Corbin, New York
Dr. William Davenport, Philadelphia
The Ethnographical Museum, Budapest
Exeter City Museums, England
Field Museum of Natural History, Chicago
The Fine Arts Museums of San Francisco
Mr. and Mrs. Leo Fortess, Hawaii
Dr. D. Carleton Gajdusek
Hamburgisches Museum für Völkerkunde, Hamburg
Kathleen Haven, New York
Mr. Gaston T. de Havenon, New York
Hawaii Volcanoes National Park Museum, Volcano, Hawaii
Wayne Heathcote, New York
Mr. and Mrs. Ben Heller Collection, New York
Historisches Museum, Bern
James Hooper Collection, England
Hunterian Museum, Glasgow
Indiana University Art Museum, Bloomington
Ipswich Borough Council (Museums), Ipswich, England
Josefowitz Collection, Switzerland
Kauai Museum, Lihue, Kauai, Hawaii
Dr. Ruth F. Lax and Dr. Leon A. Falik, New York
Jay C. Leff, Uniontown, Pennsylvania
Linden-Museum, Stuttgart
Los Angeles County Museum of Natural History
The Metropolitan Museum of Art, New York
The Minneapolis Institute of Arts
Musée des Antiquités Nationales, Saint-Germain-en-Laye, France
Musée d'Histoire Naturelle, La Rochelle, France
Musée de l'Homme, Paris

The Museum of Cultural History, University of California at Los
    Angeles
The Museum of Fine Arts, Houston
Museum voor Land- en Volkenkunde, Rotterdam
Museum Rietberg Zurich
Museum voor het Onderwijs, The Hague
Museum für Völkerkunde, Basel
Museum für Völkerkunde, Frankfurt
Museum für Völkerkunde, Vienna
National Museum of Natural History, Smithsonian Institution,
    Washington
New Orleans Museum of Art
Collection of the Newark Museum
Norfolk Museums Service, Great Yarmouth Museums, England
S. and J. Onzea, Brussels
George Ortiz Collection, Geneva
Otago Museum, Dunedin, New Zealand
Peabody Museum of Archaeology and Ethnology, Harvard University,
    Cambridge, Massachusetts
Peabody Museum of Salem, Massachusetts
Pitt Rivers Museum, University of Oxford, England
Private collection, England
Private collection, London
Private collection, New York
Rijksmuseum voor Volkenkunde, Leiden
The Michael C. Rockefeller Memorial Collection of Primitive Art, on
    loan to The Metropolitan Museum of Art, New York, from Nelson A.
    Rockefeller
Staatliches Museum für Völkerkunde, Munich
Staatliches Museums für Völkerkunde, Dresden
The St. Louis Art Museum
Bruce Seaman, Tahiti
Tropenmuseum, Amsterdam
Übersee-Museum, Bremen
University of East Anglia, Norwich, England
The University Museum, Philadelphia
University Museum of Archaeology and Anthropology, Cambridge
Mr. and Mrs. Allen Wardwell, New York
Washington University Gallery of Art, St. Louis
Katherine Coryton White Collection, Los Angeles
Raymond and Laura Wielgus Collection, Tucson
Faith and Martin Wright, New York
Mrs. Claire Zeisler, Chicago

# Acknowledgments

The assembling of an exhibition such as this one can only be made possible with the assistance, generosity, and work of many people. One of the most pleasant aspects of the project has been the unstinting measures of willing help we have been given, and it is an equal pleasure to return thanks for these gifts.

First, of course, we must express gratitude to the long roster of private lenders and representatives of institutions who have consented to grant loans from their collections. We have made requests which in some cases might seem exorbitant, given the rarity and importance of the works; and but in few cases, indeed, have we been refused. Private collectors have been willing to part with their most valued objects, and museum directors have graciously agreed to disrupt their own exhibitions, and even modify their plans for the future, on our behalf. Their cooperation has been more than willing; not only would this exhibition have been unachievable without their goodwill, but they have been, in a very real sense, our collaborators. If we do not name them individually it is not from lack of appreciation, but because we have too much to express owing to the variety of their contributions.

Some individuals, however, we would wish to mention by name for special assistance. Every curator knows that participation in an exhibition like ours puts an extra claim on his time if only through the necessary participation in its sometimes complex procedures. All our colleagues have suffered these interruptions with the greatest patience. A number of them have been even further involved because of special demands we have made, or through their offers to assume extra responsibilities. Their work has relieved us, and the staff of the National Gallery of Art, of a number of difficult problems. Among museum personnel, René S. Wassing, Rotterdam, organized the shipping of all objects from the Netherlands. Special efforts to trace photographs and objects in their respective museums, and many valuable suggestions, were made by Phillip Lewis, Field Museum of Natural History, Chicago; Phillip Gifford, American Museum of Natural History, New York; Peter Fetchko, Peabody Museum of Salem, Massachusetts; Ingrid Heermann, Linden-Museum, Stuttgart; Christian Kaufmann, Museum für Völkerkunde, Basel; Jim Specht, Australian Museum Trust, Sydney; Dieter Heintze, Ubersee-Museum, Bremen; and Fran Silverman, Peabody Museum of Archaeology and Ethnology, Harvard. Hermione Waterfield of Christie's, London, and Philippe Guimiot also tracked down elusive objects for us and arranged for them to be shipped.

Advice and work on conservation problems involved with the shipping and installation of these often fragile works was given by Alexandra Allardt, and Joseph Columbus, National Gallery of Art, whose care and experience has helped ensure their physical security and health. We are also grateful to the administration of our own museums for their kind agreement that we should work on the exhibition, and their encouragement during its progress.

The conception of this exhibition owes much to the imagination and foresight of J. Carter Brown, director of the National Gallery of Art, who has sustained the closest interest in its progress. He consistently supported our goals throughout the difficult negotiations encountered in borrowing objects for the exhibition. Indeed, without his inspiration and adventurous spirit, which he shared with us, this exhibition would never have taken place.

Many members of the staff of the Gallery have helped to bring *The Art of the Pacific Islands* to reality. Charles Parkhurst, assistant director, has employed the most skillful diplomacy in our behalf on a number of occasions, always with invaluable results. Earl A. Powell, III, executive curator and Gallery coordinator for the exhibition, also acted effectually as our advocate. Jack Spinx, chief of exhibitions and loans, has maintained a watchful eye on the difficult technical problems and complicated logistics of assembling an exhibition from many diverse sources, and Sally Freitag, assistant registrar, has carried out the essential task of ensuring the well-being of the objects in their new surroundings.

The Editors Office has given great care and attention to the editing and production of the catalogue, which has been elegantly designed by Melanie Ness. Polly Roulhac, as editor, has been unfailing in her close attention to our texts and has not only improved them but saved us from many errors.

No matter how excellent in themselves objects assembled for exhibition may be, they can often appear meaningless without an appropriate setting. The beautiful and lucid installation designed by Gaillard F. Ravenel shows every work to its full advantage, and the contribution of his design team, headed by Mark Leithauser, has been exemplary. The public, ourselves, and not least the artists are in their debt.

To all of these colleagues at the National Gallery of Art we wish to express our profoundest gratitude for their unfailing and ungrudging help in many fields.

PG ALK DN

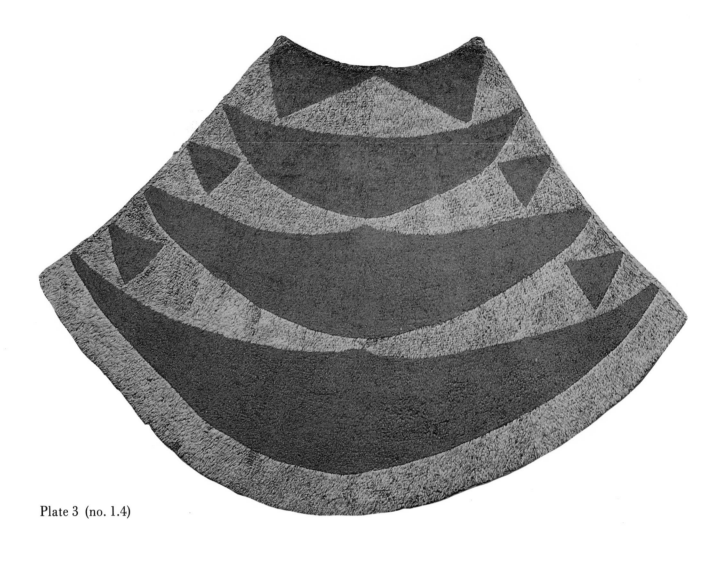

Plate 3  (no. 1.4)

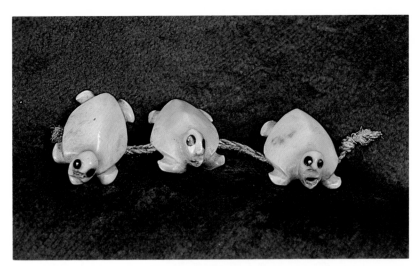

Plate 4 (no. 1.19)

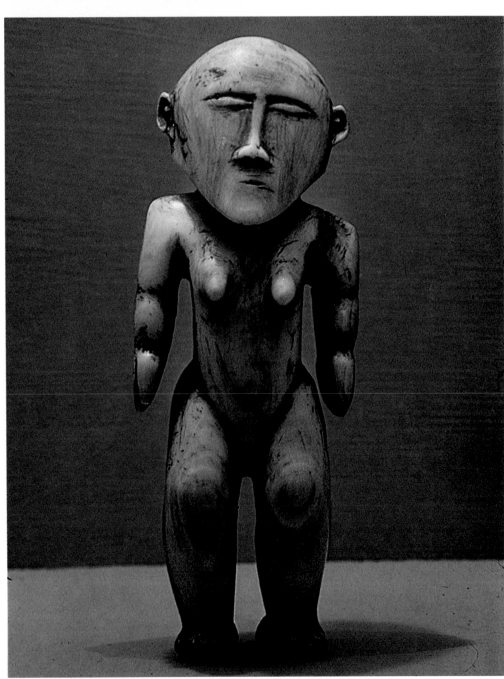

Plate 5 (no. 9.9)

15

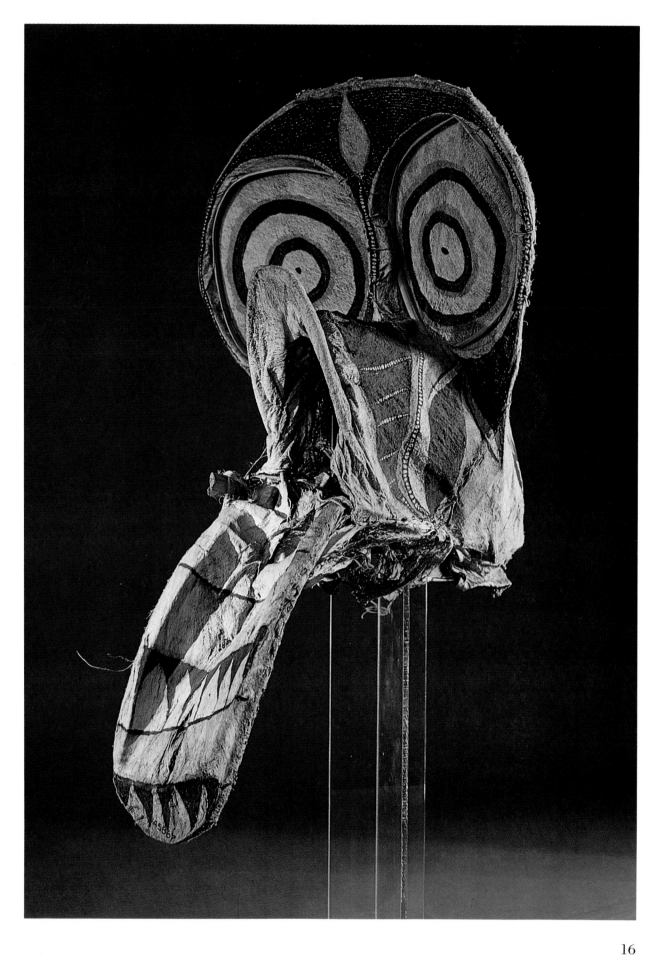

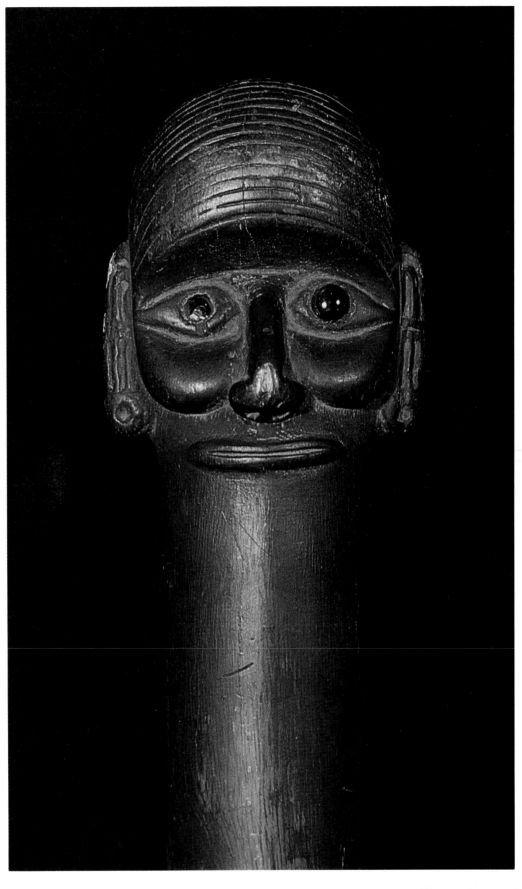

Plate 6  (no. 16.13)

Plate 7  (no. 3.10)

17

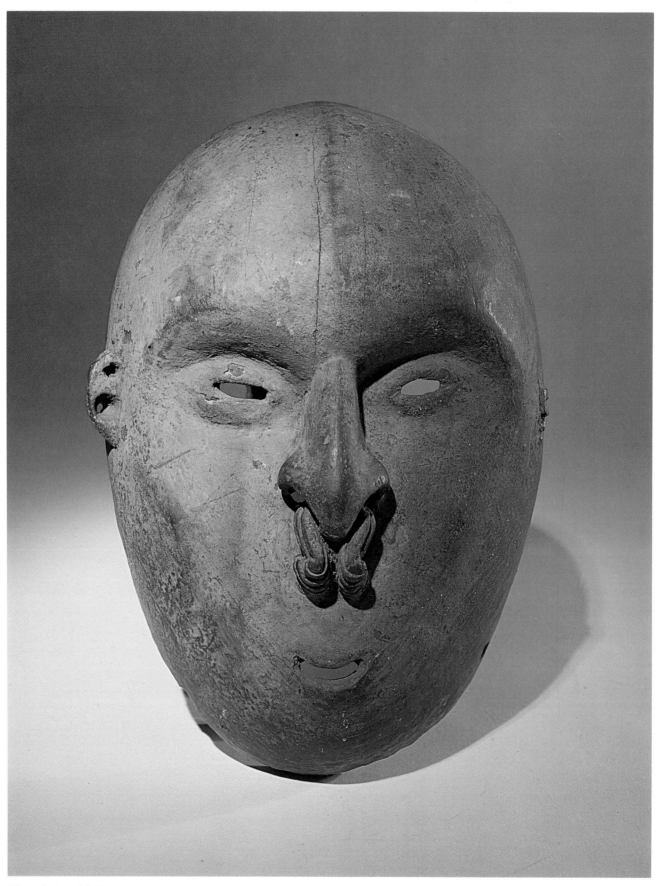

Plate 8  (no. 22.2)

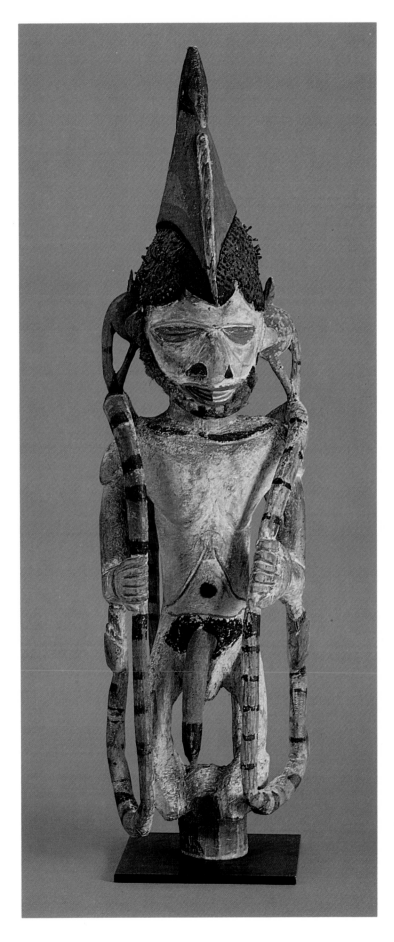

Plate 9 (no. 17.12)

19

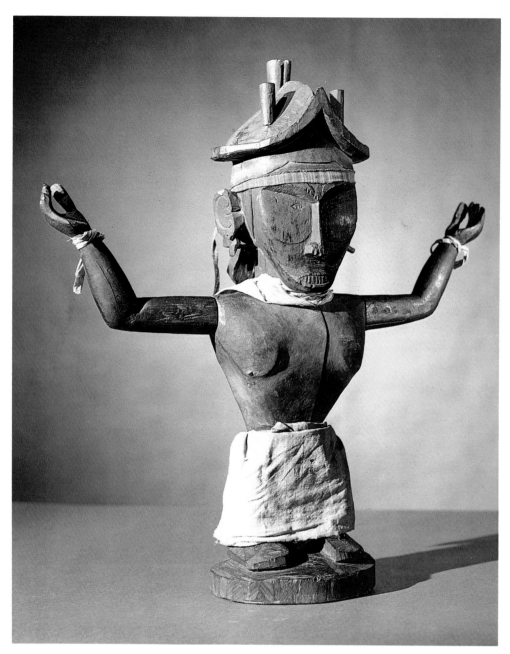

Plate 10 (no. 20.1)

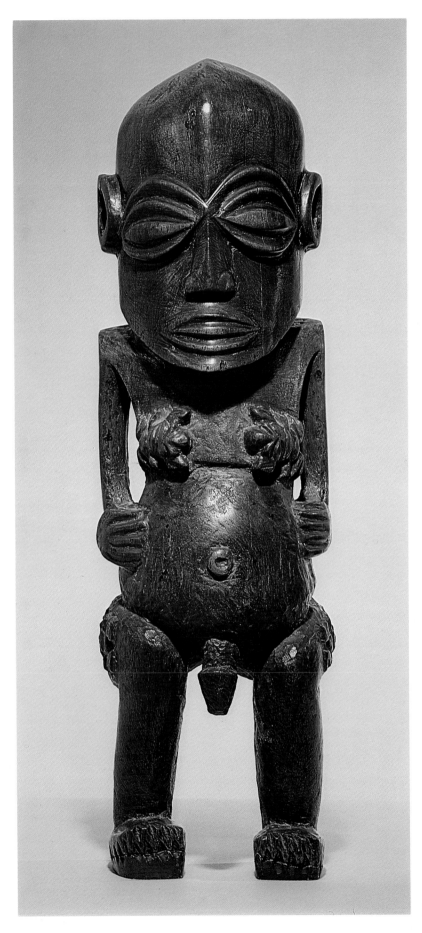

Plate 11 (no. 4.5)

21

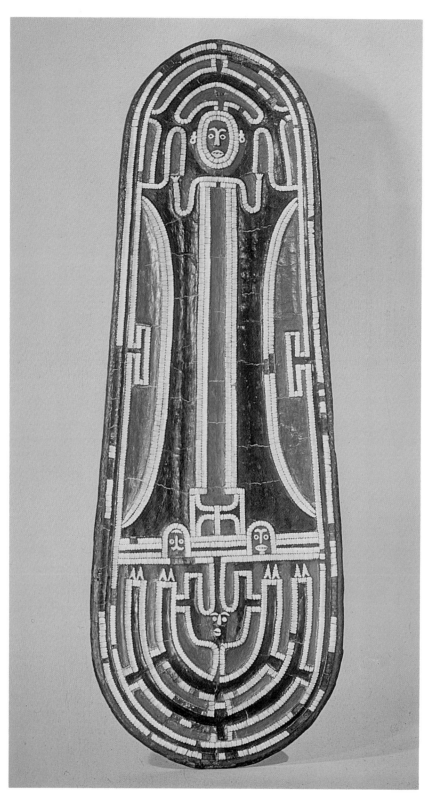

Plate 12 (no. 15.6)

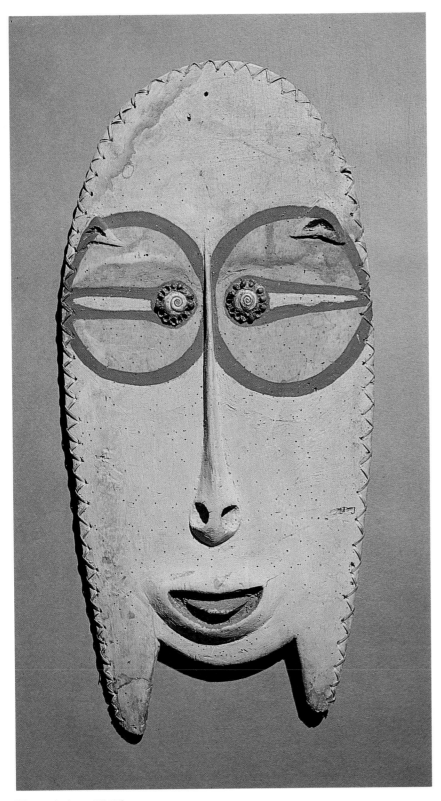

Plate 13 (no. 25.15)

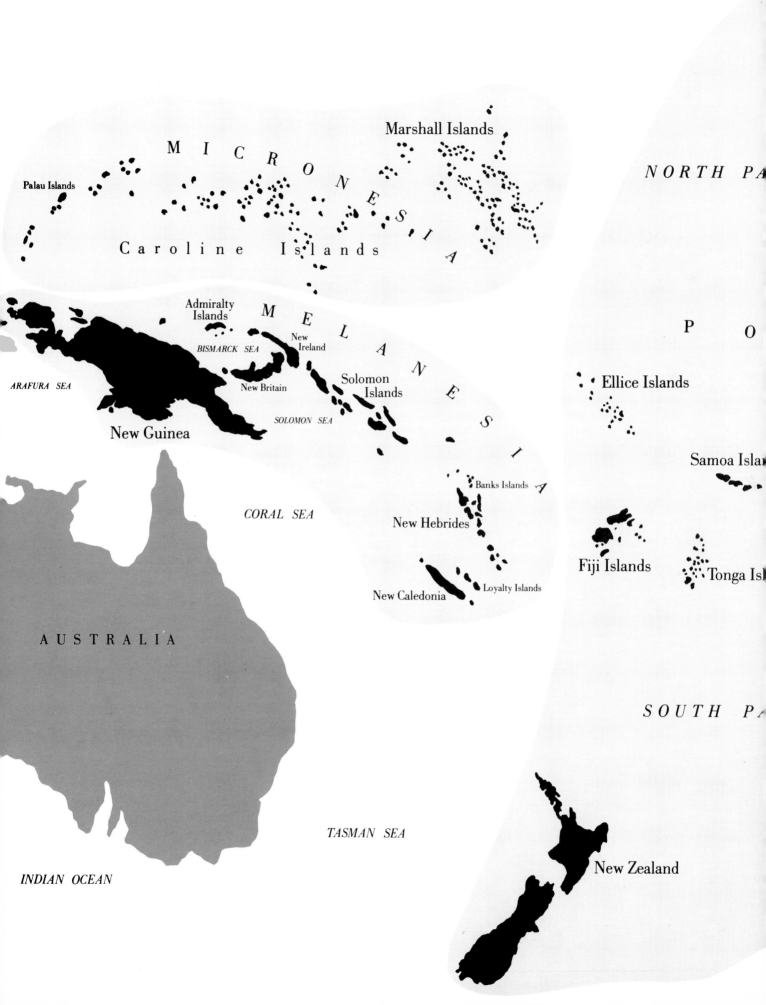

MARSHALL ISLANDS

NORTH PA

M I C R O N E S I A

Palau Islands

Caroline Islands

PO

Ellice Islands

Admiralty
Islands
M E L A N E S I A

New
Ireland

BISMARCK SEA

ARAFURA SEA

Samoa Islar

New Britain

Solomon
Islands

SOLOMON SEA

New Guinea

Banks Islands

CORAL SEA

New Hebrides

Fiji Islands

Tonga Isl

New Caledonia

Loyalty Islands

AUSTRALIA

SOUTH PA

TASMAN SEA

New Zealand

INDIAN OCEAN

Hawaiian Islands

*FIC OCEAN*

*L*
*Y*
*N*
*E*
*S*
*I*
*A*

Marquesas Islands

Society Islands

Cook
Islands

Austral Islands

Gambier Islands

Easter Island

*FIC OCEAN*

# O C E A N I A

The South Pacific (Oceania), showing Micronesia, Melanesia, and Polynesia

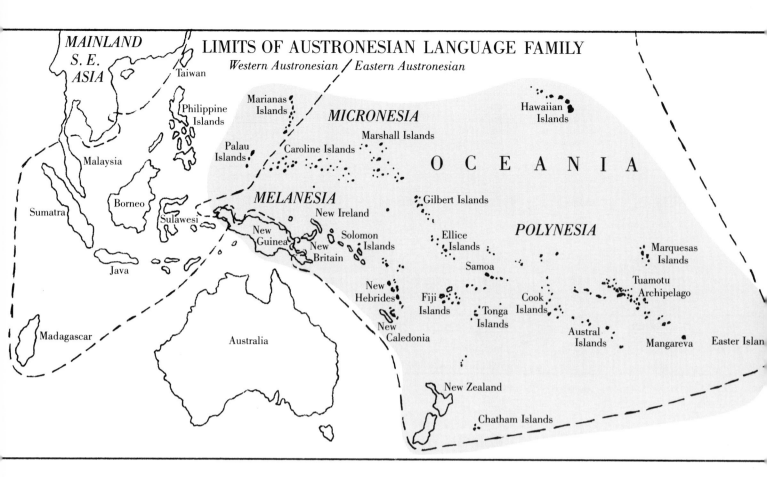

# LIMITS OF AUSTRONESIAN LANGUAGE FAMILY
## *Western Austronesian / Eastern Austronesian*

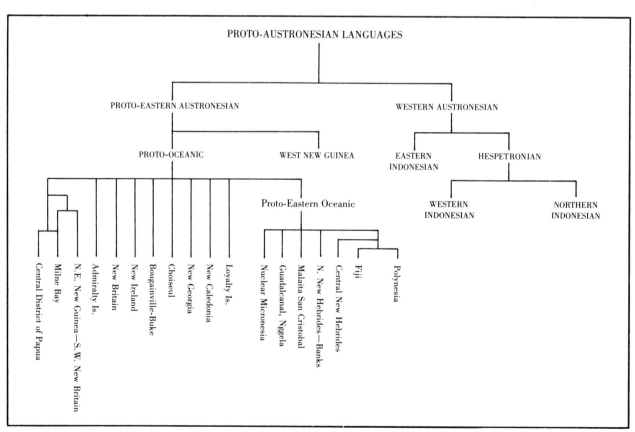

Family of Austronesian languages (after Peter Bellwood's *Man's Conquest of the Pacific* [Oxford, 1979], figs. 5.3-5.4)

# Continuities and Changes in Western Pacific Art    *Douglas Newton*

## I.  THE OCEAN AND THE ISLANDS

The Pacific Ocean is the greatest single geographical feature of our planet, no matter which precise definition is given to its limits. Geographers admit of two: one set of boundaries is marked by the coastlines of America, Asia, and Australia; the other by the same coasts but with the bordering seas, gulfs, and straits excluded. Even in the second case, the area of the Pacific Ocean stands at 64 million square miles, or just on a third of the world's surface. The vast expanse of water is interrupted by islands, the larger lying to the west. Off the coast of Asia lies Japan; to its south, Taiwan and the Ryukyu Islands, and, south again, the Philippines. Further toward the equator, and spanning it, are Sulawesi (Celebes) and Borneo. Stretching eastward from the Malay Peninsula, the Indonesian archipelago extends toward the continent of Australia.

A huge island, New Guinea lies north of the Australian continent and south of the equator. Northeast and east of New Guinea lie several groups of large islands; New Zealand, consisting of two large islands, is both east and south of Australia. A multitude of small islands lies north of New Guinea. Again, northeast, numerous archipelagoes extend north and south of the equator, roughly in northwest-southeast bands, across the Pacific toward America. The furthest inhabited land from Asia is Easter Island, some twenty-three hundred miles from the coast of Chile.

These are, in sum, the Pacific Islands. They are conventionally divided into three groups: Melanesia, Polynesia, and Micronesia (from the Greek *melanos*, black; *poly*, many; and *micros*, small; and *nesos*, island). The first term is an ethnic comment on the skin pigmentation of the inhabitants. The other two names bear on the physical characteristics of the island groups themselves. These divisions are also supposed to delineate ethnic, cultural, and linguistic differences among the inhabitants—though, as we shall see, this is not as clear a proposition as it first appears.

Works of art from Melanesia (including New Guinea), Polynesia, and Micronesia form the domain addressed in this exhibition. On purely geographical grounds a fairly logical case could be made in favor of also including works from the tribal peoples of Indonesia, the offshore islands of mainland Asia, and Australia. Indeed, recent linguistic and archaeological research have established beyond doubt that Southeast Asia was the ancient homeland of the Pacific Islands peoples, and in certain early phases it provided their material cultures and no doubt their ideologies. The

coincidence, even in recent times, of certain cultural traits and styles which have persisted in both areas has been one of the inspirations for a number of hypothetical reconstructions of Oceanic history.

Though the Pacific Islands must acknowledge the source of a human presence to be from the west, after a fairly early stage the contact, in any effective sense, lapsed. Contacts between them certainly continued—on Asian initiative—but were always peripheral. World history, or at least the conventional forms of change we associate with it, seems to have penetrated only to the end of the Indonesian archipelago. The normal impulses to conquest and proselytism, so active in that part of the world, carried no further than the extremity of Southeast Asia; and so New Guinea and the easterly islands came to know nothing of Buddhism or Hindu-Javanese culture. A little trading, fishing, and slaving on the northwest coast of New Guinea seems to have been the limit of Asian influence for many centuries.

Nor was there any effective interchange between Australia and New Guinea, its nearest neighbor, apart from minor influences on aboriginal masking traditions penetrating across the Torres Strait. At a very early period the Australian population proceeded to develop on an individual cultural path. Again, the visits of Indonesian fishers to the Australian north coast are a prime example—perhaps owing to the conservative nature of aboriginal society—of how ineffective such contacts between cultures could be. For a long period, then, the Pacific Islands went their own way without substantive interference from the outer world.

The diversity of Pacific Islands art is a feature which is bound to attract the notice of even the most casual view. Such attention can only be enhanced by the knowledge that essentially we know, with any thoroughness, only the products of somewhat more than two hundred years of collecting. The oldest date from the first collections made in Polynesia by the Cook expeditions in 1769-1770; the most recent date from about 1960, when effective Western contact was, eventually, fairly well established in certain remote areas of New Guinea. While a number of Oceanic styles, at least in their pristine form, disappeared or were profoundly modified soon after Western contact occurred, existing evidence indicates that in about the mid-eighteenth century the Pacific Islands formed one of the most artistically diverse areas in the world, notwithstanding the small size of the populations involved.

At the same time it is possible to detect not merely relationships in themes, traits, and functions, over much of the spectrum of Oceanic art, but in style itself. To even the only moderately habituated eye, there will be a closer reference among works from different places in the Pacific Islands than between works from these islands and Indonesia. We will perhaps soon come to the point where we can begin to say what exactly we mean by Pacific or

Oceanic art, and to explain why it is different from other forms. The first clues are, as always, to be found in the nature and history of the area.

## II. MELANESIA: THE ISLANDS AND THE PEOPLE

Early geographers, building on vague hints in the tales of Marco Polo, postulated a vast southern continent in the Pacific which they called Terra Australis Incognita, a fantasy which was finally dissipated by the voyages of Captain James Cook. In actuality, the total land area of the Pacific Islands is no more than about 400,000 square miles. Of these, 1,000 comprise Micronesia, and 10,000 Polynesia, while New Guinea—the second largest island in the world—accounts for about 341,400 square miles of the remainder.

The distinctions among the island groups of Oceania can be defined in several ways including the difference in the natural environment and the human cultures. When the ecological distinctions were first recognized, an imaginary boundary known as the Wallace Line (after the great natural historian who set it down) was superimposed. This ran through Indonesia, just east of Borneo, west of the Philippines, and south of Taiwan. It reflects in theory the actual geographical separation of these land masses from the islands further east, a separation that took place in the Pleistocene age, following which an interchange of flora and fauna could only occur through human agency. For our purposes, however, the more useful line is that of the Australian faunal limit, which follows closely the west of that continent. The line reflects a situation wherein primitive mammals—marsupials and egg-bearers such as the platypus and echidna—occur only east of a certain point, while primates occur only west of it. Birds of paradise and some large land birds (cassowary) also exist only to the east. Many food plants are not indigenous east of the Australian faunal limit, and have been introduced by man.

The islands themselves are of various types. Some are "continental"—that is, they once formed part of what is now a submerged continental area; these include New Guinea, the Melanesian island groups and New Zealand. Beyond this drowned shore (the Andesite Line) lie the "oceanic" islands. These are the "high" islands formed by volcanic activity, such as Tahiti, Easter Island, and the Hawaiian Islands with the great craters of Mauna Kea and Mauna Loa. The "low" islands are the coral atolls, rings of reef surrounding quiet lagoons, which have long been the most beloved images of Polynesian and Micronesian life.

Man has succeeded in colonizing all these types of environment, however variable the potential for human culture. Atolls might well provide virtually no natural resources apart from fish and a very restricted range of plant life, and, in addition, they would be

highly vulnerable to natural disaster. At the other end of the scale, the continental and high islands had far richer soils and river and marine possibilities, greater varieties of faunal and vegetable life, and a far wider range of usable materials on and through which to exercise technical skills.

Oceania was, apparently, never densely populated. It is estimated that today New Guinea has just under 3,000,000 inhabitants, Polynesia about 2,000,000, and Micronesia about 110,000. Whether these figures bear much relationship to the actual populations at the time of discovery two centuries ago is, however, highly debatable. From the earliest periods, Western influence in the Pacific has had distinctly dynamic effects on the demographic situation, for both good and bad. It is now notorious that in the early phases, such introduced diseases as tuberculosis, smallpox, and syphilis had extremely damaging results, as did the devastating dislocations caused by the indentured labor system. In more recent times, advances in medical services and the suppression of warfare have had beneficial results. Thus the effects have ranged from total extinction or severe reduction to recovery and rise in population, though in extremely irregular incidence. The real numbers of the populations in precontact times are, therefore, probably now beyond recovery. Some early estimates—among them the Cook expedition's suggestion of a million inhabitants for Tahiti—were probably grossly inflated, though at a quite recent date those for some inaccessible areas have been understated. What is clear is that throughout its pre-Western history the whole of Oceania was inhabited at any one time by a number of people who would fit comfortably, and with room to spare, into a single modern metropolis.

A major tool for the study of Oceanic culture and history has been linguistics. Through glottochronology which studies the time—or history—during which two or more languages evolved from a common source, implications may be drawn for the history of the peoples using them. Through the related techniques of lexicostatistics, statistical measurements of the rate of language evolution may clarify relationships among languages and, hence, presumably, among peoples. The Pacific Islands are a rich field for such studies: New Guinea, for instance, is calculated to have over eight hundred languages. The clustering of these into groups (families, stocks, and phyla), on the basis of descending ratios of shared vocabularies, clarifies their relationships and their possible history.

The languages of the Pacific Islands fall into two divisions. The oldest are those known as the Papuan (or, negatively, the Non-Austronesian) languages which in their original forms were probably introduced by the first immigrants. They are largely located in the mainland of New Guinea, with others in a few areas of eastern Indonesia, New Ireland, New Britain, and the Solomon Islands.

The other, even greater, group consists of the Austronesian

language family. These are classed as the Western Austronesian languages, which include those of Indonesia, Taiwan, and the Philippines; and those deriving from a postulated original language designated Proto-Oceanic. The latter branch of Austronesian comprises the languages spoken by the people of a few small pockets along the north coast of New Guinea and most of the Melanesian island groups. According to linguists, about 2000 B.C. a further division from these ancestral languages took place, from which derived the Proto-Eastern Oceanic family; and from this in turn arose, about 1000 B.C., the Central Pacific family including the Fijian languages and the other languages of the Polynesian islands. The Eastern Micronesian languages are related to the New Hebridean group of Eastern Oceanic languages.

## III. THE FIRST INHABITANTS

During about the last thirty years, archaeological investigations in the Pacific Islands have led to radical changes in our view of their history. Thickly hedged with reservations as the subject still is, a framework for that history is now emerging.[1]

Man entered the land areas of the Pacific before the late Pleistocene age (about 10,000 years ago) but at a date which remains unknown. During that period, the sea level was, at times, 270 feet lower than at present, thus exposing two huge areas of land. In the west the Sunda Shelf included not only Malaysia, Borneo, the Philippines, and Indonesia as far east as Bali, but extensive lands between and around them. The other to the east, the Sahul Shelf, united in one huge continent Australia and Tasmania with New Guinea by a belt of land across the Torres Strait. The Australian coast then extended westward to within fifty miles of Timor, and even closer to the Tanimbar and Kei islands.

These conditions obtained at two periods, during 65,000-45,000 years ago and 30,000-18,000 years ago. Consequently, the barriers presented by the sea were considerably less formidable than they are today; and it is evident that the development of water craft, however elementary—rafts, for instance—provided man with a means of travel to the eastward continent of Sahulland, the exposed Sahul Shelf. The best physical evidences for the early population of Australia are the burials and hearths found at Mungo Lake in New South Wales, dated 30,000 years before the present[2] and located in southeast Australia, far removed from any of the western approaches to the continent. Similarly Kosipe, the first known occupied site in New Guinea, is in the southeastern part of the island and is dated at 26,000 years before the present.[3] It has been suggested that the position of these sites in the east of Sahulland indicates that the continent had already been inhabited for a considerable period. Glover suggests, based on the divergencies between the tool-making traditions of Australia and southeast Asia

achieved by 30,000 years ago, that Australia (and therefore perhaps New Guinea) could have been inhabited during the earlier period of low water.[4] The fact that any earlier settlements were probably near the coasts, only to be drowned by the rise in sea level, leaves this question open for the present, and possibly for the future.

The remains discovered at Kosipe reflect the life of a people who made seasonal visits to the area for the purpose of exploiting local food supplies. Their main cultural relics are flaked stone tools, including an axe-adze type of blade that perhaps is a forerunner of the later type used throughout the island. An important implement is the "waisted blade"—an oval form strongly indented on either side—which was also found in a contemporary tool complex, known as Hoabhinian, of mainland southeast Asia. The fact that it could possibly have been used as a hoe has given rise to discussion as to whether some form of elementary agriculture was practiced by these people. At this period the temperature was probably about five degrees centigrade lower than it is today, and the main Highland area in the central cordillera of New Guinea, was probably glaciated.

A hiatus in the archaeological record follows, until about 16,000 B.C. At this time, groups of hunting and gathering people in the Eastern Highlands of New Guinea were using rock shelters at the higher levels for fairly extended periods of living; but they also maintained habitations in the lower levels of the river valleys in the form of oval, post-built houses.[5] Change in technologies took place slowly but persistently, though not consistently over the New Guinea area. The people living in the Lamari River valley had apparently abandoned the use of waisted blades at this time, but these continued to be used at Kiowa, a site to the west in the Wahgi River valley, in the Western Highlands. An important addition to the New Guinea tool kit was introduced later in this period. In Southeast Asia, ground stone adzes were being made about 6000 B.C., and these also appear in the Highlands sites between about 7000 and 5000 B.C. Pigs had been adopted as domestic animals at the same time in Southeast Asia and similarly make their appearance in New Guinea after about 7000 B.C. In island Melanesia, it appears that pockets of hunter-gatherers existed about this period at least in a few places including the Solomon Islands before 6000 B.C.[6] Waisted blades, though undated, have been found in southwest New Britain, and there are still pockets of Papuan languages on that island (notably spoken by the Baining, a mountain people), and in New Ireland, the Solomons, and Santa Cruz. On somewhat debatable evidence, there seems a possibility that New Caledonia was inhabited even a couple of millenia earlier.[7] Clearly the use of water craft for long-distance traveling persisted among these early inhabitants. It is also clear that the presence, after 7000 B.C., of ground axes and pigs in New Guinea implies that contacts between Indonesia and the Pacific Islands were active if intermittent, as does the New Guinea use of taro, an introduced crop.

Any attempt to discuss art in Oceania in a long prehistoric context must be prefaced by the statement that, owing to the paucity of surviving works, we are really asking what earlier potential for art this material indicates; it is not to be expected that much else would remain to be recovered of the arts of these early hunter-gatherers. Their tools appear to have been little suited to wood carving, for instance, though in recent times flaked stone has been used for engraving designs on arrow foreshafts. Stratified sites at Batari and elsewhere in the Eastern Highlands, however, have yielded quantities of red ochre (an iron ore) and stone blades used to shave it.[8] Evidently the pigment made from the ore was in use from before 15,000 B.C., probably—as these shelters were not permanent sites—for personal decoration. At Aibura, on the Lamari River, which was occupied from about 4000 years ago, a greater variety of colored oxides (as well as white clay) was found, giving the users the possibility of a broader palette. The only decorated object which has been found is a pebble, from Kafiavana, painted with ochre stripes about 2000 B.C.[9] Red ochre dating from about 5000 B.C. has also been recovered from Yuku, near Mount Hagen. This early use of colors may not suggest conventional forms of art, but does seem to indicate that the early inhabitants may have been involved in what is still the most important of New Guinea Highlands arts—self-decoration. In this area red ochre from secret deposits is still traded for the decoration of shell valuables and for face painting, which forms a part (though only a part) of the contemporary Melpa's magnificent system of self-adornment. The color, as in other parts of New Guinea, is regarded as particularly auspicious and vitalizing, symbolic as it is of blood.

Seashells of several species were traded over 9,000 years to the inhabitants of the rock shelter of Kafiavana in the Highlands, and they have been found in subsequent sites as well. They were evidently used as ornaments, though the very modest quantities may not reflect the true degree of ancient wealth in these valuable objects. Shells were very much less common in the period prior to the first Western contact; they were only introduced in large quantities by Europeans in the 1930s, as a medium of exchange. Styles of shell decoration have, accordingly, undergone fashionable changes.

## IV. THE EARLY AGRICULTURALISTS

Whether or not any kind of cultivation was known before about 6000 B.C., there is a reasonable chance that the ground axe-adze blades then introduced were used for forest clearing as a preliminary to the preparation of garden plots. However, the first firm evidence of any large-scale cultivation of crops has been found at Kuk, in the Western Highlands, and dates from about 4000 B.C. Ditching operations on a large scale indicate that considerable quantities of the edible tuber taro were being grown, by and for a relatively large

33

No. 12.1 *Bowl, Bird Form* (Papua New Guinea, Central Highlands Province)

No. 8.3 *Oil Dish, Bird Form* (Fiji Islands, Viwa)

resident population.

The most striking works from New Guinea at this time which can be called prehistoric are a number of stone carvings largely from the Highland areas. The earliest date of the few fragments of stone bowls discovered in controlled archaeological excavations places them about 2000 B.C. It has been proposed that some were used for grinding seeds; others are elaborate enough to suggest ritual functions.[11] The majority of these are mortars of various forms many of which are decorated with a row of bosses just below the rim. Some of them have lugs carved in human, bird, or animal heads; others are bird or human figures incorporating a receptacle. Pestles are carved with terminals in the form of various birds or bird heads—in one instance, that of the hornbill, which is no longer native to the region. A small but important group consists of what appear to be human figures with bird or animal heads. The one or two plain figures convey some fascinating information about body ornaments of the time; they evidently included armlets and anklets (perhaps woven), boar-tusk nosepieces, and elaborate wigs.

Since there are few firm dates for any of these objects, their antecedents remain a matter for speculation. One proposal is that they, with a number of somewhat eccentric stone tools or weapons, derive their inspiration from the bronze industries of Southeast Asia, which began about 3500 B.C.[12] A problem here is that the highest concentration of discoveries is far inland, in the area of the Baiyer River in the Western Highlands of Papua New Guinea. Moreover, statistically, they appear to diffuse outward from that point, for examples of the sculptures have been found in decreasing numbers as far away as the east coast and offshore islands of New Guinea and, in one remarkable instance, the coast of the Gulf Province to the south. The simpler, bossed bowls have indeed been found in west New Britain. Rather than being forms introduced to the Western Highlands, this picture suggests that the carvings show an indigenous development of both cult and utilitarian traditions, the products of which were widely dispersed by trade. Again, it is worth noting that the adaptation of animal, human, and bird forms to bowls is also found in twentieth-century work from New Britain, the Admiralty Islands, the Solomon Islands, and as far east as Fiji.

If this carving tradition can be demonstrated to be of respectable antiquity, there is a distinct possibility that its themes and even elements of its styles are ancestral to those of more recent wood carvings.[13] The animal-headed human figure, for instance, now occurs quite frequently in the art of the Iatmul and other tribes in the Sepik River system directly north of the Baiyer River. Certain figurative elements are also to be found in the current art of the Gulf Province.

A small number of stone axes which may belong to this complex of objects has also been found in Buka and Bougainville in the Solomon Islands. They are embellished with lugs in bird-head form

and with bosses, and have spreading blades. It has been proposed that these are derived from axe-blade types of the Southeast Asian bronze industry; but a case can also be made for their ultimate ancestry being the ancient waisted blades already mentioned as having been used in New Guinea, New Britain, and these northern Solomon Islands — as for other but simpler stone waisted and lugged blades of this area.[14] One might, in fact, suggest a possible, if extremely hypothetical sequence for this whole group of objects, as follows:

1. Late Southeast Asian (Hoabhianian) use of chipped, waisted blades appeared in New Guinea from about 26,000 B.C. to 8000 (?) B.C. This tradition was transferred to island Melanesia possibly before or during the last five millenia B.C.

2. A complex of stone pestles and mortars, some associated with red ochre (also used in burials), is used in the later Hoabhianian in the Southeast Asian mainland and Indonesia, probably antedating the introduction of pottery there, the latter occurring by about 6000 B.C.

Southeast Asian mortars and pestles were possibly antecedents for the use of stone mortars, probably plain, in New Guinea. They seem to have appeared in New Guinea following the rise of agriculture there by 4000 B.C. A style of sculptured mortars and pestles also originated in the Western Highlands and was disseminated by trade through adjacent islands in Melanesia. This style also subsequently became a component in the formation of contemporary styles in lowlands New Guinea.

3. An offshoot of the conjunction of the waisted blade tradition and the imported mortar bowl style was a type of elaborated, waisted stone axe peculiar to the northern Solomon Islands.

These were antecedent to, or contemporary with, a tradition of undecorated axes of similar form, which have continued almost into the present day in the southern Solomons.

## V. THE AUSTRONESIAN ADVENT

On linguistic grounds, speakers of Austronesian languages are believed to have arrived in New Guinea about 3000 B.C. That they were able to settle only on the offshore islands and in small enclaves along the coast may be taken as evidence of already well-established populations on the mainland coasts as well as in the Highlands. Among other innovations, they evidently introduced pottery, which was traded into the Highlands from coastal points, at least eighty kilometers away.

Since, however, they spread extensively into island Melanesia, it is clear that the Austronesians were in command of more efficient water craft than had been seen before in the Pacific, probably outrigger canoes, capable of traveling considerable distances.

# VI. THE LAPITA INFLUENCE

A later incursion of Austronesian immigrants to New Guinea was responsible for the creation of the first Oceanic culture to which artistic achievements of a high order can be attributed with any degree of chronological certainty. This is called the Lapita culture, after a site in New Caledonia at which its relics were first identified.[15] It has been suggested, largely on the strength of ceramic evidence, that its original homeland was in the Philippines or Taiwan (one might add Sulawesi). The culture itself seems to have taken shape in the Bismarck Archipelago. The Lapita sites have an enormous range in Melanesia and western Polynesia and fall into western and eastern groups. The western sites occur in Eloaue (St. Matthias Islands) northwest of New Ireland, and Ambitle Island east of it; in Watom Island (between New Ireland and New Britain); Talasea in New Britain itself; and Santa Cruz in the Solomon Islands. All date from about 1500 (possibly even earlier) to 600 B.C., as do sites in the New Hebrides and New Caledonia. The eastern group, in Fiji, Tonga, and Samoa, will be discussed later (see "Polynesian Cultural History" below).

The people involved with the culture (not necessarily an ethnic unity) lived in settled villages on the coastlines of the Melanesian islands, probably living off some tree and root crops, with some fishing in the coastal lagoons and gathering of shell fish. A most striking aspect of their economy is the highly important part played by trade. Obsidian, for instance, was exported to Santa Cruz, from Talasea in New Britain some seventeen hundred kilometers away, or possibly from the Admiralty Islands which are even more distant. Other stones for tools came to Santa Cruz from the southeastern Solomon Islands, four hundred kilometers away. These distances are not only impressive in themselves, but they are far greater than have been recorded for Oceanic trading complexes in recent times.

From our point of view, the most significant feature of Lapita culture was its aesthetic capability, now surviving most tangibly in its style of pottery. Also traded over long distances, this was characterized by a number of handsome forms—platters, dishes, jars with shoulders, and bottles. These were richly decorated with stamped dentate geometric designs arranged in latitudinal bands from top to bottom. This extraordinary style, highly sophisticated in organization and execution, testifies to finer craftsmanship than is shown by any other two-dimensionally decorated Oceanic pottery. Apart from the vessels, there is evidence for minor ceramic sculpture in the form of fragments of a human and a bird figure. The surface decoration of this human figure's skin and a tattooing chisel indicate that tattooing was practiced. The existence of such tools as pig-tusk gravers and stone or coral files also indicates at least the possibility of a wood-carving school.

The importance of Lapita in Oceanic art as a source for the

dissemination of stylistic traits, if not as an originator, can hardly be overstated. Green and his colleagues have demonstrated that Lapita pottery motifs were transmitted into historic times in the Polynesian arts of tattooing and tapa-cloth decoration, by way of an adaptation from one medium to another.[16] Similarly, Egloff has pointed out that the Lapita material discovered at Eloaue includes design elements which were still being used in the St. Matthias Islands at the beginning of this century.[17]

A complex curvilinear design which seems to appear on a minor number of sherds can be reconstructed as being based on three arcs forming a triangle with concave sides and convex base. This design has been found in New Caledonia and Santa Cruz, where it is dated to the earliest phase of Lapita. One example from the latter site is particularly remarkable in including at its widest part the earliest known depiction in Pacific art of a human face, while the angles are finished off with circles containing crossed motifs.[18] This is an exceedingly specific design, so much so that any recurrence in other Oceanic contexts can hardly be considered the result of convergence or of accident, and it opens a number of fascinating possibilities.

The whole design, or major parts of it, is quoted precisely in certain bronze objects of Southeast Asian origin, more especially the Roti axes and the bronze Dongson axe blades, examples of which have been excavated at Lake Sentani in Irian Jaya.[19] These—or objects like them—have been considered the prototypes of the splayed stone blades formed in the Papua New Guinea Highlands. The chronology has doubtful areas; the Roti axes are undated, and the Senati bronzes (and other finds to the west) could well have been the results of sporadic trade at almost any time up to recently. Specific Dongson influence seems unlikely as its dates (800 B.C.—A.D. 300) do not jibe with the much earlier appearance of Lapita through the area. What seems more likely is that Lapita shared certain design templates with Southeast Asian metal age art, and these were thereby transmitted to much of the Pacific.

Although only a single Lapita sherd has been found on the mainland coast of New Guinea, the area was in easy reach of the Lapita complex in the Bismarck Archipelago. In modern times, indeed, there has existed in the same area the famous trade complex between the Tami Islands (with goods including wooden bowls) and southern New Britain. Further trading complexes cover almost the whole north coast of New Guinea, linking the mainland to the offshore islands. It can be said that the two-dimensional curvilinear design has been found along the New Guinea coast between the mouth of the Sepik River and nearly to Lake Sentani. It appears to have penetrated inland by way of the mouth of the Sepik and across the north coast into what is now Abelam tribal territory; and through traditionally recorded migrations, it has reached the upper Sepik River. In the immediate vicinity of some Lapita sites in New Britain

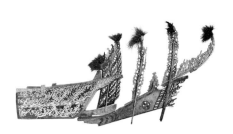

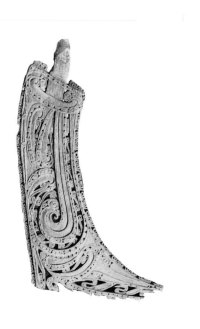

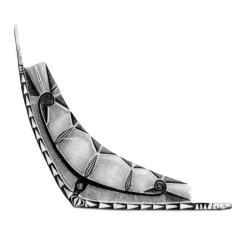

Three examples of vertical canoe prows (from the top): no. 20.2 (New Guinea, Irian Jaya, Geelvink Bay), no. 26.6 (Papua New Guinea, Milne Bay Province), no. 16.9 (New Britain, Gazelle Peninsula, Blanche Bay)

the design still exists in the *duk-duk* and *tubuan* masks of the contemporary Tolai. Further afield, it crossed the island to the Asmat area in the southwest. There are at least traces of it in the art of the Marquesas and in the faces on Easter Island paddles. We have, in fact, an instance of a component of the design in Pacific art which was introduced about 3,500 years ago to New Guinea and Melanesia, where it has survived until the present day, and which may have been transmitted to Polynesia early in the Christian era.

On formal grounds, one can trace this curvilinear design into the realm of three-dimensional art, and here one also begins to move over into a complex of religious ideology. From an early period in Indonesia, the canoe had a certain sanctity, for instance being used for burials in the Niah Cave in Borneo. This is the "ship of the dead," with high, vertical prows, on which souls are conveyed from this world to the next. Canoes are shown on Dongson bronze drums in Southeast Asia; burials in canoelike coffins have been found in the extreme west of New Guinea; and the association of the canoe with mortuary rites is recorded from the Massim area (Milne Bay Province) in the far east of the island. In several of the river areas there are beliefs that canoes embody ancestral and shamanic spirits. Elaborate vertical prows are found along much of the north coast of New Guinea, throughout island Melanesia (except for the New Hebrides), and throughout Polynesia, except for the Fiji Islands. In the other areas canoe prows are low, almost parallel to the water, as are those of island New Guinea, though this does not obviate their being richly ornamented. The Geelvink Bay prows, like those of the Trobriand Islands, New Britain, and the Solomons not only share a general form but have design elements situated in exact parallel. The same is true of Maori prows and stern pieces, and the now-vanished prows of the great Tahitian war canoes.

The distribution of this vertical style coincides with the spread of Austronesian and, later, Polynesian languages. Such prows would be viable on the seas, though certainly not on the often overgrown inland waterways. Why the New Hebrides and Fiji Islanders apparently preferred low prows is puzzling, particularly as the Marquesas, the presumed second diffusion point for Polynesian culture after western Polynesia had both types. We may be involved in two sets of cultural influences, with instances of local adaptation. It is certainly tempting to recall the Lapita curvilinear design and propose it as at least the template for some models of canoes with vertical prows at either end. The image of the Admiralty Islands feast bowls, for instance, lends credence to this idea, especially when one compares the image of the canoes of the nearby Western Islands.[20] The curled prow presents the same image as the bowls' handles; and if we remember the canoe as "ship of the dead," we must also remember in the same connection the use of bowls in the Admiralties as reliquaries for ancestral skulls.

It seems possible that we are in fact dealing with a sequence in

which an earlier group of Austronesians settled some of the offshore New Guinea islands, using canoes with horizontal prows and decorated transverse splash boards. They also spread to parts of island Melanesia. The later, Lapita culture, generated in the Bismark Archipelago, spread a style of high vertical prows into Melanesia and on into Polynesia without totally displacing the horizontal type. In inland north New Guinea the splashboards were converted into specific prow ornaments.

## VII.  OTHER EARLY TRADITIONS

If it is thought that the importance of a Lapita art style is overstated here, this indeed may be the case. Those components associated with it, which have lasted until the present, naturally assume a prominence of undue proportions by the very fact of their survival. However, though they are a striking testimony to certain continuities in Pacific art, there is no reason to suppose that there were not other influential traditions which sank without a trace or which cannot, at present, be formulated as coherent traditions because too few members of the possible equation exist.

Among the surviving are styles which apparently had a circumscribed time range. For instance, the deposition of bones in mortuary ceramic vessels was practiced in Southeast Asia and the Philippines during the first millenium B.C. In Melanesia, subsequent to the Lapita phase, it took place in a very restricted area—the Trobriand Islands and the southeast coast of New Guinea—until some period before five centuries ago.[21] Sophisticated in form and elaborate in decoration, the vessels were manufactured on the coast and evidently traded to the islands. Another Melanesian pottery tradition with distinct local characteristics is that of the Manga'asi Culture (about 700 B.C.-A.D. 1600) of Efate and other islands in the New Hebrides.[22] In its earlier phases, Manga'asi vessels are decorated with simple geometric incised patterns, applied relief bands, and, especially, small handles in the form of animal and bird heads or figures. Here again the style disappeared, and no recent parallels emerged, though a somewhat tenuous link has been proposed between early Manga'asi and the stone-bowl complex, and again between Manga'asi and the contemporary ceramics of the Atsera of the Markham Valley in Papua New Guinea. Such guesses apart, we cannot tell what relationship these once well-developed forms bore to other categories of works of art which may have been practiced at the same times, nor what influences such "other categories" may have exercised on each other, leading to those that we now know.

The most striking evidence of a complex cultural system in Melanesia has been found on Retoka, a small island off the coast of Efate in the New Hebrides.[23] Local traditions give circumstantial accounts of the migration of aristocratic strangers "from the south"

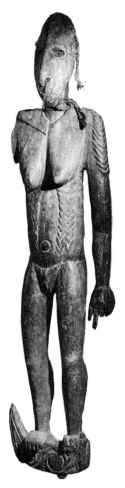

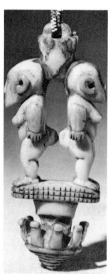

no. 22.31

No. 22.31 *Suspension Hook* (Papua New Guinea, East Sepik Province), top; and no. 9.10 *Ceremonial Hook with Female Figures* (Tonga), bottom

no. 9.10

some time before a volcanic eruption that can be dated to about A.D. 1400. Roy Mata, a chief of the group of "strangers," was said to have been buried at a known spot on Retoka, accompanied by a large number of voluntary and involuntary human sacrifices. Archaeological investigation of the site confirmed the traditions with the discovery of a mass burial dated about 1100-1400. Thirty-five bodies were disposed around a principal group of five others, the central male of which was presumably Roy Mata himself. Most of the dead had been buried wearing an impressive amount of ornaments. Some of these are of recognizable recent type, such as shell-bead aprons and armbands and pig-tusk bracelets. Others wore clusters of large shells tied at the ankles and neck and on the arms. Most interesting of all were conical whale tooth pendants and "reel"-shaped bone ornaments: these, not characteristically Melanesian, relate to similar ornaments which occurred first in the Initial Settlement Phase of the Marquesas Islands (A.D. 300-600), continued through subsequent early phases of Polynesia, and finally disappeared at the end of the Archaic Phase of Maori culture about A.D. 1300. The coincidence of these types of ornaments, given the chronology involved, remains unexplained, unless by back-migration from Polynesia into the New Hebrides, in which case Retoka might throw light upon aspects of the middle period of Polynesian culture.

Archaeological work in the southern Solomon Islands has given indications that in some aspects, at least, there has been a degree of continuity in two-dimensional design, on shell bracelets, for about the last five hundred years.[24] Other evidence is unfortunately scanty, and it seems hazardous to assume that other aspects of the art styles were equally consistent. Although it would be misleading to suppose, on the basis of preserved abstract designs from an archaeological period, that all art of the time was abstract, it would be reasonable enough to presume that similar abstract designs were used as decoration for other objects.

Granted the relative conservation of Melanesian cultures as far as their equipment went, it seems possible that certain types of utilitarian objects may have had a long history, even though they are not likely to appear in the archaeological record. The wooden suspension hook, used for hanging valuables beyond the reach of vermin, is one example. Here the distribution of the type in the Pacific area can be usefully linked to an historical framework. In the recent art of Sulawesi, the hook appears in the guise of a human figure standing upon an animal (bull) head, the horns forming the functional prongs. This is repeated in numberless variations along the northern New Guinea coast and is of great importance in both utilitarian and ritual contexts in the Sepik River area. It makes sporadic appearances in Melanesia and is again important in western Polynesia, but not in the Polynesian islands to the east. If we are to accept that western Polynesia began a phase of isolation from Melanesia about A.D. 900, we can surely assume that the hook

concept was introduced from Melanesia, probably with Southeast Asia as its original source, and had reached western Polynesia by that date.

In another realm, the distribution of the *patu* type of hand club[25] is exemplified in Melanesia by variants from the southeast of New Guinea and the Solomon Islands. An axial date for their existence in Polynesia is provided by archaeological specimens in wood and whalebone from Tahiti, dated A.D. 850-1150. The weapon is, of course, best known from New Zealand, where it was made by the Maori and Chatham Islanders.

no. 26.4

nos. 11.29, 11.22

There is also considerable evidence of continuity and development in the history of shell ornaments, especially the composite objects of turtleshell plates attached to shell disks known as *"kap-kap."* They evidently originated on island Melanesia, where they are widespread in a number of forms. Disks which might be *kap-kap* bases from the initial settlement phase have been discovered in the Marquesas and in early Tahiti. It is at least possible that the elaborate shell and ivory pectorals of Fiji are a late development of an old tradition.

no. 8.8

## VIII. EARLY RECORDS OF MELANESIA

For the student of Pacific Islands art history, it is a lamentable fact that the earliest Western explorers in Melanesia were almost totally unconcerned with the indigenous cultures of the lands and peoples they discovered. It is true that, given the nature of their missions, which were essentially to colonize and to establish commerce, and of the personalities involved, little more was to be expected. The faulty preparation for some of the expeditions and the disaffection of the crews make it almost incredible that anything was accomplished at all, let alone ethnographic research. Apart from the sheer lack of curiosity of most of the personnel, their single-minded quest for immediate and easy profit made for usually strained, often disastrous, relations with the indigenous peoples. While opportunities for making observations were usually limited, and such as were recorded were brief and superficial, it is also true enough that "in their factual observations the plain blunt sailors of the exploration period were consistent, realistic and objective."[26] Thus if what can be gleaned from the early accounts is meager, it is exceedingly valuable.

The first things that caught these explorers' eyes were, of course, the physical aspects of the people themselves, and their garments — or perhaps one should say their lack of them. Habits — particularly when theft of any kind was concerned — followed. Food supplies were always a matter of interest, largely because the explorers needed to restock their own whenever possible. Weapons, which came into play only too often, and perhaps water craft, came next, followed by accounts of houses.

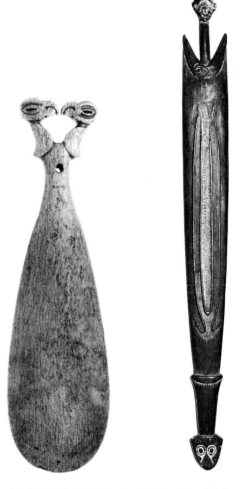

No. 11.29 *Club* (New Zealand), left; and no. 26.4 *Club* (Papua New Guinea, Milne Bay Province), right

41

All these are mentioned by Antonio Pigafetta, for instance, in his account of Ferdinand Magellan's discovery of the Marianas Islands in 1521. His note that the small outrigger boats were painted in black, white, or red is interesting, as is his observation that "there is no difference between the poop and the prow in these boats" — though he failed to mention their characteristic decorations. Micronesia was further explored during the following years by other voyagers; mention is made of fine matting used as garments in the Marshall Islands, and the flint-tipped weapons of the Hermit Islands.

nos. 19.18, 19.19

The most extensive early documentation of a voyage in Melanesia is that of Alvaro de Mendaña's expedition (1567-1568) in search of a southern continent in the Pacific. The most important result of the voyage, which failed in its main purpose of establishing colonies, was the discovery of the southern Solomon Islands. The Spaniards spent from February to August 1568 in the archipelago. The accounts left by Mendaña and his officers have a considerable amount to say of their stormy relations with the inhabitants, caused equally by the Spaniards' extortionate methods of seeking food and by the genuinely hostile nature of the islanders. A considerable amount of information is given about methods of personal decoration, including painting, hair-dying, and such ornaments as feather headdresses, shell bracelets, pectorals, and necklaces. The Spaniards noticed the great canoes, accurately described by Mendaña as "long, and pointed at the ends in the shape of a crescent moon."[27] Carvings of crocodiles and snakes were noticed on Ysabel, in what was probably a canoe house; and another such house on San Cristoval was described mistakenly as a temple, "very large and broad . . . wherein were painted many figures of devils with horns like those of goats; it had a large, wide porch, with a breastwork of boards, which seemed to be a counter. . . ."[28] The "horns" are

nos. 15.14-15.18

probably the extensions to the head to be seen on some *nguzu nguzu*. They also detailed the Malaita ceremonial batons, the heads of

no. 15.8

which they optimistically thought to be gold.[29]

Mendaña's second attempt to set up colonial communities in the Pacific Islands was launched in 1595. His intention of returning to the Solomons misfired completely, but he succeeded in reaching the Marquesas Islands. Here he noted wooden idols, but without giving details. The death of Mendaña during the course of the expedition led to the launching of the career of his chief pilot, de Quiros, who then became obsessed with his own dreams of Pacific discovery. These became reality when he received permission for a colonizing expedition in 1606.

De Quiros reached Espiritu Santo in the New Hebrides in May 1606. Idealistic and profoundly religious to the point of being maudlin, he was no more effectual than his predecessor. His associates were Torres and de Prado, whose ships became separated from his on leaving the New Hebrides. The subsequent voyage of the

latter two home took them to the islands of the Louisiade Archipelago, at the southeastern end of New Guinea. They then traveled westward through what has since been called the Torres Strait, which separates New Guinea from Australia.

Their accounts contain interesting material about the people of the area and a few drawings which accompanied them give some ethnographic details.[30] The first in this sequence is of a group at Espiritu Santo; the men are carrying large clubs, with curved ends, which are of a design still in use in the early twentieth century. In July Torres and de Prado discovered Basilaki Island and anchored in the Bay of St. Millan (now Jenkin's Bay). Another of their drawings depicts three of the inhabitants, a woman and two men, armed with lances and plain, targetlike shields. With a slight stretch of imaginative sympathy, these could be the rounded shields of the recent south Massim area.

By September the two ships were among the islands of the Torres Strait. On the "Isla de Perros" de Prado found a stock of raw turtleshell, and "a quantity of masks made of the said turtle, very well finished, and a fish called *albacora* imitated so naturally it seemed to be the very thing, and a half-man half-fish of a yard and a half high, also made as a good sculptor might have finished it."[31] The passage is of extraordinary significance; it demonstrates that by the early years of the seventeenth century the Torres Strait islanders were already making the composite works in turtleshell which are the unique feature of their art.

In the following months, Torres and de Prado were proceeding northwest up the coast of Irian Jaya. A possibly relevant drawing shows a man carrying a large, rectangular shield covered with rather random curvilinear designs. This seems to correspond to a description by Torres of natives distinguished by being "better adorned [than most they had encountered], also they use arrows and darts and large shields, seven *palmos* long and three broad, very well worked in half-relief."[32] They also used tubes of lime powder to blind their enemies. This is said to have been at what the explorers called the Bay of St. Pedro de Arlança, which is identified as being near the modern Kaimana on the south of the Vogelkop, the extreme west of Irian Jaya. One wonders if there is some confusion here: the shield is typically Asmat in form and design, especially resembling those of the southeast; and the use of the lime tubes by the Asmat has been noticed by later writers including James Cook, A. A. Gerbrands, and Michael C. Rockefeller.

Dutch aspirations to the establishment of control eastwards of Indonesia provided the impetus for the voyage of Abel Janszoon Tasman in 1642-1643. His route took him south of Australia, by way of Tasmania to New Zealand, then northward through Tonga and the Fijis; he then arrived in northeast New Ireland and followed the northern coast of New Guinea on the way back to Batavia. Tasman maintained a full record of his voyage, and the manuscript of it is

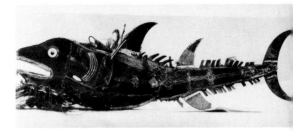

Example of a Torres Strait mask made from plates of turtleshell in the late nineteenth century. De Prado described similar masks in 1606.
The British Museum, London (2490)

43

illustrated by an unknown artist with drawings which were probably worked up from sketches made on the spot. A very detailed one shows a New Ireland canoe, "trimly made up, and adorned with wood-carving in front and behind."[33] In the drawing each carving is quite clearly a human head with a crest. How faithfully the details are rendered it is impossible to say. In the eighteenth and nineteenth centuries such carvings were placed in equivalent positions, but the difference in style between those in the Tasman drawings and the extant examples is strongly marked. The artist, or his source, evidently perceived the carvings as recognizable human representations—a fact which is by no means as readily apparent in the "baroque," complicated style of the nineteenth—twentieth-century examples. This suggests that the seventeenth-century examples were indeed in a simpler style which had developed considerably in elaboration by some 250 years later.

The great wealth of ethnographic data and specimens collected in Polynesia by James Cook's expeditions is unfortunately not equaled by the material from Melanesia. On the first voyage there was a fleeting encounter on a beach with a group of Asmat; on the second voyage, in July and August 1774, Cook visited the New Hebrides, discovering several islands more in the archipelago, and discovered New Caledonia. The artifacts from New Caledonia shown in the illustrations which accompany the accounts of the voyages, and the objects themselves which have been located by Adrienne Kaeppler,[34] clearly have exact parallels in recent forms: the illustrated examples include clubs, one of which is of the well-known "bird-head" type; a short-handled adze; and a lance with a face carved on the shaft. Rather more important is a plate in the *Atlas* based on Cook's second voyage which shows a view of the island. There are some buildings in the foreground which demonstrate that at this time the New Caledonians were building large conical houses, as they continued to do into the early years of this century. These, moreover, were already decorated with carved doorjambs and towering roof finials. It is also particularly interesting that a woman is shown carrying an infant in the manner represented in certain small carvings. Illustrations for Bruni d'Entrecasteaux's voyage (1791-1793) include, as well as a number of other styles of clubs, a mask which is recognizable as one of the *apouema* type, thus establishing a terminus for this tradition.

The New Hebrides objects which were collected on the Cook visit include two clubs of varying types (with a third illustrated in the *Atlas*) which are identical to recent clubs from Malekula, Ambrym, and Epi. Perhaps the most interesting record made in the New Hebrides is a drawing of the coast of Malekula, probably at Port Sandwich, in which a canoe, sideways on, figures prominently in the foreground. The upcurved prow is prolonged into a double-curved shape which echoes that of the recent canoe prows from the area. However, it is represented as a solid profile silhouette, without

no. 17.18

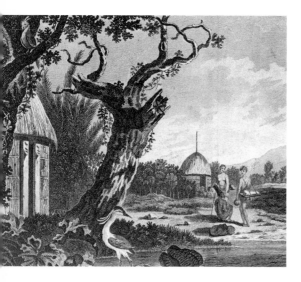

Based on a drawing of 1774, this engraving shows doorjambs, roof finials, and a woman's baby carrier of the period in New Caledonia. Similar objects are still produced. (From the *Atlas* of plates for James Cook's *A Voyage towards the South Pole, and round the World . . . in the Years 1772, 1773, 1774, and 1775,* 2 vols. [London, 1777]) Photo: courtesy of the Peabody Museum of Salem, Massachusetts       detail

nos. 13.7, 13.8

no. 13.10

no. 13.3

nos. 13.4-13.6

no. 14.7

44

the openwork carving which separates the bodies, beaks, and wings of the birds in the carvings we have. As with the case of the New Ireland prows shown by Tasman's artist, the question arises whether the artist (William Hodges in this case) was faithful to his subject, and, if so, do we have evidence of an historic modification in style?

Scanty as these disjointed items are, it can be seen immediately that every one of the kinds of objects mentioned exists in the recent ethnographic record. The question of variation in style of course remains open. It seems likely that in some cases (the Malaita batons, for instance, or the Asmat shields) there was little change; the possibilities of change in the case of some kinds of woodcarvings have already been discussed. The truly remarkable fact which seems to emerge is that, whatever happened in the preceding millenia, by the period of the two centuries between Mendaña and Cook, a considerable amount of Melanesian material culture and art had stabilized into the forms we know today. One can then propose, in general terms, a historic phase of Melanesian art which had begun before the mid-sixteenth century and which continued until a series of nineteenth-century dates in various island groups. After this one can define an "evolved traditional" phase (to use Adrienne Kaeppler's term) due to the introduction of metal tools. It is hard to see the *malanggan* tradition of New Ireland, in all its virtuoso splendor, as other than the product of necessarily introduced technological resources. Judging by some (admittedly vague) oral tradition, the same may have been true of parts of New Guinea, especially in the East Sepik Province. Certainly the hypertrophy noticed in parts of Africa by William Fagg has taken place here and there, though it would be a mistake to think it universal. Nonetheless, a convincing case could be made for the introduction of metal tools having led, at times, to an increase in physical size and elaboration of wood sculptures comparable to that of the northwest coast of America in the same circumstances. In the nature of the situation, continuities (where any evidence exists for them) are more easily traced as historical phenomena than those which have been only short-lived. Apart from the archaeological traditions which have been mentioned, other more recent changes have certainly taken place.

In many New Guinea societies, certain designs are owned by specific clans; in this situation, population movements from one area to another, with the accompanying transmittal of the designs, would obviously result in local variations, perhaps not of long duration. Such events were consequences of political action. So, perhaps, were other changes which may have taken place quite rapidly, as when one group more or less abandoned an earlier style in favor of another: this seems to have taken place among the Alamblak and Abelam. The causes here were colonization and assimilation by a more powerful group, or the introduction of new religious beliefs. Unimposed developments of new cults which had a

temporary popularity would also give rise to new art forms, such as the *uli* of New Ireland, which may have been in existence for only about thirty years around the turn of the century, or the mask cults of the Elema, which may also have been a fairly recent development at the end of the nineteenth century. The impact of Western culture on the twentieth century has certainly swept away much of the past, but clearly there were internal fluctuations in the centuries preceding.

To recapitulate, the history of art in New Guinea and Melanesia can be tentatively divided into a framework, composed of several successive periods, as follows:

*1. New Guinea pre-agricultural*
Use of ochre paints, mainly red, probably for body decoration; simple shell ornaments.
*2. New Guinea early agricultural (? after 4000 B.C.)*
Development of stone bowl-pestle complex in New Guinea Highlands, with subsequent influence on the art of the Sepik and Gulf provinces; also possible trade in these objects to western New Britain, and stylistic connections with the Solomon Islands.
*3a. Austronesian Phase I (beginning about 3000 B.C.)*
Introduction of outrigger canoes with carved horizontal prows and relief-carved splashboards.
*3b. Austronesian Phase II (beginning about 1500 B.C.-500 B.C.)*
Introduction of vertical canoe prows. Development of specific designs (used on Lapita ceramics) in Melanesia, influencing later adaptations in Sepik and Gulf provinces, and western Asmat two-dimensional art. Prototypes of *kap-kap* shell ornaments. Probably figural suspension hooks. Stone monuments, some associated with funerary or religious functions, mainly in offshore New Guinea islands and island Melanesia.
*4. Historic period (beginning before A.D. 1500)*
Art styles throughout Melanesia including many components which remained essentially unchanged into the late nineteenth century.

## IX.  THE RECENT PAST

At this point it will be appropriate to review the art of Melanesia and New Guinea as it has existed in the last century—as, in fact, it is represented in this exhibition. While in all areas the impulses to decoration, to embellishment, to the creation of the visually delightful extended over most of material forms of the culture, the greatest achievements—as in most other cultures of the world—were elicited by the purposes of religion. It is this aspect that is exemplified here. Only rarely is this not so—*as far as we know*—for instance in the arts of the Admiralty Islands and a few other places. Here,

quantitatively at least, the emphasis seems to have veered away toward the secular. We must then think of the art styles on the one hand, and of religion on the other. It would, however, be a considerable mistake to presume that through works of art alone we can understand much about the religion. While the religious systems led to the formulation of rituals, and the rituals called for works of art to be incorporated in them, those works were never directly illustrative, or narrative, of the great corpus of myth which was involved. Sculptures, paintings, and other objects are, rather, tokens, mnemonics which did not give up their messages easily, or to the uninitiated.

What was the religion of these people? It was, as with all others, an expression of their conceptions of the nature of the universe, though these conceptions were profoundly different from those of the major world religions. To generalize about them is inevitably to be misleading, as certainly they also differed, if not so profoundly, from each other. A number of common themes ran through most of the religions, however, even though these were accented differently from place to place. A basic assumption was that there existed powerful forces which were independent of natural phenomena but nonetheless were embodied in them or expressed by them. Thus the dwelling places of these forces could be the major features of nature, the forest, and the water, or, even in more localized form, the creatures that lived in them. These forces, or the beings which embodied them, were often the direct or indirect ancestors of mankind in the distant past and their numbers were constantly being increased by the more recent ancestors, through the physical transition of death. Between humanity and the supernatural forces there existed an uneasy truce, for the forces were neither benevolent nor malevolent as such. It was, however, possible to channel their power in either direction by command of communal rituals or individual magic. In both cases the undertaking could misfire and be dangerous to the participants.

While it may be inaccurate to speak of a cult of ancestors, this set of assumptions as outlined makes it clear that even the recent dead were acknowledged to have a potential to be among the highest powers. We may presume this to be the origin of the western Pacific absorption with the human head, or rather its durable relic, the skull. Headhunting was a notable manifestation of this; captured heads were gathered among the ancestral skulls, and the victims were indeed assimilated to the ancestors. Quite frequently the skulls were actually regarded as the most truly sacred objects of all.

That there was a distinction between the secular and sacred was reflected in the institution of initiation; and that the sacred was divided into a hierarchical order led to initiatory disclosures in sequence, which, of course, entailed an elaboration of ritual and therefore its appurtenances. In some cases the stress of the ceremony was upon the revelation of those objects through which the

47

theology of the cult was expressed. In others, as in the New Hebrides, the participant was himself, as it were, the sacred object and progressed through stages of ritual to a superhuman state of sanctity.

An extraordinary aspect of Melanesian religion was its concentration in the realm of men. Only men prepared the rituals, were initiated into them, and learned their secrets, which were concentrated in guarded ceremonial houses or screened enclosures of which no trespass was permitted. The paradox implicit in this state of affairs is obvious. If religion is intended to mediate the natural and supernatural worlds in their totality, how can half the natural world—the world of women—be omitted from it? The stratagem adopted to solve this dilemma was an ingenious one. Women were enjoined to take part in some rituals, and for others they were allowed to see substitutes for the true sacred objects—even though they were never told their meaning. It is probably due to this impulse that they were shown the small *uli* figures of New Ireland; the huge lanceolate masks of the Gulf of Papua, which relate to the secret bull-roarers (a musical instrument) and the gable paintings of some Sepik area ceremonial houses, the imagery of which refers to the objects kept within.

no. 17.1

no. 25.9

nos. 22.12, 22.58

With rare exceptions the primary subject of art was the human figure, for this was a world and ideology that centered around the image of man, to which all other natural images could be assimilated. Technically, this was done by a method of assemblage rather than recreation. If man and bird shared the same spiritual being, they were shown as a group; if other animals were of a man's clan group, they were carved or painted clustered on his body. If human features were distorted, it was not to satisfy fantasy; rather the mythology described them as so. The men of the islands believed in their image of the world and reported it faithfully in their art.

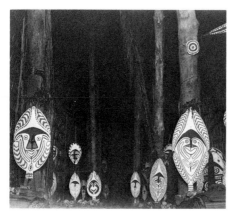

Interior of a Men's ceremonial house in Papua New Guinea, Purari River Delta, 1912. Photo: courtesy of the Field Museum of Natural History, Chicago

## New Caledonia

The visual arts of New Caledonia are limited to sculpture, which itself is severely limited in types of object. The northern part of the island was the only area in which masks and figure sculpture were produced. The masks fall into several types, both seminaturalistic and those with huge, curved noses, staring eyes, and grinning teeth. With their towering caps of human hair and shaggy feather cloaks, these representations of water spirits are among the most ferocious images of Oceania. By contrast the naturalistic figures of ancestors are blander in their softer forms, except perhaps for those which show masked men.

nos. 13.4-13.6

nos. 13.1, 13.2

In the rest of the island, sculpture is concentrated on the decoration of men's ceremonial houses, the conical roofs of which are almost unique in Melanesia. The main elements are massive doorjambs, lintels, and finials. Generally speaking the jambs have human faces at the top, the rest of the surface being covered with

nos. 13.7-13.8

48

lozenge designs in relief, lintels being decorated in the same way. Both the faces and the specific lozenge designs vary in different parts of the island.

The finials are even more diverse. Uniform for the most part, they are based upon human faces surmounted by stylized forms symbolizing added human facial features. The faces progress from being, in many cases, extremely grotesque with pendant bulbous cheeks, to forming rhythmical groupings of completely abstract forms. A towering spire above such an assemblage was used to hold large marine shells. In the interiors of the houses, the posts were carved with human faces, and long horizontal planks demarcated platforms to which men repaired in search of divinatory dreams. Similar in style to the architectural elements were coffins or caskets made for the storage of ancestral bones. Much care was lavished on the production of weapons: spears and more particularly clubs of numerous types, the best known being the halberdlike "bird-head" form. An object of weaponlike appearance is the *gi okono*, a baton mounted with a large nephrite disk, which is actually a staff of office. A striking feature of New Caledonian sculpture is that it is monochromatic. The chosen color is black, with very slight touches of red or white, which only deepen the somber and weighty effect of the generally massive forms.

no. 13.10

no. 13.11

## The New Hebrides

Sculpture, and to some extent painting, flourished mainly in some of the northern and central islands of the New Hebrides: the Banks Islands, Malekula and its offshore islands, Ambrym, and Pentecost. The impulse for most of it was generated by the ceremonial needs of the great men's grade societies. The rites by which a man passed, first through his entry into adult society—circumcision—and subsequently upward through the grades (whatever the local name of the society), finally into the rites for the dead, entailed the production of a great many types of objects. These included masks, figurines, and large figures (some commemorative in intent). There were also ritual accessories, such as clubs used for the many pig sacrifices the rites demanded. Most of the ceremony was celebrated by the beating of huge, vertically set slit gongs in long batteries, to simulate the voices of ancestors.

The artists of the New Hebrides did not avoid wood carving, even in hard woods; but the most remarkable and common techniques used involved carving in fernwood and modeling in a compost of vegetable matter, clay, and spiderweb, over either cane frames or tree-fern armatures.

The fern figures of the Banks Islands are in a distinctively attenuated style on pole supports. The material is indeed treated as freely as though it were solid wood, with semi-detached and undercut elements. These figures were placed at the front outside corners

no. 14.1

of the ceremonial houses, the façades of which were decorated with painted panels that repeat the same elongated figures with sometimes circular, sometimes triangular, faces.

The Big Nambas people of the interior mountains of northern Malekula also work largely in fernwood, the most striking objects being colossal heads projecting as finials from the gables of their small ceremonial houses. Apart from weapons and faces on slit gongs, they appear to have carved little else.

The Small Nambas (Bot'gote) in the southern part of the island were extremely productive, creating ceremonial objects of all kinds. Whether they were carved or modeled, these works were brilliantly painted in browns, reds, blues, black, and white. Each grade of the men's society had one or more type of figure associated with it, in wood or fernwood, decorated with the color schemes of body paint specified for the members of the grade. Masks represented legendary beings and were often huge constructions in lighter materials towering up to eight feet high. The gestures—the arms are usually sharply upraised—are dramatic; the noses are elongated, eyes project on stalks, and boar tusks project from the corners of the mouths. Some of these characteristics are carried over into the painted fernwood figures made for important deceased men, which are fitted with their overmodeled skulls. In the mortuary ceremonies at which these figures were displayed, lesser figures also appeared as their children and were manipulated as if dancing. In spite of the gaudy color and ramshackle construction, there is a marked spirituality about this strange, violent style; it is human, ephemeral, and aspiring. These are qualities perhaps most fully expressed in the

no. 14.10

soaring form of a club once used for killing pigs—an act which led the performer upward to spiritual power. More clearly still, perhaps, such associations cling to the heads of the monumental wood slit gongs and fernwood figures from Ambrym Island. The use of the material in the latter is, of course, totally different from that of the Banks Islands or even southern Malekula, though it has affinities to the style of the Big Nambas and is partially used in north Malekula. The simpler body forms, with tightly constricted limbs are surmounted by enormous heads which seem to deny the importance of the rest. Huge disks of eyes give a dreamlike effect which was not contradicted by the former (now usually vanished) polychrome.

## The Solomon Islands

The first impression given by Solomon Islands art is that it is dramatic, elegant, and curiously luxurious. This is due mainly to the predominance of black as an overall color, with very minor highlights in red and small linear patterns in white. This kind of pattern is frequently carried out in the form of small mother-of-pearl shell inlaid in units. These units, against a black background, give off a jewellike shimmer.

50

The two northern islands of the archipelago, Buka and Bougainville, have a few large figure sculptures, which seem mainly to have been used as representations of the dead, though others were carried in women's puberty ceremonies. The most prevalent figural motif, however, appears in low-relief designs, the body shown squatting with raised arms, the head crowned with a peaked coiffure. This relief carving is used in many contexts, from the sides of canoes and slit gongs to spoon handles. It appears, perhaps, at its best on ceremonial paddles, where its versatility is expressed in a considerable number of variations.

no. 15.2

The central Solomon Islands are rich in small sculptures the most famous examples of which are the small *nguzu nguzu* carvings attached to the prows of war canoes. These islanders were notable from the earliest times for their constant head-hunting activities, and their canoes were celebrated for their great size and elaborate decoration. The prow and stern posts were exceptionally tall—up to ten feet high—and decorated with shell inlay and rows of shells attached from top to bottom. Small figure carvings, including the *nguzu nguzu*, were attached at various points. In all, the sculptures' great focus is the head, which is given prognathous jaws that distort the whole into a horizontal rather than vertical form. These islands are celebrated also for their superb overmodeled and inlaid human skulls, and are the area of the finest shellwork.

nos. 15.14-15.18

nos. 15.9, 15.10

The ceremonial batons of Malaita have already been mentioned; the most magnificent works, however, are the painted and shell-encrusted shields. These are of two types: one is convex and rectangular, the other flat and somewhat elliptical. The latter type, of woven cane, is also used, undecorated, for warfare. The designs, usually showing elongated figures with small heads, are outlined in small pieces of shell adhered to a painted background usually black with touches of red. Skulls of ancestors and chiefs were carefully presented in small "house"-shaped shrines, their entrances being closed with some of the most remarkable accomplishments of Solomons shellwork. Here the entrance coverings were composed of heavy slabs of tridacna clamshells, carved into openwork designs of human figures.

no. 15.8

nos. 15.6, 15.7

no. 15.5

Animals, birds, and fish are often represented in the art of the central Solomons, but even more in the southeast islands, where fish, including shark deities, and birds figure repeatedly in many forms. Among the most attractive are bowls in both small and mammoth sizes devoted to the service of the deities. There are also several local styles, some using human figures as handles, some only fish; the most elaborate have the bowl itself in the form of the frigate bird with accessory fish. The most important ceremonial centers were the buildings in which the sacred bonito fishing canoes were housed. (These also were the models for feast bowls: one about twenty-five feet long is recorded.) The tops of house posts were carved with figures of deities who controlled the bonito shoals and

no. 15.19

no. 15.21

51

the predators—birds and sharks—which followed the fish. The figures are carved in a severe, faceted style, the arms stiff and the legs slightly flexed. Often sacred objects were a peculiar type of skull shrine, carved in the form of a shark or bonito according to the dead man's totemic affiliation; the remaining bones were preserved in model canoes.

no. 15.22

The Santa Cruz Islands, to the east of the Solomons, are inhabited by people speaking both Austronesian and Papuan languages; they seem also to have had contacts with Micronesia (witness their canoe types and the technique of weaving). Their art, however, is clearly related to that of the Solomon Islands. The human figures show a very similar treatment of the head, with minute geometrical painted patterns and the constant use of bird and fish imagery. This is seen at its best in pectorals composed of openwork turtleshell plates over clamshell disks, the most beautiful variant of this type of ornament in Melanesia.

nos. 19.20, 19.21

nos. 19.23, 19.24

## New Britain

Stretching between New Ireland and New Guinea, New Britain is a mountainous island with relatively narrow coastal lowlands, and a corresponding contrast between the inhabitants of the two regions. Among the more important groups are the Tolai of the northeast coast and the Sulka to the southeast. The Baining inhabit the mountains of the northern area (the Gazelle Peninsula).

Masks are an important feature of the art of New Britain and the Witu Islands off the north-central coast. While there is a large number of types, few are wood carvings: most are constructed of fragile and impermanent materials such as bark cloth, pith, and netting over cane frames, sometimes with carved wooden accessories attached. There is little large-scale carving, and even that has a tendency to filigree, real or simulated, which gives it an airy, ephemeral quality.

These characteristics are marked in the art of the Tolai, who inhabit the northern coastal area of the Gazelle Peninsula. Said to be immigrants from southern New Ireland, their art shares the forms and, to some extent, the styles of that area but is considerably more refined in execution. Masks and carvings are associated with the men's Iniet society.

Part of the Iniet initiatory rituals involved dancing with staffs of openwork design in mock assaults on the novices. The wearing of masks modeled over the facial bones of ancestral skulls was also incidental to the ritual. Small stone figures, comparable to those of southern New Ireland, were heirlooms transmitted to new members of the society. In further rituals of name giving, the novices were taken to a display of life-sized figures of ancestors, similar in style to the dance staffs, some capped with skull masks. These were clearly related in theme and intent to the *rambaramb* figures of the New

no. 16.3

no. 16.1

nos. 16.4-16.6

Hebrides, the skull-mounted figures in New Guinea, and possibly the early forms of the New Ireland *uli*.

The Dukduk society of the Tolai used only two types of masks, both basically conical, of netted and painted material. Whereas the Iniet society seems to have been involved with magic and a cult of the dead, the Dukduk was very largely involved with social control.

no. 16.8

Basically conical masks built up of strips of pith were made by the Sulka. Features, carved in wood or outlined in more of the same material, were attached. Some such masks (*hemlaut*, "old man") are crowned with huge umbrellalike disks supported by carved animal or insect figures. Small figure carvings also exist which were probably additions to the masks; but large-scale wood carving is rare with the exception of an animal with a tall bannerlike extension at its back. Its use is not known, though it has been called a canoe prow; and a function as a dance object seems more likely. The prevailing color range of Sulka masks is unusual: a cinnabar red, now usually faded to pink, with some black, white, and green. The same scheme is found on the Sulka's heavy shields, which also show the patterns painted on the dance banners.

no. 16.19

no. 16.17

The Baining people live in the mountainous area between the Tolai and Sulka. They created masks and dance objects entirely from bark cloth on light bamboo frames, used in day and night ceremonies. Among the most astonishing works from the Pacific are the enormous *hareiga* figures, of which examples up to forty feet high are recorded, which appeared in ceremonies held in the daytime. These were male and female, in pairs, with elongated trunks, spindly limbs and tall domed heads with elementary features. They were probably related to human fertility. Not worn as masks, they were carried by means of a spinal pole strapped to a man's back. The true masks (*kavat*) of the night dances were helmets that fitted over the whole head and were used, apparently, without accompanying costume except for an exaggerated bark cloth phallus and live pythons held in the hands. Owlish in construction, they represented spirits of the bush, which was the home of these seminomadic tribesmen. The masks of the Witu Islands fall into only three types, one of which—a wooden helmet mask—seems to have been used in ceremonies for the dead.

nos. 16.13, 16.14

nos. 16.21-16.23

At the farthest point west of the island, the Kilenge still exist as part of a trading complex which spans the Vitiaz Strait; and consequently their masks and other carvings fall into the same style area as those of the Huon Gulf and the adjacent New Guinea mainland. A chain of small islands stretches southeast between New Britain and the Solomon Islands archipelago. Some of them, including Nukumanu and Tauu, are Polynesian outliers. Nissan Island, however, while administratively part of the Solomon Islands, produces masks which continue the New Britain tradition of using impermanent materials with wood accessories. At the same time, their surface treatment has much in common with some of the

no. 15.1

decorative elements used in Buka and Bougainville in the northern Solomons.

## New Ireland

Although the people of New Ireland were culturally diverse and spoke a number of Austronesian languages, there were three main stylistic areas on the island: the northern and northwestern area, the home of the Malanggan style; the central plateau, where the main works are the *uli* figures; and the southeast and south, notable mainly for small chalk commemorative figures similar to those of the Iniet society of New Britain.

*Malanggan* is the collective name for a series of rites and the carvings and masks associated with it—works of a physical complexity unequalled in Oceanic art. While there are a number of variants of the style, there is one feature common to them: the surrounding of a figure, human or animal, or even a vacant space with thin parallel rods connected with short bridges. These rods are themselves incised or carved and, like all the elements in the sculpture, painted minutely with patterns in black, red, and white. This manipulation of negative space creates a density of levels which is rendered even more mysterious by the shimmering layers of color. Even simpler objects, such as the reliefs of large birds set against openwork backgrounds, still have much of the same dazzling quality.

nos. 17.13-17.17

nos. 17.10-17.12

no. 17.6

no. 17.3

The long totem-pole-like carvings, designed to be seen vertically or horizontally, and the reliefs are apparently the true *malanggans*, subtypes of which have specific names. Standing figures, in which the compositional stress on enclosing elements is diminished, are *totok*. There are a number of types of masks, including the *matua*, in full *malanggan* style, not worn but placed on ceremonial displays; they are similar to carved heads used for constructed full figures. Other types include *tatanua*, which were possibly intended as portraits and were used in the dance as were *kepong* masks.

*Malanggan* (including *totok*) carvings are displayed at *malanggan* rituals, which are primarily held in memory of the dead, though sometimes initiation ceremonies are incorporated in a symbolic replacement of them. The carvings are commissioned from experts by a patron representing the clan of the deceased, and the content of the carvings probably refers to ancestoral myths. At the climax of a long ceremonial cycle, the *malanggans* were displayed in specially built shelters with an enclosed area, their magnificence and the lavishness of the associated feasts redounding to the prestige of the patron and his clan.

no. 17.2

The memorial ceremonies of central New Ireland had as the focus the large *uli* figures only. These certainly include some of the formal features of *malanggan*—some use of enclosing bands, for

instance, and upraised hands—but not the aerial quality nor the animation of surface. By contrast all *uli* are monumental, even ponderous. Effigies of important men, they are symbolic rather than illustrative. Being displayed at rites associated with the burial of chieftain's skulls, carried out only by men, from which women were barred, they epitomized the totality of society by being endowed with both male and female sexual characteristics. Smaller *uli* figures were also displayed in such a way that they could be seen by the women outside the ceremonial enclosure; it is a typical example, similar to many practices in New Guinea and Melanesia, of the way in which intimations of the major ritual objects were conveyed to those unqualified to see them.

no. 17.1

The styles of southeastern New Ireland are similar to those of northern North Britain. Small memorial chalk figures were set up in temporary shelters; simple in style, they are very similar to the stone figures of the Iniet cult of the Tolai. The canoe prows also correspond in general form to those of the Tolai but are less elaborate.

Masks do not appear on the mainland, but a few types are made in the Tanga Islands off the east coast, in somewhat eccentric forms and of ephemeral materials.

no. 17.20

## Admiralty Islands and the Western Islands

The Admiralty Islands group consists of one large island, Manus, with a number of much smaller islands clustered around it. The people fall into four distinct groups. The interior of Manus is inhabited by the Usiai. The group called *Manus* are largely offshore islanders, with a foothold on the coast, while the main coast dwellers are the Matankor, who also inhabit three of the islands. The Usiai are, accordingly, largely agriculturalists, and the Manus primarily fishers and traders. The Matankor, in a favorable central position, are producers and traders for both the other groups—in this they somewhat resemble the Tami islanders of northeast New Guinea, with whom the Admiralties had trading relations.

The Matankor were in fact craftsmen, with wood carving as their general product and some local specialization in particular materials, such as obsidian blades for weapons. Accordingly, their work is, to a most unusual degree in Melanesia, secular and utilitarian—there was, for instance, no masking tradition. Furniture (head stands and house ladders in particular), household objects such as scoops and ladles, and large slit gongs are common. The most spectacular objects in this range, however, are the huge, hemispherical feast bowls. The handles of these, like terminals and handles on some other objects, are large elaborated spirals. Human figures, often associated with, or actually between, the jaws of crocodiles are also sometimes incorporated into some of these objects. Figures as such, however, are less common and less varied

no. 18.4

no. 18.2

than in other parts of Melanesia, and their significance is unclear.

no. 18.1    The larger figures were used almost as architectural elements, but it is very possible that they also were ancestral representations. The predominant color used for Admiralties sculpture was red, applied to forms which are consistently rounded or geometricized in an almost naive manner. Surfaces are enlivened to some extent by lozenge patterning or rows of tiny triangles; but in general the sculpture is formal and static in terms of the Melanesian world.

While there is even less figure sculpture from the Micronesian people of the nearby Western Islands, and little on the ambitious scale of some Admiralties work, the kinship between them is very clear. The same patterning is found, and above all the use of the

no. 19.1    spiral. Examples of it vary in size from the prows of the huge plank-built canoes, constructed in the past, to the highly elaborate

nos. 19.2-19.4    terminals for lime spatulas. These carry a refinement of filigree carving to a remarkable degree of virtuosity.

## New Guinea

The enormous expanse of the island of New Guinea  and the dispersal of its small population have resulted in one of the most heterogeneous assemblages of cultures on earth. One minor reflection of this is the great number of languages spoken by some three million people living there: approximately eight hundred, or a quarter of the known languages of the world. This among other factors—one of them the constant state of local warfare which existed until quite recently, and the undoubted difficulty of much of the terrain—has led to a general conception that the cultures were isolated and insulated from each other. That situation would, of course, have been the ideal condition for an ever-increasingly idiosyncratic development. In practice—and ignoring the large-scale speculations that may be made about prehistoric activities—it is evident considerable small shifts of population were constantly taking place, and that short-link trading complexes spanned large areas of the island. All these entailed, if in circles of decreasing influence, repercussions for the ideology of both allies and enemies. The stability of the local culture, opportunities for changing it, and degrees of receptivity to those opportunities must have been in a constant state of balance.

The languages of New Guinea can be organized by linguists into phyla, large groups with certain percentages of shared vocabulary; and a similar process can be extended to the artistic styles. (It may be remarked that languages and artistic styles are not by any means coterminous). A number of classifications of the New Guinea styles have, in fact, already been proposed on the basis of geographical location and affinities. A simple and somewhat arbitrary form of division has been adopted here, each area including several subareas, styles, and substyles.

The areas are:

1. The northwest coast, including the Geelvink Bay area, the coastline eastward, Humboldt Bay, and Lake Sentani.
2. The southwest coast, including the Mimika, Asmat, and Marind-anim peoples.
3. The Sepik area; the coast and the area southward spanning the Sepik River and its tributaries.
4. The northeast coast
5. The central Highlands of Papua New Guinea
6. The Gulf of Papua, including the Torres Strait Islands.
7. The southeast, including the terminal capes of the island, and the Trobriand, d'Entrecasteaux, and other archipelagoes.

These are not by any means mutually exclusive; there are external relationships to be traced in all of them. The Gulf of Papua, as a style area, could be extended to include aspects of Marind-anim art. Asmat and Mimika art have traits in common with that of Geelvink Bay, which itself has stylistic links with the southeast islands. The styles of the eastern Sepik River tributaries have remote connections with that of Astrolabe Bay; while some aspects of Sepik River styles are quite close to those of the Gulf of Papua and even the western Asmat. Some of these connections are given support by linguistic theory, as in Laycock's proposal of relationships between the languages of the central Sepik and the Gulf of Papua. Evidently it will become reasonable to think of the artistic styles of New Guinea not only in fairly large clusters of styles, but in macro-styles of far wider range.

## 1. *The Northwest Coast*

With the Radja Ampat Islands, the westernmost of which can be called part of New Guinea, one also approaches closest to Indonesia. Like that of Geelvink Bay, the sculpture of these islands is notable for small figures of the type known as *korwar*. Those of Radja Ampat are, with their prismatic body and facial forms, the    no. 20.1
most "Indonesian" of all New Guinea art. The *korwars* in the various styles of Geelvink Bay also have features comparable, in a schema-    nos. 20.3-20.6
tic way, to some Balinese art; especially the long, pointed noses and the curves of the openwork panels are Indonesian in feeling. This openwork is even more elaborately worked out in the panels making up the composite canoe prows.    no. 20.2

On the coast of the bay, running eastward, and on some of the islands offshore, the main works are small, simple human figures with oversized heads and prominent, sharp noses; their features are repeated on the canoe prow decorations which combine human    no. 20.9
heads and stylized birds in the round with silhouette reliefs of fish and birds. There are also in this area (the Seko coast) somewhat coarsely executed paintings on sheets of bark cloth. A distinct change in style appears in the villages of Humboldt Bay, further east    no. 20.11

still, where the heavy shields, figure sculpture, and other works are carved in a bold, rather heavy manner.

no. 20.15

Inland from Humboldt Bay lies Lake Sentani, the home of one (or rather several) variants of the most individual styles of New Guinea. Set on piles over the Lake, the Sentanis' buildings were unusually specialized: the common peoples' houses were less grand than the huge houses with pitched roofs of their chieftains, and both types were distinguished from the pyramidal ceremonial houses. The chiefs' houses were embellished with numbers of figural sculptures, both as part of the structural members (the posts supporting the roofs) and as terminals of posts projecting through the floors. In the former, the expanding winglike forms at the top are actually the roots of an up-ended tree, as are the *mbis* pole of the Asmat (mentioned below). These areas are often carved with spiral designs and with silhouetted reptiles in openwork form; and the trunks have human figures in high, almost detached, relief. The post terminals are carved completely in the round, as simple figures or couples, sometimes side by side or back to back. The style is reduced to essentials. Legs tend to be elongated; arms, when shown undetached from the bodies, are worked in the lightest of low relief. The heads are a simple form, with features which are not much more than incisions on the surface. Tranquillity and balance—due, Kooijman suggests, to lifetimes of actual balancing in small canoes on the waters of the lake—are the spirit of Sentani sculpture. These themes are reflected to a high degree in a house post (now in Amsterdam) and the famous pair of figures on a single base,

no. 20.16

no. 20.14

formerly in the Epstein collection—possibly works by a single sculptor, but certainly two of the most beautiful images in Pacific art. Minor objects, such as bowls, are also decorated with relief carvings of elegant, springy design, as are some painted bark cloth hangings. Other bark cloth paintings, of totemic animals, are a

nos. 20.12, 20.17

complete departure from the repose of most Sentani art in the direction of an explosive liveliness and intuitive layout.

## 2. *The Southwest area*

The great alluvial plain which stretches between the south flanks of the central mountain range and the sea is a country of three large tribes. The best known (they have been almost popularized by a number of documentary films) are the Asmat, from the middle of the area. West of them are the lesser-known Mimika, and eastward the "-anim" groups, of whom the most important are the Marind-anim.

The Mimika and Asmat cultures share a number of traits, including large carved poles for mortuary celebrations (Mimika: *mbitoro*; Asmat: *mbis*); elaborate openwork canoe prows; relief-carved shields; large ancestral figures; and masks made of netted cord with attached wooden features. There is, however, a distinct contrast between the art styles. The forms of Mimika figural

nos. 21.1-21.3

sculpture tend to be rounded, almost bulbous and are incised with

58

small areas of angular, spurred designs, which, on two-dimensional objects as well, appear in low relief and cover the whole surface in asymmetrical arrangements.

Asmat sculpture, on the other hand, is considerably more dynamic in feeling. It is often crudely carved from soft wood, as much of it was made for temporary, specific religious occasions and not for long-term preservation as cult objects. Surface designs are curvilinear, often spirals ("animal tails") or stylizations of a squatting figure in profile. This figure represents the praying mantis, a powerful symbol in this cannibalistic and head-hunting society of a creature in the natural world sharing similar proclivities. The most famous Asmat carvings are the *mbis* poles set up for the deceased as reminders that such deaths must be avenged. In the last thirty years, *mbis* became, for a while, highly complex in imagery and huge in size following the introduction of steel tools. Earlier Asmat work seems always to have been on a much more modest scale. The earliest *mbis* collected (now in Basel) is also remarkably close to Geelvink Bay work in the style of the principal figure.

no. 21.6

The art of the Marind-anim, apart from some very simply carved posts, animal figures, and drums, consisted of astonishingly elaborate and flamboyant costumes for the various *dema* festivals. The *dema* spirits were symbolized by carvings and painted panels which were inserted among masses of feather and floral ornamentation. Carved in light wood, these were then encrusted with multicolored seeds in vivid polychrome—a style used nowhere else in New Guinea. As sculpture, only in a few instances do the basic carvings have much to recommend them—one of the coconut spirit, Koneim, is rare in showing a certain brutal strength—though their richness of color indicates what the splendor of the costumes in their totality must have been.

nos. 25.19-25.20

## 3. *The Sepik area*

The area of Papua New Guinea most famous for its art, deservedly so, is the northeastern sector surrounding the Sepik River. Its boundaries are approximately set by a coastal range of mountains on the north, a range of mountains to the west, and the foothills of the island's central ranges to the south. Much of it consists of a low-lying plain through which the Sepik River flows along with a number of large tributaries rising in the south. The varying coastal, hill, and lowland environments set the stage for a correspondingly diverse group of art forms. These were practiced by the people with a vigor and creativity unusual, even for New Guinea. Consequently, though the styles can be distinguished with considerable confidence, the picture is too complex for detailed treatment here. Several fundamental features may be indicated, however, which in numerous combinations and permutations are to be found through the whole area. One, a widely used compositional scheme, consists of a biaxially symmetric structure used for two-dimensional design. It is

no. 22.71

common in the western part of the area and extends into the Highlands; it is often so badly expressed that it is reduced to little more than a linear diagram, as on shields and door boards from the Oksapmin and Telefolmin people. It can, as well, be traced under more complex assemblies of motifs.

A trait that appears to be found only in the Sepik area is the use of what have come to be known as "opposed hooks"; these are curved, pointed projections arranged in series or groups along an axis, which are concentric on one or more focal element. The hooks themselves can be pure abstractions or they are recognizable as stylized bird heads. Investigation over the last twenty years has made increasingly clear how widespread was their use in Sepik art styles. The "opposed hook" was first noted (by Anthony Forge and A. Bühler) in the now famous *yipwon* figures of the middle Karawari River, one of the Sepik's tributaries, and in carvings from the Bahinemo of the Hunstein mountains south of the upper Sepik. South of the Sepik, the range of the motif also extends eastward in a belt that crosses the Yuat River to the people of the middle Ramu River, near the coast. North of the river, the "opposed-hook" style figures prominently in the huge cult figures of the Abelam, living in the Prince Alexander Mountains (part of the northern coastal range), and the plains south of them. It is also assimilated, to some extent, in a naturalistic style of human figure sculpture.

When one speaks of a naturalistic sculpture in this context, it is, of course, with considerable qualifications. The figures themselves are recognizably anthropomorphic, but proportions and facial features are often severely modified. The most famous aspect of the face is an extremely long nose which occurs on sculpture along part of the northeast coast and the middle and lower reaches of the Sepik River. In some cases a definite transformation of the face into bird form is indicated, in others the wearing of a nose ornament. Painting is an important adjunct to most Sepik sculpture as an applied polychrome decoration. It also appears as a two-dimensional, self-contained art form on bark sheets. In the latter instance, colors are usually red, white, and black, but some shades of brown, orange, and yellow ochres were also used. The major use of bark paintings was for the decoration of ceremonial houses, often grand in size and built in a number of local styles.

As remarked, the use of a sculptural motif of long-nosed faces extends in an arc along the north coast and penetrates the course of the river itself. Legs and arms on these forms are slightly flexed, the shoulders are bowed, and the heads lean forward. This configuration also reaches into the lower reaches of the easternmost tributaries of the Sepik, the Keram, and Yuat rivers. The Biwat and Mekmek people of the lower Yuat, by exaggerating these conventions, have transformed its rather limp manner into one of great intensity.

The Iatmul, the largest group living along the middle stretch of

no. 23.3

no. 22.29

nos. 22.62, 22.63

no. 22.17

no. 22.55

nos. 22.7, 22.8

nos. 22.15, 22.19

the Sepik River, carve figures which are usually expressed in rounded, bulky forms. Like most of the other river people they were head hunters, and in their sculptures the human head not only is shown naturalistically but is given the striking face-painting patterns worn in life. Trophy skulls, and some of those of ancestors, were overmodeled with clay and painted to create virtual portraits of the dead. Figures were posed in a rigid, erect stance, and there is a tendency to give the form a shallow depth in relation to the breadth of the body. This is also found in the sculpture of the related Sawos tribe, in the lowlands just north of the Iatmul, with their unique, openwork boards representing mythological figures.

no. 22.32
no. 22.33

no. 22.52
nos. 22.50, 22.51

Further north still, between the Sawos and the coast, in the lowlands and in the Prince Alexander Mountains, the large Abelam tribe produced a vast amount of carving, basketry masks, and paintings, all created for use in initiatory ceremonies and the cult surroundings their food staple, the yam. The gables of Abelam ceremonial houses were huge triangular structures entirely covered in brilliant paintings. For this group, paint is itself a magical power-endowing substance, and its lavish application to sculpture conceals, in many cases, a rather perfunctory assemblage of convex and tubular forms. There exists an extremely complex relationship not only in the cults but in the art of the Abelam and the Kwoma, a tribe living in the mountains near the upper Sepik River, though Kwoma art is distinctively simpler in form and more limited in themes. The most individual and accomplished works of the Kwoma are, however, their modeled pottery heads and vessels made for cult purposes.

no. 22.58

no. 22.68

South of the Sepik the variations of the "opposed-hook" style predominate. Akin to the purer forms carved by the Alamblak of the middle Karawari River and in the Hunstein Mountains is the sculpture of the Ewa of the upper Karawari. Their haunting figures, in a style obsolete for perhaps several centuries, replace the plain hooks with incised panels and elaborated hooks in irregular arrangements. To the west of the mountains, elements of the style are found in the rare wood carvings of the small Wogumas and Nggala tribes.

nos. 22.65, 22.66

## 4. *The Northeast Coast*

Two important areas of artistic production lie on the coast east of the mouths of the Sepik and Ramu rivers: those of Astrolabe Bay and the Huon Gulf. South of these there extends a long stretch of New Guinea in which the visual arts play a negligible role until the island groups of the southeast are reached.

Astrolabe Bay figure sculpture appears in large-scale works and in at least two styles. One is massive, prismatic, and self-contained. Here limbs are set close to the body, feet and hands turned inward, heads set low between the shoulders; the faces are triangular, and the features extremely simplified. The other style,

no. 24.3

used for both figures and masks, maintain the eyes and mouths in essentially the same conventions, though the main forms are heavy and rounded with protuberant noses. In this instance bordering elements of loops and rings represent shell and boar-tusk ornaments. The surfaces are undecorated in this austere and impressive style.

no. 24.4

Cult activities in the coastal Huon Gulf and nearby islands appear to have been similar to those of Astrolabe Bay, centering on circumcision ceremonies which took place about every decade. The wooden masks represent a devouring monster who absorbs each young boy in the ceremony and who then restores him to adult life.

no. 24.5

Bark cloth masks (*tago*) used in the Huon Gulf are clan ancestors, who are welcomed at a cycle of year-long ceremonies. In form these closely resemble some of the Astrolabe Bay masks; otherwise the two styles have little in common.

no. 24.9

Huon Gulf figures are typically square cut, in kneeling or crouching positions; the over-large, rectangular heads have compressed, flattened features. Smaller objects are often covered with geometricized designs, some showing crocodiles, fish, human heads, ornaments, and a variety of other subjects. Ceremonial houses had posts in the form of large figures and panels carved in high relief. Large numbers of utilitarian objects—headrests, scoops, and tools were carved decoratively. The best-known products are the bowls made in the Tami Islands, which were an important item in the trade complex of the Vitiaz Strait between the gulf area and west New Britain. Inland, tribes living in the mountain ranges seem to have produced very little wood sculpture. The Atsera, for instance, carve headrests and stools in the form of reclining figures but are better known for pattern-decorated pottery with small modeled lugs. Among the few large carvings is a unique openwork pole with multiple figures from the Oertzen Mountains. The most spectacular objects from the mountain peoples, however, are enormous bark cloth headpieces and panels of the most ephemeral nature—into which some small wood figures (*jawik*) are incorporated—by the Pasum.

no. 24.10

no. 24.11

no. 24.13

no. 24.12

## 5. *The Central Highlands*

The central cordillera of New Guinea may well have been the earliest area to be inhabited, and it is now the most heavily populated with tribes practicing developed agricultural systems. Ceremonial life was rich, involving large-scale festivals attended by great numbers of participants. Personal decoration, especially in the form of headdresses of irridescent beetle shells, flowers, massive shells, boar tusks, paint, and above all the splendid plumage of many species of birds-of-paradise, was carried to a pitch of great magnificence. With all this, their painting and carving were elementary by comparison with the other areas of the island. Much of it was based on simple geometric forms, mainly circles and

diamonds, engraved, painted, woven, or pyrographed on two-dimensional surfaces. The most elaborate uses of these are on the painted shields, and the *gerua* boards displayed at festivals. Anthropomorphs and zoomorphs are relatively rare, though some wooden figures of both types have been collected in the last couple of decades; these perhaps owe their existance to outside influence. More traditional, apparently, are figures plaited out of cane in the Western and Southern Highlands. Masks were not common and never had the importance they enjoyed in other areas; made of gourd, they were used in initiations and farces in the Eastern Highlands.

## 6. *The Gulf of Papua*

The enormous bay known as the Gulf of Papua, which forms the central southern coast of New Guinea, is the home of a number of formerly head-hunting (and in some cases, cannibal) tribes. In the central part of this area much emphasis—as in the Sepik—was laid on the accumulation and decoration of human skulls; among the Kerewa and neighboring tribes. These were attached to flat, stylized ancestor figures *(agibe)*. A most common form for several types of objects is a long, flat ellipse, which seems to derive from the form of the bull-roarer. The latter is a slat of wood which, when whirled on the end of a cord, produces an impressive booming noise, and which is considered to be the voices of powerful spirits associated with the sky and thunder. The ellipse is used for the most important masks and for low-relief carved boards (called *kaiaimunu*, *gope*, and *kwoi* in various languages), which seem to have embodied protective spirits. These were carved in very large numbers and virtually paneled the interiors of the men's ceremonial hourse. Small figures were cut out like silhouettes, for much the same purpose. On the whole, much of the art of the central gulf employs a great deal of abstract curvilinear design overlying flat surfaces. It is either carved, so that areas are described by parallel ridges in the case of the wooden objects, or painted between cane borders on the bark cloth masks. The significance of the designs is debatable; probably, as among the Gogodala, they were generally totemic.

   Among the Elema to the west, masks included three-dimensional bark cloth figures. There were fewer wood figure sculptures, in the round, here than in other parts of New Guinea, although a certain number of considerable visual power come from, in particular, the west-central area (the Turama River) and Kiwai Island at the mouth of the Fly River. A curious custom, springing more from the cult life than visual preferences, was the use of oddly shaped natural objects, sometimes slightly modified by carving, which were considered to possess supernatural power. Basketry was used for the creation of large animal figures of great sanctity and also for masks with elongated noses that bear a strong likeness to those of the middle Sepik River area.

no. 25.5

nos. 25.9, 25.2-25.4

no. 25.6

no. 25.14

no. 25.1

nos. 25.10, 25.11, 25.16, 25.17

no. 25.18

The Fly River wood figures show facial conventions which relate to those of wooden masks from the islands of the Torres Strait with which the Fly River people had trade relationships. The most nos. 25.21-25.23 famous masks from this area are constructed from plates of turtleshell, in a technique not found elsewhere in New Guinea. The major element is the human head, though this is often combined with fish or crocodile features. A few figures of these creatures alone are extant, as is a small human figure. Some works in this material are surprisingly large scale. One nearly life-size human figure of the god Waiet is preserved (in Brisbane), with accouterments of human bones, and is still revered by the islanders. A few very large masks in turtleshell were perhaps not worn but kept as shrines for human skulls attached to them. Wood carving in the Torres Straight was limited to very small objects, including amulets for dugong fishing no. 25.25 and love magic. Small stone figures were carved for rain-making magic.

## 7. The Southeast area

The people of the island groups at the southeast extremity of Papua New Guinea (the "Massim area") were involved in what has become the most famous trade complex of the Pacific, the Kula ring. Ostensibly the main valuables involved were shell ornaments, one type of which circulated westward through the islands while another circulated east. At the same time, many other manufactured goods were also exchanged simultaneously between trade partners, thereby receiving wide distribution; consequently the localization of specific styles is difficult to propose. It is probable, however, that much of the finer carving of small objects was made on Kilivila (Kiriwina) in the Trobriand Islands.

Perhaps the most common small wood objects are the lime spatulas, made as paraphernalia for betel chewing. The blades are usually a graceful leaflike form, while the butt is carved in a human, animal, bird, or abstract shape. Some were split, to be used as clappers. Most of the art is considerably stylized and show much use of the reversed spiral which is the hallmark of the Massim style in general. The design derives from the head and neck of the frigate bird and is manipulated in complex assemblies on, for instance, the no. 26.6 low-relief canoe prow carvings.

The only flat painted objects from the area are oval, convex no. 26.5 shields with a design incorporating abstract elements and stylized frigate birds, of debatable significance. It must be of supernatural and undoubtedly minatory significance, like the designs on Melanesian and New Guinea shields in general. This is a rare instance in Massim art of an object being almost certainly nonutilitarian, as the people were not given to elaborate ritual; but this is no reason to believe that references were not made in many objects to the supernatural. Equipment for betel chewing (often a semisacred activity) and the elaborate carvings for canoes (in the religious aspects which have been mentioned earlier) are possible cases.

1 Peter Bellwood's *Man's Conquest of the Pacific* (Oxford, 1979) is the most comprehensive survey of the subject written so far.

2 J. M. Bowler, R. Jones, H. Allen, and A. G. Thorne, "Pleistocene Man in Australia: A Living Site and Human Cremation from Mungo, Western New South Wales," *World Archaeology, 2* (1971): 39-60.

3 J. P. White, K. A. W. Crook, and B. P. Buxton, "Kosipe: a late Pleistocene site in the Papuan Highlands," *Proceedings of the Prehistoric Society, 36* (1970): 152-170.

4 I. Glover, "Island Southeast Asia and the Settlement of Australia," in D. E. Strong, ed., *Archaeological Theory and Practice* (London, 1973).

5 V. D. Watson and J. D. Cole, *Prehistory of the Eastern Highlands* (Seattle and London, 1977), 112.

6 Roger L. Green, *A First Culture History of the Solomon Islands* (Auckland, 1977), 11.

7 Shutler, "Radiocarbon Dating and Oceanic Prehistory," *Archaeology and Physical Anthropology in Oceania, 13* (1978): 215-228.

8 J. P. White, *Ol Tumbuna* (Canberra, Australia, 1972).

9 White, *Ol Tumbuna*.

10 Bellwood, *Conquest of the Pacific*, 238

11 Watson and Cole, *Prehistory*, 20-21

12 Carl A. Schmitz, "Steinerner Schalenmörser, Pistolle und Vogelfiguren aus Zentral Neuguinea," *Baessler-Archiv*, n.s. vol. 14 (1966): 1-60.

13 D. Newton, in S. M. Mead, ed., *Exploring the Visual Art of Oceania* (Honolulu, 1979), 32-51.

14 Bellwood, *Conquest of the Pacific*, 242-244.

15 Mead et al., *The Lapita Pottery Style of Fiji and Its Associations*, Polynesian Society Memoir, No. 38 (1973), and references.

16 Green, in S. M. Mead, ed., *Art of Oceania*, 13-31.

17 B. Egloff, *Archaeological Investigations in the Coastal Madang Area and on Eloaue Island of the St. Matthias Group*, Records of the Papua New Guinea Museum No. 5 (Port Moresby, 1975), 28-29.

18 Green, "Lapita Pottery and the Origins of Polynesian Culture," *Australian Natural History*, June 1973, 332-337.

19 Kooijman, *The Art of Lake Sentani* (New York, 1959), figs. 11, 12.

20 Mino Badner, "Some Evidences of Dong-Son derived Influence in the Art of the Admiralty Islands," in N. Barnard, ed., *Early Chinese Art and Its Possible Influence in the Pacific Basin* (New York, 1972), is a full statement on this point. A different view is of course taken here.

21 Bellwood, *Conquest of the Pacific*, fig. 7.7, pp. 266-267.

22 J. Garanger, *Archéologie des Nouvelles Hébrides* (Paris, 1972).

23 Garanger, *Archéologie*.

24 Green, *First Culture History*, 28-30.

25 H. D. Skinner, *Comparatively Speaking* (Dunedin, New Zealand, 1974), 147-180.

26 Andrew Sharp, *The Discovery of the Pacific Islands* (London 1960), 3.

27 Lord Amherst and Basil Thomson, *The Discovery of the Solomon Islands* (London, 1901), 227.

28 Amherst and Thomson, *Discovery*, 355.

29 Amherst and Thomson, *Discovery*, 184, 202, 343, 350.

30 Roberto Ferrando Pérez, "Zeichnungen von Südsee-Eingeborenen dem frühen 17. jahrhundert," *Zeitschrift für Ethnologie, 79* (1954).

31 H. N. Stevens, *New Light on the Discovery of Australia* (London, 1930), 159.

32 Stevens, *New Light*, 173, 231.

33 A. J. Tasman, *Tasman's Journal of his Discovery of Van Dieman's Land . . . translated by J. E. Heeres* (Amsterdam, 1898), 103.

34 Adrienne L. Kaeppler, *"Artificial Curiosities": Being an Exposition of Native Manufactures Collected on the Three Pacific Voyages of Captain James Cook R.N. . . .* (Honolulu, 1978), 242-250.

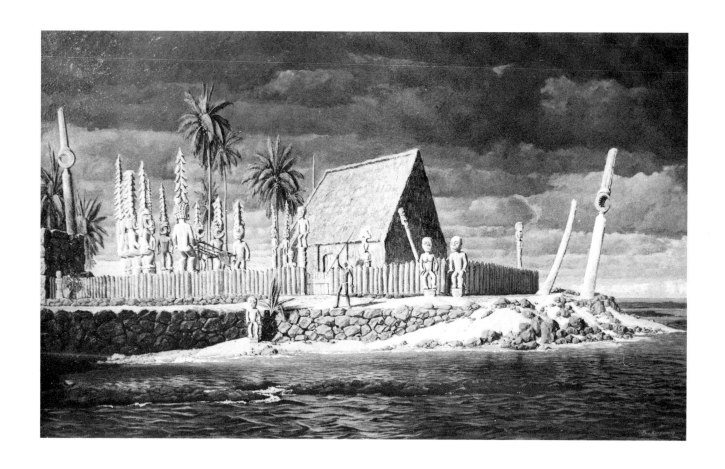

# Polynesian Cultural History

*Peter Gathercole*

The world of the Polynesian peoples has fascinated the mind of Western man for the past two hundred years.[1] But those European voyages of discovery in the late eighteenth century that first brought the Polynesians to the attention of the outside world led ultimately to the destruction of much of their traditional life. As their cultures changed, often drastically, through contact with Europeans and Americans, whose governments eventually divided up the islands between them, so evidence concerning their cultural history was lost. Until quite recently, much of the writing on the Polynesian past was cast, perhaps inevitably, in speculative terms. Only in the last thirty years has research, particularly in linguistics and archaeology, provided reliable evidence concerning the prehistoric origins and development of Polynesian cultures.

The visual arts of Polynesia are less varied than those of Melanesia. They have, to a great degree, a basic homogeneity, however much they differ from one island to another. This homogeneity was remarked on by eighteenth-century explorers and is also clearly expressed in the results of linguistic and archaeological research. All Polynesian languages comprise one branch of the widespread Austronesian language family, other branches of which are found in island Southeast Asia, Micronesia, Malagasy, parts of mainland Southeast Asia, and much of Melanesia. (In Australia, much of New Guinea and parts of the Solomon Islands, quite different and much older languages are spoken.) Work on the reconstruction of ancestral Austronesian languages has demonstrated that the ancestral Polynesian language was most closely related to ancestral Fijian and, less directly, to other languages which have been classified together as the Proto-Eastern Oceanic subgroup and which were once spoken in other parts of eastern Melanesia. The Proto-Eastern Oceanic subgroup was, in turn, derived from the larger Proto-Oceanic subgroup, which probably existed in western Melanesia by 3000 B.C. Proto-Eastern Oceanic began to appear about a thousand years later, and by 1500 B.C. a language ancestral to present Fijian and all the Polynesian languages was being spoken in Fiji. The initial settlement of Polynesian speakers within the Polynesian region proper probably took place in the Tongan Islands, after which Polynesian speakers moved to Samoa and, later, into eastern Polynesia.

This sequence of linguistic differentiation is supported by the work of archaeologists, who have recently concentrated their attentions on western Polynesia and island Melanesia. In particular, they have studied sites of the so-called Lapita culture,[2] which have a

Example of a sacred walled enclosure, *heiau*, at Honaunau, Hawaii (*Hale-o-Keawe at the "City of Refuge*," by Paul Rockwood after a drawing in William Ellis' *A Narrative Tour of Hawaii* [London, 1826]). Photo: courtesy of the Bernice Pauahi Bishop Museum, Honolulu

marked coastal distribution from northern New Guinea in the west to Samoa in the east. The most diagnostic artifact is pottery, especially finely decorated forms, which is extremely uniform throughout the area. There is evidence of trade at Lapita sites, which, with the homogeneity, coastal distribution, and rapid spread of the culture, suggest that the Lapita settlers were very competent canoe voyagers. In Melanesia they appear to have established themselves adjacent to other existing populations. But in Tonga and Samoa they were the initial settlers. Their sites are inferred to have belonged to Polynesian language speakers, and so we can link the Lapita culture to the eastward movement of the earliest Polynesians. The earliest archaeological sites in Polynesia are found in Tonga and date from about 1300 B.C.; those in Samoa are probably slightly later. The early Tongan sites are coastal; in the Samoan islands, however, a sequence of occupation from about 500 B.C. covers a range of coastal and inland environments. This suggests that a measure of economic differentiation, including the practice of horticulture, developed in these high volcanic islands, a pattern which might be regarded as typically Polynesian. For example one Samoan innovation was the triangular-sectioned adze made from flakable basalt; others were the earthern house mound and, by A.D. 400, the fortified earthwork. Pottery making had died out by this time, but not before further virgin settlements had been established in the eastern Pacific.

From the evidence of radiocarbon dating it appears that the earliest settlement in eastern Polynesia was in the Marquesas Islands, not later than A.D. 300. This was followed, by A.D. 700, by other settlements in the Society Islands, the Hawaiian Islands, and Easter Island and, between A.D. 700 and 1100, in the Cook and Austral islands and even New Zealand. This rapid expansion of colonists, initially from a small homeland on the western margin of the enormous triangle of islands which today constitutes Polynesia, is surely one of the most remarkable facts in the history of human settlement. Before the expansion of modern Europe, Austronesian language speakers were the most widespread peoples in the world.

One reason for the successful settlement of eastern Polynesia was the islanders' ability to sail large, probably double, canoes without the aid of instruments but with an appreciation of the navigational significance of the positions of stars, wind directions, swell patterns, and other oceanographic phenomena.[3] Another reason was their adaptability; indeed this probably was a factor in the rapid spread of the ancestral Lapita culture. Early eastern Polynesian fishing gear, adzes, and ornaments differ in many respects from those found in western Polynesia, and it is generally assumed these modifications reflect different ecological conditions at initial settlement. The sites demonstrate an initial reliance on fishing and coastal gathering and, subsequently, the development of horticulture, perhaps when inter-island sailing became more restricted and

Polynesian earth mound at Tongatapu, 1965.
Photo: courtesy Adrienne Kaeppler

specific island cultural specializations began to develop in a major way. Ultimately specialization resulted in the cultural differences evident to European observers when they first arrived.

Within this time frame it is possible to see Polynesian cultural history as a coherent and understandable phenomenon. Islanders controlled their environmental resources by means of a range of cultural practices directed to similar social ends, but differing in detail from island to island. Effective settlement presupposed maritime skill, an understanding of available natural resources, and an ability to use a limited number of domesticated plants and animals of Southeast Asian origin, i.e. the chicken, pig, dog and rat, the yam, taro, breadfruit, coconut, and sugar cane. To this list should be added the sweet potato, of American origin but widely distributed in Polynesia. The types of terrestrial plants and animals naturally represented were fewer in the east than the west. On the other hand, marine fauna was, and is, very rich throughout the area.

Yen has suggested that, in the development of Polynesian agriculture, there were three significant practices: the use of the Cordyline root for food, the fermentation of breadfruit in pits, and terrace cultivation of taro.[4] These practices might have led not only to the successful development of agriculture as such, but also to particular specializations found in different islands—for example, the extensive use of breadfruit fermentation in the Marquesas, and the elaborate character of taro cultivation which developed in Hawaii. Alongside these developments was an ingenious exploitation of such plants as pandanus, which is tolerant of a wide range of habitats, including atolls. Its leaves were used for making thatch, containers, and mats, and its fruit sometimes used for food. Polynesians possessed no metals; they commonly used as raw materials stone, shell, wood, leaves, coconut, and other plant fibers, and, to a lesser extent, bone. A variety of flaking, grinding, and polishing techniques were employed, often to a high degree of sophistication.

Their cultural heritage, therefore, was a factor which helped Polynesians to colonize a new world—and so, one might say, become Polynesians. At the same time, the smallness and separateness of their islands must have limited possible population growth to a certain size, even allowing for the fact that initially the capacity to increase was very great within an attractive and hitherto uninhabited environment. To the physical constraints should be added the dangers inherent in island living: famine, drought, and drowning in ocean storms. Such ever-present factors, coupled with a profound understanding of island conditions, must have encouraged the islanders to migrate if the necessity arose.

Polynesian social organization reflected the need to combine the principle of order with flexibility in its operation. The most significant social group was one of the consanguineal kin, whose members often traced their descent from a common ancestor. Relationships were reckoned bilaterally (i.e. through either parent),

although inheritance had a patrilineal emphasis. Thus, generally speaking, "all members of the group were ranked according to their 'distance' from the real or legendary group founder, with the eldest son of a line of eldest sons at the top, and the youngest sons of youngest sons at the bottom."[5] On marrying, a girl usually lived with her husband's close kin. The normal settlement pattern consisted of homesteads situated in the territory of the group. On high islands, this might incorporate whole blocks of land, including mountainous interiors, valley bottoms, strips of coastlines, and adjacent portions of lagoon, reef, and ocean. On atolls, however, territories comprised little more than islets and lagoons.

Society was ordered by principles of inherited status, and rule was by chiefs whose authority rested on descent from ancestors claiming affiliation with the gods. Over time, this form of social organization became highly stratified, especially on the high and more heavily populated islands. Thus, by the 1770s, society in Tonga, Samoa, Hawaii, and the Society Islands was organized into hierarchical groups, with powerful chiefs and their close kin at the top, then craftsmen, priests, and other specialists; below were commoners with restricted rights. In some societies there were also so-called slaves, usually conquered enemies and their descendants. Chiefs possessed much power and prestige (*mana*) and were regarded as sacred (*tapu*).

There exists a good deal of archaeological evidence that this social differentiation was of long standing. The most influential dynasty in Tonga, from apparently A.D. 1200, was that of the Tui Tonga. A large coral trilithon (two uprights supporting a lintel slotted into the tops) on Tongatapu is thought to have been erected around this time to represent the sons of the ruling incumbent. Coral-faced earthen burial mounds are also associated with this dynasty. There are also other earthen mounds, some of which were thought by Cook to have been used for pigeon snaring, while on others were structures used during burial rites. In Samoa many sites are known, including "terraces or earthen mounds for houses, horticultural terraces, and forts defended by ditches cut across steep ridges. . . . Archaeological evidence indicates that the round-ended form of house, used ethnographically for large dwellings or council meetings, goes back into the ceramic phase [i.e. prior to A.D. 300], and many abandoned house-mounds still support oval settings of kerbstones. Ethnographic records also indicate that the Samoans maintained open spaces for ceremonies (*malae*), as well as god-houses; the latter were probably built on rectangular or star-shaped mounds."[6]

In eastern Polynesia the place of god-houses was taken by sacred, roofless enclosures (*marae*) which had many forms. The simplest (and probably earliest) consisted of small stone platforms or upright pillars, which persisted in the northern Marquesas. In most of central Polynesia, however, *marae* became much more

Trilithon at Maui, Hawaii. Photo: courtesy Adrienne Kaeppler

Coral-faced earthen burial mound, Tui Tonga dynasty, Tonga. Photo: courtesy Adrienne Kaeppler

complex, often comprising a rectangular court in the form of a pavement or terrace, sometimes walled, with a platform (*ahu*) at one end and individual uprights placed in various positions. *Marae* were used predominantly for religious ceremonies, involving the invocation of gods or ancestors; some uprights were backrests for seats reserved for ancestral spirits. In the Society Islands, which have many *marae*, other archaeological evidence includes many round-ended or rectangular house footings and platforms connected with the sport of archery. *Marae* are also found in the Tuamotu, Cook, Austral, and Marquesas islands. The latter possesses superb house platforms, and large rectangular dancing grounds edged with platforms, on which stood certain ceremonial houses or where seating was provided for spectators. Forts are also found on the Marquesas, and on Rapa at the southern end of the Australs.

Example of an Hawaiian rock carving. Photo: courtesy of the Bernice Pauahi Bishop Museum, Honolulu

The Hawaiian Islands, which had a population of perhaps two hundred thousand at European contact, have many archaeological remains. There are still miles of field boundary walls made of stone, and valley terracing for taro cultivation. Here, too, there are numerous house platforms, as well as stone trackways, coastal fishponds, and rock carvings. Sacred walled enclosures, called *heiau*, often complex in form and incorporating combinations of platform and terrace constructions, have also survived. Honaunau, on the island of Hawaii, is a massive walled structure enclosing remains of three *heiau*, one of which was still in fair condition in 1820. The latter incorporated a sacred house in which were placed the bones of chiefs. Wooden figures were found inside and outside the house. Stone images were made in Hawaii, the Society Islands, the Marquesas, Raivavae (Australs), and even on tiny Pitcairn Island, which was uninhabited when settled by the *Bounty* mutineers in 1790 but clearly had once supported a prehistoric Polynesian population.

Such was the complexion of life in tropical Polynesia. Outside this zone lay Easter Island and New Zealand. Each showed modifications, sometimes extensive, to the tropical Polynesian pattern. At the time of Western contact the Easter Islanders possessed the Polynesian domesticates except for coconut and breadfruit, pigs and dogs. Local timber resources were exploited to near extinction, but much use was made of local volcanic rocks, especially for the construction of platforms (*ahu*), on which often stood large statues. Some *ahu* are dated to the early period (A.D. 400-1100), but most, and almost all statues, belong to the middle period (1100-1680). The amount of statue construction was enormous; 600 survive, of which over 150 lie unfinished in the famous quarry of Rano Raraku. This suggests that, during the middle period, Easter Island possessed a considerable population, perhaps as large as ten thousand. Thereafter, probably through tribal warfare, there was a general decline in population, resources, and culture. If, as was thought in 1774 by Cook's scientists, the statues did represent dead chiefs, then this

Easter Island stone images. Photo: Y. Siwoto

71

impressive art form was one expression of Polynesian social structure in a highly specific setting, very directly molded by available natural and cultural resources.

The process of adaptation in New Zealand was even more dramatic. New Zealand is the only large island group in Polynesia, and it is also the most varied geographically. There is evidence of settlement on the east coast of both the North and South islands by A.D. 1000, mostly by groups who relied on hunting, gathering, and fishing. On the other hand, archaeologists believe that horticulture, in the form of sweet potato cultivation, could have been present from this early (Archaic) phase, during which, as extensive midden sites show, the moa and other birds were extensively hunted. Types of fishhooks, adzes, and ornaments demonstrate that this settlement was from eastern Polynesia. Climatically New Zealand was more favorable to occupation at this time than it became after about A.D. 1400, when horticulture declined in some areas. It is likely that these eastern Polynesian colonists extended their settlements quite rapidly through the most amenable portions of both the North and South islands. Even nephrite (a jadelike rock) from the west coast of the South Island is found at a few Archaic sites, as well as artifacts made from such rocks as quartzite, argillite, and basalt. The environment did not encourage the introduction of many tropical domesticates, and the sweet potato had to be stored in winter in underground pits. The only introduced animal was the dog.

The settlers elaborated a version of eastern Polynesian culture which had many unusual features. In the place of bark cloth, clothing was made from woven flax. This material was also used for cordage of all sorts. Fishing, gathering, and hunting were often rather specialized and seasonal activities, indicating a very specific understanding of the varied environments.

This early culture was widespread, but it seems that, in the fourteenth and fifteenth centuries, changes began to take place in northern areas. This was the time of the initial building of forts (*pa*) in the north, which eventually assumed increasingly elaborate forms, suggesting that warfare had developed sufficiently to lead to both their construction and refinement. It was in this context that the phase, recognizable in the 1770s as "Classic Maori," developed. By that time, much of the North Island was quite heavily populated. This was also true in the northern part of the South Island, but further south the hunting, fishing, and gathering economy persisted. The social organization of the Classic Maori phase was broadly similar to that which developed in eastern Polynesia, but there was considerable stress on loyalties to the tribe and particularly the subtribe (*hapu*). The latter was the basis of the marriage system and, usually, of residence. Chiefs and their kin possessed great *mana* and acquired much *tapu*, which were also imbued in their possessions.

The impact of the Western world on Polynesia, though not

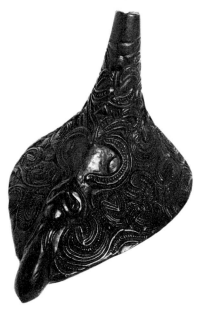

No. 11.18 *Feeding Funnel* of a Maori chief (New Zealand)

nos. 11.30, 11.18

72

fatal, was certainly profound and all-embracing. The environment and all aspects of life were fundamentally affected. Lack of immunity to introduced diseases—smallpox, typhus, typhoid, measles, tuberculosis, leprosy, and syphilis—decimated whole populations. Precise numbers are often difficult to determine, but it has been estimated that between the end of Magellan's voyage in 1522 and 1939 the population of Oceania decreased between one-third and one-fifth, i.e. from 2½-3 million to 2 million.[7] Initially, whalers, sealers, and traders for such materials as sandalwood, trepang, pearls, and turtleshell disrupted traditional economies. Then, after about 1850, merchants, planters, and large commercial companies began to introduce cash cropping and to alienate land, the very basis of island life. Ports and other urban centers appeared. Throughout this time missionaries, Protestant and Catholic, often in competition with each other, searched for and won men's souls away from their ancient gods, which helped to undermine the cohesion of indigenous societies and threw in doubt the authority of their leaders. That Polynesia was drawn into the wider polity of colonialism was not, of course, wholly negative. As positive elements one might instance the end of tribal warfare, the development of literacy and of certain forms of education and public health, trade in some material goods, and an enhanced status for the individual as against the group. But these gains were long-term, if indeed gains they were, and they necessarily involved placing the Polynesian in a subordinate position to the white man.

The shattering of cultural continuity meant that in many societies the arts either did not survive, or were so changed that they lost most of their indigenous meanings and forms. For example, except among Maoris, traditional forms of wood carving almost completely disappeared. Sennit plaiting, many styles of singing and dancing, tattooing and other forms of body decoration became lost arts. In Fiji, Samoa, and Tonga, where considerable social cohesion was maintained, bark cloth manufacture persisted, at times adapted to the demands of a growing external market. Indeed, since 1945, there has been a rapid growth of "airport art," a term designed to cover a somewhat bizarre assortment of objects produced to satisfy the demands of tourists, such as wooden curios, pandanus baskets and table mats, shell necklaces, and small pieces of bark cloth. These are often made without any significant reference to the aesthetics of the makers.

Maori carving did not disappear. Traditional forms died in some regions, but in others, notably in the Bay of Plenty—East Coast, it persisted and evolved, to become an expression of local solidarity and integrity. Among some tribes carved meetinghouses, churches and their fittings, other buildings, and individual carvings were authentic examples of the development of the art in the nineteenth century. Today, carving in certain "evolved traditional" styles is still vigorous, if at times rather mechanical. On the other

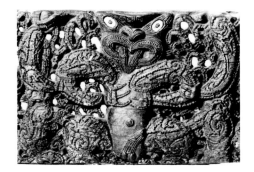

No. 11.31 *House Front* (New Zealand, Bay of Plenty)

nos. 11.15, 11.31, 11.32

hand, some carvers also use new materials and styles including Western ones.

There are other indications of artistic resurgence in Polynesia. New styles of dance and music are emerging, some seen at Pacific Arts Festivals which are now held regularly. There is a growing number of creative writers whose medium is either English or a Polynesian vernacular, or both. There are also a few painters. Although numbers are small, these developments are hopeful signs for the future.[8]

The Polynesians have survived the rigors of Western influence, and have adapted to the economic, political, and ideological conditions which emerged after the second World War. Western Samoa is politically independent. The Cook Islanders have internal self-government. There are important political stirrings among Tahitians and Hawaiians, while the Maoris, who never quite lost their own political leverage, are now more vocal and influential than ever before. One must hope that, increasingly, the Polynesians become the makers of their own future.

# NOTES

1 To attempt to summarize Polynesian cultural history so briefly is almost indecent and inevitably invites distortion. This summary is based mainly on the following books, to which the reader is directed for further details and more specific references: Peter Bellwood, *The Polynesians: Prehistory of an Island People* (London, 1978); Jack Golson, "The Pacific Islands and their Prehistoric Inhabitants," in R. Gerard Ward, ed., *Man in the Pacific Islands: Essays on Geographical Change in the Pacific Islands* (Oxford, 1972), 5-33; Bryan H. Farrell, "The Alien and the Land of Oceania," in Ward, *Man in the Pacific Islands*, 34-73; William Howells, *The Pacific Islanders* (London, 1973); and Douglas L. Oliver, *The Pacific Islands* (Cambridge, Mass., 1962). I am much indebted to Peter Bellwood for reading the manuscript and suggesting several improvements.

2 Named from a site in New Caledonia.

3 David Lewis, *We, the Navigators* (Canberra, 1972). Controversy among scholars over the voyaging capabilities of early Polynesians has been intense, particularly concerning their ability to make long distance two-way voyages. There is now wide agreement that the main Polynesian settlements were the result of deliberate long distance one-way expeditions of small groups of men and women, who took with them, of course, necessary plants and animals. There is also support for the idea that certain two-way voyages could have taken place before A.D. 1400, when a measure of climatic deterioration set in. Cf.: the experimental voyage from Hawaii to Tahiti made in 1976 by the *Hokule'a*, a replica of a Hawaiian double canoe (B. R. Finney, "Voyaging Canoes and the Settlement of Polynesia," *Science*, 196 (1977): 1277-1285).

4 D. E. Yen, "The Development of Agriculture in Oceania," in R. C. Green and M. Kelly, eds., *Studies in Oceanic Culture History*, 2, Bishop Museum, Pacific Anthropological Records, Honolulu, 12 (1971): 7-10.

5 Oliver, *The Pacific Islands*, 72.

6 Bellwood, *The Polynesians*, 74.

7 Oliver, *The Pacific Islands*, 364.

8 Contemporary Maori literature and arts are surveyed by J. Metge, *The Maoris of New Zealand: Rautahi*, 2nd ed. rev. (London, 1976), ch. 17; for examples of contemporary Polynesian writing, see the novels by Albert Wendt, a Samoan, *Sons for the Return Home* (Auckland, 1973) and *Pouliuli* (Auckland, 1977); also M. Orbell, *Contemporary Maori Writing* (Wellington, 1970); and Witi Ihimaera, *Pounamu, Pounamu* (Auckland, 1972).

76

# Aspects of Polynesian Aesthetic Traditions     *Adrienne L. Kaeppler*

The exploration of Polynesian aesthetic traditions that will be attempted in this introductory essay should be considered as a first step in trying to understand some extremely complex and elusive phenomena. The aesthetic traditions that produced most of the works in this exhibition no longer exist, and, unlike Melanesia and New Guinea, the objects are no longer part of the everyday or ceremonial life of Polynesians. It follows, then, that an attempt to understand these aesthetic traditions through the eyes of their makers or users is not only difficult but in most cases impossible. On the other hand, looking at Polynesian art from the Western viewpoint, of what constitutes art or has aesthetic merit, would give a false idea of the criteria that Polynesians might have considered during the long formulation of their aesthetic traditions. Isolated Polynesian objects brought together in an exhibition hall can tell us little about Polynesian aesthetics. Instead there is the danger that the viewer will approach them only with Western eyes and assimilate them into a Western aesthetic tradition that transforms objects from places like Polynesia into "primitive art." Objectively "primitive art" is simply art that is not understood in terms of the culture that produced it, and usually there is little attempt to understand such works of art as manifestations of aesthetic traditions far different from our own.

If it is impossible, then, to examine each Polynesian aesthetic tradition from the view of its makers and users (and each island group would have its own aesthetic), and if to apply a Western or "universal" aesthetic viewpoint is unsatisfactory, is there any other possibility through which we might try to understand, and more fully appreciate, the aesthetic productions of Polynesians? I suggest that we should consider the totality of Polynesian objects that have been preserved in museums and private collections and not just those that we usually consider art. This should be related to written documents—including those of early explorers, missionaries, residents, and anthropologists—and to views of contemporary Polynesians. It might then be possible to isolate aesthetic themes that emerge as characteristic and distinctive of specific island groups. Although this will result in a rather personal view, it may assist the viewer in developing wider aesthetic horizons useful in approaching the arts of Polynesia.

Before we proceed, it is appropriate to define both art and aesthetics so that they can be applied cross-culturally. Western art history usually uses these terms in ways that are really inappropriate for an analysis of the works of other cultures. Because these works are not productions of the Western world and are not based on such

"A Young Woman of Otaheite, Bringing a Present" (to Captain James Cook). Engraving after James Webber (from the *Atlas* to James Cook's *A Voyage towards the South Pole, and round the World . . . in the Years 1772, 1773, 1774, and 1775*, 2 vols. [London, 1777])

no. 5.10

no. 5.4

No. 5.10 *Image (to'o)* (Society Islands)

no. 8.3

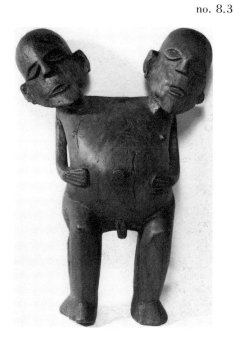

No. 5.4 *Double-Headed Figure* (Society Islands, probably Matavai Bay)

principles as usually concern the Western mind, there is little hope of understanding them in Western terms. For example, coconut fiber and the aesthetic ramifications of the sennit made from it, by braiding or twisting, do not square very well with Western aesthetic ideas, in which plaiting or braiding are usually considered on the level of a craft at best. To a Tahitian, however, images made of sennit constitute a very important artistic form. They were in fact much more important than wooden images, which, according to a Western view, would certainly rank at a high level among the artistic works of the Tahitians. Thus, to encompass all the necessary elements, very broad and neutral definitions of art and aesthetics will be employed. Art is here defined as "cultural forms that result from creative processes which manipulate movements, sounds, words, or materials in time and space" and aesthetics will be defined as "ways of thinking about such forms."

The most important art in Polynesia was oral—poetry, oratory, and speech making. This was aesthetically extended, aurally in music and visually in dance. The visual material arts (dance being visual and temporal) were manifested three-dimensionally as sculpture, executed in wood, stone, ivory, and such unusual materials as sea urchin spines, dog teeth, wicker, sennit, and feathers. Three-dimensional sculptural form, as well as intricate relief incising, were important in themselves and did not depend on polychromed paint for immediate dramatic impact. Visual arts were also manifested two-dimensionally by surface applications and impressions into bases of stone, wood, bark cloth, plaited materials, and human skin (tattoo). Other arts were aimed at the olfactory sense but were visually enhanced during use. Scented coconut oil was laboriously produced and was applied from superbly carved wooden oil dishes, and simple gourd oil containers were presented in elaborate baskets, sometimes lined with finely plaited mats. Flowers, chosen for scent rather than beauty, were formed into intricate necklaces and girdles. Oral, visual, and olfactory arts were important individually but, in combination, became more than a sum of their parts. Such varied manifestations are a vivid indication of Polynesian ways of thinking about creative processes and the resulting cultural forms. An exhibition hall, however, lends itself best to two- and three-dimensional material forms, and the emphasis will be on these more easily encapsulated works of art.

Unlike Melanesian artistic objects, Polynesian artistic productions were meant to endure. Time and creative energy were freely lavished on objects that were to be passed as heirlooms from generation to generation. Occasions on which they were used became important points in history; and those for whom they were made, those who used or wore them, and those to whom they were given, were remembered and included in recitations as important personages of history. Important events of an individual's life were recounted to accompany specific objects used on those occasions.

78

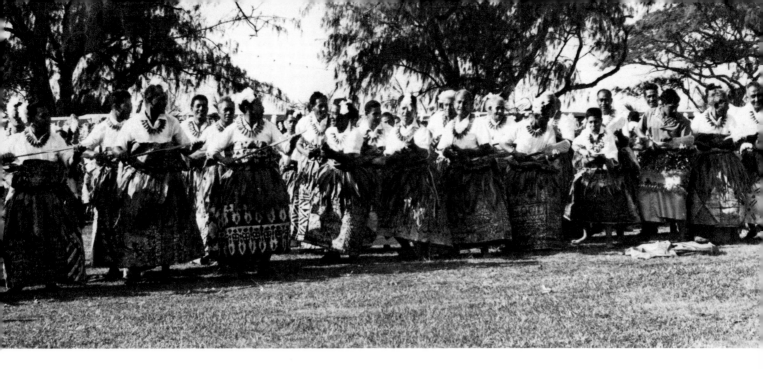

Political regimes were long and enduring based on chiefly rank and genealogical connections. Like the social systems in which they were embedded, objects were visual symbols of status, rank, and power and were important indicators of hierarchical order among gods, priests, chiefs, and people. Interwoven with the importance of objects in rank and status was an emphasis on appropriateness for the occasion. The right object must be used at the right time — depending on the reason for the occasion and on who was present — or the aesthetic tradition was violated. Objects were chronicles of history objectified in visual form and were inherited not only as forms but as information. Persons, places, events, and emotions were recounted and cherished and became part of the aesthetic power or *mana* of the objectified form. Polynesian aesthetic traditions were not concerned primarily with external static form or product. Rather, relevant aesthetic considerations included the process of fabrication from appropriate materials for an object's use within the limits of prescribed form, the visual representation of status and rank within an ever-expanding symbolic system, the historic associations and sense of occasion that were enlarged through time, and the interrelationships among various artistic forms. In other words, the process of an object becoming what it was over time as form and repair in addition to its symbolism and history were all aspects of an aesthetic tradition concerned with ongoing process and use.

It follows, then, that the aesthetic traditions and the individual objects which express them that must be explored are not simply indigenous ones that existed before contact with Europeans. The influence of the Western world on Polynesia has been long and profound. In most island groups new ideas and visual images, as

Tongan men's paddle dance (*me'etu'upaki*), July 5, 1967, for the coronation of a king. Wrap-around skirts made of bark cloth, overskirts of *ti* leaves, and necklaces of pandanus fruit. Photo: courtesy of Adrienne Kaeppler

79

well as tools with which objects were made, were incorporated into Polynesian aesthetic traditions beginning in the late eighteenth and early nineteenth centuries. Indeed, they became so inextricably interwoven that the only way to separate out some indigenous forms would be to consider only objects collected by the first Europeans in an area—such as objects collected during Captain Wallis' sojourn in Tahiti, objects collected on Cook's first voyage in New Zealand, objects collected on Cook's second voyage in Tonga, and objects collected on Cook's third voyage in Hawaii. This would not only be too narrow but still would not really convey a realistic idea about Polynesian art. In an aesthetic tradition concerned with ongoing process, such a procedure would simply make the cut-off time different. For example, the aesthetic traditions of Tonga were changed over time owing to differential influences from Fiji and Samoa, while the aesthetic traditions of Tahiti were affected by influences from other islands in the Society group as well as from the Austral Islands and probably the Cooks and Marquesas. European influence expanded the aesthetic traditions in new and different ways. For example, simply because a Hawaiian image or bark cloth beater has been carved with metal tools does not make it less "Hawaiian." Metal tools enabled Hawaiians more easily to exploit, elaborate, or extend their own aesthetic ideas. If a man on horseback has been incorporated into a Hawaiian petroglyph, this does not make the tradition of which it is a part less "Hawaiian." Similarly, if a European sailing ship has been incorporated into an incised Tongan club or added to an Easter Island stone figure, this does not make the club or figure less Polynesian. They are simply new visual images added within an ongoing aesthetic tradition. Whether an object is "precontact" or not is quite irrelevant to its aesthetic merit. And, indeed, the introduction of metal tools to Polynesia made possible an artistic efflorescence that probably would not have occurred without them.

In short, Polynesian aesthetic traditions, i.e., Polynesian ways of thinking about cultural forms resulting from creative processes which manipulate materials in time and space, were concerned with appropriate materials, form, and use. Objects conforming to Polynesian aesthetic ideas preserved in visual form the cultural concern with hierarchical ranking, status, and power. They gave pleasure to Polynesians if used in appropriate ways on appropriate occasions. And through their use they acquired a kind of historic and aesthetic power and became objectified representations of social relationships among gods and men.

Objects in the exhibition illustrate selected aspects of these aesthetic traditions. Examples of human sculpture are featured and relationships with other aesthetic threads that have emerged as distinctive features are indicated. Each object exhibited is unique, but, at the same time, it is usually an example of a cultural form specific to a particular society or island area, which usually makes it

possible to assign to it a geographical provenance, if this is undocumented. To illustrate uniqueness pieces of similar type have sometimes been included. In addition to showing uniqueness, these similar pieces suggest some dimensions of allowable variation within the accepted limits of the specific aesthetic tradition for that cultural form. Examples of each artistic medium have not been included from each island area. The use of feathers as a decorative element, for example, was characteristic of several island areas. Feathers became a major artistic media in Hawaii and featherwork is featured in the Hawaiian section. The manufacture and decoration of bark cloth was a major Polynesian art form, but examples have been included from only a few areas. Even the sculptures have been chosen with the view of emphasizing specific features that were elaborated in a distinctive way in a specific area. Thus, the objects exhibited do not form a comprehensive overall view of Polynesian art. Rather objects that are distinctive of various aesthetic traditions have been brought together that the viewer might examine the varied styles and materials of the several island groups and their relationships to one another and that the use and importance of material objects in Polynesian social and belief systems might be suggested.

Comparing existing collections of Polynesian objects with those from other areas of the world, such as Africa, North America, South America, or Melanesia, the total number of objects is really quite small. Often there are no suitable alternatives from which to choose, and consequently some crucial objects are unfortunately not included in the exhibition. A few objects were reserved for exhibitions about the Cook voyage or other exhibitions in their home institutions and could not be sent. Owing to their scarcity, Polynesian objects are really not "collectibles" as far as most private collectors or even museums are concerned. They are rare and valuable superb works of art that, for the most part, have not been produced for a long time. Except for Hawaii, comparable pieces are no longer in their countries of origin. Some of the pieces have not been exhibited before—at least not outside their home institutions—and an effort has been made to include less known examples in preference to those that have been included in other international exhibitions.

## Hawaii

At the time of first contact with Europeans, Hawaii was a complex hierarchical society in which objects functioned as visual symbols of status, rank, prestige, and power, based primarily on genealogical connections and descent from the gods. The Hawaiian sociocultural system evolved during centuries of isolation from the ancestral founding populations in southern Polynesia. This isolation contributed to the substantial differences between the aesthetic traditions of Hawaii and the ancestral homelands. Yet, it is quite evident that

81

southern Polynesian prototypes gave rise to the variant cultural forms known ethnographically from Hawaii and the Marquesas and Society islands from whence the ancestors of the Hawaiians are thought to have migrated. By the eighteenth century, the three island groups were the end products of long and diverse evolutionary histories. Hawaii is thought to have been isolated for some five hundred years—voyages to the homelands apparently had ceased. Although Hawaiian cultural forms are substantially different from the other island groups, it is probably more remarkable that objects from these widely separated societies have as much in common as they do. For example, carved human figures from all three areas are in many ways quite similar, but differ in the rendering of the head, the placement of the hands, and in surface decoration. They are unmistakably, however, all products of east Polynesians.

Hawaiian featherwork can be related by technology and form to southern Polynesia, although the variety and abundance of suitable birds made it possible for Hawaiians to exploit this colorful part of their environment in more intricate and elaborate forms. Thus, it is unproductive to "explain" Hawaiian feather helmets by resorting to non-Polynesian origins or influences from Greece, Spain, Nepal, or anywhere else. Hawaiian feather helmets, Tahitian wicker and feather headdresses *(whow)*, and Marquesan feather headdresses must surely have evolved from a common cultural form. One would only expect that over several hundred years the forms would evolve in different ways. They remained, however, visual indicators of status and prestige in all three areas. In spite of long separation, the Tahitian feathered headdress and the Hawaiian helmet had a striking similarity in form. If the forward curving front piece of the Tahitian feathered headdress (see, for example, Kaeppler, *"Artificial Curiosities,"* 126) was shortened, it would be remarkably similar to the front curving crest of some Hawaiian helmets.

Eighteenth-century contact with Europeans brought new tools and visual images which resulted in changes in the manner in which objects were produced and in expanded symbolism. These changes did not, however, significantly alter the relationships between objects and status. Indeed, in the late eighteenth and early nineteenth centuries, objects such as feather cloaks and bowls with supports in the shape of human figures became visual validations of power and prestige acquired not only by genealogical right but also with the aid of European weapons.

The relationships between gods, priests, chiefs, and people, and an aesthetic tradition concerned with ongoing process and use, in which works of art became chronicles of history objectified in visual form, are exemplified by Hawaiian featherwork. Certainly one of the high points of Polynesian art from any point of view, featherworking was the most prestigious artistic medium for Hawaiians. The making of a feather cloak or cape required the attainment of technical perfection in several difficult techniques—

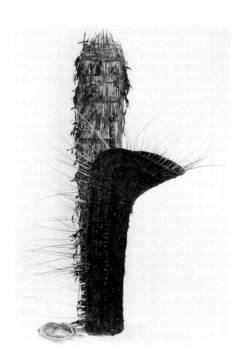

Tahitian headdress. The British Museum, London (TAH 9)

no. 1.27

bird snaring and the selection, sorting, and preparation of feathers; the gathering and preparation of *olonā (Touchardia latifolia)* fiber and its fabrication into the *nae* backing; the attachment of feathers to backing with prepared fine fibers; the incorporation of designs fabricated two dimensionally but meant to be seen draped on a human form; and the technical problems of finishing the edges. The whole social system—gods, chiefs, priests, and commoners—was activated and called upon at different stages. Only a chief with support of his *kahuna* (priests and craftspeople) had access to the necessary feathers and workers. Commoners gathered feathers, prepared the fiber, and probably fabricated the backing, but apparently only men of chiefly status attached the feathers. Though made for an individual, a feather cloak or cape would be handed down as an heirloom along with its acquired history and *mana*. Cloaks and capes varied in size, length, and shape and could be worn only by male chiefs of appropriate rank—rank which was traditionally acquired by birth and genealogical connections, but expanded in the nineteenth century to include power attained through warfare. Cloaks were worn in battle and were taken as battle prizes in the name of the conquering chief. Thus, the cloak worn by the high-ranking Kiwala'ō became the property of his cousin Kamehameha when Kiwala'ō was killed in a battle with the warriors of Kamehameha.

<div style="text-align: right;">nos. 1.2-1.8</div>

Feathered images served as receptacles for the highest gods. Although such images are usually said to represent the god of war, Kūkā'ilimoku, it is likely that Lono, god of peace and agriculture, also took this form, and it is even possible that any of the four national gods (Ku, Lono, Kane, and Kanaloa) might be called to these images through prayers and offerings. In Hawaii gods could take various forms depending on context and function. The god Kūkā'ilimoku is historically associated with several existing images, including large wooden temple images and the feathered image now in Bishop Museum. Lono is associated with a pole image, possibly with some wooden temple images, and probably with at least some of the feathered images collected on Cook's voyage—Cook having been thought to be an incarnation of Lono. It is likely that feathered images were made by high-ranking *kahuna* (priests) in the service of high chiefs who built, rebuilt, or activated *heiau* (temples) of national importance. Images in any form were likely to have immediate power only when activated, although they probably had historic residual power which depended largely on successful use on former occasions.

<div style="text-align: right;">no. 1.25</div>

One of the earliest known wooden images is that now in New Orleans collected on the third voyage of Captain Cook. I have suggested elsewhere that it, and a likely mate now in the British Museum, may have been part of a fence removed by Cook's men for firewood from Hikiau *heiau*. Fortunately they were preserved. They can be considered prototypes for the large temple images of the style

<div style="text-align: right;">no. 1.17</div>

<div style="text-align: right;">no. 1.1</div>

83

that developed on the island of Hawaii in the late eighteenth and early nineteenth centuries. The carving of these later, much larger images would be considerably eased by the metal tools traded from the ships of Cook and others. The Bishop Museum image, which probably dates from the late eighteenth or early nineteenth century, has a unique sennit skirt which has parallels with the sennit caskets of two protohistoric chiefs Liloa and Lonoikamakahiki.[1]

The forward thrust of the lower jaw found in the Bishop Museum image is a recurring element in Hawaiian art. The same upturned curve is found in the lower jaws of the faces which adorn the Field Museum carrying pole. In the Utah post image and the Bishop Museum stick image this curved thrust occurs in an overhanging position. The hooklike curve is the basis of the distinctively Hawaiian bone and hair necklace, of which the tiny bone pendant image from the Metropolitan Museum of Art is a unique variant. The ivory hook ornament from the Hewett collection has a raised ridge on its lower surface forming an inverted version of the Bishop Museum stick image. Ornaments express the same aesthetic principles found in the more imposing works of art. Tiny bone turtles have a similar sculptural power and show the same mastery of technique in both form and finish.

Daggers and shark-tooth implements are undecorated but exhibit an elegance of form and finish that is unsurpassed in Pacific weaponry. Such weapons are relatively rare because their usefulness immediately ceased with the advent of European weapons. Hawaiian bark cloth, on the other hand, continued to be made well into the nineteenth century but with interesting changes. Bark cloth collected on Cook's voyage is heavy in quality and bold in design. Straight lines, triangles, and steps were combined in parallel groupings and intersections to form designs that contribute to the overall style of vitality and boldness also found in wooden figures and feather cloaks. Nineteenth-century bark cloth is finer in quality and has impressed "watermarks" from intricately carved beaters. Smaller designs applied in series with fine bamboo stamps and more consciously placed in groups became a new fashion which quickly replaced the eighteenth-century style. The nineteenth-century finely carved beaters and bamboo stamps and the subsequent changes in the bark cloth made with them appear to be a direct result of the introduction of metal tools.

The use of human figures as supports for functional objects was an aesthetic element that was exploited more fully in Hawaii than elsewhere in Polynesia. These figures have an intrinsic vitality similar to that of the free-standing images but probably had associations with human ancestors rather than gods. Support figures on food bowls, for example, were apparently carved to degrade the memory of vanquished chiefs. The demeaning task of serving food desecrated the conquered and elevated the conqueror so served. Unfortunately Hawaiian traditions and symbolic associations of

no. 12.1

nos. 1.9, 1.22

nos. 1.18, 1.23

no. 1.19

no. 1.10

nos. 1.11-1.15

no. 1.11

84

most of the support figures such as those found on spear rests, those    no. 1.15
supporting the unique game board, or those carved in relief on stone
bowls have not been preserved.

Who, for example, do the figures carved into the base of the    no. 1.12
Christchurch drum represent? Do they climb atop one another for a
glimpse of the dancer they accompany? Do they aid the chanter by
improving the sound of the drum or by adding historic *mana* from
the ancestors? Are they symbolically bracing up the heavens as
poetically related in a text they accompany? The full impact of this
magnificent drum can only be imagined as part of a multi-
dimensional artistic production. This *pahu* would be used to ac-
company a *hula pahu*, the most elevated of Hawaiian dances which
honored gods and the highest of chiefs. Poetry phrased in allusion
and metaphor and filled with hidden meaning would be chanted by a
professional *ho'opa'a* (chanter/musician) trained under the
restrictions of Laka, god/goddess of the *hula*. The drum would
provide the rhythmic setting for an *'olapa* or standing dancer who
would transpose the poetry into movement. In effect, several cul-
tural forms would contribute their own allusions and hidden mean-
ings symbolically to create a total aesthetic experience for an
audience trained to accept the artistic challenge posed by such
complex creations.

## Society Islands

Wooden images in human form from Tahiti and other islands of the    no. 5.5
Society group lack the vitality of Hawaiian wooden figures. Al-
though legs and buttocks have a feeling of strength and power, the
arms, shoulders, and chest are pinched and lifeless. Rounded head
and pointed chin form the base of an almost expressionless face.
However, as it is likely that most of the known free-standing images
were part of canoe prows, such features should not be considered as
showing a lack of understanding of sculptural form. Instead, the
form suggests that images did not require fine detailing meant to be
seen or admired at close range and also that they probably derived
stylistically from stone temple figures of larger size. Indeed, the
small human figures which adorned the rare fly-whisk handles have    nos. 5.6-5.8
a kind of miniature monumentality. Human images probably served
as temporary dwelling places for gods who were called to them at
unspecified intervals, their outward appearance having little rele-
vance for their successful use. *Marae* (temple) "images" depicted by
Webber during Cook's third voyage were flat slabs without human
form. It is likely that human images carved of wood (*ti'i*) were
relatively unimportant protective devices to which lesser gods and
ancestors were called.

Important gods were called to *to'o*, objects which consisted
mainly of braided coconut fiber (sennit) which might be embellished    no. 5.10
with red feathers. The intricately braided sennit sometimes incorpo-

rated abstract anthropomorphic features such as arms, mouth, or eyes. These "images" were said to represent national gods, and specifically Oro, the god of war. Production of sennit was a time-consuming and difficult task which depended on mastery of diverse technical skills. Only certain kinds of coconuts had suitable fibers for the lengthy preparation, and, although twisting coconut fiber is comparatively simple, braiding it is not. In addition to forming the "body" of high-ranking gods, sennit became an artistic medium in its own right and can be considered a distinctive element of the Tahitian aesthetic tradition. The Tahitian regard for this material can be seen in the addition to a Tahitian image of a genital covering and headdress made of pieces of a Tongan decorative girdle made of sennit. This covering may have added a kind of puritanical sacredness to this figure—possibly after the introduction of Christianity.

no. 5.5

Braided sennit in two colors was used to form the fabric of the breast gorgets to which feathers, dog hair, shark teeth, and pieces of shell were attached. Worn as prestigious protection and status symbol, breast gorgets were also considered appropriate gifts for visiting dignitaries such as Captain Cook, documented by Webber's illustration. Sennit also played a functional and decorative role in the manufacture of Tahitian mourning dresses from a composite of diverse materials—pearl shell, turtleshell, feathers, bark cloth, coconut shell, and wood are all held together by finely braided coconut fiber.

no. 5.3

nos. 5.1, 5.2

nos. 5.9, 5.13, 5.12

Household furnishings, such as food pounders, stools, neck rests, and tools, took abstract and aesthetic forms. Although functional, braided sennit was applied decoratively on adze bindings, chisel grips, shark-hook snoods, nose-flute bindings, drum lashings, and neck rest repairs, and used in the joinery of whale-ivory pieces to form fly-whisk handles, and in the attachment of decorative end pieces to treasure boxes. In each case the sennit added an elaboration beyond function which can be appreciated by comparing, for example, the hafting of Tahitian and Hawaiian adzes.

nos. 5.6, 5.7

no. 5.11

Bark cloth was beaten with finely lined beaters, which left an imprint of fine parallel lines. Distinctive features of Society Island bark cloth were the use of leaf stamps as design elements and the overlaying of a fine lacelike sheet as a top layer.

## Mangareva

nos. 7.1-7.3

A notable art form of Mangareva is a series of free-standing wooden images strangely reminiscent of Society Island wooden figures. Although the Mangarevan stylization of the body is considerably elongated, there is a similar lack of vitality, especially in the area of the chest and arms and in the detached expression of the facial features. This lack of vitality and detached expression reach a logical extreme in the Mangarevan figure now in St. Germain in

which arms are straight and formless and facial features are entirely lacking.

The several known examples of Mangarevan images are so similar that they might have been made by the same carver.

## Marquesas Islands

The human figure in Marquesan wood carving, although it too has an apparent lack of concern for musculature and realistic proportions in the arms and chest, projects more vitality. The distinctive features of Marquesan figures, however, are the addition of shallow surface carving, the facial stylization, and especially the emphasis on the eye. The eyes, which were almost invariably divided horizontally by a raised ridge, are the dominating feature of the carved Marquesan face and form an important motif in all surface design. Elaborate use of intricate incised design is virtually absent in some parts of Polynesia, while in others it was highly developed, primarily in the Marquesas, Australs, and Cook islands, New Zealand, and Tonga. Although there are notable exceptions, such as the carved end pieces of Tahitian treasure boxes and carved details on Easter Island figures, intricate relief carving was not a distinctive feature of Hawaii, Society Islands, Easter Island, Mangareva, or Samoa.

Marquesan surface carving often places rectilinear and curvilinear designs in creative combinations with negative space. Sometimes the relief carving is located in limited areas; but even if an object was entirely carved, the surface design did not overwhelm the form, and richly carved objects would be incorporated in, or used with, less ornate objects. Thus, ornately carved bowl covers no.-2.8 served as tops for undecorated coconut bowls, carved stilt steps were attached to poles which were mainly undecorated and carved no. 2.4 fan handles were the focal point of plain (but exquisitely plaited) fan no. 2.14 blades. The canoe prow ornament from the Hooper Collection is a no. 2.17 splended example of distinctive features of the Marquesan aesthetic tradition. The squarish arms and hands are not free from a central Polynesian chest and stomach. Energetic legs rest on two secondary heads and horizontally divided eyes dominate the surface carving of all three heads. Overall form takes precedence over the decorative surface carving; the designs do not continue onto the base, which serves as an undecorated frame.

Many of the long clubs are beautifully proportioned and carved. An outstanding example is in the Sainsbury-University of no. 2.3 East Anglia collection. Secondary heads become eyes and nose while secondary eyes form a mouth. The upper ridge serves as a horizontal eye division of a secondary face and the lower set of eyes is emphasized by the noncompletion of the encircling radiating lines. It is an excellent example of the combination of straight and curved lines with negative space in restricted forms that is charac-

teristically Marquesan and a distinctive element of this aesthetic tradition.

Some of the distinctive features of wood carving, minus the surface decoration, are also found on stone and ivory carvings, such as the Janus-headed food pounders, small stone images and the ivory and bone ornaments for hanging bowls and for human ears. Ivory or wood fan handles are artistic transformations of one form in different media. The composite headdresses translate wood carving into turtleshell, while seashell serves the function of negative space. The sennit headbands and joinery echo the artistic use of this material in the Society Islands. A final transformation is the use of human skin designs on bark cloth and wood. Although both the Bishop Museum bark cloth construction and the arm from the Peabody Museum, Salem, are variously said to be tattooing models or ritual objects, their specific use is unknown. There can be little doubt, however, that the stylized eyes, concentric circles, and the placement of various design combinations in space demonstrate the same principles which underlie the Marquesan aesthetic tradition.

The final piece in this section has similarities to the "tattooed" arm; however, its use and provenance are not known. It lacks a distinctive combination of features, but its similarity to the Marquesan arm suggests that its origin may have been in the Marquesas, the Tuamotu Islands, or Mangareva.

## Easter Island

The wood carving of Easter Island shares a number of traits with its ancestral homeland in east Polynesia but elaborates them in yet another way. Distinctive details are the rendering of the human hand and the small round eyes inset with obsidian. The well-known "classic" wooden male figures are distinguished by the "emaciated" appearance of the rib cage, but this is characteristic of only a limited number of figures — most of which are surely from the second half of the nineteenth century. Details of the human head and hand are more diagnostic than the body form. The earliest known rendering of the human hand in wood is the realistic sized hand now in the British Museum collected on Cook's second voyage,[2] and the earliest known carved wooden face is on a stave in Janus form. It, too, is apparently from Cook's second voyage. These two pieces along with the Musée de l'Homme human head supported by human hands illustrate the distinctive features of Easter Island style: round eyes inset with obsidian, overhanging brows, and high foreheads which are often incised, bulbous cheeks, straight noses with flaring nostrils, horizontal lips, and realistic hands with shaped fingers. Many of these features are present on the much earlier stone images — similar (but undecorated) brows and foreheads, straight noses with flaring nostrils, horizontal lips, and realistic hands with shaped fingers.[3]

nos. 2.5, 2.6
nos. 2.10, 2.11

nos. 2.12, 2.13

no. 2.1
no. 2.2

no. 7.4

no. 3.10

The distinctive features of the carved face in wood are repeated in a carved dance staff, translated into paint on another dance staff, nos. 3.9, 3.12, 3.11 and abstracted in a third dance staff. The features of the painted dance staff are found once again in the bark cloth covered figures nos. 3.7, 3.8 from Peabody Museum, Harvard, which also portray the human hand in a realistic manner.

Full figures in wood with the earliest known date of collection are three now in Leningrad.[4] Apparently, they were collected either on the 1804 voyage of Lisjanskij or the 1816 voyage of Kotzebue. The three figures might be considered prototypes of the three "classic" forms known as *moai kavakava*, a male figure with protruding ribs, *moai papa*, a flat figure that is usually female, and *moai tangata manu*, a figure which combines features of man and bird. Although Heyerdahl considers these figures "aberrant," their early collection date suggests that they are early forms which are ancestral to the later "classic" objects. The later, more familiar images were collected in considerable number well into the nineteenth century. Almost invariably they were carved with metal tools.

The male figure developed into two main types—the Leningrad male figure having elements of both—the classic emaciated type with protruding ribs, represented here by single- and double- no. 3.2 headed male figures collected in 1870 by the Gana Expedition, and the more realistic type, represented here by the fine Otago Museum figure from the Oldman collection which incorporates the distinctive no. 3.1 elegant hands. The female figure from Leningrad can be considered an early form which developed into the *moai papa*. "Classic" *moai papa* include features of the Leningrad female image, such as the flat body form, and features of the large stone images such as the elegant hand carved in relief and raised designs copied from the backs of the images.[5] The example exhibited was found in New no. 3.3 Bedford in 1879, but its earlier history is unknown.

The Leningrad bird-man is an early form which developed into the many carved, creative combinations of man and animal. Early representations of man/bird combinations are found on carved no. 3.5 and/or painted boulders. These usually include human hands and bodies with bird heads.

The *rei miro* breast ornament is apparently the Easter Island transmutation of the Polynesian breast ornament which took various forms throughout Polynesia. The Easter Island form is remarkably similar to the crescentic wood chest piece of Tahitian mourning dresses. Some *rei miro* are incised with *rongorongo*, a symbolic no. 3.4 "script" which was probably used as a memory aid while chanting. Such symbols may have objectified a recitation in a way similar to the Hawaiian objectification of a prayer—in which sennit was braided while reciting and then the sennit was used as an offering.

## Austral Islands

Free-standing human figures from the Austral Islands are quite rare, but the incorporation of the human figure or parts of it into other objects is a distinctive design motif. The British Museum figure and a similar figure in the Auckland Museum illustrate the relationship between the Australs artistic tradition and their neighbors in central Polynesia. The squared shoulders with hands resting on the stomach, slightly flexed knees, and basic shape of the head have similarities to figures from Tahiti, Mangareva, and the Marquesas. The same kinds of figures, in whole or in part, are intricately incorporated into the magnificent drums from Raivavae. The images wear what appears to be a pectoral or breastplate similar to the *rei miro* of Easter Island. The surface carving, although reminiscent of the Marquesas, is composed of motifs which are distinctively different—a combination of elements found specifically in Raivavae carving.

nos. 6.8

nos. 6.1-6.3

These images, although they have a good deal in common, contrast with human figures from the neighboring island Rurutu. The back to back images on fly-whisk handles have the central Polynesian body form but Rurutu style. Encircling the center point of the handle are a number of stylized phalli carved in relief. This phallic motif appears more realistically in the three-dimensional ivory elements which are part of the ivory and hair necklaces and as carved in high relief on the spearhead/staff gods. With only slight changes the phallic elements are transformed into human figures carved in relief on the Auckland whalebone bowl—in which they become almost miniature versions of fly-whisk handle images. The Cambridge canoe carving, in turn, combines stylistic elements found in these pieces—chevroned incising, Janus figures from two fly-whisk handles holding hands, and a transformation of the phallic necklace elements, which are often said to represent dogs or pigs, into a realistic animal form.

nos. 6.6, 6.7

no. 6.12

nos. 6.4, 6.5

no. 6.11

no. 6.9

Finally, the large piece of bark cloth is apparently from one of Cook's voyages. Although it could have been obtained in Rurutu, it is equally likely to have been collected in Tahiti. Its stylistic analogues, however, are with the Austral Islands, particularly with tattoo patterns. The small black forms apparently represent creative variations of sea slugs, and the huge horizontal forms seem to be a combination of centipedes and sea animals known as *varua*.

no. 6.10

## Cook Islands

The various renderings of the human figure in the Cook Islands are closely related to those of their neighbors in central Polynesia—the Australs, Marquesas, and Tahiti. In Rarotonga especially, many of the distinctive features appear to be elaborations of artistic features also found elsewhere. Facial features are like sculpturally embel-

90

lished Marquesan features with a vertically emphasized center line. Body forms are similar to Tahiti and the Marquesas with an elaboration of genitals more closely related to the Australs. Staff gods include an upright head, a large phallus, and a number of horizontal secondary figures—the central portion of the long staff being wrapped in bark cloth. Similar secondary figures appear on the body of free-standing male images. These rare figures are of naturalistic proportions and are thought to represent gods in the act of creating other gods and men—an example of oral tradition in objectified form. Compressed male figures without secondary figures are said to represent fishermen's gods. Several examples of this type of image are known. The example included has painted motifs which have similarity to the carved surface motifs found on the human figures of Raivavae (Australs). In the transformation and miniaturization of the Rarotonga figure into a Janus fan handle, the resulting profile bears a striking resemblance to the New Zealand *mania*.

no. 4.1

no. 4.5

no. 4.6

no. 4.2

A female figure said to be from the island of Aitutaki elaborates a less dynamic sculptural form with painted motifs similar to motifs used on bark cloth. It is not known, however, whether the lack of vitality is characteristic of Aitutaki carving in general or if this is specific to female figures. The latter would be consistent with the Polynesian attitude toward the public presentation of male and female which contrasts virility and grace.

no. 4.4

Staff gods from the island of Mitiaro, in spite of their overall abstraction, are probably related to the staff gods of Rarotonga. The hollow dome and spatulate handle replace the head and phallus, while abstract secondary figures are carved from the shaft with delicate openwork.

no. 4.8

Surface decoration was elaborated by fine incising on the intricately carved adze handles from Mangaia which were said to represent craft gods. This carved surface elaboration is distinctive of Mangaia but is reminiscent of the surface carving of Raivavae scoops and paddles. These Mangaia adzes were greatly enlarged and elaborated with openwork carving during the nineteenth century. Many of them were probably made for trade and might be considered early pieces of tourist art.

no. 4.3

The Cook Islands also produced some of the finest weapons of Polynesia, such as long serrated clubs that often incorporate male sexual symbolism linking virility and warfare.

Musical instruments from the Cook Islands include slit gongs which are not characteristic of east Polynesia but were found in pre-European times primarily in west Polynesia. The Cook Islands form, which, by its carving motifs, appears to be primarily from Mangaia, is similar to the slit gong of Tonga known as *nafa*, which is quite different in form from the slit gongs of Samoa and Fiji. Only in Mangaia, however, are they elaborated as artistic forms in their own right.

no. 4.7

# Tonga

The human figure in Tonga is represented by a magnificent series of female carvings in ivory and wood. Strangely enough, most of the images have associations with suspension. The small ivory images have holes from which they were probably suspended from necklaces. Larger ivory images, which are usually in back-to-back pairs, surmount hooks and may have been the lower parts of so-called "rat safes" in which flat disks are placed horizontally above a hook to keep whatever is hung from the hook out of reach of rats from either above or below. According to information associated with the wooden images by missionaries, some of the images were "hung in disgrace." One wonders, however, if these images might have been parts of elaborate hooks used in chief's houses and used in much the same way as the ivory hooks. Similarly sized, but less beautifully carved, wooden hook figures were used in neighboring Fiji. Tongan images are usually localized in Ha'apai, the central group of islands in the Tongan archipelago, but most of the images do not have specific collection information. A few of them were collected in Fiji but were said to be Tongan.

nos. 9.6, 9.7
nos. 9.8 - 9.10

Two of the small ivory images exhibited were collected on one of Cook's voyages. The two larger ivory figures and the double image hook were collected in the nineteenth century. The earliest wooden images were collected in 1830. They are usually labeled "goddesses," but it is equally likely that the figures represent ancestors. All,

no. 9.3
no. 9.2

except one, stand with their legs securely and demurely placed in a parallel position. The other sits in a position called *faite* which is the proper sitting position for a female. They vividly portray Tongan values about women—the upper legs should always be parallel whether standing, sitting (to sit cross-legged is to sit *fakata'ane*—in the manner of a man), working, or dancing. Large calves are greatly admired, and generous shoulders and breasts contribute to the statuesque quality of women. In short, the images objectify desirable female qualities, but whether they represent goddesses, ancestors, or portraits is impossible to determine.

no. 9.4

Human figures in paint, ivory inlay, and incised wood were also incorporated as two-dimensional forms. Painted images occur on the under side of the disks of "rat safes."[6] An exquisite ivory figure is inlaid in the incised handle of a fly whisk which was given to Captain Cook by the Tongan high chief Paulaho. Human figures included in the intricately incised surface designs of Tongan clubs are miniature masterpieces. Although there are hundreds of such

no. 9.1

figures carved on clubs, an outstanding example is the carved club now in Cambridge, collected on Cook's third voyage. Traditionally, bark cloth design in Tonga shows similar geometric motifs to those carved on clubs. The human figure, however, was never incorporated into designs on bark cloth.

Bits of ivory were also used in other ways, namely as birds and

nonrealistic forms that were hung from necklaces or inlaid into neck rests. The beautifully abstract shapes of the neck rests were given a surface enhancement by the inlaying of ivory pieces, on the cross-bars, at the "knees" of the legs, and sometimes at the feet.

no. 9.5

The fabrication of basketry in Tonga constitutes another of the high points of Polynesian "artsmanship." Hundreds of fine Tongan baskets were collected during the late eighteenth and early nineteenth centuries—some seventy are traceable to Cook's voyages.[7] Examples included here are a wooden container covered with fine basketry made of coconut fiber in two colors and decorated with beads of seashell and turtleshell, a flat basket of the same materials, and a basket plaited from pandanus leaf. Each basket incorporated complex designs in the making. These designs are the same as those used in the surface incising of clubs and on bark cloth.

## Samoa

The arts of oratory and tattooing were cultural forms of highest importance in Samoa—neither can be adequately appreciated in an exhibition hall. The ceremonial mixing and serving of kava (prepared by infusing the root of a pepper plant with water) was intimately associated with ceremonial oration. Kava bowls and ceremonial clothing were finely made. Samoan kava bowls of various sizes can be distinguished from those of other areas by the number of legs. In contrast to kava bowls of Fiji and Tonga which have only four legs, Samoan kava bowls have six or more.

no. 10.1

The most important piece of ceremonial clothing is the *tuiga* headdress. The example included here from Munich is one of the finest extant. Decorative combs carved in delicate openwork made use of the same design motifs used in the decoration of bark cloth. Finely plaited pandanus leaf mats and bark cloth were the appropriate clothing for ceremonial wear—along with pungent flower necklaces and coconut oil which, in addition, made the skin shine.

no. 10.2
no. 10.3

Carved human images are rare and were apparently of minor importance. One now in the British Museum was found in 1836 with the preserved bodies of two chiefs.[8] The images lack the vitality of the Tongan figures and appear to have relationships with some figures of central Polynesia, on the one hand, and with Fiji on the other.

no. 10.4

## Fiji

The most remarkable human figures from Fiji are a series of eight ivory pendants which form a unique necklace. The figures are closely related in style and function to the small ivory images from Tonga which were also neck pendants. Indeed, the Hewett and

no. 8.7

no. 8.3

no. 8.2

no. 8.4

no. 8.8

no. 8.5

no. 8.6

Fijian post image. National Museum of Natural History, Washington (3275)

Sydney[9] Tongan figures would not be out of place if added to the Fijian necklace. The Tongan figures are smaller, which made possible the completion of the feet within the limited area of a whale tooth. The other nonhuman carved ivory elements on the Fijian necklace are also similar to carved ivory pieces used in Tonga on necklaces and decorative girdles. Although similar to some Tongan ivory figures the Fijian necklace figures also have similarities to Samoan and Fijian wooden images—for example, the British Museum Samoan figure and, from Fiji, the anthropomorphic oil dishes and some free-standing figures.[10]

A Fijian post image from the National Museum of Natural History has a sublime yet dynamic quality similar to the necklace figures and to the oil dishes in anthropomorphic form. Indeed, except for the enlarged flaring arms of the oil dish, the central necklace figure, the oil dish, and the post image have striking similarities in style.

Perhaps the most elegant of all Fijian oil dishes is a pair in the form of birds. The example included from the Hewett collection is so much like a similar piece in the Fiji Museum that they may have been carved by the same artist. Bowls in turtle form have a similar elegant feeling. The double-turtle oil dish from the Field Museum in which the two parts are joined by a wooden ring was carved from a single piece of wood. The turtle-shaped kava bowl from the Metropolitan Museum of Art is a more naturalistic rendering. It, unlike most Fijian wooden bowls, has no legs. It may have been placed on a circular fiber-covered ring, as were bowls made of pottery.

Ivory and shell breast ornaments appear to combine Fijian/Tongan whalebone breastplates and Tongan shell necklaces into a form distinctively Fijian. The basic part of the ornament is a large pearl shell. This is extended around its edges with carved pieces of ivory and decorated on its surface with ivory pieces in the form of stars, abstracted birds, or other simple shapes. The example included here from the Baltimore Museum of Art is decorated with birds and stars.

Similar small pieces of ivory were inlaid into the heads and ends of clubs. The club included here of the so-called "rootstock" form is inlaid with twenty-three ivory pieces and is incised at the grip end with typical zigzag motifs. Fijian weaponry included several diverse types of clubs and a varied array of spears which were carved and decorated with sennit lashings in geometric designs.

An exhibition of some 125 pieces to illustrate the diverse aesthetic traditions of Polynesia can only be a meager introduction to their wealth and variety. Some of the underlying themes and traditions can be considered threads which bind the islands together. These threads indicate, or at least suggest, historic relationships between the various islands. On the other hand, each Polynesian society conceptualized the relationships among social organization, religion, oral literature, music, dance, and the visual

arts in different ways. The individual compositions and objects that resulted offer vivid testimony to the varied ways of thinking about cultural forms that developed over time in new, slightly different island homes. These differences were even more striking, however, when Polynesians encountered the essentially nontropical land mass of New Zealand.

NOTES

1 Peter H. Buck (Te Rangi Hiroa), *Arts and Crafts of Hawaii*, Bishop Museum Special Publication 45 (Honolulu, 1957).

2 See Adrienne L. Kaeppler, *"Artificial Curiosities": Being an Exposition of Native Manufactures Collected on the Three Pacific Voyages of Captain James Cook, R.N. . . .*, Bishop Museum Special Publication 65 (Honolulu, 1978), 168-169, for color photographs of both sides of the hand; and Thor Heyerdahl, *The Art of Easter Island* (London, 1976), pl. 94, for three views of the hand.

3 See Heyerdahl, *Art of Easter Island*, pls. 12, 13.

4 Heyerdahl, *Art of Easter Island*, pls. 63, 65, 66.

5 Heyerdahl, *Art of Easter Island*, pls. 5, 13.

6 See Kaeppler, *"Artificial Curiosities,"* 225.

7 See Kaeppler, *"Artificial Curiosities,"* 217-223.

8 Janet Davidson, "The Wooden Image from Samoa in the British Museum: A Note on Its Context," *The Journal of the Polynesian Society* [Wellington, New Zealand], *84* (1975): 352-355.

9 See Kaeppler, *"Artificial Curiosities,"* 208.

10 See also the Fijian wood figures published in Allen Wardwell, *The Sculpture of Polynesia* (Chicago, 1967), 13; T. Barrow, *Art and Life in Polynesia* (Rutland, Vermont & Tokyo, 1972), 88-89; and Stephen Phelps, *Art and Artefacts of the Pacific, Africa and the Americas: The James Hooper Collection* (London, 1975), 186.

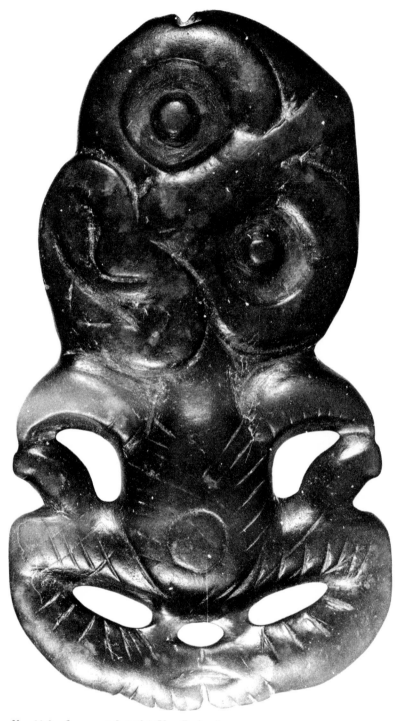

No. 11.2 *Ornament (hei-tiki)* (New Zealand)

# New Zealand Maori

Peter Gathercole

T he traditional arts of the Maoris were similar in many respects to those of the rest of Polynesia, though the relative importance of each form was probably different. For example, according to one authority, S. M. Mead, "in the field of woodcarving the Maori reached an excellence unparalleled by any other Pacific Island folk."[1] However, one should not assume (as some scholars have done) that carving, painting, weaving, or plaiting comprised the totality of Maori arts. Poetry, oratory, music, and dance were all significant. Poetry was a major figurative element in most types of oral literature. "Maori experts classify Maori literary forms into six major categories: *whai-korero* (speeches), *korero* (stories), *whakatauki* (proverbs), *moteatea* (song-poems), *haka* (shouted exhortations with actions) and *waiata-a-ringa* (action songs)."[2] The latter are a post-European development, but the remainder have considerable antiquity, often with an enduring significance for ceremonial occasions. In a society where gatherings of tribe and subtribe were very important for social, political, and military reasons, oratory and *haka* songs and dances expressed and enhanced the prestige of both the chief and the group. Buck gives a vivid account of mobilization for war by subtribes on the home *marae*, where complicated and highly conventionalized physical movements, dances, and songs were carefully coordinated. Any mistake was regarded as an ill omen for the projected campaign.[3]

Maori songs are classified according to function.[4] The most common are *waiata* (generally laments and love songs), but there are also *pao* (extemporaneous, topical songs), *poi* (dance songs to accompany *poi* dances), *oriori* (lullabies), and other more specialized songs, such as *marae* calls. One form of particular importance is the *karakia*, or incantation, which Buck defined as "a formula of words which was chanted to obtain benefit or avert trouble."[5] Many have been composed, dealing with every human situation, and a large number are highly *tapu* and probably of great antiquity.

The *marae* was (and still is) the main arena for artistic performance—an appropriate setting indeed for the appreciation of large examples of carving decorating the chief's house, which, in the nineteenth century, evolved into the meetinghouse.[6] A decorated chief's house expressed not only the corporate status of the tribe but also wider symbolic relations among its members. The chief was directly descended from a tribal ancestor, and his house was a visual link between past and present. The meetinghouse, certainly (and perhaps the earlier chief's house), was the physical embodiment of the tribe. For example, the central ridge pole represented its backbone, and the side boards were carved with representations of

97

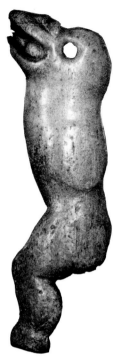

No. 11.8 *Ornament, Bird-Headed Man* (New Zealand, Akaroa): example of curvilinear form with morphological features

nos. 11.15, 11.17, 11.31

nos. 11.21, 11.23
nos. 11.11, 11.13; 11.24; 11.19

nos. 11.28; 11.15,
11.20, 11.30, 11.31

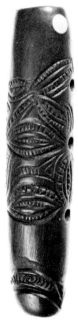

No. 11.13 *Flute (koauau)* (New Zealand)

ancestors who were thus ever-present in the tribe. It was a place unique to one group. As Mead has said, "The carved meeting house . . . can be perceived as a created environment in which dangerous spirit forces are checked and neutralised by displaying within the house an imposing gallery of the ⸝group's benevolent ancestors. Theoretically, a person is safest within the carved structure of his own tribe than anywhere else in the world."[7]

Carvers, therefore, were mediators between the material and nonmaterial world. It is hardly surprising that carving was not confined to communal houses. Storehouses were also carved with symbols, some of which (e.g. copulating couples) represented fertility. Other carved objects included canoes and canoe furnishings, clubs and other weapons, tool handles, musical instruments, bowls, treasure boxes, and a range of personal ornaments. The design repertoire was predominantly curvilinear, with much attention given, in one way or another, to the human figure. Other forms were also used, including the *manaia*, the *marakihau*, and the lizard. The *manaia* looks rather like a human face in profile, often with a birdlike beak. It may have served as a protector to ward off evil spirits. The *marakihau* was a part-human, part-sea monster of obscure meaning, and the lizard was, perhaps, a symbolic guardian against evil and death.[8]

Much nineteenth-century carving has a profusion of detail which can be explained at least partly by the increase of technical proficiency following the introduction of iron and steel tools. Rich carving is also found, however, on some objects recorded or collected on Cook's voyages.[9] Others are decorated only in limited zones, e.g. at the proximal ends or midpoints of weapons, tools, musical instruments, paddles, and canoe bailers. By the eighteenth century, carving was obviously conventionalized. It was perhaps often devoid of specific symbolic meaning, except to the extent that an object was thought to be incomplete unless it had some decoration. At the same time, certain regional styles flourished, notably in North Auckland and Taranaki, and in the Bay of Plenty—East Coast areas.

The origin of the curvilinear style has been vigorously debated by scholars.[10] The problem is that eighteenth-century Polynesian carving is typically geometric, usually with small design fields, although exceptions are found in the Marquesas and Austral Islands. Today most scholars agree that the curvilinear style developed solely within New Zealand, being an expression of the evolution of the Classic Maori phase from the Archaic phase and having its genesis in the northern part of the North Island. Mead correlates this change in style from the basically rectilinear art form of the Archaic phase with a "major change in political and social alignments" following large-scale southward population movements by the Awa people in the fifteenth century, when it became necessary to provide a new art form to validate a changed social order.[11]

It is certainly possible to see both continuity and change in the limited evidence of art from the Archaic phase of New Zealand prehistory. Some Archaic neck ornaments are very similar to early examples found in eastern Polynesia,[12] where rectilinear designs always predominated. Similarly the so-called chevroned amulets often possess morphological characteristics similar to those found elsewhere in Oceania and may therefore be ancient forms.[13] Many South Island ornaments reflect Archaic traditions whatever their actual dates but some have curvilinear designs.

Despite the vitality, variety, and originality of these small-scale carvings, one can hardly create from them alone a scheme of artistic development. Even if we extend the discussion to include apparently atypical wood carvings, the evidence remains meager and the argument essentially speculative. Thus the well-known but undated roof ornament from Kaitaia, North Auckland,[14] can be regarded as an example of Archaic wood carving because its central human figure recalls eastern Polynesian figures (notably those on a canoe ornament), and its chevron designs are very similar to those on chevroned amulets. Mead dates the Kaitaia carving between A.D. 1350-1450, but points out that "its compositional structure . . . is the same as in Classic Maori door lintels, that is, a central human figure flanked by a terminal non-human figure."[15]

Another North Auckland carving can be placed slightly later, within a phase of Archaic-Classic Maori transition, which Mead calls Proto-Maori (A.D. 1450-1650).[16] This is the canoe prow from Doubtless Bay, with its striking curvilinear ornament—though (if one wishes to make it an element in the argument) the curves are thicker and coarser than in those found in eighteenth-century carving. But the *manaia* form is present, as well as "spikes" that Mead relates stylistically to the knobs on Proto-Maori combs.[17] "Spikes" and knobs are examples of edge ornamentation similar to the notching found on many Archaic and some Classic Maori artifacts, a practice which may have had enduring symbolic significance.[18] Certainly one should not regard the Classic Maori style as wholly antithetical to its predecessor, just as the rock art of the South Island, which flourished particularly in the fifteenth century, has some designs similar to Classic Maori carving.[19] To note such continuities, however, is only to emphasize the extent of the change that occurred.[20]

no. 11.6

nos. 11.3, 11.9

nos. 11.2-11.4, 11.8-11.10

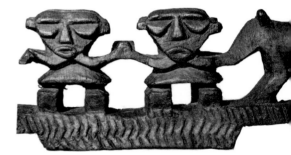

No. 6.9 *Canoe Ornament* (Austral Island, Rurutu) detail

no. 11.27

nos. 11.5, 11.6

NOTES

1 S. M. Mead, *The Art of Maori Carving* (Wellington, 1961), 11.

2 J. Metge, *The Maoris of New Zealand: Rautaki*, 2nd ed. rev. (London, 1976), 266. Metge notes that, although much oral literature was recorded in the nineteenth century, a great deal is still unpublished. She instances Sir George Grey's collection in the Auckland Public Library which "consists of 9,800 pages of manuscript, of which only 126 pages of prose and 500 pages of poetry have been published" (267).

3 Sir Peter Buck (Te Rangi Hiroa), *The Coming of the Maori* (Wellington, 1949), 390-391.

4 M. McLean, "Song Types of the New Zealand Maori," *Studies in Music*, 3 (1969): 53-69.

5 Buck, *Coming of the Maori*, 489.

6 It is now widely held that the meetinghouse and the storehouse *(pataka)*, as such, did not exist in pre-European times but developed when Maoris acquired potatoes, pigs, and metal tools (cf. L. M. Groube, "Settlement patterns in prehistoric New Zealand," M. A. thesis, University of Auckland, 1964). This nineteenth-century economic revolution was matched ideologically by conversion to Christianity and by building churches, sometimes in the Maori idiom. Some of the implications of these changes are discussed elsewhere.

7 S. M. Mead, "The Origins of Maori Art: Polynesian or Chinese," *Oceania, 45* (1975): 177.

8 H. D. Skinner, "Crocodile and Lizard in New Zealand myth and material culture," *Records of the Otago Museum, Anthropology, 1* (1964).

9 E.g. Canoe prows drawn at the Bay of Islands, and a house post at Tolaga Bay, 1769 (British Library Add. Ms. 23.920.79 and 23.920.75; cf. A. Kaeppler, *"Artificial Curiosities"* (Honolulu, 1978), figs. 396, 397, 394).

10 Well-surveyed by Mead, "Origins of Maori Art."

11 Mead, "Origins of Maori Art," 202-203.

12 E.g. at Maupiti, Society Islands (K. Emory and Y. H. Sinoto, "Eastern Polynesian Burials at Maupiti," *Journal of the Polynesian Society, 73* [1964]: 143-160).

13 E.g. the motif of triangle-with-serrated base (H. D. Skinner, *Comparatively Speaking: Studies in Pacific Material Culture 1921-1972* [Dunedin, 1974], 80-81).

14 Cf. Mead, "Origins of Maori Art," 199-203, for discussion and major references.

15 Mead, "Origins of Maori Art," 199.

16 Mead, "Origins of Maori Art," 189 ff., especially 203-206.

17 Mead, "Origins of Maori Art," 203.

18 P. Gathercole, "Obstacles to the Study of Maori Carving: the Collector, the Connoisseur, and the Faker," in M. Greenhalgh and V. Megaw, eds., *Art in Society* (London, 1978), 285. Cf. Mead, "Origins of Maori Art," 203-206.

19 M. Trotter and B. McCulloch, *Prehistoric Rock Art of New Zealand* (Wellington, 1971), 65-69.

20 For example, a wooden comb, which may be dated to even as late as the early nineteenth century, has two terminal human heads which resemble stylistically both the human head on the comb from Moa-Bone Point Cave (H. D. Skinner, "Archaeology of Canterbury: Moa-Bone Point Cave," *Records of the Canterbury Museum, 2* [1923], pl. 20) and that on the sperm whale tooth ornament from Little Papanui, Otago Peninsula (Skinner, *Comparatively Speaking*, 69)—both Archaic ornaments. Of course, one can play these stylistic games forever.

# The Catalogue

***Note to the catalogue***

Each catalogue entry is arranged in the following sequence:

Title of object

Material
Dimensions in centimeters (inches)
Place of origin by country, political division (in some cases an identifying geographical feature, e.g. "Ambunti Mountains"), village if known: tribal or language name. (Note that the country name follows popular usage; "Hawaii" stands alone, although part of the United States, as do New Britain, New Ireland, etc., which are part of the state of Papua New Guinea.)
Collection data and former locations if known

Present location (lender)

Notes on the object(s)

Selected references in abbreviated form (full references, p. 359)

**POLYNESIA**

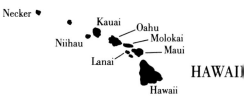

Necker

Kauai
Oahu
Niihau    Molokai
Maui
Lanai

HAWAII

Hawaii

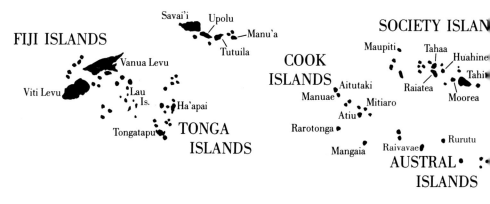

SAMOA ISLANDS

Savai'i   Upolu

Manu'a

FIJI ISLANDS

Tutuila

SOCIETY ISLANDS

Vanua Levu

COOK
ISLANDS

Maupiti

Tahaa   Huahine
Tahiti

Viti Levu

Lau
Is.

Ha'apai

Aitutaki

Manuae

Raiatea

Moorea

Mitiaro

Tongatapu

TONGA
ISLANDS

Atiu

Rarotonga

Rurutu

Mangaia

Raivavae

AUSTRAL
ISLANDS

North Island

NEW ZEALAND

South Island

ANDS

MARQUESAS ISLANDS

hiva ⸱ Uahuka

Uapou ▾ Hivaoa

Tahuata ⸱ Fatuhiva

Mangareva

GAMBIER ISLANDS            EASTER ISLAND

# 1 Hawaii

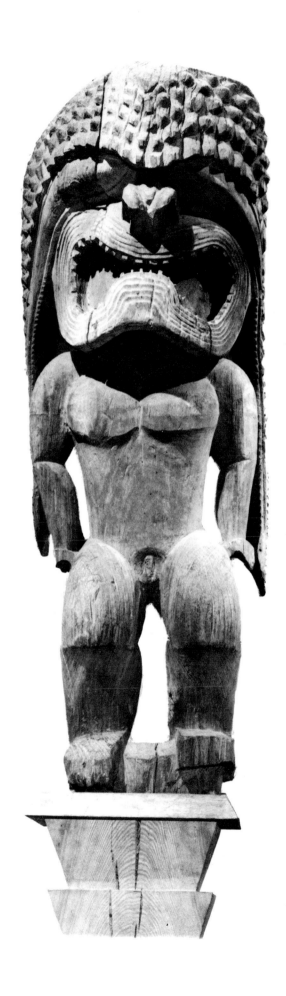

## 1.1 TEMPLE IMAGE

Wood
198 (79) high
Hawaii
Formerly East India Marine Society, 5041
Given by John T. Prince, 1846

Peabody Museum of Salem, Massachusetts,
E 12071

Buck, *Arts and Crafts of Hawaii*, 490; Cox and
Davenport, *Hawaiian Sculpture*, 121

**1.2 CLOAK** (*'ahu 'ula*)

Feathers on netted fiber backing
117 (46) high
Hawaii
History unknown
Obtained through an exchange with the British
Museum in the 1890s

Bernice Pauahi Bishop Museum, Honolulu,
323

Brigham, *Hawaiian Feather Work*, 59; Buck,
*Arts and Crafts of Hawaii*, 228

**1.3 CLOAK** (*'ahu 'ula*)

Feathers on netted fiber backing
264.5 (108) wide
Hawaii
In the possession of the earls of Elginshire,
October 1792 to 1968

Bernice Pauahi Bishop Museum, Honolulu,
D. 4592

Kaeppler, "Feather Cloaks," 6

**1.4 CLOAK** (*'ahu 'ula*) Color plate 3

Feathers on a netted fiber backing
237.5 (93½) wide
Hawaii
Said to have been given by Kamehameha III to
General William Miller (Honolulu), in 1831
Formerly Dover Museum; entered the James
Hooper Collection, 1948

Private collection, New York

Brigham, *Additional Notes on Hawaiian
Feather Work*, 16-17; Phelps, *James Hooper
Collection*

**1.5 CAPE**

Feathers on netted fiber backing
124 (48¾) wide
Hawaii

Lent by the Trustees of the British Museum,
London, Q27. Oc. 848

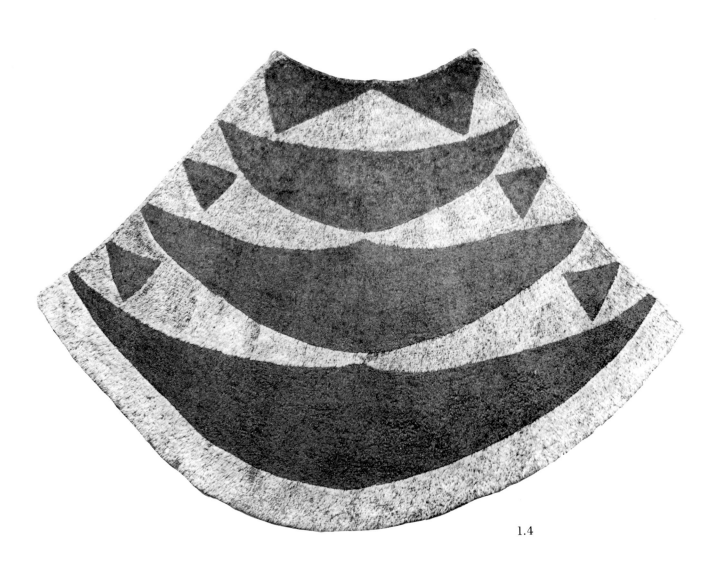

1.4

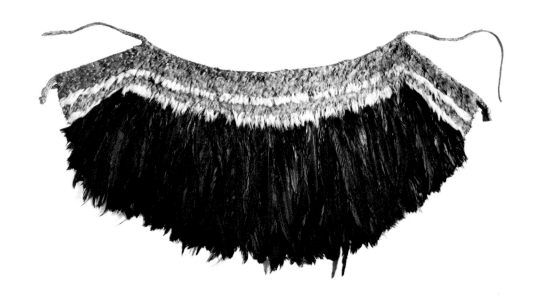

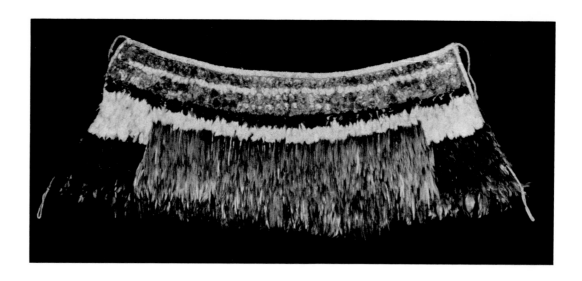

## 1.6   CAPE

Feathers, bark cloth, fiber, bird skin
112 (44⅜) wide
Hawaii
Collected on Captain James Cook's third voyage, 1778-1779
Formerly in the Leverian Museum, London, dispersed 1806

Museum für Völkerkunde, Vienna, 180

This is one of the rare trapezoidal feathered capes, of which only six are known. It has a bark cloth band at the top edge covered with pieces of bird skin with feathers adhering from the 'apapane (Himatione sanguinea), 'i'iwi (Vestiaria coccinea), and 'o'o (Moho braccatus). The body of the cape is composed of feathers from the Hawaiian chicken and the body feathers of the white-tailed tropic bird. The shape of the cape and the feathers used suggest that it is from the island of Kauai.

Kaeppler, "Artificial Curiosities," 60, 63; Moschner, "Die Wiener Cook-Sammlung: Südsee-Teil," 234; Buck, Arts and Crafts of Hawaii, 219

## 1.7  CAPE

Feathers on a netted fiber backing
129 (51) wide
Hawaii
Collected on Captain James Cook's third voyage, 1778-1779

By courtesy of the Australian Museum Trust, Sydney, H 104

This cape was apparently retained by Captain Cook's widow and inherited by the descendants of her cousin, Rear Admiral Isaac Smith. It was exhibited at the *Colonial and Indian Exhibition* in London in 1886 and subsequently purchased by the government of New South Wales in 1887. It is a unique piece in that almost the entire cape of *'i'iwi (Vestiaria coccinea)* feathers is overlaid with tail feathers of red and white tropic birds and cock feathers.

Kaeppler, *"Artificial Curiosities,"* 59, 63, 281-282; Brigham, *Hawaiian Feather Work*, 4, 73

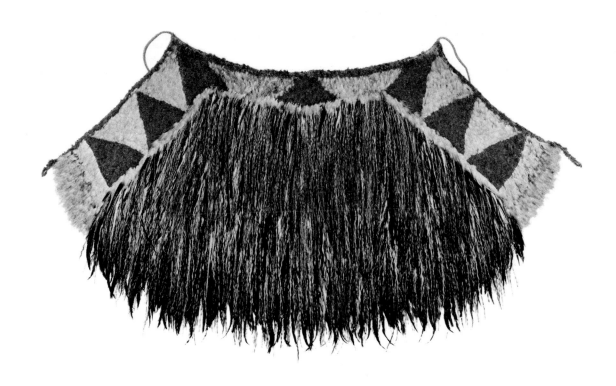

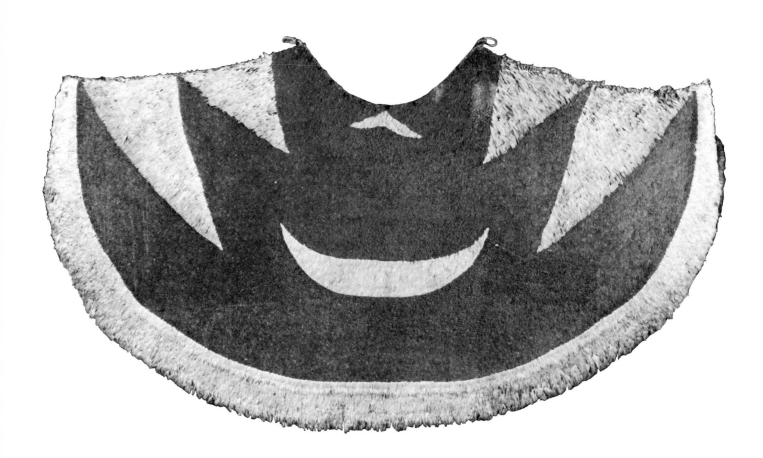

**1.8   CLOAK**

Feathers on a netted fiber backing
234 (92) wide
Hawaii
The history prior to 1926 is unknown, though
this piece was in the collection of Wilfred Peel,
Devonshire, in the 1920s

University Museum of Archaeology and An-
thropology, Cambridge, Z.6140

## 1.9  CARRYING POLE (*'auamo*)

Wood
103 (40½) long
Hawaii
Formerly A. W. Fuller, London

Field Museum of Natural History, Chicago, 272597

Carrying poles were placed across the shoulder to carry wood or gourd bowls suspended in fiber nets.

Force and Force, *Fuller Collection*, 90, 95; Cox and Davenport, *Hawaiian Sculpture*, 178-179

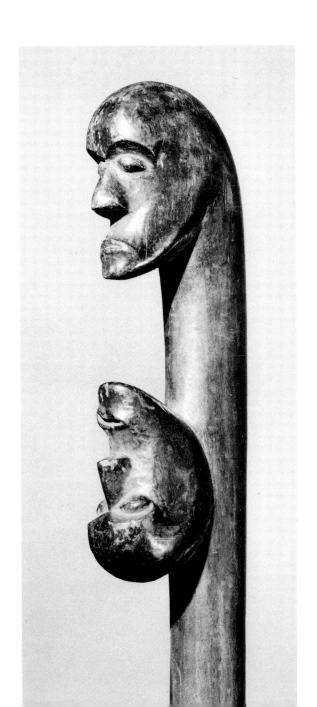

## 1.10  BARK CLOTH *(kapa)*

Inner bark of the paper mulberry plant
80 (31½) long
Hawaii
Collected on Captain James Cook's third voyage, 1778-1779
Formerly in the Leverian Museum, London, dispersed in 1806

Museum für Völkerkunde, Vienna, 72

This is one of the few existing pieces of Hawaiian bark cloth collected on Cook's third voyage that has not been cut up into small samples. It preserves the striking and bold design composition of eighteenth-century Hawaiian bark cloth.

Kaeppler, *"Artificial Curiosities,"* 89

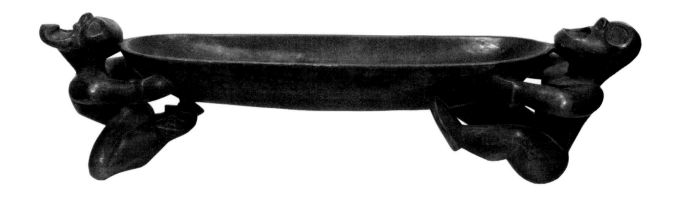

## 1.11  BOWL WITH HUMAN FIGURE SUPPORTERS

Wood
116 (45½) long
Hawaii

Bernice Pauahi Bishop Museum, Honolulu, 408

The figures are said to symbolize the chief Kahahana and his wife Kekuapai in a servile position to commemorate the victory of the chief Kahekili over Kahahana. It is from the Princess Ruth Ke'elikōlani's collection—one of the orginating collections of the Bishop Museum. Kahekili was the biological father of Kamehameha I, who was the grandfather of Princess Ruth.

Cox and Davenport, *Hawaiian Sculpture*, 168, 169; Dodd, *Polynesian Art*, 165

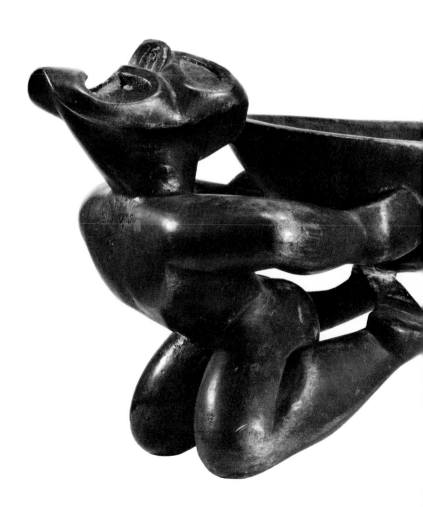

## 1.12 DRUM (*pahu hula*) WITH HUMAN FIGURES

Wood, shark skin, cords
46.8 (18½) high
Hawaii
Formerly W. O. Oldman, London, 127

Canterbury Museum, Christchurch, New Zealand, E 150.1185

Carved of one piece of wood, this drum is one of the most marvelous pieces of Hawaiian art. Only one other skin drum with human figure supports is known and was probably collected during Cook's third voyage. Unfortunately the history of this drum is unknown. The horizontal fluting is unusual in Hawaiian art.

Cox and Davenport, *Hawaiian Sculpture*, 112, 183; Roger Duff, *No Sort of Iron* (Christchurch, 1969), 128

## 1.13 BOARD (*papamu*)

Wood
20.3 (8) high
Hawaii, Kawaihae, Honokoa Gulch burial cave
Formerly David McHattie Forbes

Hawaii Volcanoes National Park Museum, Volcano, Hawaii, 02 HNPK-01

The game *konane*, which resembled checkers, was indigenous to Hawaii. The "men" of black and white stones were moved on prepared boards of wood or stone. This unique example supported by two human figures was found in 1904.

Cox and Davenport, *Hawaiian Sculpture*, 176

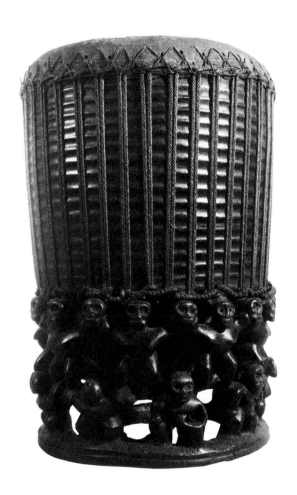

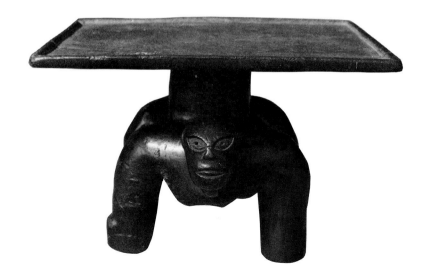

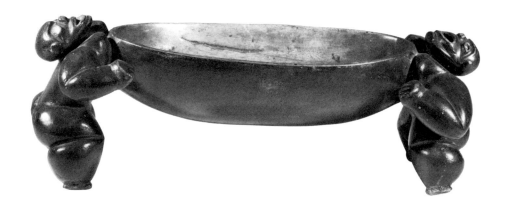

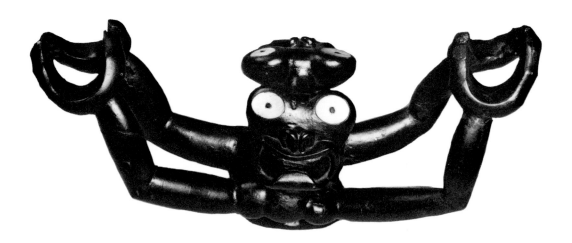

**1.14   BOWL WITH HUMAN FIGURE
SUPPORTERS**

Wood
38 (15) long
Hawaii
Said to have been owned by Liholiho (King
Kamehameha II, 1798?-1824) and his ances-
tors

Bernice Pauahi Bishop Museum, Honolulu,
5181

Cox and Davenport, *Hawaiian Sculpture*,
168-169

**1.15   SUPPORT RACK WITH HUMAN
FIGURES**

Wood
44 (17¼) long
Hawaii

Exeter City Museums, England, 46/1908

This support rack was probably used as a spear
rest in a canoe. It came to the museum in 1908
from R. Cumming.

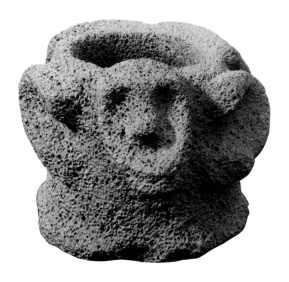

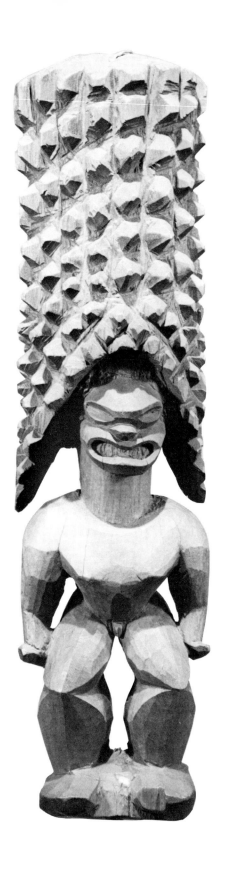

## 1.16 BOWL

Stone
20.3 (8) diameter
Hawaii
Formerly Bernice Pauahi Bishop Museum

Kauai Museum, Lihue, Kauai, Hawaii

This bowl was found when a field in Kalaheo, Kauai, was being plowed in 1926.

## 1.17 TEMPLE IMAGE

Wood
80.4 (31⅝) high
Hawaii
Collected on Captain James Cook's third voyage, 1778-1779
Formerly in the Leverian Museum, London, dispersed 1806

New Orleans Museum of Art, Victor K. Kiam Bequest

Cox and Davenport, *Hawaiian Sculpture*, 130; Kaeppler, *"Artificial Curiosities,"* 78-79

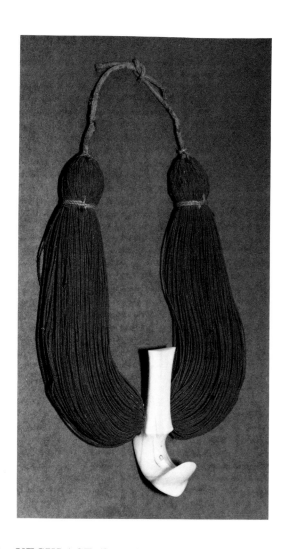

**1.18 NECKLACE (*lei niho palaoa*)**

Ivory, human hair
29.8 (11¾) high
Hawaii

Private collection, England

Hawaiian necklaces with a hook-shaped orna-
ment are usually referred to as *lei niho palaoa*,
which literally means "necklace of the tooth of
a whale." Most large hooks of this type, how-
ever, are made of walrus ivory, acquired by the
Hawaiians through trade from the northwest
coast of America. The ivory of this necklace
has not been analyzed, but it is of the large
nineteenth-century type—eighteenth-century
examples are much smaller. The hook orna-
ment is mounted on a multistrand necklace
composed of two finely braided human hair
loops which are attached to each other through
a lateral hole in the ivory hook. This necklace
is one of the most beautiful and interesting
extant, especially in the incorporation of the
highly raised central ridge on its lower surface.

**1.19 ORNAMENT, THREE TURTLES** Color plate 4

Ivory on fiber cord
2.3 (⅞) long (each)
Hawaii
Collected on Captain James Cook's third voy-
age, 1778-1779

By courtesy of the Australian Museum Trust,
Sydney, H 151 a-c

This ornament has the same history as the
feather cape (no. 1.7).

Kaeppler, *"Artificial Curiosities,"* 97, 281-282

117

## 1.20  IMAGE, probably from a temple

Wood
54.5 (21.5) high
Hawaii
According to W. T. Brigham the image was a gift of King Kalākaua

The Historical Department, The Church of Jesus Christ of Latterday Saints, Salt Lake City

Cox and Davenport, *Hawaiian Sculpture*, 37, 133; Kaeppler, *Eleven Gods Assembled*, 12

## 1.21  IMAGE

Wood, coconut fiber skirt, pearl shell
39.3 (15½) high
Hawaii
Located in private hands in Washington, D.C. in 1941

Bernice Pauahi Bishop Museum, Honolulu C9595

This type of free-standing wooden figure is usually known as an *'aumakua* image, although how such images were actually used is unknown. Complex, braided sennit similar to the sennit covering of the Tahitian *to'o* (no. 5.10) forms a unique sennit skirt. Prototypes for the sennit skirt are the sennit caskets shaped to hold the skull and other bones of two historic chiefs. The braiding of sennit *('aha)* in conjunction with the chanting of a prayer *('aha)* was thought to capture the prayer and objectify it, and it is possible that the sennit skirt served to envelop the image in a perpetual prayer.

Buck, *Arts and Crafts of Hawaii*, 477; Cox and Davenport, *Hawaiian Sculpture*, 43, 160; Dodd, *Polynesian Art*, 234

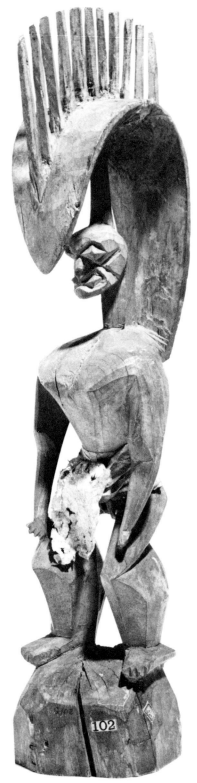

1.20

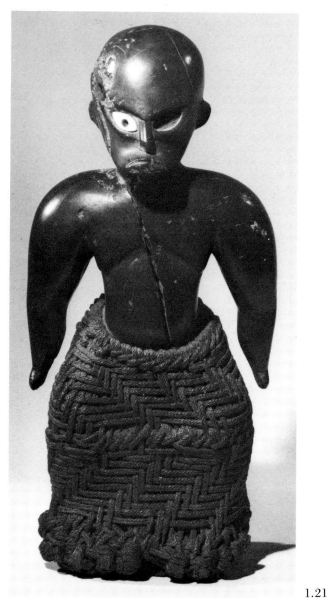

1.21

## 1.23 NECKLACE ORNAMENT

Bone
6.1 (2⅜) high
Hawaii

The Michael C. Rockefeller Memorial Collection of Primitive Art, on loan to The Metropolitan Museum of Art, New York, from Nelson A. Rockefeller, L.P. 61.35

This bone ornament was probably suspended from a human hair necklace similar to no. 1.18. It is the only example known in which the hook ornament has been shaped into a human figure. Strictly speaking, it should not be called a *niho palaoa* because it is not made of whale tooth.

Wardwell, *Sculpture of Polynesia*, 69; Dodd, *Polynesian Art*, 138

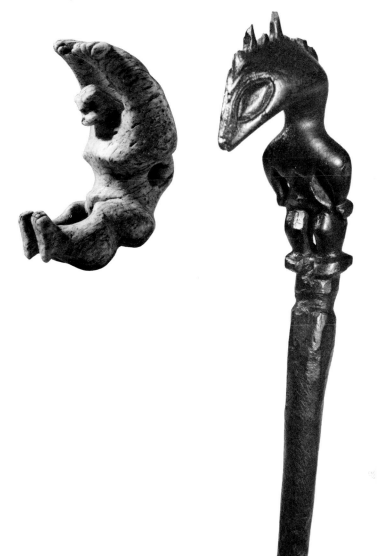

## 1.22 IMAGE, on pointed prop

Wood
36.5 (14.5) high
Hawaii

Bernice Pauahi Bishop Museum, Honolulu C10,189

Usually said to represent a bird or a lizard, it is likely that it is simply an abstraction of the human head in an overhanging, hook-shaped form. It was collected by R. R. Bloxam, chaplain on H.M.S. *Blonde*, in 1825. It was then taken to New Zealand by a Bloxam descendant and presented to the Bishop Museum in 1949.

Buck, *Arts and Crafts of Hawaii*, 484; Cox and Davenport, *Hawaiian Sculpture*, 86, 142-143; Kaeppler, "*L'Aigle* and HMS *Blonde*," 28-44

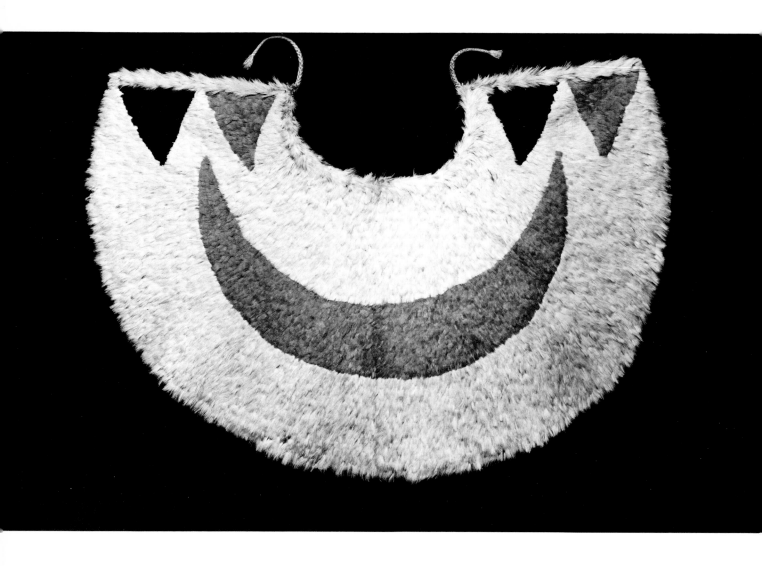

**1.24 CAPE**

Feathers on fiber net
75 (29½) wide
Hawaii

The University Museum, Philadelphia, 29-58-156

**1.25 IMAGE** Color plate 1

Feathers, wicker, dog teeth, pearl shell, wood
62 (24.5) high
Hawaii
Collected on Captain James Cook's third voyage, 1778-1779
Formerly in the Leverian Museum, London, dispersed 1806

Museum für Völkerkunde, Vienna, 202

Although feathered images are usually associated with the war god, Kūkā'ilimoku, there is no indication of this in the writings from Cook's voyage. It is equally likely that these images served as receptacles for Lono, god of peace and agriculture, who flourished during the *makahiki* season which was in progress during Cook's visit to the island of Hawai i.

Kaeppler, *"Artificial Curiosities,"* 53-55; Moschner, "Die Wiener Cook-Sammlung," 230-231; Danielsson, *La Découverte de la Polynésie*, no. 172

### 1.26 HELMET

Wickerwork
23.5 (10) high
Hawaii

Peabody Museum of Archaeology and Ethnology, Harvard University, Cambridge, Massachusetts, 53561

### 1.27 HELMET (*mahiole*)

Wickerwork, feathers
26 (10¼) high
Hawaii

Staatliches Museum für Völkerkunde, Munich, 364

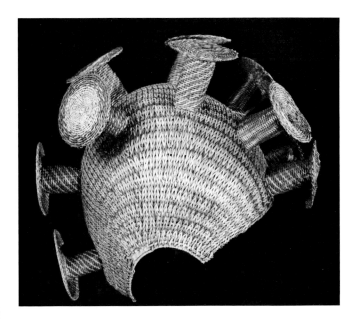

This helmet is said to be from Cook's third voyage; however, its documentation goes back only as far as its purchase, along with several other pieces, by Dr. Johann George Wagler of Nürnberg in 1825 in London from a collection said to derive from Sir Joseph Banks. Banks traveled only on Cook's first voyage, but was the recipient of gifts from Cook's second and third voyages. Banks also had objects from other early voyages that called in Hawaii including those of Vancouver and of Portlock and Dixon. Thus, although the Cook voyage provenance cannot be verified, it is likely that it was collected during the eighteenth century. There is some European cloth underlying some of the yellow feathers of the crest, which may be a restoration done in Europe.

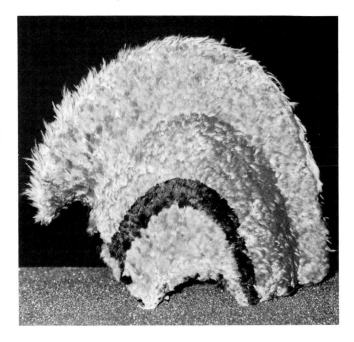

# 2 Marquesas Islands

## 2.1  IMAGE

Wood, tapa, paint
61 (24) high
Marquesas Islands

Bernice Pauahi Bishop Museum, Honolulu,
6807

These rare bark cloth and wood constructions
are thought to be patterns for tattoo artists,
although it is also possible that they are ancest-
ral figures that recorded the pattern of an
individual's tattoo. According to Bishop Mu-
seum records, this example was given to
Lahainaluna School on Maui by Marquesan
visitors in 1853. It then went into the collection
of the American Board of Commissioners for
Foreign Missions and subsequently returned to
Hawaii in 1895.

Barrow, *Art and Life in Polynesia*, 95; Linton,
*Marquesas Islands*, 181

## 2.2  ARM

Wood
61 (24) long
Marquesas Islands
Collected by Robert Louis Stevenson, about
1890-1894; museum acquisition, 1915

Peabody Museum of Salem, Massachusetts
E 16.063

Linton and Wingert, *Arts of the South Seas*, 40;
UNESCO, *Art of Oceania*, panel 42

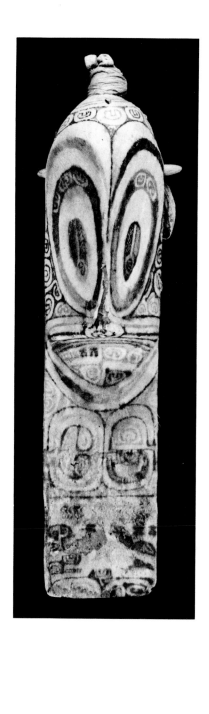

## 2.3  CLUB

Wood
148 (58¼) long
Marquesas Islands

University of East Anglia, Norwich, England,
Robert and Lisa Sainsbury Collection, 1963
UEA 193

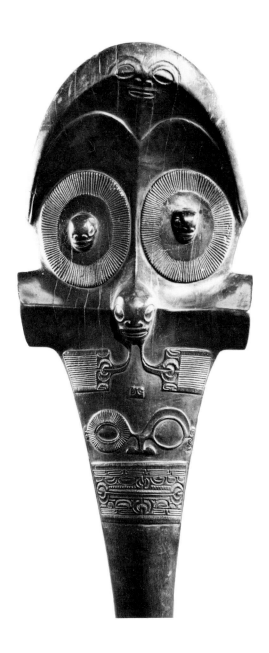

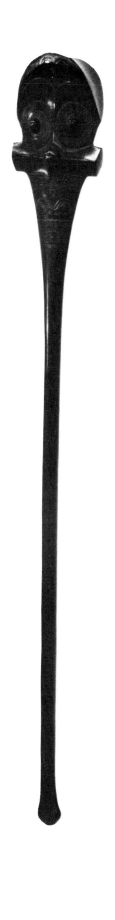

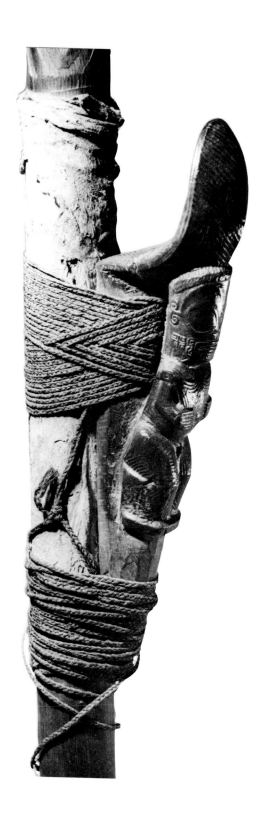
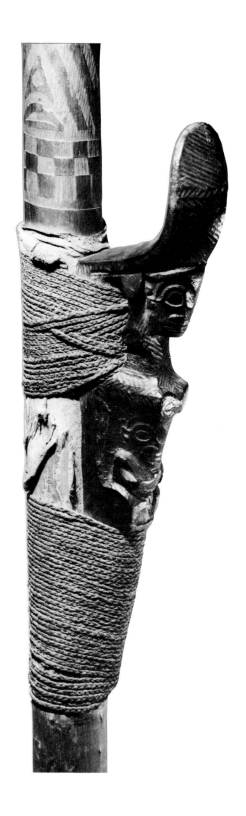

**2.4  PAIR OF STILTS** *(tapuva'e)*

Wood, sennit
194 (76⅜) long
Marquesas Islands

Musée de l'Homme, Paris, 87.31.6, 1-2

UNESCO, *Art of Oceania*, panel 42

125

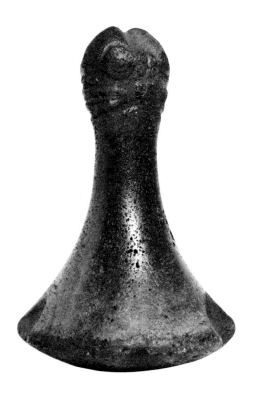

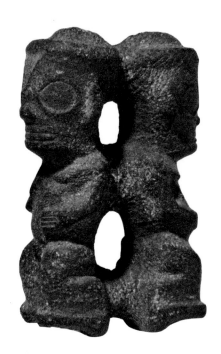

**2.5 FOOD POUNDER**

Stone
20.3 (8) high
Marquesas Islands
Collected by Ralph Linton in 1920-1921

Bernice Pauahi Bishop Museum, Honolulu,
B. 3040

**2.6 DOUBLE IMAGE**

Stone
14 (5½) high
Marquesas Islands

Bernice Pauahi Bishop Museum, Honolulu,
C. 5404

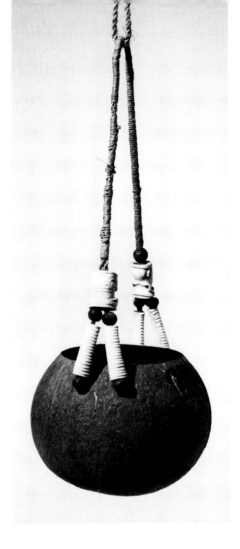

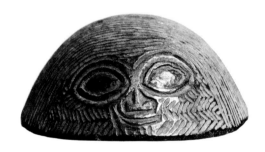

**2.8  HANGING BOWL COVER**

Wood
16.5 (6½) diameter
Marquesas Islands

Mr. and Mrs. Leo Fortess, Hawaii, F. 2636

**2.7  HANGING BOWL**

Coconut shell, sennit, ivory, hair
19.5 (7½) to top of ornament; bowl 11 (4¼) high
Marquesas Islands
Collected by Samuel Alexander in 1896

Bernice Pauahi Bishop Museum, Honolulu,
8031

Linton, *Marquesas Islands,* 356

**2.9  COVERED BOWL**

Wood
47 (18½) long
Marquesas Islands

Private collection, New York

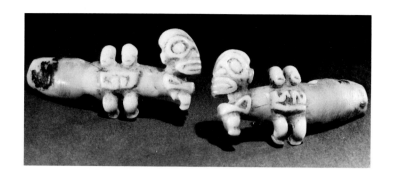

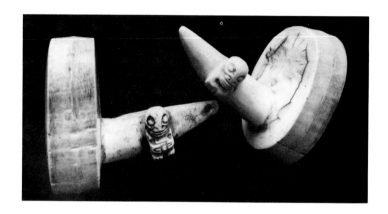

**2.10   PAIR OF EAR PLUGS**

Ivory
4.5 (1¾) long
Marquesas Islands
Formerly A. W. Fuller collection, London

Field Museum of Natural History, Chicago, 272786 A, B

Force and Force, *Fuller Collection*, 97, 104

**2.11   PAIR OF EAR PLUGS**

Ivory
7.7 (3) long
Marquesas Islands
Formerly East India Marine Society, 314, 315, given by Captain Nathaniel Page, 1817

Peabody Museum of Salem, Massachusetts
E 3544

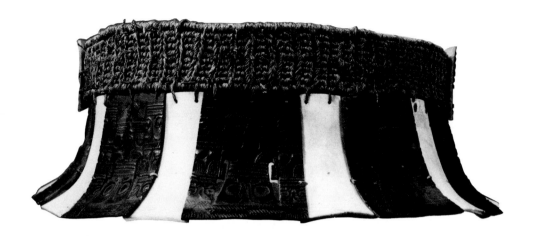

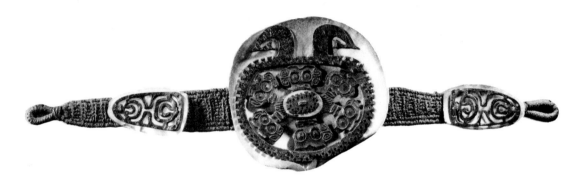

2.12  **CORONET** *(paekaha)*

Turtleshell, shell, sennit
58.5 (23) long
Marquesas Islands

Indiana University Art Museum, Blooming-
ton, Raymond and Laura Wielgus Collection,
RW 58.103

Wardwell, *Sculpture of Polynesia*, 51

2.13  **HEADBAND** *(uhikana)*

Turtleshell, pearl shell, sennit
49.2 (19⅜) long
Marquesas Islands
Formerly Yves Petit-Dutaillis Collection

Raymond and Laura Wielgus Collection, Tuc-
son, 59-144

Wardwell, *Sculpture of Polynesia*, 51

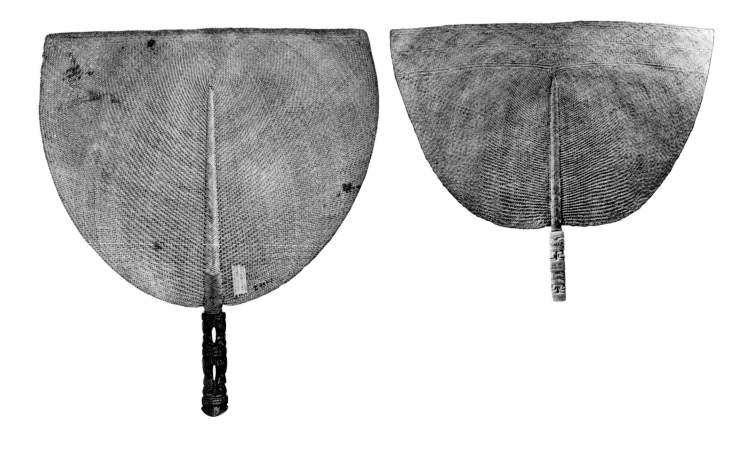

**2.14   FAN** *(tahi)*

Wood, sennit, immature coconut leaflets
46 (18⅛) high
Marquesas Islands
Museum acquisition, 1895

University Museum of Archaeology and Anthropology, Cambridge, Z.5947

**2.15   FAN** *(tahi)*

Whale ivory, human teeth, immature coconut leaflets
46.5 (18¼) high
Marquesas Islands

Raymond and Laura Wielgus Collection, Tucson, 59-155

Barrow, *Art and Life in Polynesia*, 98; Wardwell, *Sculpture of Polynesia*, 47

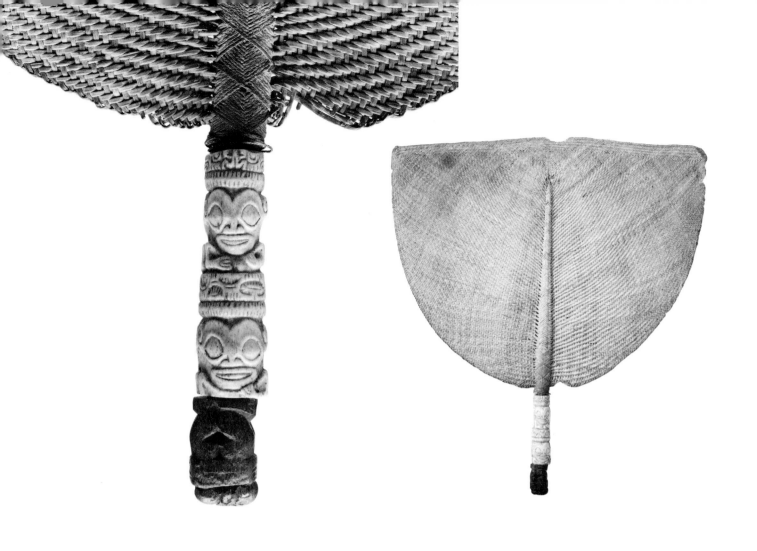

**2.16   FAN** *(tahi)*

Ivory, wood, pandanus
44.5 (17½) high
Marquesas Islands
Given to the East India Marine Society by
Captains Clifford Crowninshield and Matthew
Folger, 1802
Formerly East India Marine Society, 433

Peabody Museum of Salem, Massachusetts,
E 5099

131

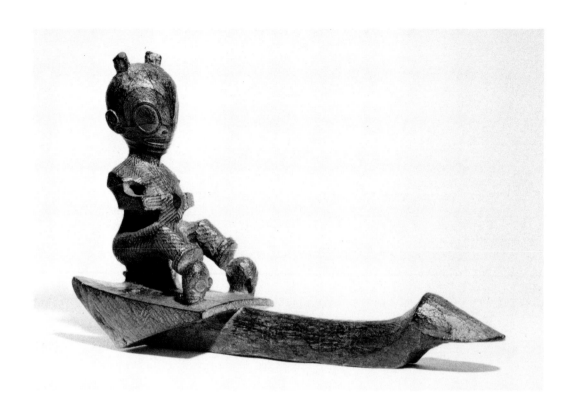

**2.17 CANOE PROW ORNAMENT**

Wood
47 (18½) long
Marquesas Islands
Presented by George Lane Fox to the Leeds
Literary and Philosophical Society, 1858

James Hooper Collection, England, 395

Phelps, *James Hooper Collection*, 98, 419

# 3 Easter Island

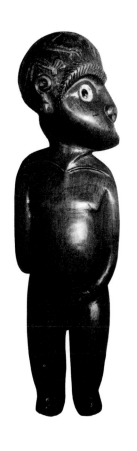

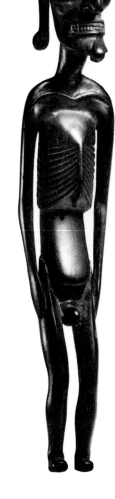

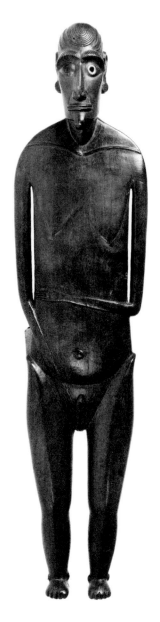

## 3.1  MALE FIGURE

Wood, bone, obsidian
20.1 (8) high
Easter Island
Brought to England by Captain J. Toppin, R. T.
Formerly W. O. Oldman, London

Canterbury Museum, Christchurch, New Zealand, E 150.1129

Barrow, *Art and Life in Polynesia*, 137; Duff, *No Sort of Iron*, 57; Heyerdahl, *Art of Easter Island*, 278, pls. 72, 73

## 3.2  FIGURE

Wood, bone, obsidian
47 (18½) high
Easter Island
Collected by Ignacio L. Gana, on the corvette
*O'Higgins*, 1870

Private collection, New York

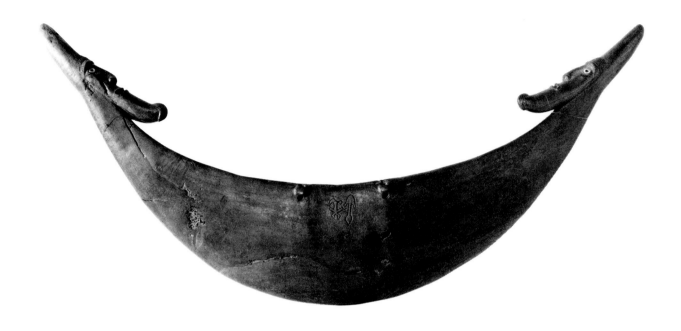

### 3.3 FEMALE FIGURE

Wood, bone, obsidian
56.5 (22¼) high
Easter Island
Collected before 1879; museum acquisition
1895

Peabody Museum of Archaeology and Ethnology, Harvard University, Cambridge, Massachusetts, 47752

Linton and Wingert, *Arts of the South Seas*, 48; Wardwell, *Sculpture of Polynesia*, 58-59

### 3.4 PECTORAL *(rei miro)* WITH INSCRIPTION

Wood
70.5 (27¾) wide
Easter Island

Lent by the Trustees of the British Museum, London, 6847

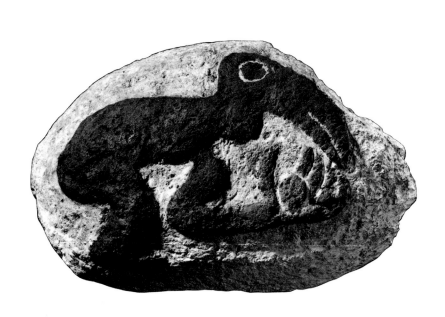

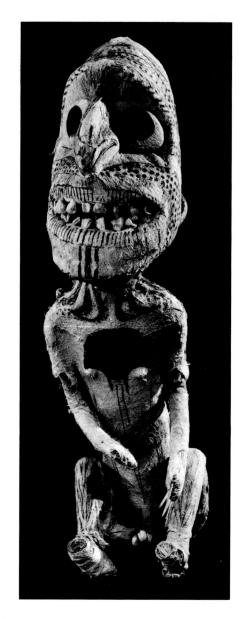

**3.5　RELIEF, BIRD MAN**

Boulder, paint
45.7 (18) wide
Easter Island
Collected by C. S. Routledge, 1915

Lent by the Trustees of the British Museum,
London, 1920  5-6.1

Barrow, *Art and Life in Polynesia*, 134; Heyer-
dahl, *Art of Easter Island*, pl. 180; UNESCO,
*Art of Oceania*, panel 43

**3.6　DOUBLE-HEADED FEMALE FIGURE**

Wood, bone, obsidian
40.8 (16) high
Easter Island
Collected by Ignacio L. Gana, on the corvette
*O'Higgins*, 1870

Faith and Martin Wright, New York

**3.7　SEATED FIGURE**

Bark cloth, pith, paint
30.5 (12) high
Easter Island
Acquired from the Boston Museum (gift of the
David Kimball heirs), 1899

Peabody Museum of Archaeology and Ethnol-
ogy, Harvard University, Cambridge, Massa-
chusetts, 53542

Barrow, *Art and Life in Polynesia*, 140-141;
Heyerdahl, *Art of Easter Island*, 262-266, pls.
16-20; Linton and Wingert, *Arts of the South
Seas*, 47; Poignant, *Oceanic Mythology*, 33;
Wardwell, *Sculpture of Polynesia*, 60-61.

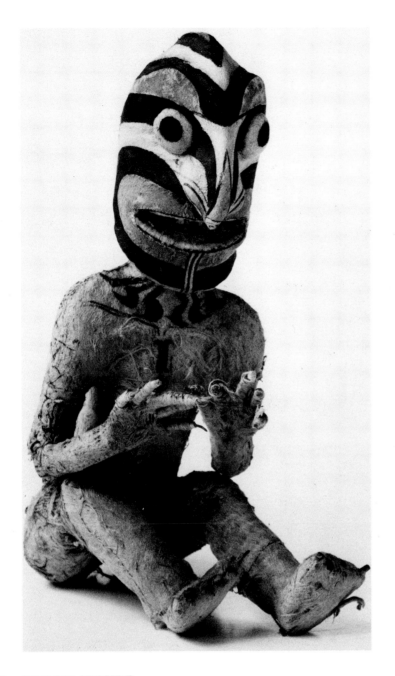

### 3.8 SEATED FIGURE

Bark cloth, pith, paint
39 (15⅝) high
Easter Island
Acquired from the Boston Museum (gift of the
David Kimball heirs), 1899

Peabody Museum of Archaeology and Ethnology, Harvard University, Cambridge, Massachusetts, 53543

Barrow, *Art and Life in Polynesia*, 140-141;
Heyerdahl, *Art of Easter Island*, 262-266, pls.
16-20; Linton and Wingert, *Arts of the South
Seas*, 47; Poignant, *Oceanic Mythology*, 33;
Wardwell, *Sculpture of Polynesia*, 60-61.

**3.9   DANCE STAFF** *(ao)*

Wood, bone, obsidian
216 (85⅞) long
Easter Island

Museum für Völkerkunde, Vienna, 22845

Heyerdahl, *Art of Easter Island*, 275, pl. 55

**3.10   STAVE**   Color plate 7

Wood, obsidian, bone
109 (42⅞) long
Easter Island
Collected on Captain James Cook's second
voyage
Formerly in the Leverian Museum, London,
1784-1786

Exeter City Museums, England, E 1216

Kaeppler, *"Artificial Curiosities,"* 169-170

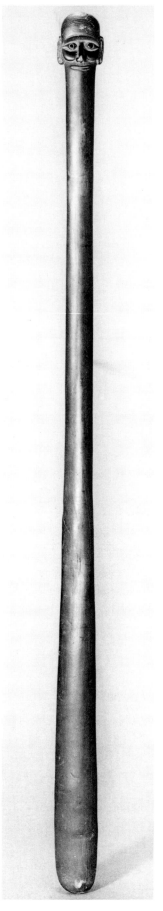

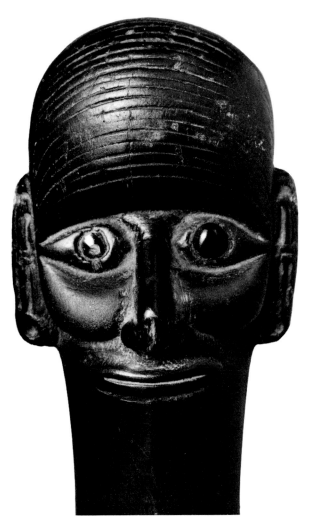

3.10 detail                                    3.10

138

**3.11  DANCE STAFF**

Wood
91 (35¾) long
Easter Island

Field Museum of Natural History, Chicago,
273253

Dodd, *Polynesian Art*, 174; Force and Force,
*Fuller Collection*, 78-79

**3.12  DANCE STAFF**

Wood, bone, obsidian, paint
223 (87¾) long
Easter Island
Collected by W. J. Thomson, on the U.S.
*Mohican*, 1886

National Museum of Natural History, Smithso-
nian Institution, Washington, 129749

Barrow, *Art and Life in Polynesia*, 142; Dodd,
*Polynesian Art*, 174; Heyerdahl, *Art of Easter
Island*, 275, pls. XIV and 56; Linton and
Wingert, *Arts of the South Seas*, 46

139

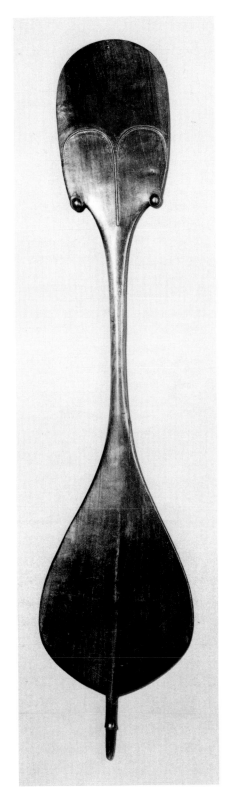

3.11

# 4 Cook Islands

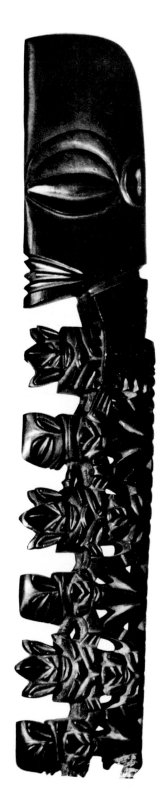

## 4.1 STAFF GOD

Wood
79.4 (31¼) long
Cook Islands, Rarotonga

University of East Anglia, Norwich, England,
Robert and Lisa Sainsbury Collection, 1953
UEA 188

Danielsson, *La Découverte de la Polynésie*,
no. 143; Wardwell, *Sculpture of Polynesia*, 24-25

## 4.3 ADZE

Wood, basalt, sennit
61 (24) long
Cook Islands, Mangaia

Otago Museum, Dunedin, New Zealand,
DO9-3

Although this adze is said to have been collected
on one of Cook's voyages, this is certainly not the
case.

Barrow, *Art and Life in Polynesia*, 130; Duff, *No
Sort of Iron*, 63; Simmons, *Craftsmanship*, 25

## 4.2 FAN

Wood, pandanus, sennit
51 (20¼) long
Cook Islands, probably Rarotonga

University Museum of Archaeology and An-
thropology, Cambridge, Z.6101

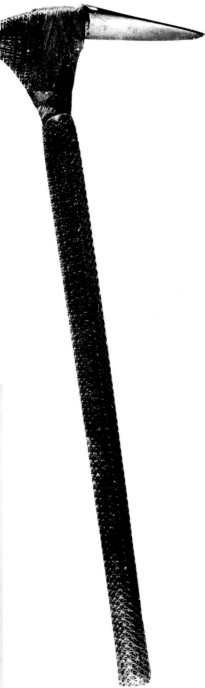

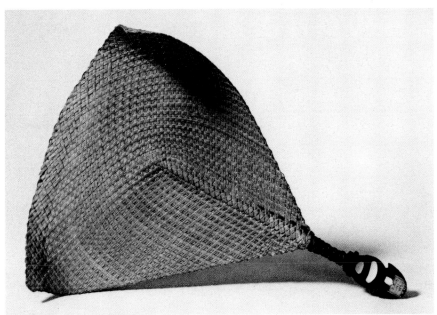

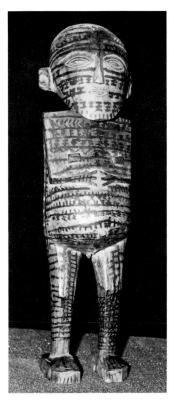

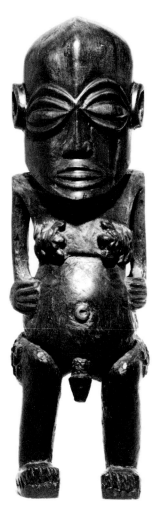

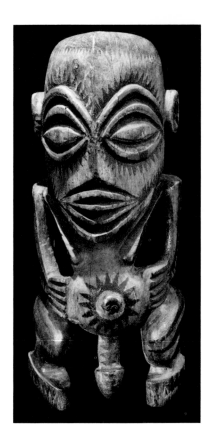

## 4.4 FIGURE OF GODDESS

Wood, paint
40.4 (15⅞) high
Cook Islands, Aitutaki

Staatliches Museum für Völkerkunde, Munich, 190

Poignant, *Oceanic Mythology*, 32; UNESCO, *Art of Oceania*, panel 39

## 4.5 MALE FIGURE   Color plate 11

Wood
56.5 (22½) high
Cook Islands, Rarotonga
Collected about 1834 by Elijah Armitage
of the London Missionary Society

George Ortiz Collection, Geneva

The ivory ear pendants were said to have been on this male figure when collected. The pendants are necklace elements which probably came from Rurutu in the Austral Islands. Their procreative symbolism is eminently suitable for this image which represents the creation of gods and men.

Parke Bernet, *George Ortiz Collection*, 158-165, 170-171; Idiens, "A Recently Discovered Figure," 359-366

## 4.6 FISHERMAN'S GOD

Wood, paint
42.5 (16¾) high
Cook Islands
Acquired from the Boston Museum (gift of the David Kimball heirs), 1899

Peabody Museum of Archaeology and Ethnology, Harvard University, Cambridge, Massachusetts, 53.517

Barrow, *Art and Life in Polynesia*, 122-123; UNESCO, *Art of Oceania*, panel 39; Wardwell, *Sculpture of Polynesia*, 22

142

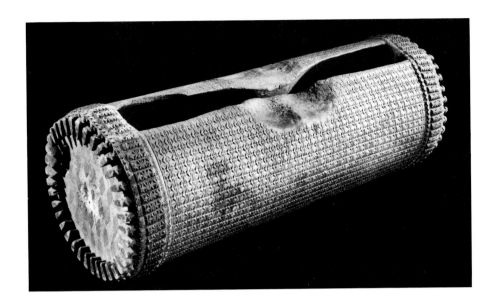

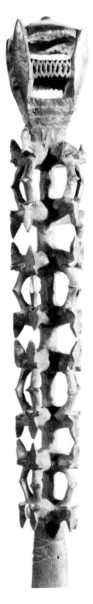

**4.7  SLIT GONG**

Wood
79 (31⅛) long
Cook Islands

Peabody Museum of Archaeology and Ethnology, Harvard University, Cambridge, Massachusetts, 53509

**4.8  STAFF GOD**

Wood, sennit
42.2 (16½) high
Cook Islands, Mitiaro
Formerly in the Ortiz Collection

Private Collection

Parke Bernet, *George Ortiz Collection*, 168-169

143

# 5 Society Islands

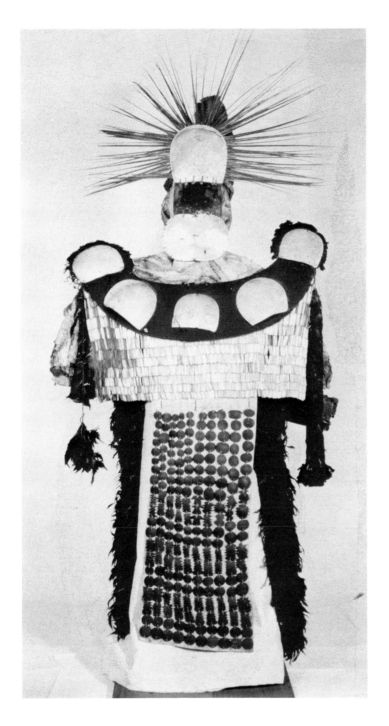

### 5.1  MOURNING DRESS

Pearl shell, turtleshell, coconut shell, feathers, bark cloth, sennit
220 (86⅝) high
Society Islands
Collected on one of Cook's voyages (probably on the second voyage, by Surgeon Patten)
Given to Bishop Museum in 1971 by the National Museum of Ireland, Dublin

Bernice Pauahi Bishop Museum, Honolulu, 1971.198.01

The death of a chief or another important person was the occasion for a spectacular display of grief in which an elaborate costume was worn by a priest or close relative of the high-ranking deceased. The shell-face mask is surmounted by tail feathers of tropic birds and has only one small peephole through which to see. The chest apron is made of thousands of tiny slips of pearl shell. The feather cloak is one of the few surviving examples of Tahitian featherwork.

Freeman, "Polynesian Collection" 7; Kaeppler, *"Artificial Curiosities,"* 122, 124

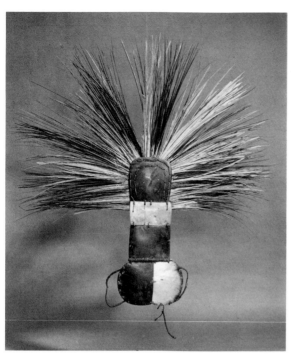

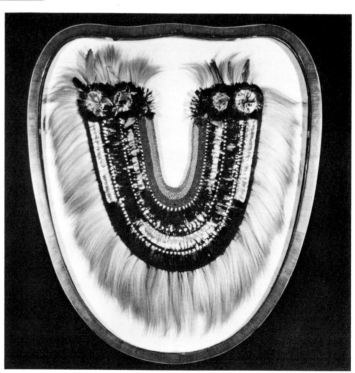

**5.2  MASK FROM MOURNING DRESS**

Shell, feathers
50 (19⅞) high
Society Islands
Acquired from the Sheffield Museum, 1891

University Museum of Archaeology and Anthropology, Cambridge, Z.28.418

**5.3  GORGET**

Sennit, feathers, shark teeth, dog hair, wicker
76 (30) high
Society Islands

Private collection, London

Encased in a fitted eighteenth-century frame, its history is unknown.

Kaeppler, *"Artificial Curiosities,"* 6, 10

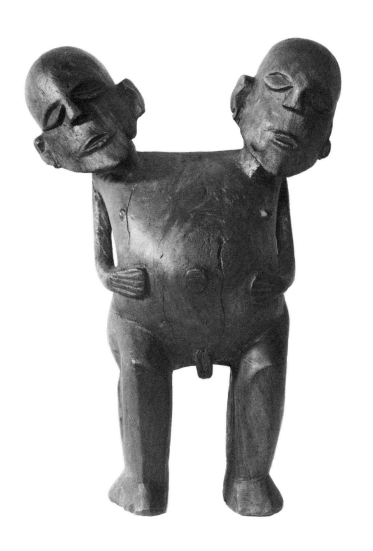

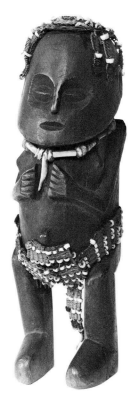

## 5.4 DOUBLE-HEADED FIGURE

Wood
58.5 (23) high
Society Islands, probably Matavai Bay
Collected by Captain Sampson Jervois (H.M.S. *Dauntless*), January 1822

Lent by the Trustees of the British Museum, London, 1955.Oc 10.1

Archey, *Art Forms*, 67; Barrow, *Art and Life in Polynesia*, 103; Cranstone, "A Unique Tahitian Figure"; Dodd, *Polynesian Art*, 242

## 5.5 IMAGE *(ti'i)*

Wood, coconut fiber
21.5 (8½) high
Society Islands
Registered in the British Museum about 1885-1895

Lent by the Trustees of the British Museum, London, Tah. 63

This Tahitian image is decorated with pieces of a Tongan feathered "apron," which at one time was covered with red feathers. The "apron" was probably traded by the Tongans to a European visitor such as Captain Cook who used the feathers to trade to Tahitians for important Tahitian objects such as mourning dresses. This secondary use of Tongan coconut fiber to decorate a Tahitian image is reminiscent of the sennit covering of Tahitian *to'o* (no. 5.10).

Archey, *Art Forms*, 69

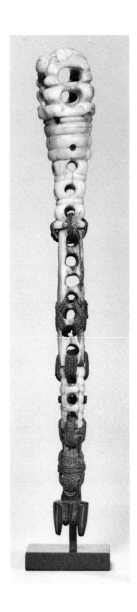

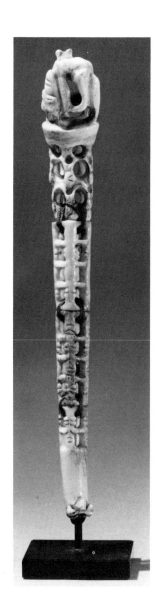

## 5.6  FLY-WHISK HANDLE

Sperm whale ivory, wood, sennit
31 (12¼) long
Society Islands
Given by Pomare II to Reverend Thomas
Haweis, 1818

Raymond and Laura Wielgus Collection, Tucson, 65-271

This fly-whisk handle illustrates another creative combination of raw materials, characteristic of the art of the Society Islands. The incorporation of abstract human figures in a stafflike handle recalls the staff gods of Rarotonga (no. 4.1) and Mitiaro (no. 4.8) in the Cook Islands.

Barrow, *Art and Life in Polynesia*, 107; Wardwell, *Sculpture of Polynesia*, 32-33.

## 5.7  FLY-WHISK HANDLE

Sperm whale ivory, sennit
29.8 (11¾) high
Society Islands
Given by Pomare II to Reverend Thomas
Haweis, 1818

The Metropolitan Museum of Art, New York, The Michael C. Rockefeller Memorial Collection of Primitive Art, Gift of Nelson A. Rockefeller, 1965, P.65.80

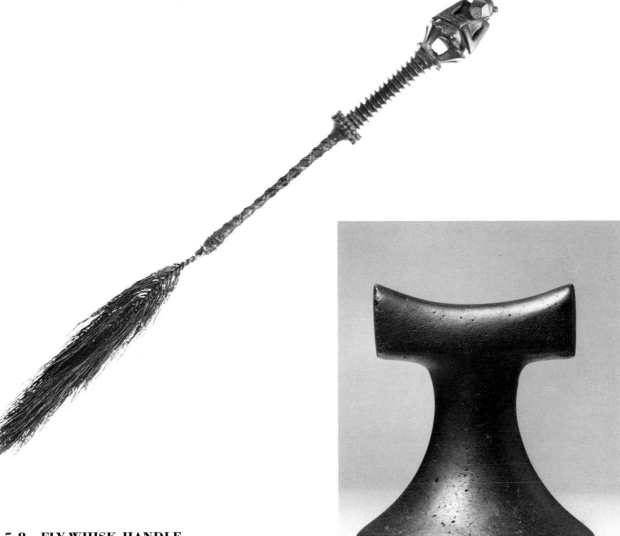

## 5.8 FLY-WHISK HANDLE

Wood
34.3 (13½) long
Society Islands
Collected by George Bennet of the London
Missionary Society about 1823
Formerly W. O. Oldman Collection, 370

Otago Museum, Dunedin, New Zealand

This fly-whisk handle was attributed by Duff to
Rurutu on the basis of an engraving which he
attributes to Parkinson (Duff, *Polynesian Art*,
26). The drawing to which he refers, however,
is not by Parkinson but by J. F. Miller and
the note identifying a fly whisk as "Oheteroa"
refers to the middle specimen only. The Otago
fly whisk should be related to the other two de-
picted fly whisks, which are from the Society
Islands.

Dodd, *Polynesian Art*, 226; Duff, *No Sort of
Iron*, 26; Simmons, *Craftsmanship*, 8

## 5.9 POUNDER

Basalt
16.8 (6⅝) high
Society Islands, Tahiti
From the collection of William Parry, whose
estate at Highnam Court, Gloucester, was sold
on November 3, 1971.

George Ortiz Collection, Geneva

The eighteenth-century artist William Parry
painted the Tahitian, Omai, with Banks and
Solander, and it is possible that this pounder
was given to Parry by one of them. If so, it may
have been collected on one of Cook's voyages.

## 5.10 IMAGE *(to'o)*

Wood, coconut fiber
47 (18½) high
Society Islands

University Museum of Archaeology and Anthropology, Cambridge, E 1907.342

Said to represent the Tahitian war god, Oro, this *to'o* has abstract human features. Its history is unknown.

## 5.11 TREASURE BOX

Wood
80 (31½) long
Society Islands
Collected on one of Captain James Cook's voyages
Formerly Leverian Museum, London, dispersed in 1806

Museum für Völkerkunde, Vienna, 30

Treasure boxes were used to store small valuables. The end pieces are usually beautifully carved.

Kaeppler, *"Artificial Curiosities,"* 136; Moschner, *Die Wiener Cook-Sammlung*, 178

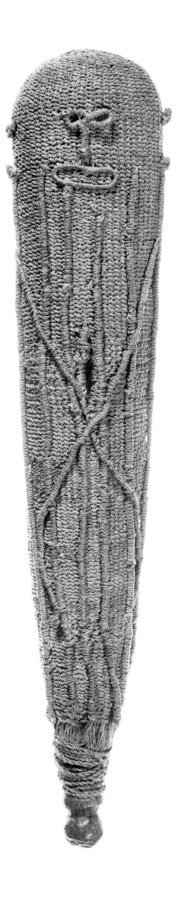

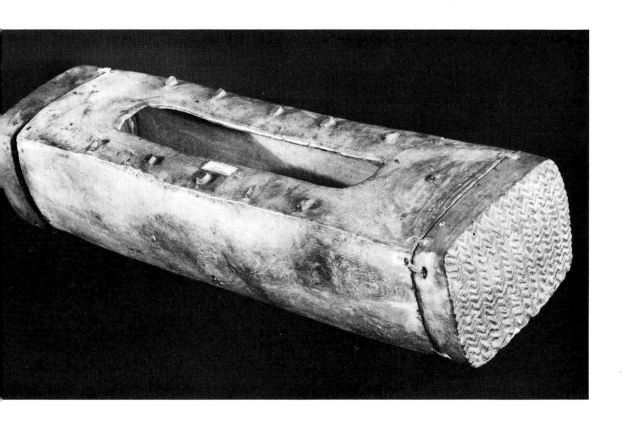

151

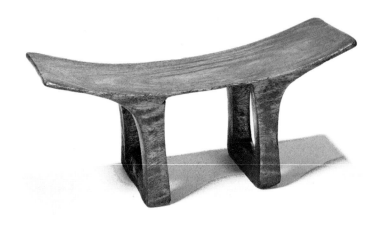

## 5.12 NECKREST

Wood
31.5 (12½) long
Society Islands
Collected on Captain James Cook's second
voyage

University Museum of Archaeology and An-
thropology, Cambridge, D.1914.14

Barrow, *Art and Life in Polynesia*, 103; Kaep-
pler, *"Artificial Curiosities,"* 145

## 5.13 STOOL

Wood
86.1 (33¾) long
Society Islands, Tahiti

George Ortiz Collection, Geneva

This is one of the largest stools known from the
Society Islands. Its history is unknown.

## 5.14 DRUM *(pahu)*

Wood, sennit, fish skin
64 (25¼) high
Society Islands
Collected on one of Captain James Cook's voy-
ages
Formerly in the Leverian Museum, dispersed
in 1806

Museum für Völkerkunde, Vienna, 152

Kaeppler, *"Artificial Curiosities,"* 140, 143;
Moschner, *Die Wiener Cook-Sammlung*, 247

# 6 Austral Islands

**6.1 DRUM** *(pahu-ra)*

Wood, sharkskin, sennit, pandanus
133.4 (52¾) high
Austral Islands, Raivavae
Collected by George Bennet, London Missionary Society, 1821-1824

James Hooper Collection, England, 651

This is one of the few drums known in which the resonating chamber is covered with a braided and decorated sleeve.

Dodd, *Polynesian Art*, 181; Phelps, *James Hooper Collection*, 151, 425

155

**6.2   DRUM** *(pahu-ra)*

Wood, sennit, ray skin
128 (50⅜) high
Austral Islands

University Museum of Archaeology and Anthropology, Cambridge, Z.6096

Danielsson, *La Découverte de la Polynésie*, no. 148

### 6.3 DRUM (pahu-ra)

Wood, sharkskin, sennit
136 (53½) high
Austral Islands

Raymond and Laura Wielgus Collection, Tucson, 60-120

### 6.4  SPEAR HEAD

Wood
55.6 (21⅞) high
Austral Islands, Rurutu
Possibly given by Omai or Joseph Banks to
William Parry (1742-1791), Highnam Court,
about 1776, with no. 5.9
Formerly George Ortiz Collection

Private collection, New York

The use of these delicately carved objects has
not been satisfactorily explained. Conjecture
assigns them such varied uses as gods and
spearheads.

Parke Bernet, *George Ortiz Collection*, 169, 173

### 6.5  SPEAR HEAD

*Toa* wood
43 (17) long
Austral Islands, possibly Rurutu
Collected by George Bennet, London Mis-
sionary Society, 1831-1832

James Hooper Collection, England, 660

Phelps, *James Hooper Collection*, 153, 425

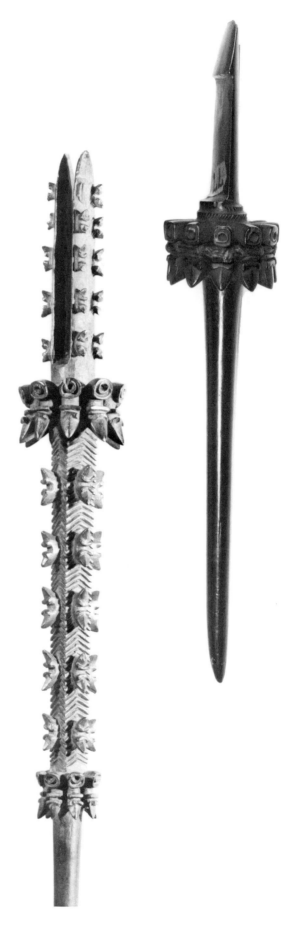

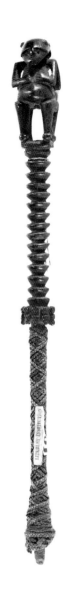

**6.6  FLY WHISK**

Wood, sennit, shell
Handle 33.5 (13¼) long
Austral Islands, Rurutu
Collected on one of Cook's voyages
Formerly in the Leverian Museum (disbanded 1806)

Museum für Völkerkunde, Vienna, 143

Kaeppler, *"Artificial Curiosities,"* 159, 162;
Moschner, *"Die Wiener Cook-Sammlung,"* 223

**6.7  FLY-WHISK HANDLE**

Wood, sennit
39 (15⅜) long
Austral Islands, Rurutu
In the Literary Institution, Ipswich, before 1850

Ipswich Borough Council (Museums), Ipswich, England

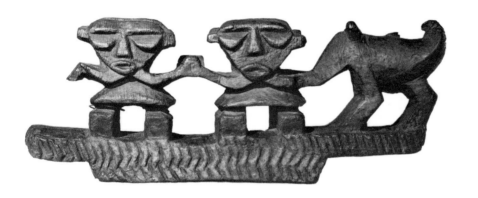

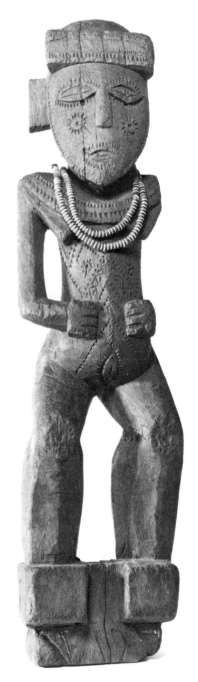

**6.8 FEMALE FIGURE**

Wood
65.4 (25¾) high
Austral Islands

Lent by the Trustees of the British Museum, London, 54.12-29.120

Archey, *Art Forms*, 22; Barrow, *Art and Life in Polynesia*, 116; Dodd, *Polynesian Art*, 211; UNESCO, *Art of Oceania*, panel 38; Wardwell, *Sculpture of Polynesia*, 34

**6.9 CANOE ORNAMENT**

Wood
52 (20½) long
Austral Islands, Rurutu
Collected on Captain James Cook's first voyage, 1768-1771

University Museum of Archaeology and Anthropology, Cambridge, D.1914.35

Barrow, *Art and Life in Polynesia*, 49; Danielsson, *La Découverte de la Polynésie*, no. 150; Emory, *"A Kaitaia Carving,"* 253-254; Kaeppler, *"Artificial Curiosities,"* 159-160; UNESCO, *Art of Oceania*, panel 36

**6.10 BARK CLOTH**

Bark cloth, pigment
518 (203¾) long
Austral Islands
Collected on one of Captain James Cook's voyages
Formerly the Leverian Museum, before 1786

Exeter City Museums, England, E 1263

Kaeppler, *"Artificial Curiosities,"* 160, 164

160

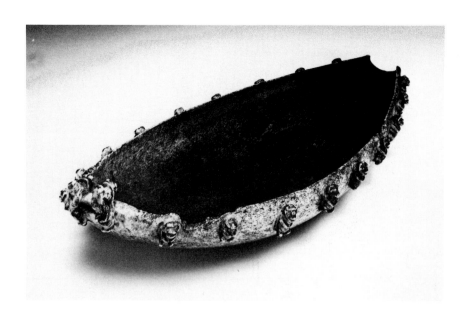

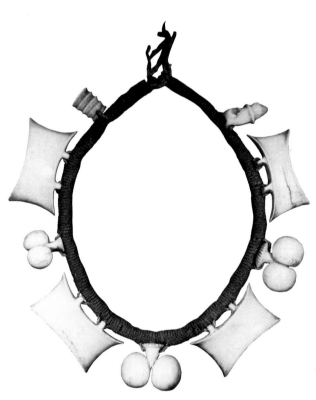

**6.12 NECKLACE**

Ivory, sennit, human hair
21 (8¼) long
Austral Islands, Rurutu
Collected by Rev. William Ellis, 1841
Formerly in the Wisbech Museum
Canterbury Museum, Christchurch, New Zealand, E 149.19

Duff, *No Sort of Iron*, 27; UNESCO, *Art of Oceania*, panel 37

**6.11 BOWL**

Sperm whale jawbone
37 (14½) long
Austral Islands, Rurutu
Formerly W. O. Oldman, London, 476
Auckland Museum, New Zealand

Duff, *No Sort of Iron*, 28-29; UNESCO, *Art of Oceania*, panel 37

## 6.13  POUNDER

Stone
14 (5½) high
Rapa Island

Otago Museum, Dunedin, New Zealand,
D.34.229

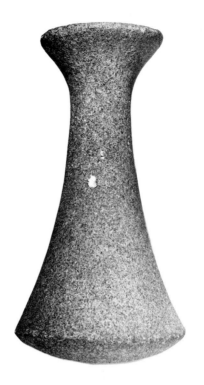

# 7 Gambier Islands

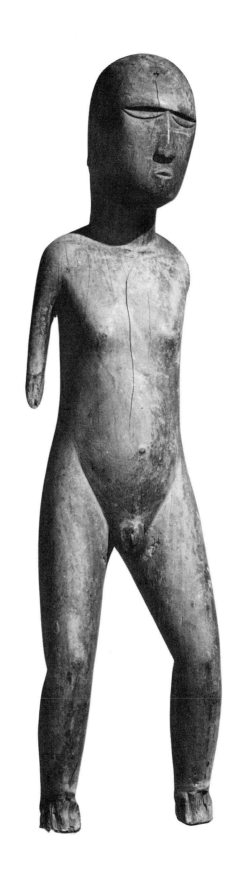

## 7.1 FIGURE OF THE GOD RONGO

Wood
98.4 (38⅜) high
Gambier Islands, Mangareva

The Michael C. Rockefeller Memorial Collection of Primitive Art, on loan to The Metropolitan Museum of Art, New York, from Nelson A. Rockefeller, 1978, L.P.57.91

Dodd, *Polynesian Art*, 260

## 7.2 FIGURE OF A GOD

Wood
108 (42½) high
Gambier Islands, Mangareva
Collected by J. S. C. Dumont d'Urville, August 1838

Musée d'Histoire Naturelle, La Rochelle, France, H 498

Dodd, *Polynesian Art*, 260; Danielsson, *La Découverte de la Polynésie*, no. 153; UNESCO, *Art of Oceania*, panel 38

## 7.3 FIGURE OF THE GOD RAO

Wood
104 (41) high
Gambier Islands, Mangareva
Collected by missionaries of the Order of Picpus, 1836; numbered 3, and sent to Brain-le-Comte

Musée des Antiquités Nationales, Saint-Germain-en-Laye, France, 53287

Barrow, *Art and Life in Polynesia*, 119; Danielsson, *La Découverte de la Polynésie*, no. 152; Dodd, *Polynesian Art*, 260; UNESCO, *Art of Oceania*, panel 38; Wardwell, *Sculpture of Polynesia*, 39

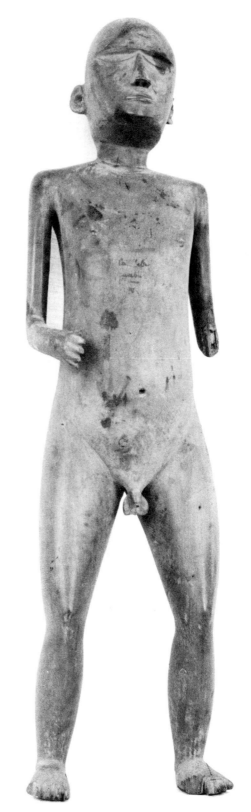

7.2

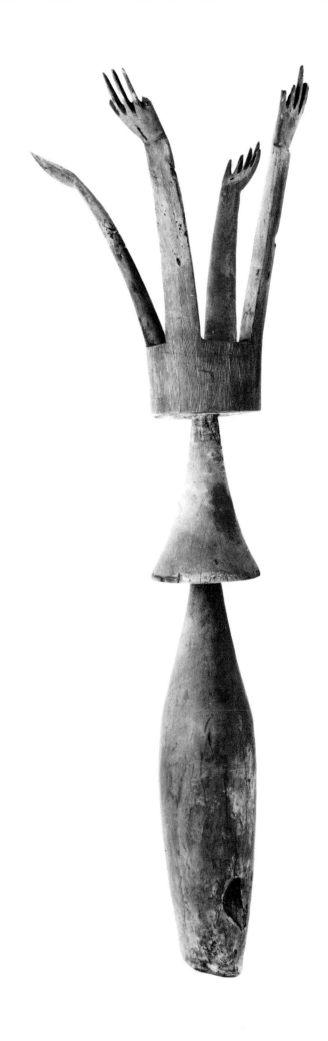

**7.4   SUPPORT** *(patoko)*

Wood
178 (70) high
Central Polynesia, possibly Mangareva
Collected by Dr. P. Couteaud, 1884

Musée de l'Homme, Paris, 29.14.921

167

# 8 Fiji

## 8.1 ANTHROPOMORPHIC BOWL

Wood
37 (14½) long
Fiji Islands
Formerly W. O. Oldman, London, 585

Auckland Museum, New Zealand

Archey, *Art Forms*, 41; Barrow, *Art and
Life in Polynesia*, 82; Dodd, *Polynesian Art*, 248

## 8.2 DOUBLE OIL DISH, TWO TURTLES

Wood
80.8 (31¾) long
Fiji Islands
Formerly A. W. Fuller Collection, London

Field Museum of Natural History, Chicago,
273955

Dodd, *Polynesian Art*, 164-165; Force and
Force, *The Fuller Collection*, 160, 163

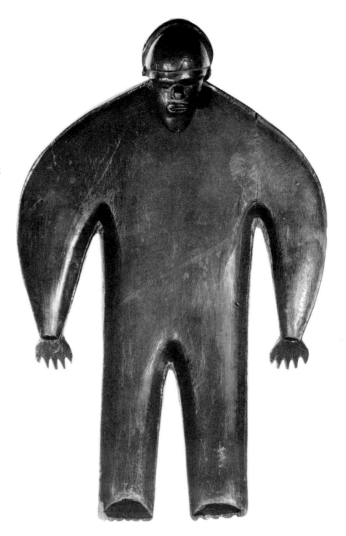

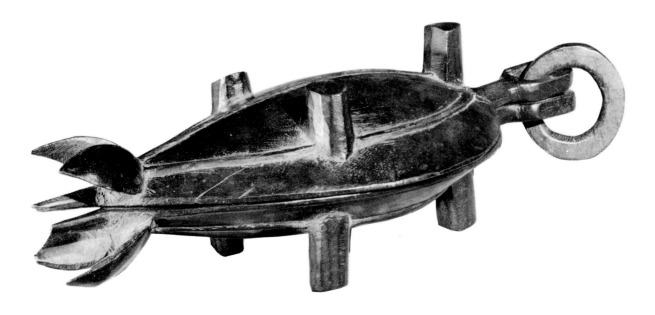

169

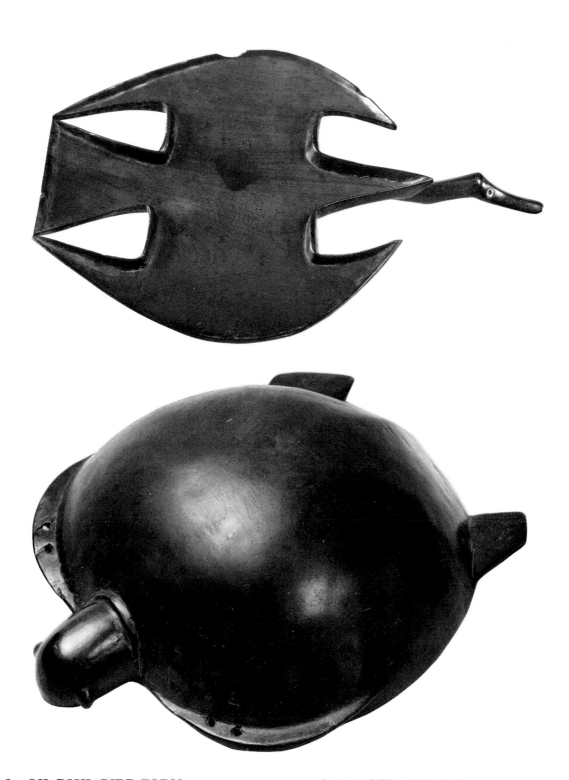

**8.3   OIL DISH, BIRD FORM**

Wood
46.5 (18¼) long
Fiji Islands, Viwa
Probably collected by Erskine, 1849
Formerly H. G. Beasley Collection, acquired 1908

Private collection, London

**8.4   BOWL, TURTLE**

Wood
56.5 (22¼) long
Fiji Islands

The Michael C. Rockefeller Memorial Collection of Primitive Art, on loan to The Metropolitan Museum of Art, New York, from Nelson A. Rockefeller, 1978, L.P.60.83

Wardwell, *Sculpture of Polynesia*, 14-15

## 8.5 CLUB

Wood, ivory
115.5 (45⅞) long
Fiji Islands

James Hooper Collection, England, 864

Phelps, *James Hooper Collection*, 198, 429

## 8.6 SPEAR

Wood, sennit
123.3 (48½) long
Fiji Islands
Formerly A. W. Fuller Collection, London

Field Museum of Natural History, Chicago,
274213

Force and Force, *Fuller Collection*, 171

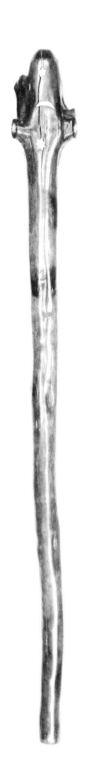

## 8.7 NECKLACE WITH EIGHT HUMAN FIGURES

Sperm whale ivory, sennit
Figures from 7.4 (2⅞) to 9.6 (3¾) high, 52
(20½) long
Fiji Islands
Said to have been presented to Lady Gordon
(wife of the governor of Fiji), about 1884

University Museum of Archaeology and Anthropology, Cambridge, Z.2752

Barrow, *Art and Life in Polynesia*, 85; Larsson,
*Fijian Studies*, 117; UNESCO, *The Art of
Oceania*, panel 35

## 8.8 BREAST ORNAMENT

Whale ivory, shell
25.5 (10) diameter
Fiji Islands

The Baltimore Museum of Art, The Alan
Wurtzburger Collection of Oceanic Art

## 8.9 FIGURE

Wood
105.5 (41½) high
Fiji Islands, Viti Levu
Collected by the Commodore Wilkes U.S. Exploring Expedition, 1840

National Museum of Natural History, Smithsonian Institution, Washington, 3275

Barrow, *Art and Life in Polynesia*, 90-91;
Dodd, *Polynesian Art*, 212; Larsson, *Fijian
Studies*, 39-40; Linton and Wingert, *Arts of the
South Seas*, 20

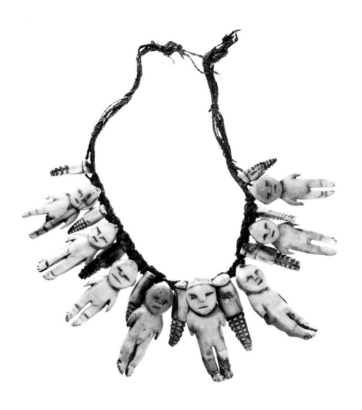

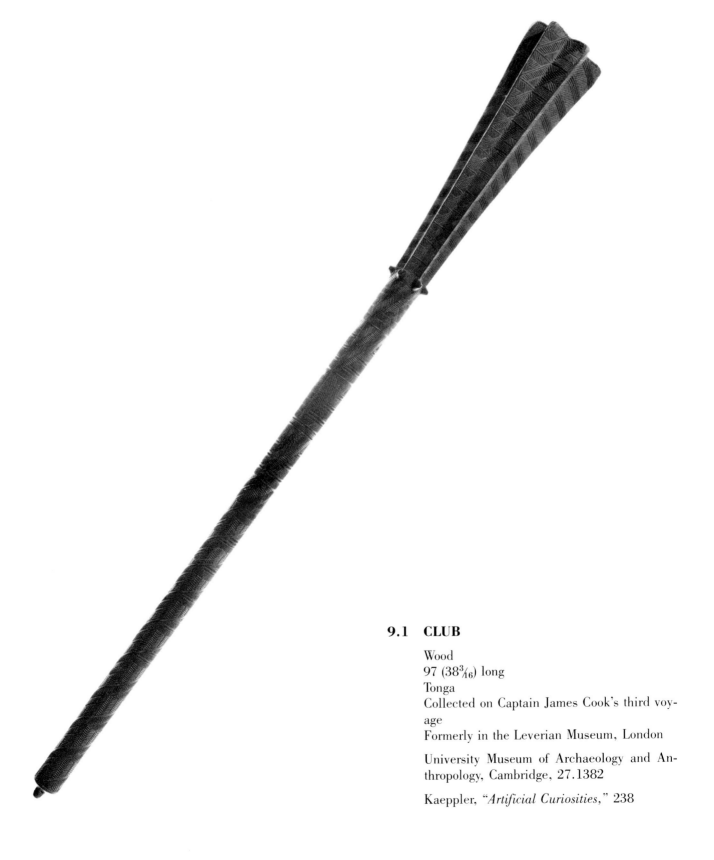

### 9.1  CLUB

Wood
97 (38³⁄₁₆) long
Tonga
Collected on Captain James Cook's third voyage
Formerly in the Leverian Museum, London

University Museum of Archaeology and Anthropology, Cambridge, 27.1382

Kaeppler, *"Artificial Curiosities,"* 238

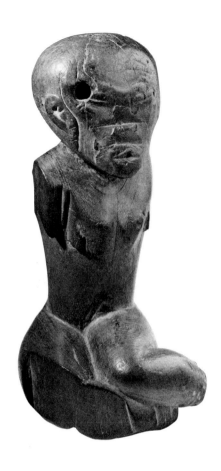

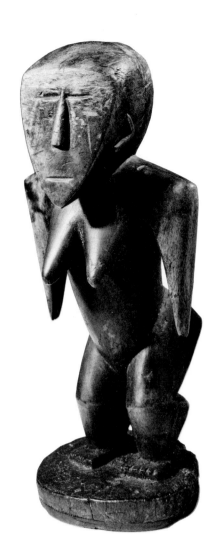

**9.2 FIGURE OF A SEATED GODDESS**

Wood
19 (7½) high
Tonga Islands, Ha'apai Group, Lifuka
Collected by O. Belsham, about 1846
Formerly W. O. Oldman, London

Auckland Museum, New Zealand, 32650

Archey, *Art Forms*, 43; Barrow, *Art and Life in Polynesia*, 66; Duff, *No Sort of Iron*, 80; Larsson, *Fijian Studies*, 60

**9.3 FIGURE OF A GODDESS**

Wood
33 (13) high
Tonga Islands, Ha'apai Group, Lifuka
Probably collected by Reverend John Williams, London Missionary Society, 1830
Formerly W. O. Oldman Collection 531

Auckland Museum, New Zealand, 32652

Archey, *Art Forms*, 43; Barrow, *Art and Life in Polynesia*, 62-63; Dodd, *Polynesian Art*, 205; Duff, *No Sort of Iron*, 49; Larsson, *Fijian Studies*, 65; UNESCO, *Art of Oceania*, panel 34

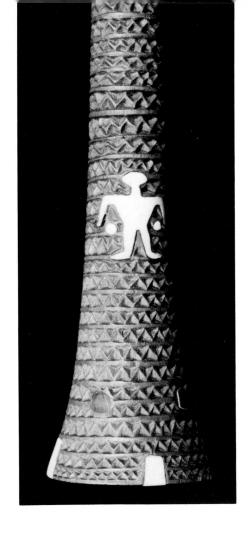

### 9.4 FLY WHISK

Wood, ivory
Handle 33.5 (13³⁄₁₆) long
Tonga
Collected on Captain James Cook's third voyage
Formerly in the Leverian Museum, London

Museum für Völkerkunde, Vienna, 89

Kaeppler, *"Artificial Curiosities,"* 223-224;
Moschner, *"Die Wiener Cook-Sammlung,"* 221-222

### 9.5 NECK REST

Wood, ivory
83.5 (32⁷⁄₈) long
Tonga
Collected on one of Captain James Cook's voyages
Formerly in the Leverian Museum, London, 1784-1786

Private collection, London

Kaeppler, *"Artificial Curiosities,"* 228-229

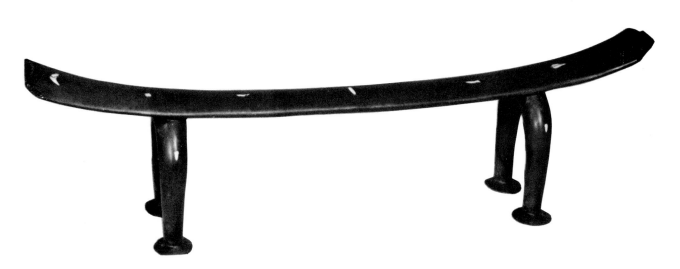

**9.6  FEMALE FIGURE**

Ivory
6.2 (2½) high
Tonga Islands
Collected on one of Captain James Cook's voyages
Formerly in the Leverian Museum, London

Museum für Völkerkunde, Vienna, 146

Danielsson, *La Découverte de la Polynésie*, no. 74; Dodd, *Polynesian Art*, 206; Kaeppler, *"Artificial Curiosities,"* 207; Larsson, *Fijian Studies*, 60; Moschner, *"Die Wiener Cook-Sammlung,"* 228

**9.7  FEMALE FIGURE**

Ivory
3.5 (1⅜) high
Tonga Islands
Collected on one of Captain James Cook's voyages

Private collection, England

Kaeppler, *"Artificial Curiosities,"* 207

**9.8  FEMALE FIGURE**

Whale-tooth ivory
12.7 (5) high
Tonga Islands, Ha'apai Group

Raymond and Laura Wielgus Collection, Tucson, 59-159

Barrow, *Art and Life in Polynesia*, 70-71; Wardwell, *Sculpture of Polynesia*, 19-20

**9.9  FEMALE FIGURE**   Color plate 5

Walrus ivory
13.3 (5¼) high
Tonga Islands, Ha'apai Group
Collected on Viti Levu, Fiji Islands, by Cyril G. Hawdon, 1868

The Michael C. Rockefeller Memorial Collection of Primitive Art, on loan to The Metropolitan Museum of Art, New York, from Nelson A. Rockefeller, 1978, L.P. 57.108

Barrow, *Art and Life in Polynesia*, 70; Dodd, *Polynesian Art*, 206; Larsson, *Fijian Studies*, 70; Wardwell, *Sculpture of Polynesia*, 20-21

**9.10  CEREMONIAL HOOK WITH FEMALE FIGURES**

Ivory, beads
12 (4¾) high
Tonga, collected in Fiji
Formerly in the collection of Lord Stanmore (Sir Arthur Gordon)

University Museum of Archaeology and Anthropology, Cambridge, 55.247

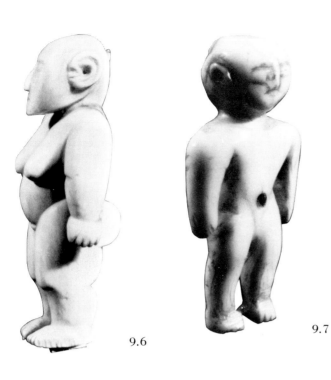

9.6

9.7

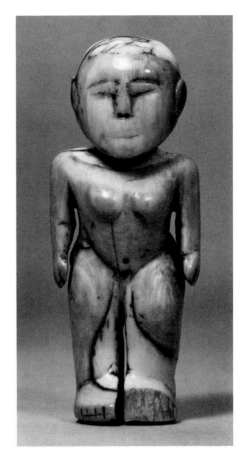

9.8

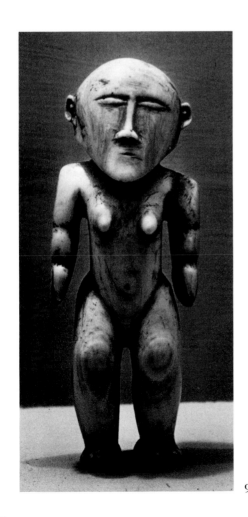

9.9

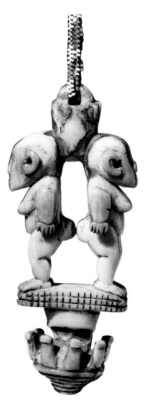

9.10

177

# 10 Samoa

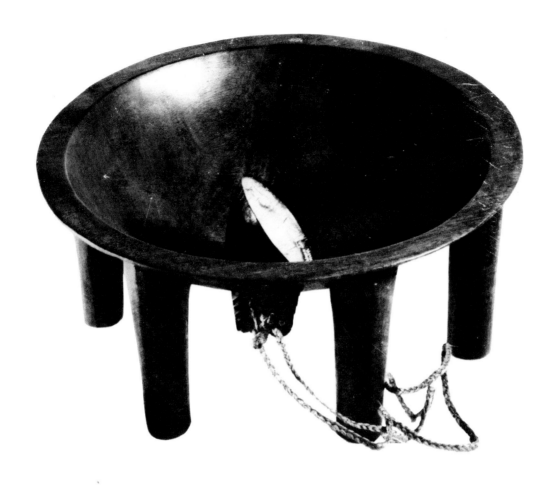

**10.1  BOWL**

Wood
45.8 (18) diameter
Samoa

Otago Museum, Dunedin, New Zealand,
D 43.400

Simmons, *Craftsmanship*, 20

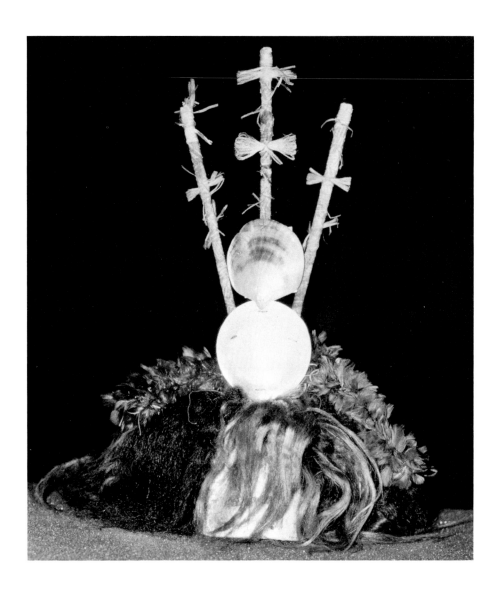

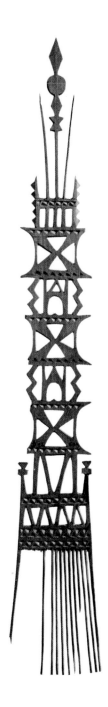

**10.2 HEADDRESS** *(tuiga)*

Human hair, coconut shell, bamboo, tapa, feathers, hibiscus fiber
54 (21¼) high
Samoa

Staatliches Museum für Völkerkunde, Munich, 15-16-67

**10.3 COMB**

Wood
42 (16½) long
Samoa

Otago Museum, Dunedin, New Zealand, D 24.698

Simmons, *Craftsmanship*, 37

180

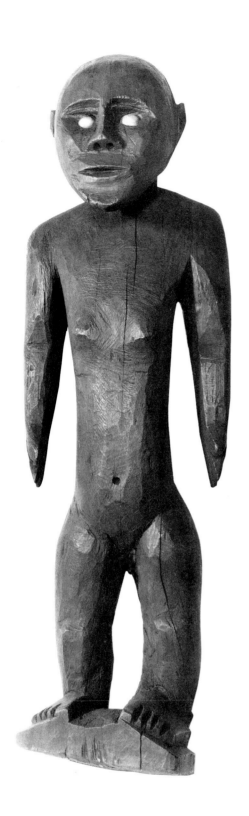

**10.4  FIGURE**

Wood, shell
69 (27⅛) high
Western Samoa, Upolu

Sent to Queen Victoria in 1840 by the London Missionary Society missionary Reverend Thomas Heath. Queen Victoria presented it to the British Museum in 1841.

Lent by the Trustees of the British Museum, London, 41.2-11.52

It was associated with the preserved bodies of two chiefs apparently of the Mata'afa family.

Archey, *Art Forms*, 43; Barrow, *Art and Life in Polynesia*, 77; Davidson, "The Wooden Image from Samoa in the British Museum," 352

# 11 New Zealand

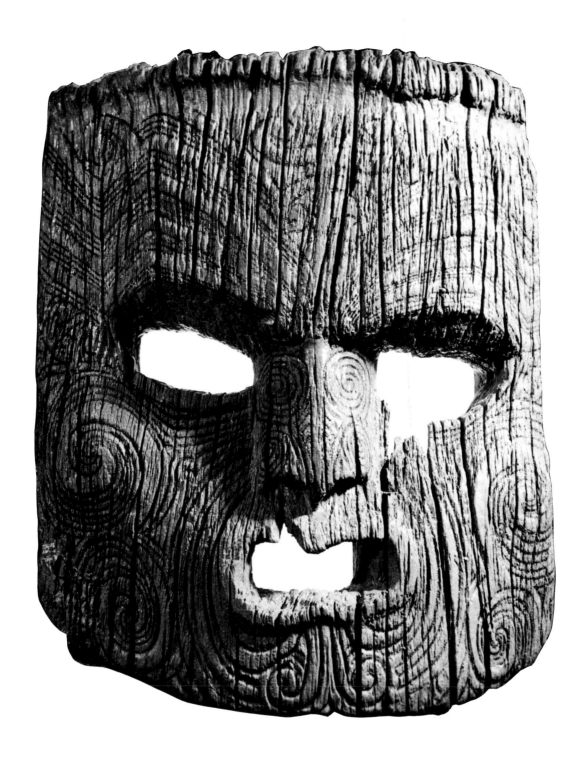

**11.1 MASK**

Wood
61 (24) high
New Zealand, Whirinaki River, Okorea *pa*

Otago Museum, Dunedin, New Zealand,
D 34-455

11.3

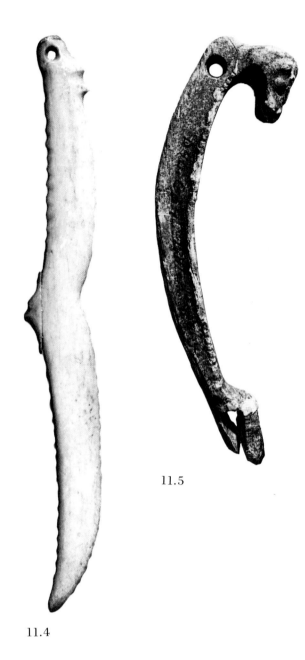

11.5

11.4

**11.2 ORNAMENT** *(hei-tiki)*

Nephrite
8.4 (3⅜) high
New Zealand, Murdering Beach

Otago Museum, Dunedin, New Zealand,
D.40.47

**11.3 ORNAMENT, FISH**

Bowenite
7.3 (2⅞) high
New Zealand, Ruapuke Island

Otago Museum, Dunedin, New Zealand,
D.12.8

**11.4 ORNAMENT, HUMAN FIGURE**

Human tibia
15.5 (6⅛) high
New Zealand, Waikouaiti sandhills

Otago Museum, Dunedin, New Zealand,
D.50.231

**11.5 AMULET**

Sperm whale tooth
11.5 (4½) long
New Zealand, Otago Peninsula, Little Papanui

Otago Museum, Dunedin, New Zealand,
D.46.663

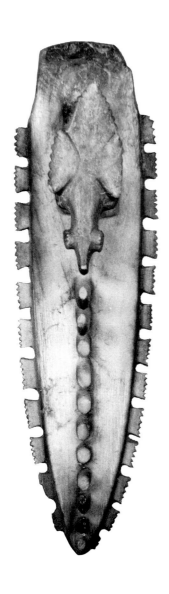

**11.6  AMULET**

Whale ivory
13.7 (5⅜) long
New Zealand, Banks Peninsula, Okain's Bay

Canterbury Museum, Christchurch, New Zealand

**11.8  ORNAMENT, BIRD-HEADED MAN**

Human bone (limb)
7.5 (3⅜) high
New Zealand, Akaroa

Canterbury Museum, Christchurch, New Zealand

**11.7  ORNAMENT, HUMAN FIGURE**

Nephrite
5 (2) high
New Zealand, Murdering Beach

Otago Museum, Dunedin, New Zealand, 61.20

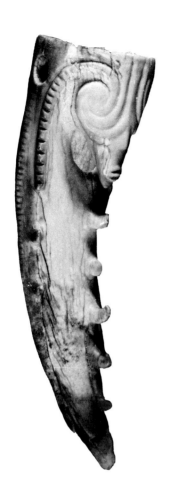

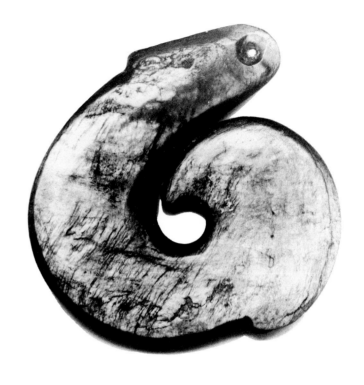

**11.9  AMULET**

Cetacean tooth
11.3 (4½) long
New Zealand, Outram

Otago Museum, Dunedin, New Zealand,
D.55.375

**11.10  AMULET, HOOK-SNAKE FORM**
*(hei-matau)*

Nephrite
8.6 (3⅜) high
New Zealand, Southland, Pahia

Otago Museum, Dunedin, New Zealand,
D.24.1416

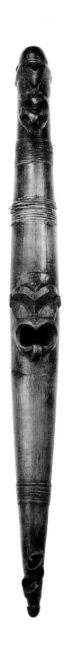
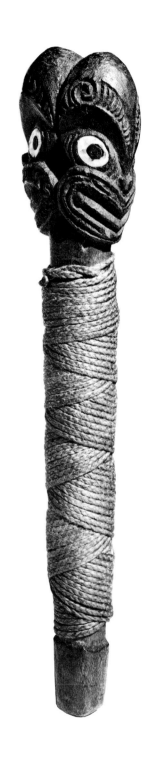

**11.11   FLUTE** *(putorino)*

Wood
54.3 (9⅜) long
New Zealand

Hunterian Museum, Glasgow, E.438

**11.12   GODSTICK, JANIFORM**

Wood, sennit
31.5 (21⅜) high
New Zealand, Taranaki, Waimate
Collected by William Hough, about 1840

Auckland Museum, New Zealand

**11.13   FLUTE** *(koauau)*

Wood
10.4 (4⅛) long
New Zealand
Collected on one of Captain James Cook's voyages

University Museum of Archaeology and Anthropology, Cambridge, D.1914.55

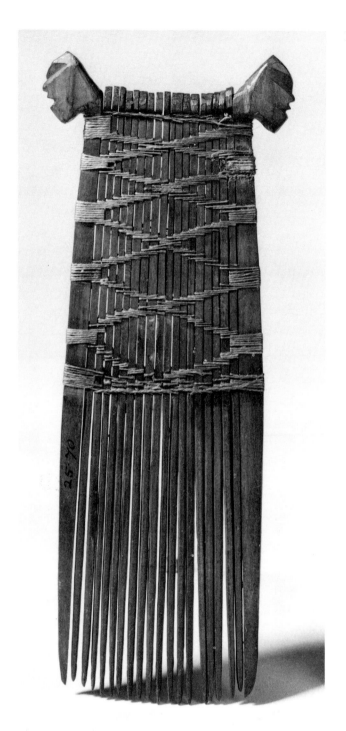

**11.14 COMB**

Wood
44 (17¼) long
New Zealand

University Museum of Archaeology and Anthropology, Cambridge, 25.70

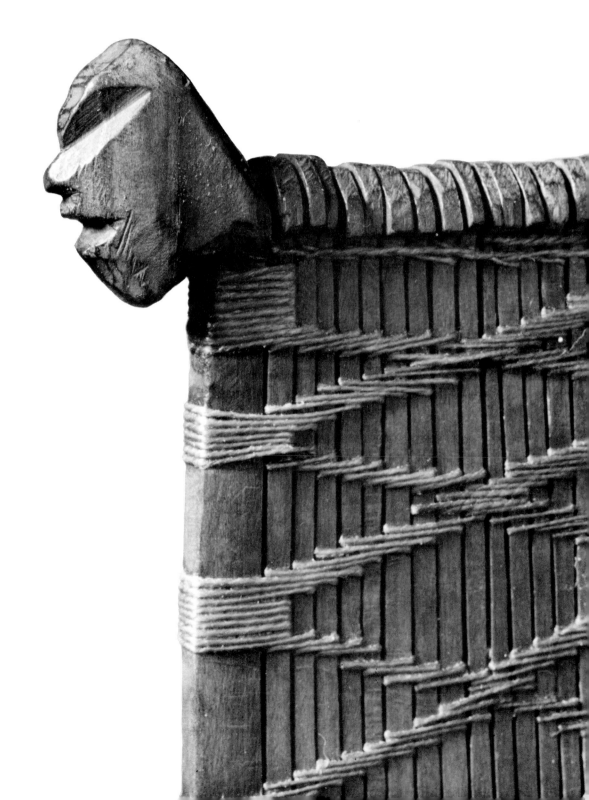

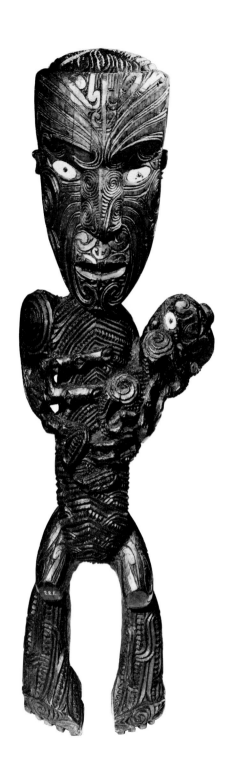

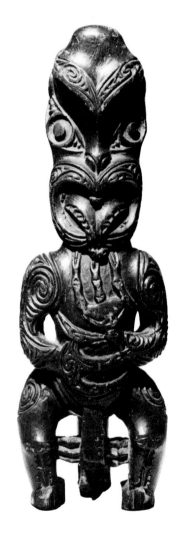

**11.15   MADONNA AND CHILD**

Wood, shell
82.5 (32½) high
New Zealand, Maketu
Carved by a Maori convert for a Roman
Catholic church, 1840

Auckland Museum, New Zealand

**11.16   FINIAL FIGURE** (*tekoteko*)

Wood
27.3 (10¾) high
New Zealand, North Island

Dr. Robert M. Browne, Honolulu

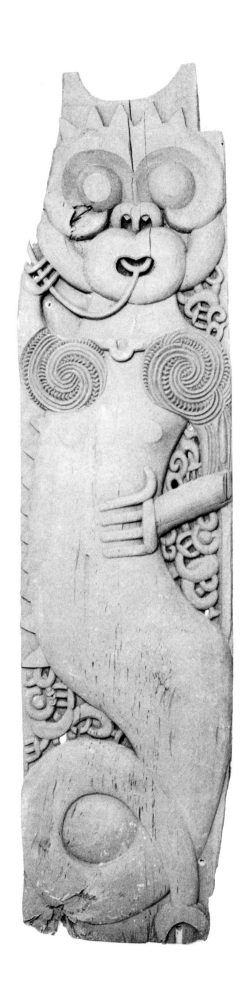

## 11.17  PANEL FROM MEETING HOUSE

Wood
236 (93) high
New Zealand, Maketu

Bernice Pauahi Bishop Museum, Honolulu,
1421

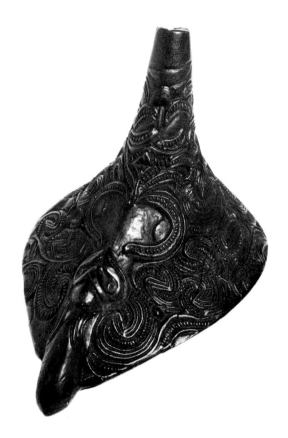

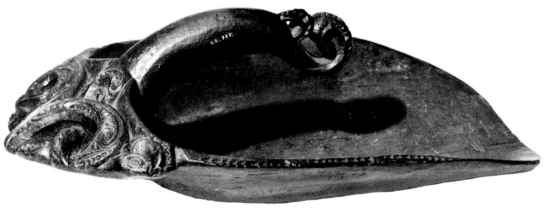

**11.18  FEEDING FUNNEL**

Wood
18.5 (7¼) long
New Zealand

Norfolk Museums Service, Great Yarmouth
Museums, England

**11.19  BAILER**

Wood
43 (16⅞) long
New Zealand
Probably collected on Captain James Cook's
voyages

University Museum of Archaeology and An-
thropology, Cambridge, 22.933

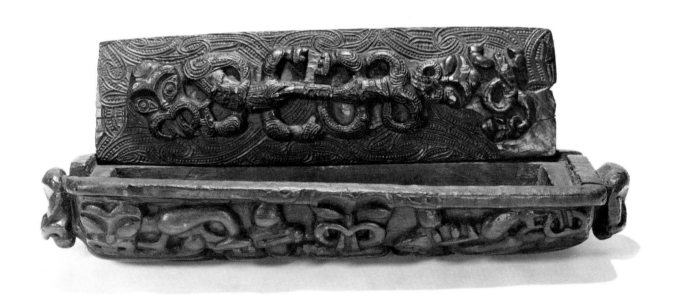

**11.20  FEATHER BOX**

Wood
72 (28⅝) long
New Zealand

University Museum of Archaeology and Anthropology, Cambridge, Z.6593

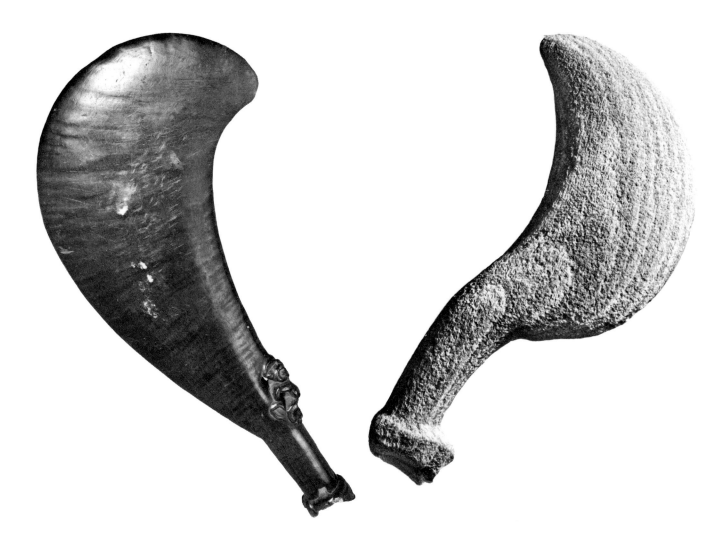

**11.21 CLUB** *(waha-ika)*

Wood
40.8 (16) long
New Zealand
Collected on one of Captain James Cook's voyages
Formerly the Leverian Museum, London, before 1786; presented by H. Vaughan, 1868

Exeter City Museums, England, E 1220

**11.22 CLUB** *(patu)*

Stone
38 (15) long
Chatham Islands, Matarakau: Moriori

Otago Museum, Dunedin, New Zealand, D.21.342

**11.23 STAFF** *(tewhatewha)*

Wood
136 (53) long
New Zealand
Collected on Captain James Cook's first voyage, 1770
Presented by the earl of Sandwich to Trinity College, Cambridge, 1771

University Museum of Archaeology and Anthropology, Cambridge, D. 1914.64

**11.24 PADDLE**

Wood
180 (70⅞) long
New Zealand
Collected on Captain James Cook's first voyage, 1770
Presented by the earl of Sandwich to Trinity College, Cambridge, 1771

University Museum of Archaeology and Anthropology, Cambridge, D. 1914.67

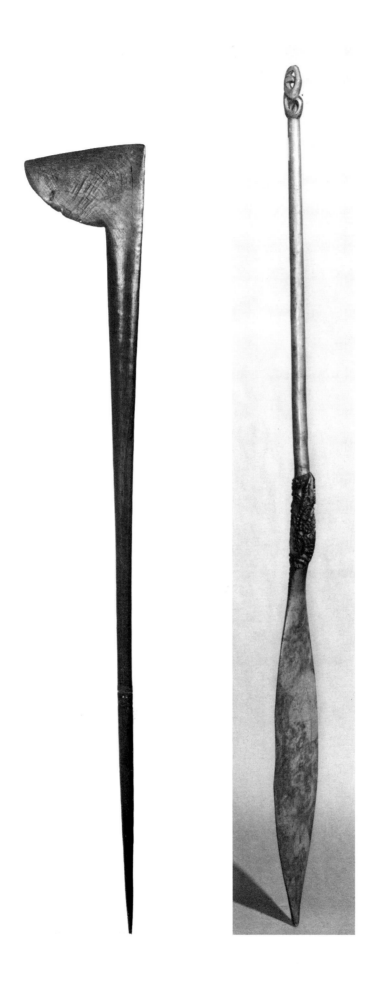

195

**11.25   CANOE STERN PIECE**

Wood
206.3 (81⅛) high
New Zealand

Auckland Museum, New Zealand

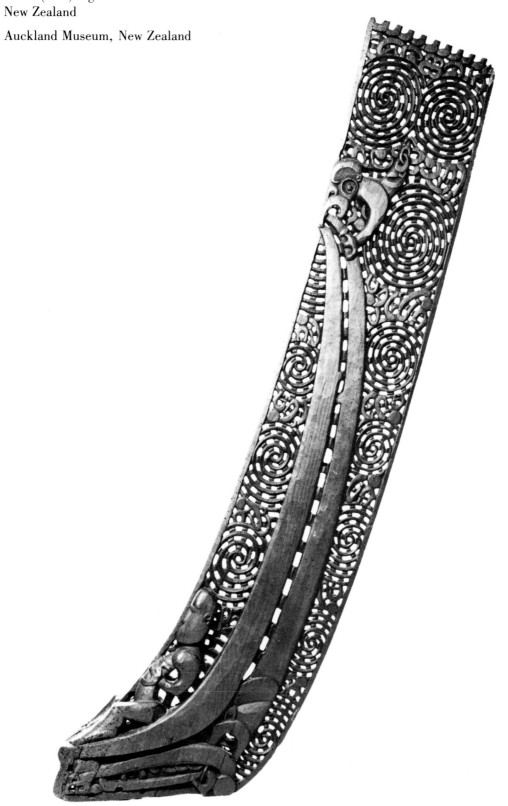

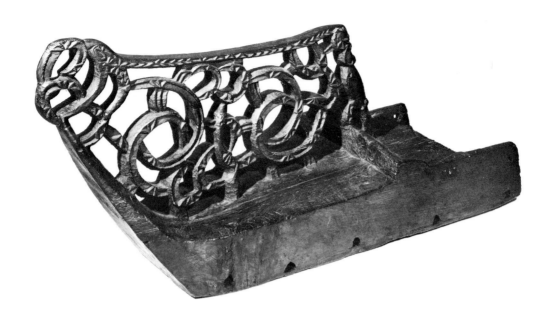

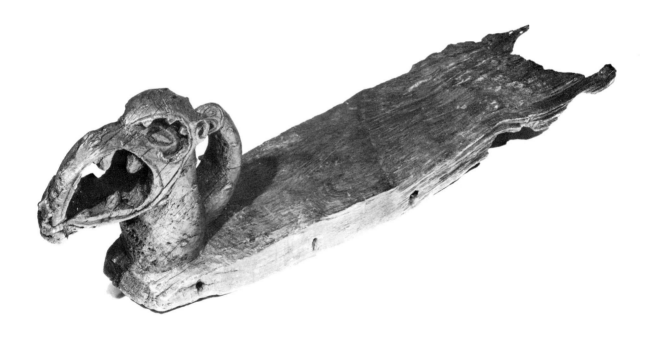

**11.26 CANOE PROW**

Wood
77.5 (30½) long
New Zealand

Auckland Museum, New Zealand, 5676

**11.27 CANOE PROW** *(tau-ihu)*

Wood
106.7 (42) long
New Zealand, Auckland, Doubtless Bay

Auckland Museum, New Zealand

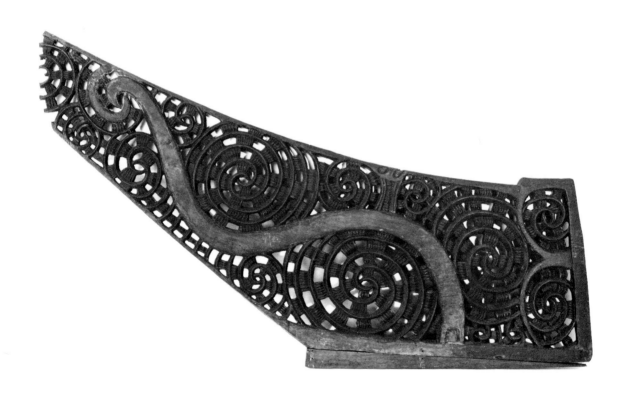

**11.28  CANOE PROW**

Wood
101 (39¾) wide
New Zealand

Lent by the Trustees of the British Museum,
London, 1927. 11-12.1

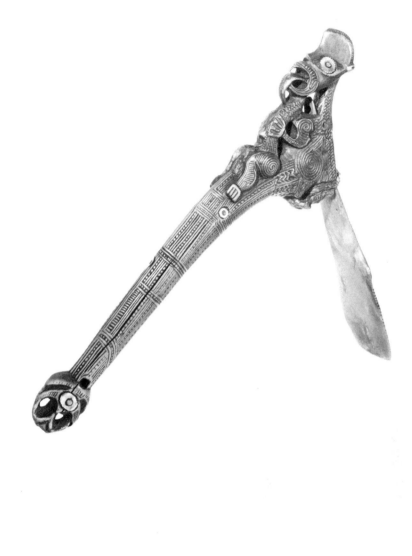

**11.29  CLUB (patu)**

Whalebone
48 (18⅞) long
New Zealand
Transferred from Jesus College, 1887

University Museum of Archaeology and An-
thropology, Cambridge, D.1887.6

**11.30  ADZE (toki pou tangata)**

Wood, green stone
44 (17¼) long
New Zealand
Formerly the Blackmore Museum, Salisbury,
acquired 1886

Otago Museum, Dunedin, New Zealand,
D.51.509

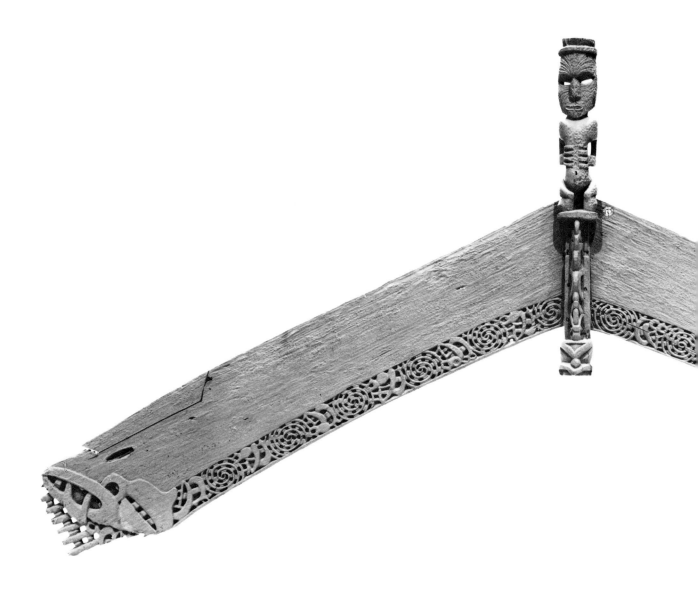

**11.31   HOUSE FRONT**

Wood
337.4 (133) wide
New Zealand, Bay of Plenty

Auckland Museum, New Zealand, 173

**11.32   HOUSE CARVING, BASE BOARD**

Wood
251.5 (99) long
New Zealand, Northland

Auckland Museum, New Zealand, 198

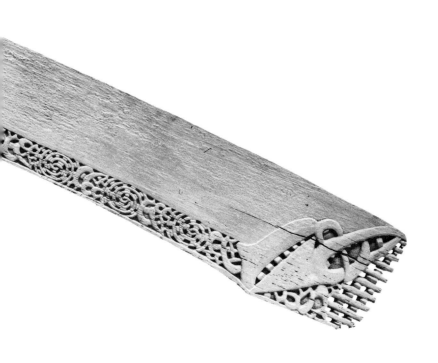

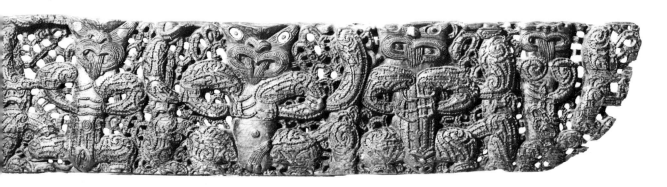

201

# 12 Prehistoric Oceania

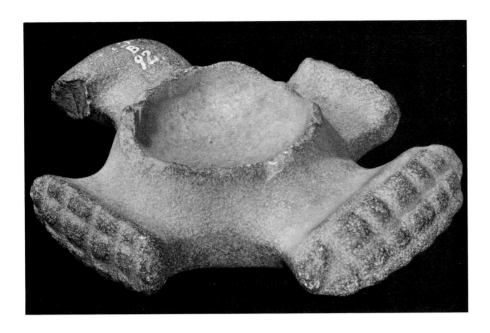

## 12.1  BOWL, BIRD FORM

Stone
50 (19⅝) long
Papua New Guinea, Central Highlands Province, Wahgi Valley

By courtesy of the Australian Museum Trust, Sydney, E 49702

Bramell, *Australian Museum Magazine*, 40-42

## 12.2  BIRD-HEADED FIGURE

Stone
17 (6⅝) high
Papua New Guinea, Madang Province, upper Ramu River

Private collection, New York

The head of this figure evidently represents that of a bird, possibly a hornbill, though the body has human features, creating a mythological bird-human. The bosses around the head relate the style to that of no. 12.1, on which similar bosses appear at the ends of the wings and tail. A few other such figures have been found in the Highland areas of Papua New Guinea. While this carving, like the others in the exhibit, belongs to a prehistoric period, the general conformation is also reflected in recent stylizations of bird forms (see no. 22.54).

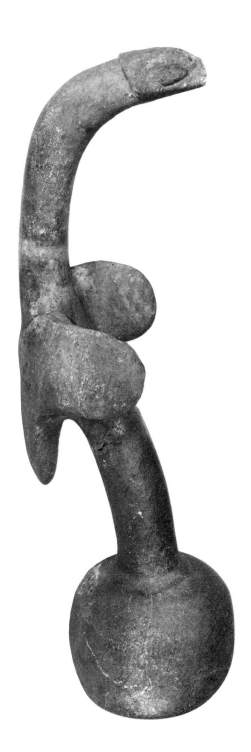

### 12.3 PESTLE, BIRD FORM

Stone
36.3 (14¼) high
Papua New Guinea, Northern Province, Aikora
River

Lent by the Trustees of the British Museum,
London, 1908.4.23.1

Prehistoric stone pestles frequently have terminals in bird or bird-head form. This pestle, perhaps the finest example of its kind, was discovered by prospectors under nine feet of gravel. Its provenance, about 125 miles from its presumed place of manufacture in the Highlands, suggests that there existed a trade in such objects. A closely similar example has been found even further off, in the Western Province near the Gulf of Papua.

Barton, "Stone Pestles"

### 12.4 GROUP OF SHERDS

Clay
Lapita style, about 1500-1000 B.C.
Excavated by J. Specht
Papua New Guinea, New Ireland, Ambitle Island; East New Britain, Watom Island; West New Britain, Talasea, Tsobu site

By courtesy of the Australian Museum Trust, Sydney

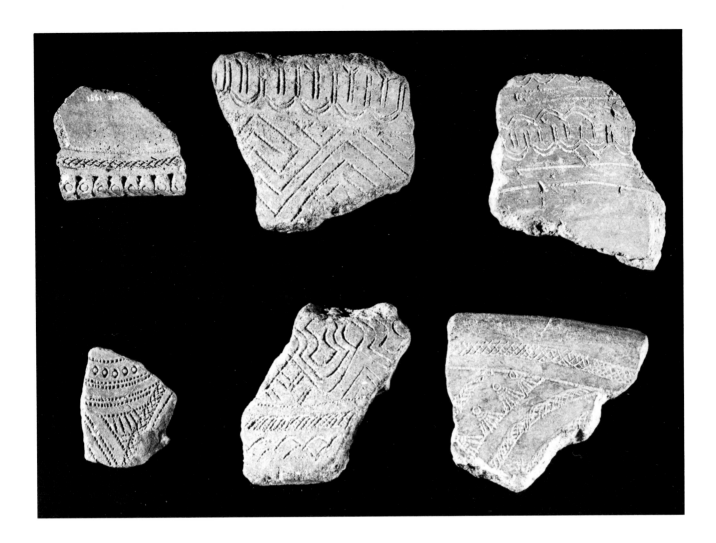

## 12.5 FIGURE

Basalt
20.5 (8⅛) high
Hawaii, Necker Island

The Metropolitan Museum of Art, New York, Rogers Fund, 1976.94

Necker Island figures occupy a crucial and controversial position in Polynesian archaeology, partly owing to their association with a particular type of temple platform. Although there is considerable discussion about the distribution and history of the temple platforms, the most coherent theory at present is that the type existed in the Marquesas Islands in their Phase II (A.D. 650-1300). At least one fragmentary figure with a resemblance to Necker Island sculpture has been found from this period; another may date from Phase III (A.D. 1300-1600). Migration from the Marquesas to Hawaii took place about A.D. 650-800, and Necker Island was being visited from Hawaii, probably as a place of pilgrimage, about A.D. 1000. There is, therefore, a strong possibility that the Necker Island figures may belong to a tradition that began in the Marquesas (where it developed into the more recent styles), was transferred to Hawaii about A.D. 650-800, and was present on Necker Island about A.D. 1000.

Emory, *Necker Island*, pl. 20

# MELANESIA

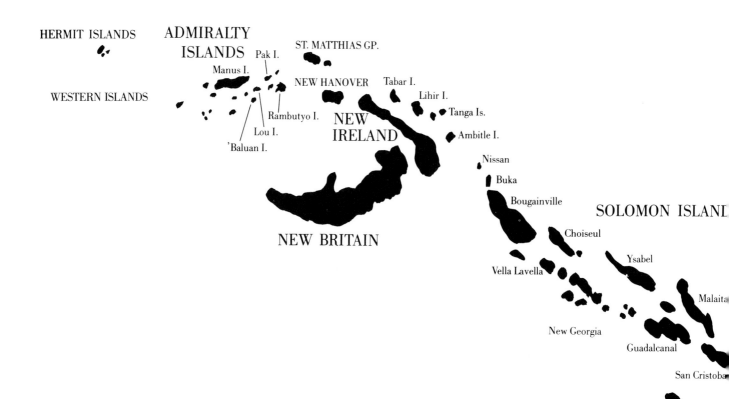

HERMIT ISLANDS

WESTERN ISLANDS

ADMIRALTY
ISLANDS

Manus I.

Pak I.

ST. MATTHIAS GP.

NEW HANOVER

Rambutyo I.

Lou I.

'Baluan I.

NEW
IRELAND

NEW BRITAIN

Tabar I.

Lihir I.

Tanga Is.

Ambitle I.

Nissan

Buka

Bougainville

SOLOMON ISLANI

Choiseul

Vella Lavella

Ysabel

Malaita

New Georgia

Guadalcanal

San Cristoba

*C O R A L      S E A*

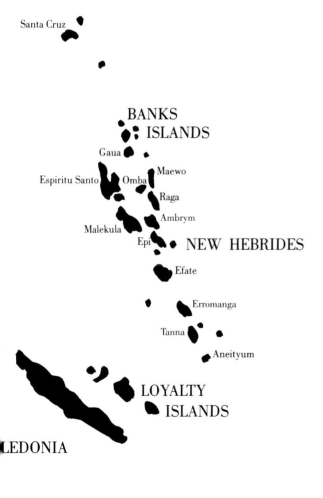

Santa Cruz

BANKS
ISLANDS

Gaua

Maewo
Espiritu Santo  Omba
Raga
Ambrym
Malekula
Epi  NEW HEBRIDES

Efate

Erromanga

Tanna
Aneityum

LOYALTY
ISLANDS

LEDONIA

# 13 New Caledonia

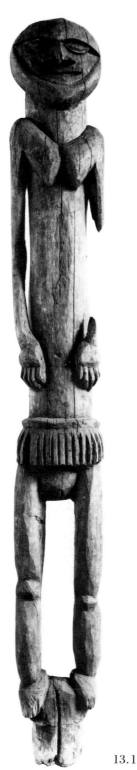

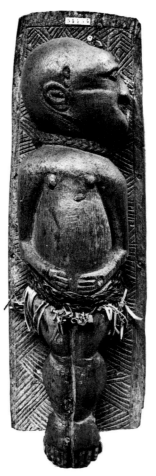

13.3

## 13.1  FIGURE

Wood

13.1

166 (65½) high

New Caledonia, northern area

Musée de l'Homme, Paris, 95.15.2

Three-dimensional sculpture, including figures and masks, is confined to the northern part of New Caledonia and does not occur east of Ponerihouen. The statues, kept in ceremonial houses, are presumably of ancestral significance.

## 13.2  FIGURE

Wood

134 (53) high

New Caledonia, northern area

Hamburgisches Museum für Völkerkunde, Hamburg, E 3754

## 13.3  FIGURE

Wood

24 (9⅜) long

New Caledonia, northern area

Musée de l'Homme, Paris, 03.24.2

A number of carvings from northern New Caledonia, curious in subject matter and of unknown significance, show infants on cradles or carrying boards. This method of carrying children was noted at the discovery of the island by Captain James Cook in 1774.

Guiart, *L'Art autochtone*, pl. 4, 10

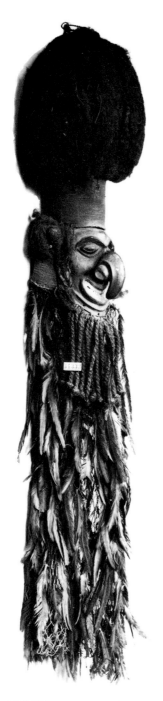

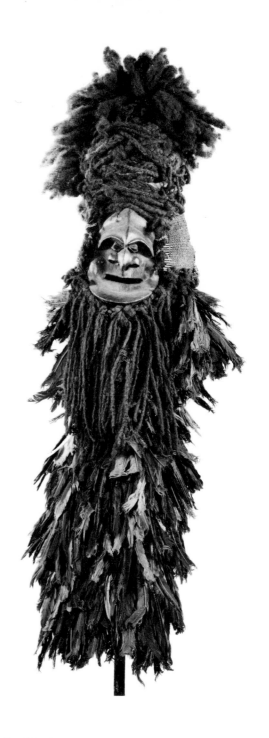

**13.4** **MASK** *(apouema)*

Wood, feathers
130 (51⅛) high
New Caledonia, northeastern area

Musée de l'Homme, Paris, 93.21.17

The use of masks is restricted to the northeast of
New Caledonia. Though each mask has a dif-
ferent personal name, all appear to be avatars
of a single divinity, a water spirit associated
with the ancestors and with fecundity.

Guiart, *Mythologie du masque*, pl. opp. p. 80

**13.5** **MASK**

Wood, hair, feathers
127 (50) high
New Caledonia, northern area
Collected 1895

American Museum of Natural History, New
York, S 3329

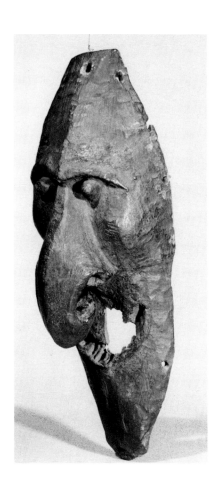

**13.6  MASK**

Wood
44 (17¼) high
New Caledonia, northeastern area
Museum purchase from Vignier

The University Museum, Philadelphia, P 4994

Davenport, "Sculpture from La Grande Terre,"
7

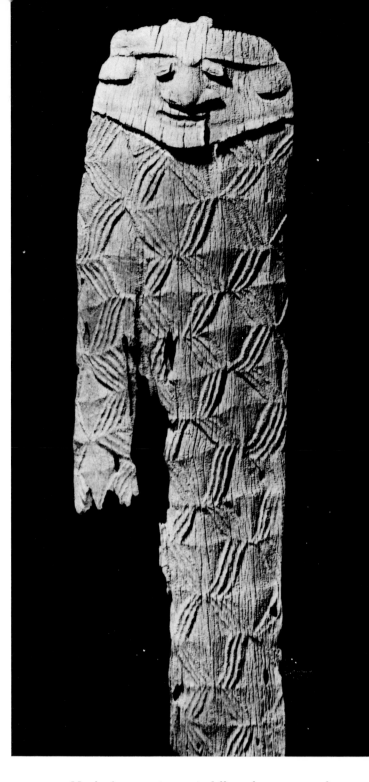

**13.7  DOOR JAMB** *(jovo)*

Wood
167 (65¾) high
New Caledonia
Collected in the second half of the 18th century

Barbier-Müller Collection, Geneva, 4700/C

Men's houses *(moaro)* followed an unusual round plan with high conical roofs. They were ornamented with massive doorjambs, lintels and carved finials (no. 13.10), and some interior decoration. The human representations were those of important ancestors. By custom the new carvings decorating the men's houses were removed at the feasts inaugurating the house by the guests from other villages, who then used them for their own purposes.

Barbier, *Indonésie et Mélanésie*, 97

## 13.8 DOORJAMB *(jovo)*

Wood
165 (65) high
New Caledonia

Josefowitz Collection, Switzerland

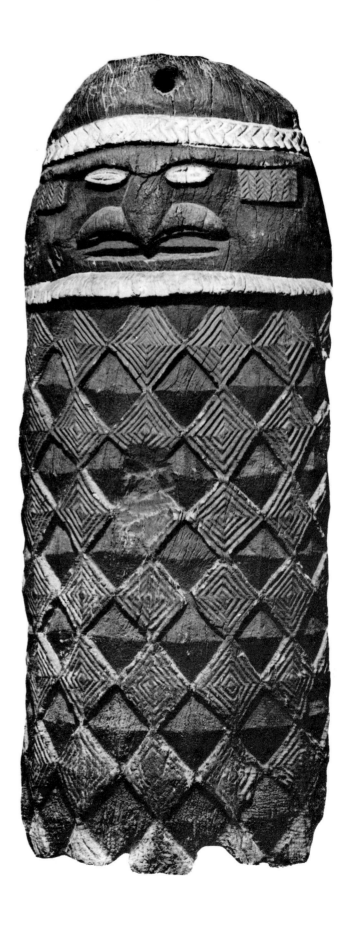

**13.9 CEILING PLANK (boedu)**

Wood
214 (72¼) high
New Caledonia, Warai, near Houaïlou
Collected by F. Sarasin, 1910-1912

Museum für Völkerkunde, Basel, Vb 2650

This object was part of a structure marking a platform where the elders slept to obtain divinatory dreams.

Sarasin, *Atlas*, pl. 66, 5, p. 238; Guiart, *Arts of the South Pacific*, pl. 242

**13.10 ROOF FINIAL (gomoa)**

Wood
125 (49¼) high
New Caledonia, Houaïlou area
Collected about 1850

Josefowitz Collection, Switzerland

**13.11 CEREMONIAL STAFF (gi okono)**

Wood, jade, binding
60.9 (24) high
New Caledonia

The University Museum, Philadelphia, P 2126

These well-known ceremonial batons were important possessions of chieftains. They were held during oratorical sessions and also used as instruments during the procedures of rain-making magic.

Davenport, "Sculpture from La Grand Terre," 18

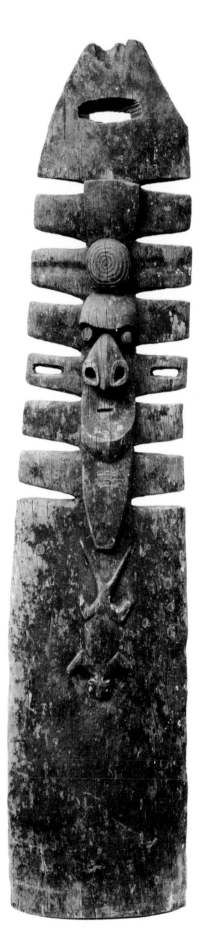

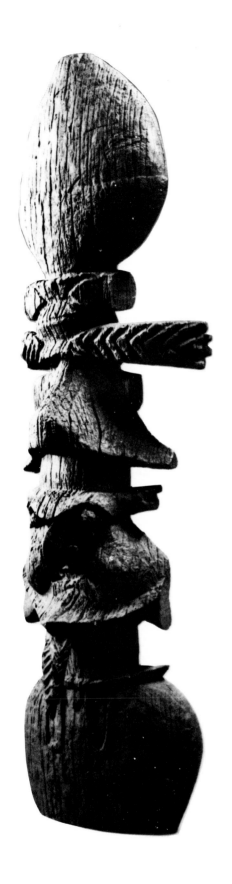

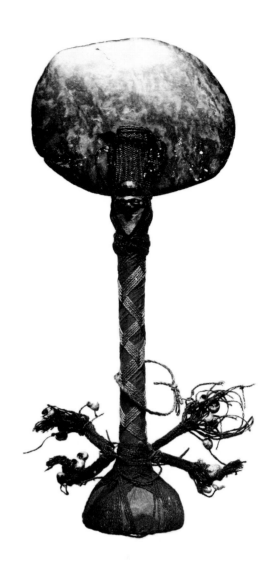

# 14 New Hebrides

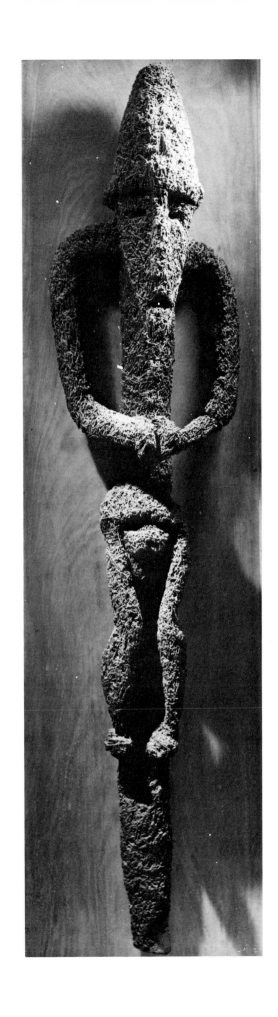

## 14.1 GRADE SOCIETY FIGURE

Fernwood
104.1 (41) high
New Hebrides, Banks Islands

Mr. and Mrs. Ben Heller Collection, New York

Men in the New Hebrides are members of
societies, each of which consists of many
grades in ascending order. Among these
societies are the Sukwe of the Banks Islands,
the Mangki of Ambrym (see no. 14.11), and the
Nimangki of Malekula. Progress from grade to
grade was marked by sacrifices (see no.
14.10), the right to wear specific ornaments,
and the erection of various types of carved
figures in wood or fernwood.

217

## 14.2 FOOD KNIFE

Wood
45.7 (18) high
New Hebrides, Banks Islands

Private collection, New York

## 14.3 FOOD KNIFE

Wood
48 (18⅞) long
New Hebrides, Banks Islands

University Museum of Archaeology and Anthropology, Cambridge

Harrisson, *Savage Civilization*, pl. opp. p. 360

## 14.4 RAIN CHARM

Stone
18 (7) high
New Hebrides, Raga

Musée de l'Homme, Paris, 34.186.244

Between the forearms of the two figures are shown pairs of pigs' mandibles, with the exaggerated, ingrown tusks which are important features of animals sacrificed in ritual.

Guiart, "Les Effigies réligieuses," 22

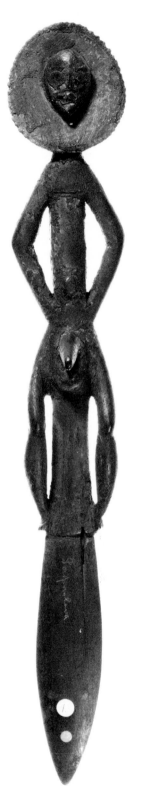

14.3

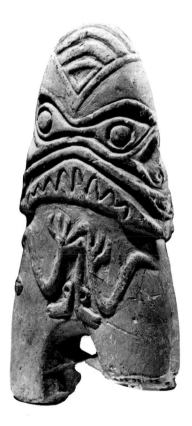

14.4

## 14.5 MASK

Wood
33 (13) high
New Hebrides, Raga
Collected by Aubert de la Rue, 1934

Musée de l'Homme, Paris, 34.186.229

Guiart, *Arts of the South Pacific*, 232

## 14.6 CANOE PROW

Wood, paint
72 (28½) long
New Hebrides, Achin Island
Museum acquisition from Dr. Hannibal Hamlyn, 1943

Bernice Pauahi Bishop Museum, Honolulu, C9594

The highly stylized openwork design represents a pair of birds.

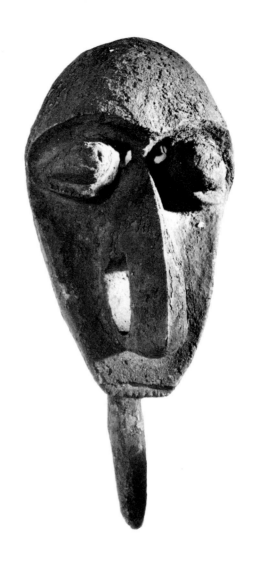

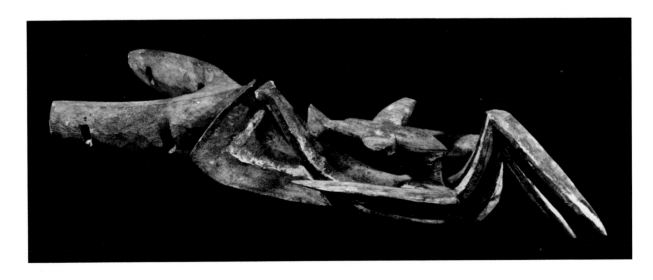

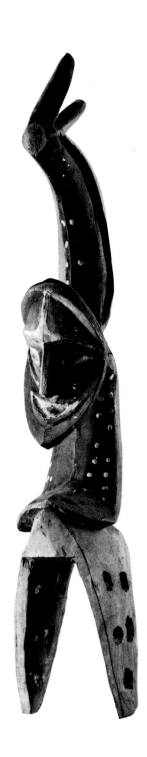

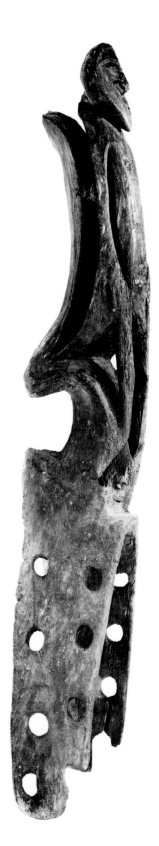

**14.7   CANOE PROW**

Wood, paint
69 (27⅛) long
New Hebrides, Malekula

Musée de l'Homme, Paris, 41.7.1

**14.8   CANOE PROW**

Wood, paint
110 (43¼) long
New Hebrides, Vao Island

Musée de l'Homme, Paris, 36.31.1

**14.9  MEMORIAL FIGURE** *(rambaramb)*

Fernwood, human skull, pig tusks, bead
bracelets, hair, clay, cloth
172 (68) high
New Hebrides, Malekula: Bot'gote
Collected by the *La Korrigane* expedition,
1934-1936

Kathleen Haven, New York

Upon the death of an important man, his skull
was mounted on fernwood that had been carved
with a figure. The figure was painted and or-
namented with the insignia of his rank in the
grade society; the skull was overmodeled to as
close a resemblance to his actual features as
possible.

**14.10  PIG-KILLING CLUB**

Wood, paint
94 (37) long
New Hebrides, Malekula or Ambrym

Museum Rietberg Zurich (Collection von der
Heydt), Zurich, RME 703

Passage from one grade to another is often ac-
complished by the sacrifice of numbers of pigs;
the clubs used were often elaborately carved.

Bühler, *Art of Oceania*, 224-225

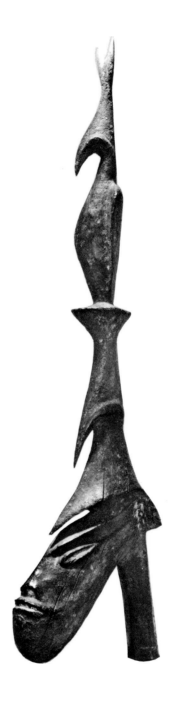

## 14.11  GRADE SOCIETY FIGURE

Fernwood, paint
217 (84½) high
New Hebrides, Ambrym Island

Private collection, New York

## 14.12  HEAD FROM A SLIT GONG

Wood
155.3 (61¼) high
New Hebrides, Ambrym Island, Fanla

The Metropolitan Museum of Art, New York, The Michael C. Rockefeller Memorial Collection of Primitive Art, Gift of Nelson A. Rockefeller, 1972, P 59.281

Batteries of slit gongs, planted vertically, are arranged at the sides of dancing grounds. They are beaten in groups, during the rites of Mangki grade society, with rhythms of great complexity. The sounds produced appear to represent the voices of the ancestors.

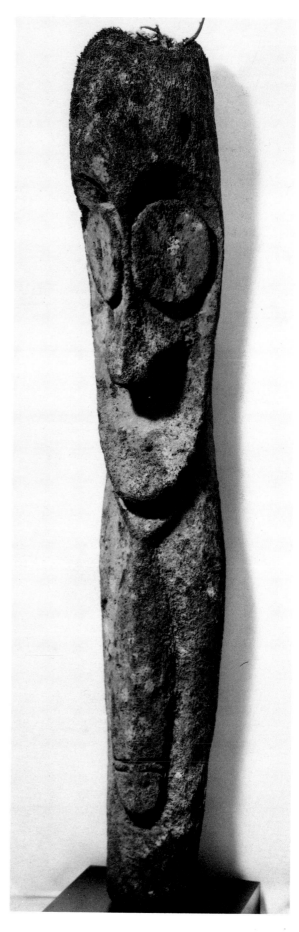

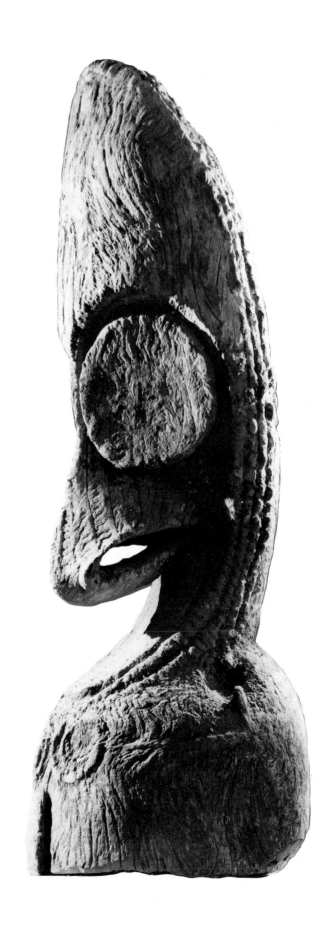

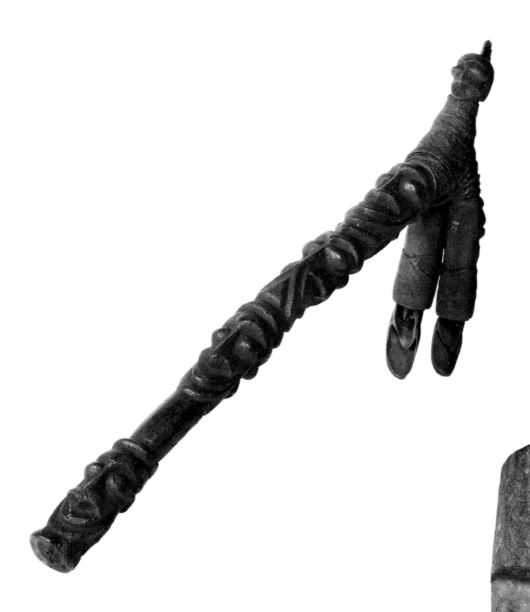

**14.13  ADZE**

Wood, shell, fiber
67 (26⅜) long
New Hebrides, Ambrym
Presented by Captain Leah, R.N.

Lent by the Trustees of the British Museum,
London, 1900.9-11.1

**14.14  MASK**

Wood, paint
40 (15¾) high
New Hebrides, Ambrym

Collection of the Newark Museum, 25.465

Wingert, *South Pacific Islands*, pl. 63

224

# 15 Solomon Islands

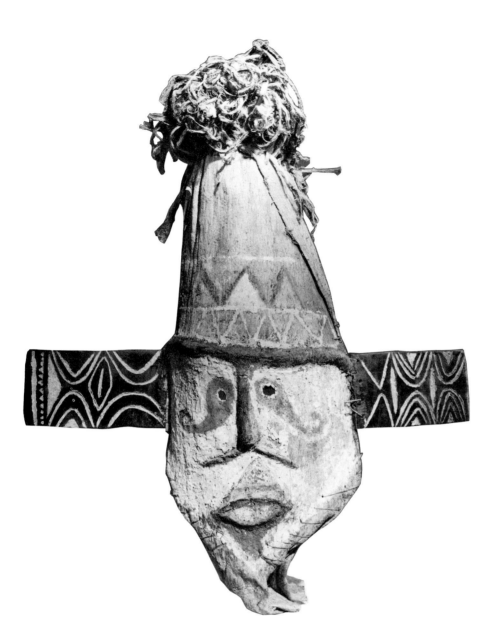

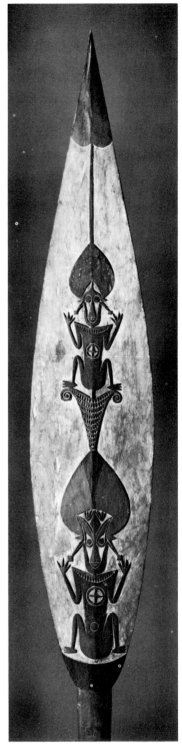

**15.1 MASK**

Bark cloth, paint, wood
75 (29½) high
Solomon Islands, Nissan

Rijksmuseum voor Volkenkunde, Leiden,
1.1181-7

**15.2 CEREMONIAL PADDLE** *(boe)*

Wood, paint
170.2 (67) long
Solomon Islands, Buka or Bougainville Islands: Buka

The Metropolitan Museum of Art, New York, The Michael C. Rockefeller Memorial Collection of Primitive Art, Gift of Nelson A. Rockefeller, 1966, P 66.20

## 15.3  DANCE SHIELD *(koka)*

Wood, paint
45.5 (17⅞) high
Solomon Islands, Bougainville: Telei

The Ethnographical Museum, Budapest

At important weddings, these plaques were
carved by the guests, who held them up as they
danced round the couple being married.

Bodrogi, *Oceanian Art*, pl. 120

## 15.4  KNEELING FIGURE

Wood, shell, fiber
17.8 (7) high
Solomon Islands, Vella Lavella?

University of East Anglia, Norwich, England,
1971, Robert and Lisa Sainsbury Collection
UEA 172

The style of this figure—unusually naturalistic
for the Solomon Islands or indeed Oceania as a
whole—is known to have been used since at
least 1860.

The University of East Anglia, *Sainsbury Collection*, 151, no. 236

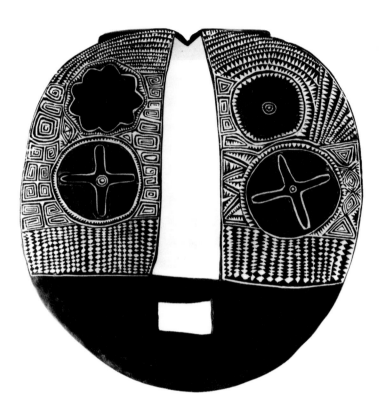

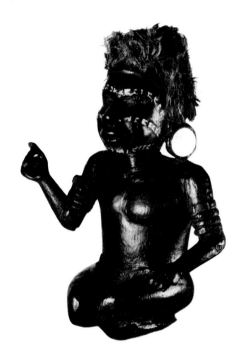

### 15.5  GRAVE DECORATION (*mbarava*)

Tridacna shell
34 (13⅜) high
Solomon Islands, Vella Lavella

Buffalo Museum of Science, New York, C11752

Openwork clamshell carvings, showing rows of
figures in dance position, were made as screens
for miniature houses containing ancestral
skulls. They are also known as *saru Mbangara*,
denoting their original manufacture by the sea-
god and ancestor, Mbangara.

### 15.6  CEREMONIAL SHIELD  Color plate 12

Basketry, mother-of-pearl inlay on resin base
83 (32⅝) high
Solomon Islands, Ysabel
Collected by Surgeon Captain James Booth,
R.N., and presented to the Montrose Museum,
1852

The Brooklyn Museum, New York, Frank L.
Babbott and Carll H. DeSilver Funds, 59.63

Shields of this type seem to have been made, for
only a limited period in the nineteenth century,
as ceremonial insignia of important chiefs.
Only a few dozen exist, of which this is one of
the first to have been collected.

15.6

## 15.7  SHIELD

Bark, cane, shell inlay
74 (29⅛) high
Solomon Islands

Pitt Rivers Museum, University of Oxford, England

## 15.8  CLUB *(wari hau or hau aano rereo)*

Wood, stone, cane, shell
40.2 (15¾) long
Solomon Islands, Malaita: 'Are 'Are

University Museum of Archaeology and Anthropology, Cambridge, Z.10826

*Wari hau* ("round stone") or *hau aano rereo* ("stone decorated with mother-of-pearl") were perhaps the first Oceanic objects to be noted by Europeans, when Count Alvaro de Mendaña's exploring expedition discovered the archipelago at the beginning of 1568. In May, at Malaita, they bartered caps for *wari hau:* "we found on this island knobs the size of oranges, of a metal that appeared to be gold, beneath which metal was pearlshell [inlay]. They have them fixed upon a stick to fight at close quarters." It was not gold but a metallic stone containing the glittering iron pyrites known as "fools' gold." The illusion persisted, however; hence the name of the "Islands of Solomon," after the king's legendary wealth. The clubs were actually the ceremonial batons of men licensed to carry out executions of those who had transgressed tribal regulations.

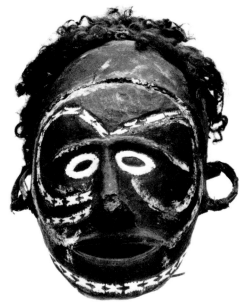

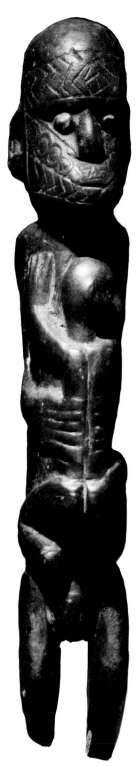

### 15.9 OVERMODELED SKULL

Human skull, paste, shell
16 (6¼) high
Solomon Islands, New Georgia

The Ethnographical Museum, Budapest

Bodrogi, *Oceanian Art*, pl. 114

### 15.10 OVERMODELED HUMAN SKULL

Human skull, paste, shell
15 (5⅞) high
Solomon Islands, New Georgia
Purchased 1926

Peabody Museum of Salem, Massachusetts,
E 19898

Linton and Wingert, *Arts of the South Seas*, 189

### 15.11 MOTHER AND CHILD

Wood, shell
48.5 (19¹⁄₁₆) high
Solomon Islands, New Georgia

Buffalo Museum of Science, New York, C
12072

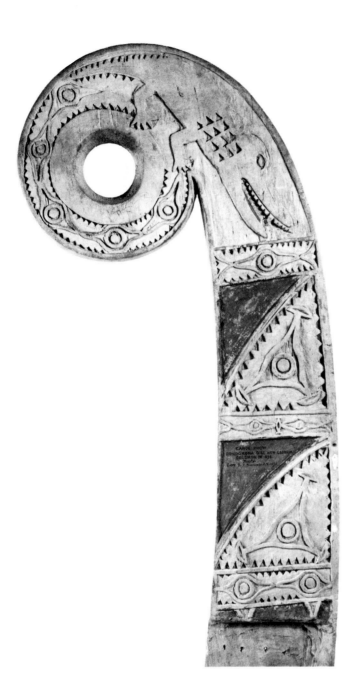

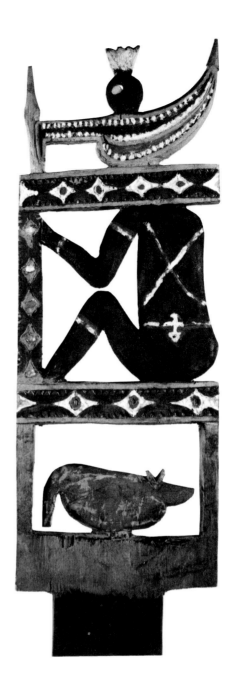

**15.12 CANOE PROW ORNAMENT**

Wood, paint
70 (27½) high
Solomon Islands, New Georgia group, Simbo
Collected by Naval Lieutenant B. T. Somerville
in 1894

Pitt Rivers Museum, University of Oxford,
England

**15.13 CANOE PROW ORNAMENT**

Wood, paint
56 (22) high
Solomon Islands, New Georgia, Ramada Island
Collected by Naval Lieutenant B. T. Somerville
in 1894

Pitt Rivers Museum, University of Oxford,
England, D II 1895.22.162

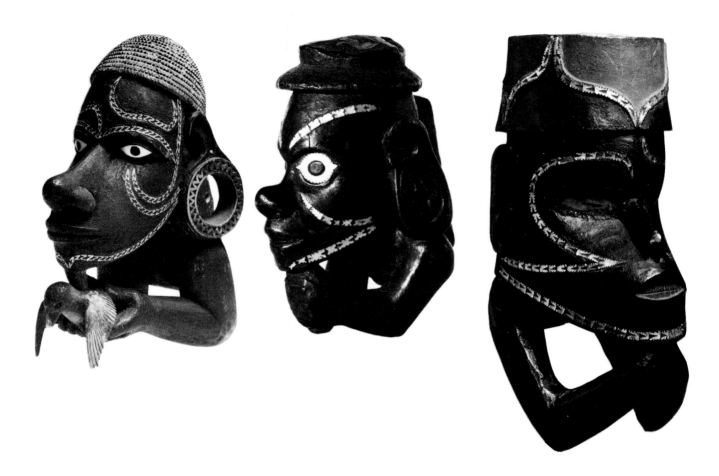

**15.14 CANOE PROW ORNAMENT** *(nguzu nguzu)*

Wood, shell, paint
17 (6¾) high
Solomon Islands, New Georgia, Marovo Lagoon

Museum für Völkerkunde, Basel, Vb 7525

Guiart, *Arts of the South Pacific*, pl. 332

*Nguzu nguzu* were fastened just above the waterline on the prows of war canoes *(tomako)*. They represented spirits who protected the canoes from accidents at sea and exercised a malign influence on the enemy under attack.

**15.15 CANOE PROW ORNAMENT** *(nguzu nguzu)*

Wood, paint, pearl shell
13.7 (5⅜) high
Solomon Islands, New Georgia

Indiana University Art Museum, Bloomington, 100.6.5.75

**15.16 CANOE PROW ORNAMENT** *(nguzu nguzu)*

Wood, shell, paint
28.6 (11¼) high
Solomon Islands, New Georgia

Indiana University Art Museum, Bloomington

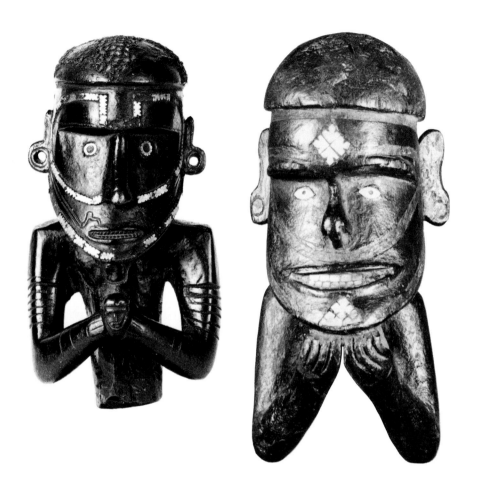

**15.17 CANOE PROW ORNAMENT** *(nguzu nguzu)*

Wood, shell, paint
21.5 (8½) high
Solomon Islands, New Georgia

Mr. Gaston T. de Havenon, New York

**15.18 CANOE PROW ORNAMENT** *(nguzu nguzu)*

Wood, paint, shell
31.8 (12½) high
Solomon Islands, New Georgia

Faith and Martin Wright, New York

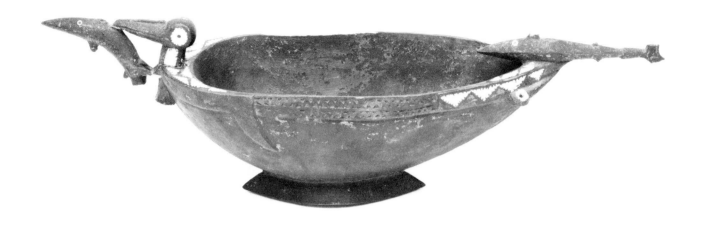

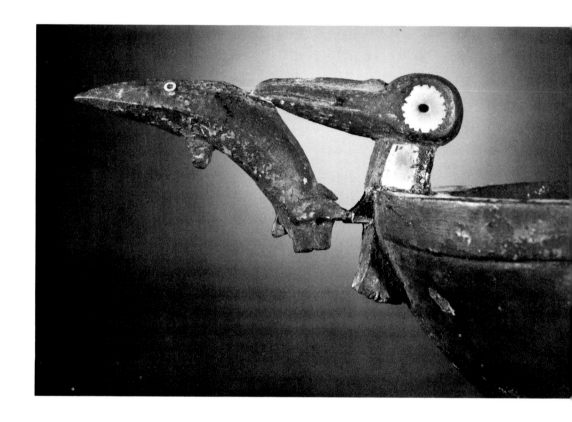

**15.19 BOWL**

Wood, paint, shell
40 (15¾) long
Solomon Islands
Given by Dr. Charles Goddard Weld, 1909

Peabody Museum of Salem, Massachusetts,
E 12028

In spite of small damages, this is one of the most delicate of eastern Solomon Islands bowls. This elaborate form is used by an individual man for ritual meals taken in communion with his supernatural patron. The fish are bonito, regarded as a manifestation of the deities, while the birds are those which appear in association with bonito shoals.

Linton and Wingert, *Arts of the South Seas*, 183

**15.20  SCRAPER**

Pearl shell
15 (5⅞) long
Solomon Islands, San Cristoval

Buffalo Museum of Science, New York, C
10834

**15.21  HOUSE POST**

Wood
163 (64) high
Solomon Islands, San Cristoval
Collected by Jack London, in 1908

Josefowitz Collection, Switzerland

London, *The Log of the Snark*, pl. opp. p. 400

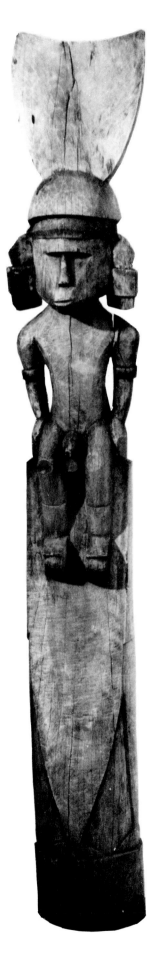

15.21

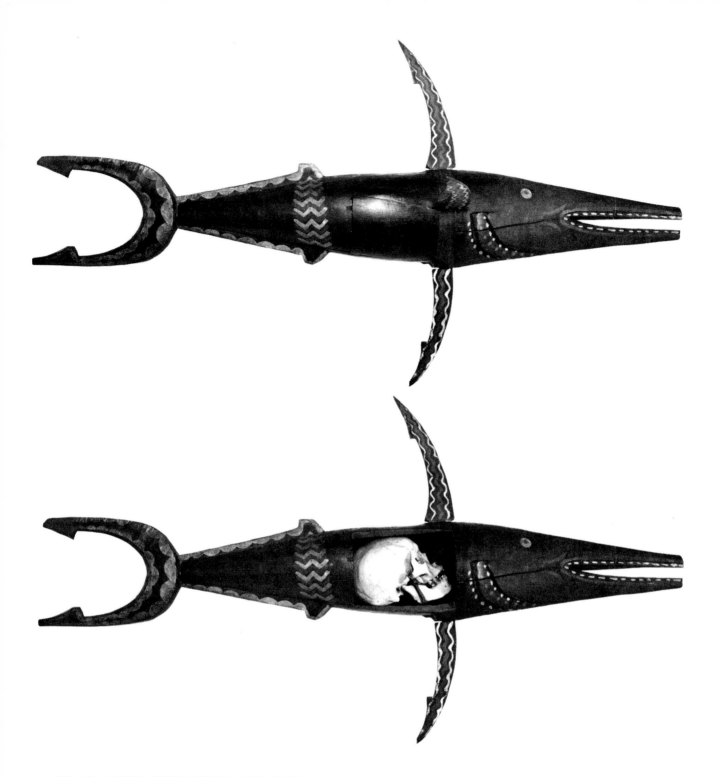

**15.22 FISH, CONTAINER FOR HUMAN SKULL**

Wood, paint, skull
141 (56½) long
Solomon Islands, Santa Ana
Collected by Admiral Davis, in H.M.S. *Royalist*, 1890-1893

Lent by the Trustees of the British Museum, London, 1904.6-21.13

Cranstone, *Melanesia*, pl. 13 (c)

# 16 New Britain

## 16.1 DOUBLE FIGURE

Chalk, paint
47 (18½) high
New Britain, Gazelle Peninsula: Tolai

Hamburgisches Museum für Völkerkunde, Hamburg, E 928

The main religious grouping of the Tolai men was the Iniet society, which, like others in Melanesia, exercised regulatory social functions. On completion of their initiations the members were presented with small figures carved in chalk or other stones. These had secret names, and were conceived as interrelated in ways which governed the interrelationships within the society of their owners.

## 16.2 DANCE WAND

Wood, paint
180 (71⅛) high
New Britain, Gazelle Peninsula: Tolai

Pitt Rivers Museum, University of Oxford, England, 473

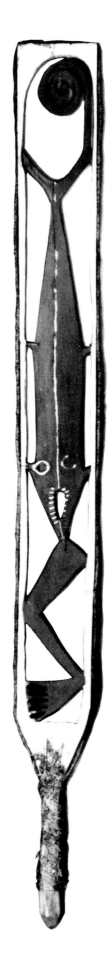

### 16.3 MASK (lor)

Frontal bones of human skull, clay, paint
24 (9½) high
New Britain, Gazelle Peninsula: Tolai
Collected by Janos Pauer, before 1913

The Ethnographical Museum, Budapest,
104490

*Lor* masks were associated with the Iniet society. They were considered the relics of important ancestors and were carried in dances as masks, held in the teeth by a wooden bit fastener across the back.

Bodrogi, *Oceanian Art*, pl. 105

### 16.4 FIGURE (marawot)

Wood, paint
232 (91⅞) high
New Britain, Gazelle Peninsula; Tolai
Collected by R. Parkinson, 1896-1898

Staatliches Museums für Völkerkunde, Dresden, 9506

Foy, *Tanzobjekte*, pl. 7,1

### 16.5 FIGURE (marawot)

Wood, skull, clay, paint, hair
207 (81½) high
New Britain, Gazelle Peninsula: Tolai
Collected by R. Parkinson, 1895

Staatliches Museums für Völkerkunde, Dresden, 8096

Meyer and Parkinson, *Schnitzerei und Masken*, pl. 15, 3

### 16.6 MALE FIGURE

Wood, paint
107 (42⅛) high
New Britain, Gazelle Peninsula, Blanche Bay, Kininigunau: Tolai
Collected by J. Weisser, 1883

Staatliches Museums für Völkerkunde, Dresden, 8071

Meyer and Parkinson, *Schnitzerei und Masken*, pl. 16, 10

**16.7 MASK**

Wood, paint, fiber
40 (15½) high
New Britain, Gazelle Peninsula, Blanche Bay,
Raluana: Tolai
Collected by Robert Parkinson, 1895

Staatliches Museums für Völkerkunde, Dresden, 8114

Meyer and Parkinson, *Schnitzerei und Masken*, pl. 3, 9

**16.8 MASK** *(tubuan)*

Netting, paint, fiber
160 (63¼) high
New Britain, Gazelle Peninsula: Tolai
Collected by Robert Parkinson, 1895

Staatliches Museums für Völkerkunde, Dresden, 8057

*Tubuan* (female) and *duk duk* (male) masks are made by the Tolai and the Duke of York Islanders to the north, between New Britain and New Ireland. In the Duke of York Islands, they are associated with mortuary ceremonies in which the female is a wild spirit which has to be tamed, as a symbol of social order. Among the Tolai on the mainland of New Britain the society acts as a maintainer of social control with a considerable stress on sorcery.

Errington, *Karavar;* Meyer and Parkinson, *Schnitzerei und Masken*, pl. 7,2

**16.9 PROWS FOR FUNERARY CANOE**

Wood, paint
183, 166 (72, 65⅜) long
New Britain, Gazelle Peninsula, Blanche Bay,
Raluana: Tolai
Collected by A. B. Lewis, 1909-1913

Field Museum of Natural History, Chicago, 138895.2, 138895.3

Linton and Wingert, *Arts of the South Seas*, 156

**16.10 MASK** *(oggeroggeruk)*

Bark cloth, paint, bamboo
228.5 (90) long
New Britain, Gazelle Peninsula, Walmatki:
Chachet Baining
Collected 1972

George Corbin Collection, New York

**16.11 MASK** *(oggeroggeruk)*

Bark cloth, paint, bamboo
289.5 (114) long
New Britain, Gazelle Peninsula, Randoulit (or Malaseit): Chachet Baining
Made 1971-1972

George Corbin Collection, New York

*Oggeroggeruk* masks appear to have been assimilated by the Chachet from the central Baining in the last forty years. They are worn in dances held in the daytime. Painted with designs symbolizing the growth of plants, they are said "to represent the slow growth of trees toward the sun," which is also metaphorically the development of human bones during life. The head of 16.10 is that of a hornbill; that of 16.11 is possibly in the form of a pig's pelvis, such bones being used as amulets and in garden magic.

Corbin, *Art of the Baining*, 53-59

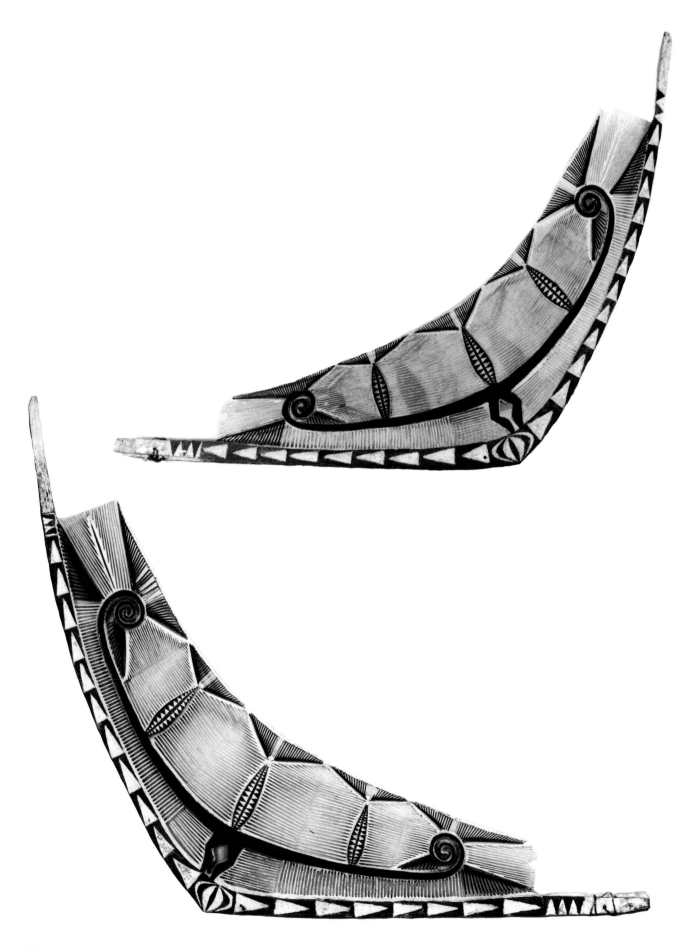

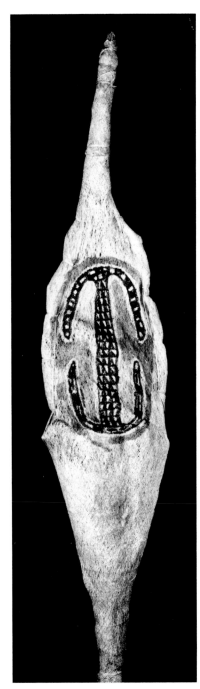

16.12

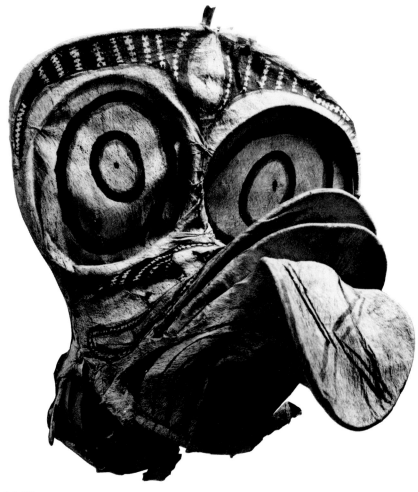

16.13

16.13  **MASK** *(kavat)*   Color plate 6

Bark cloth, paint, cane frame
53.5 (23) high
New Britain: Baining
Collected by Captain Voogdt, 1910-1912

Field Museum of Natural History, Chicago,
145861

16.12  **MASK**

Bark cloth, paint
115 (45¼) high
New Britain, Gazelle Peninsula near Varzin:
Mali Baining
Collected by A. Hahl, 1899

Linden-Museum, Stuttgart, 4456

16.14  **MASK** *(kavat)*

Bark cloth, paint, cane
55 (23⅝) high
New Britain: Baining
Collected by Captain Voogt, about 1910-1912

Field Museum of Natural History, Chicago,
145867

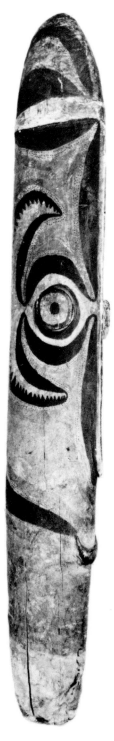

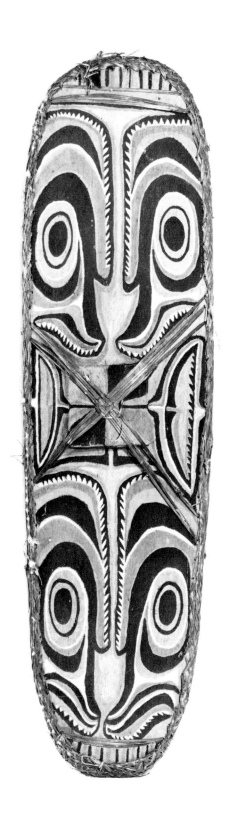

**16.15 FEMALE FIGURE** *(burbur)*

Wood, paint
159 (62⅝) high
New Britain, Maso: Sulka or Arawe
Collected by Mrs. R. Parkinson, 1911-1912
Formerly Museum für Völkerkunde, Leipzig

Barbier-Müller Collection, Geneva, 4458

Damm, "Sacrale Statuen"; Barbier, *Indonésie et Mélanésie*, 83-84

**16.16 SHIELD**

Wood, paint, cane
142 (55⅞) high
New Britain: Sulka

Museum für Völkerkunde, Frankfurt, NS 6275

## 16.17  DANCE HEADDRESS

Wood, paint
152 (60) high
New Britain: Sulka
Collected by the warship *Panther* expedition, before 1905

The Ethnographical Museum, Budapest, 72063

The animal shown in the round on this dance headdress is, in spite of its mammalian appearance, a totemic praying mantis. In a different stylization, the mantis also appears on the towering, bannerlike projection.

Bodrogi, *Oceanian Art*, pl. 102

## 16.18  DANCE HEADDRESS

Wood, paint
208 (82) high
New Britain: Sulka
Collected by the warship *Panther* expedition, before 1905

The Ethnographical Museum, Budapest, 72070

Bodrogi, *Oceanian Art*, pl. 101

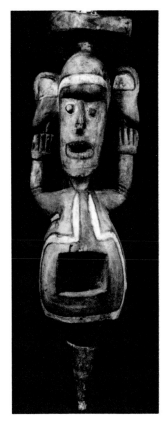

16.18 detail

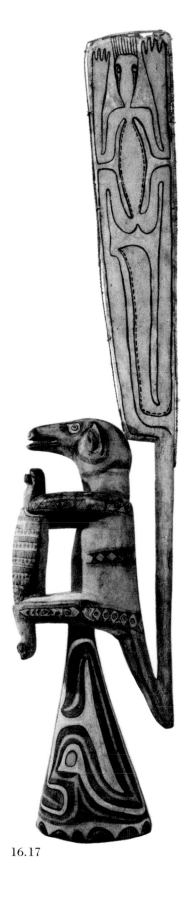

16.17

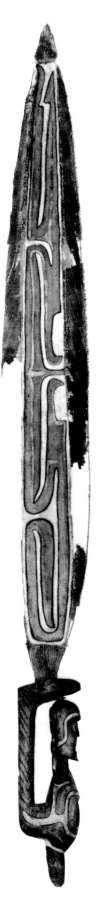

16.18

244

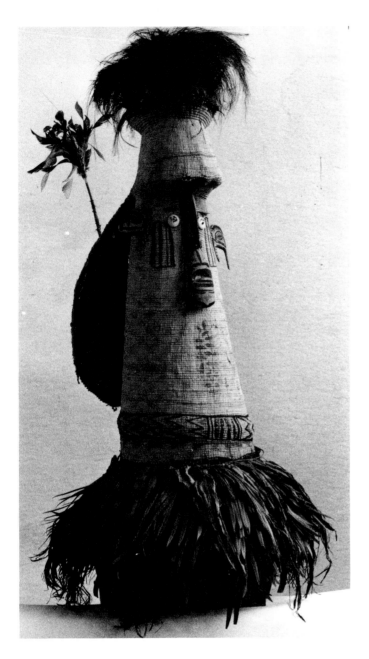

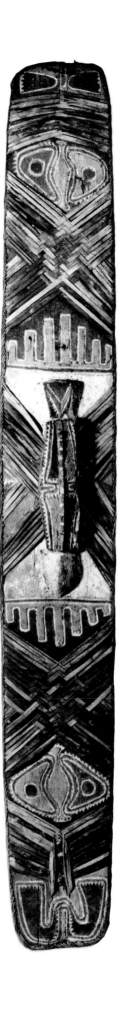

**16.19   MASK**

Pith, paint, wood, feathers
120 (47¼) high
New Britain, Simpsonhafen, Herbertshöhe:
Sulka
Given by M. Rhode & Co., 1909

Ubersee-Museum, Bremen, D 13 680

**16.20   SHIELD**

Wood, cane, paint
166 (65⅜) high
New Britain, Witu Island

Rijksmuseum voor Volkenkunde, Leiden,
1485-N:491

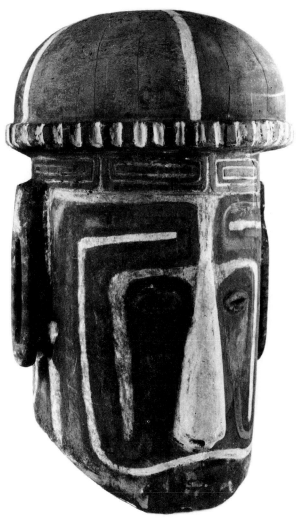

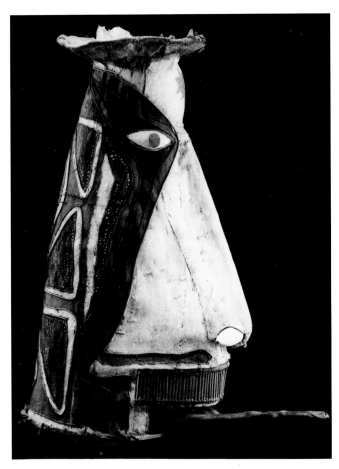

16.22

16.21

### 16.21  MASK

Wood, paint
45.5 (17⅞) high
New Britain, Witu Island
Collected by Lajos Biró, 1900

The Ethnographical Museum, Budapest, 67819

Guiart, *Arts of the South Pacific*, pl. 282; Bodrogi, "Ethnographie der Vitu- (French-) Inseln," 47-51

### 16.22  MASK

Bark cloth on frame, paint
78 (30⅝) high
New Britain, Witu Island
Collected by Lajos Biró, 1900-1901

The Ethnographical Museum, Budapest, 67281

### 16.23  MASK

55 (21⅝) high
New Britain, Witu Island
Collected by Robert Parkinson, 1893

Staatliches Museums für Völkerkunde, Dresden, 8044

Meyer and Parkinson, *Schnitzerei und Masken*, pl. 8, 3

# 17 New Ireland

## 17.1 MEMORIAL FIGURE *(uli)*

Wood
64.2 (25¼) high
New Ireland, Malóm: Mandak

Mr. and Mrs. Allen Wardwell, New York

Krämer, *Die Malanggane*, fig. 26

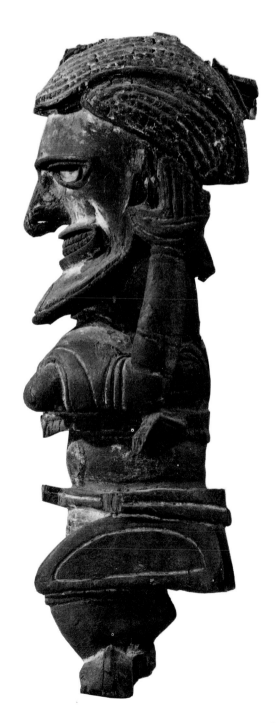

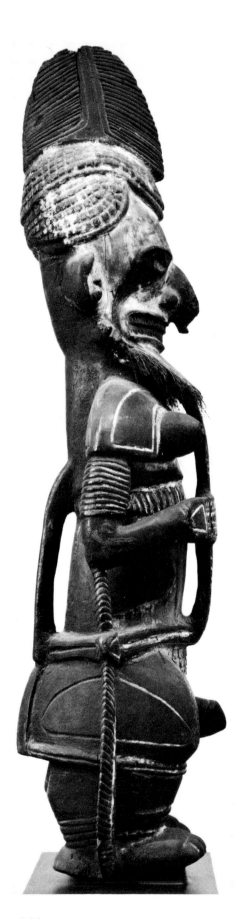

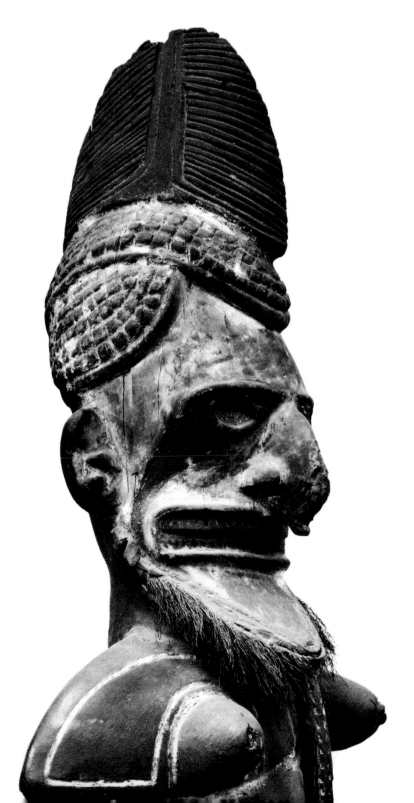

**17.2   MEMORIAL FIGURE (*uli, lembankakat egilampe* type)**

Wood, paint
139.7 (55) high
New Ireland, Malóm: Mandak
Formerly Linden-Museum, Stuttgart

Raymond and Laura Wielgus Collection, Tucson, 59-152

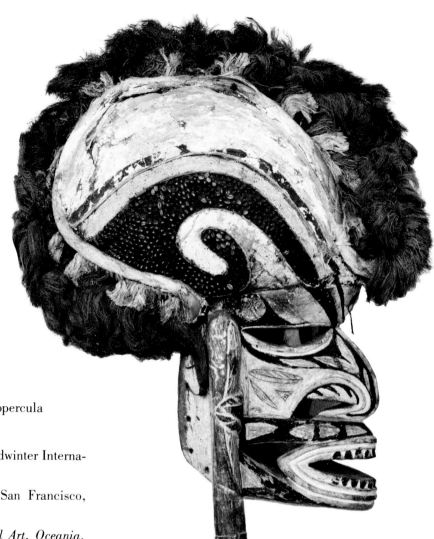

**17.3 MASK** *(tatanua)*

Wood, paint, fiber, sea-snail opercula
43.2 (17) high
New Ireland
Exhibited at the California Midwinter International Exposition, 1895

The Fine Arts Museums of San Francisco, 5616

Dwyer and Dwyer, *Traditional Art, Oceania,* 19

**17.4 MASK**

Wood, paint
102 (40⅛) high
New Ireland
Collected by Robert Parkinson, 1896-1898

Staatliches Museums für Völkerkunde, Dresden, 12074

Foy, *Tanzobjekte,* pl. 9

**17.5 MASK**

Wood, paint
131.5 (51¾) high
New Ireland
Museum acquisition, 1897

Staatliches Museums für Völkerkunde, Dresden, 12073

Foy, *Tanzobjekte,* pl. 10, 2

17.3

250

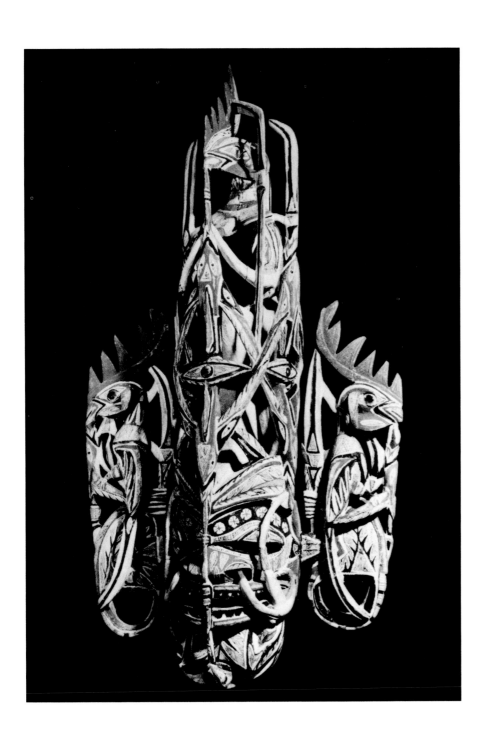

**17.6  MASK** *(matua)*

Wood, paint
93 (36⅝) high
New Ireland
Collected by Robert Parkinson, before 1895
Formerly in the Staatliches Museums für Völkerkunde, Dresden

Barbier-Müller Collection, Geneva, 4318

Barbier, *Art d'Océanie . . .*, 66, 117

### 17.7 MASK

Wood, paint
53.3 (21) high
New Ireland, Tabar Island

Mr. and Mrs. Ben Heller Collection, New York

### 17.8 MEMORIAL CARVING *(malanggan)*

Wood, paint
256 (101) long
New Ireland

American Museum of Natural History, New York, 80.1.1140

### 17.9 MEMORIAL CARVING *(malanggan)*

Wood, paint
277 (109) long
New Ireland

American Museum of Natural History, New York, 80.0.195

### 17.10 FIGURE *(totok)*

Wood, paint
133 (52⅜) high
New Ireland
Given to the Museum für Völkerkunde, Dresden, by Robert Parkinson, 1894

Barbier-Müller Collection, Geneva, 4328

Barbier, *Indonésie et Mélanésie*, 70; Barbier, *Art d'Océanie . . .*, 65, 115

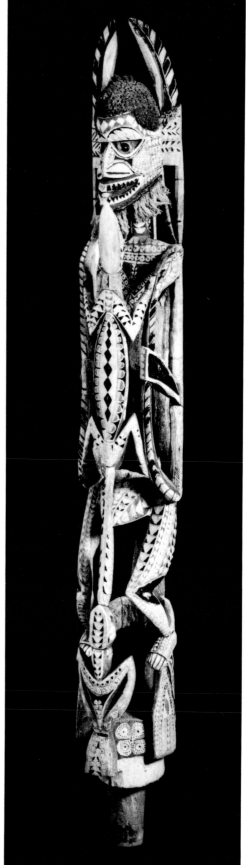

17.10

## 17.11 MEMORIAL CARVING (totok)

Wood, paint
125 (49¼) high
New Ireland

Faith and Martin Wright, New York

## 17.12 MEMORIAL CARVING (totok) Color plate 9

Wood, paint
78.8 (31) high
New Ireland

Herbert Baker, Los Angeles

## 17.13 MEMORIAL CARVING (malanggan)

Wood, paint
104 (41) long
New Ireland

Faith and Martin Wright, New York

## 17.14 MEMORIAL CARVING (malanggan)

Wood, paint
201 (79⅛) long
New Ireland, Tabar (Fischer) Islands
Collected by Robert Parkinson, 1893

Staatliches Museums für Völkerkunde, Dresden, 8049

Meyer and Parkinson, *Schnitzerei und Masken*, pl. 14, 1

## 17.15 MEMORIAL CARVING (malanggan)

Wood, paint
127 (50) long
New Ireland
Collected by A. Baessler, 1894

Staatliches Museums für Völkerkunde, Dresden, 8102

Meyer and Parkinson, *Schnitzerei und Masken*, pl. 13, 3

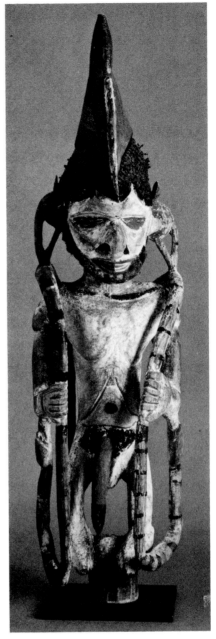

17.12

253

## 17.16    MEMORIAL CARVING *(malanggan)*

Wood, paint
124 (49¼) long
New Ireland
Museum acquisition, 1882

Staatliches Museums für Völkerkunde, Dresden, 7182

Meyer and Parkinson, *Schnitzerei und Masken*, pl. 13, 1

## 17.17    MEMORIAL CARVING *(malanggan)*

Wood, paint
207 (82½) long
New Ireland, "20 miles east of Cape Sass"
Collected by Robert Parkinson, 1894

Staatliches Museums für Völkerkunde, Dresden, 8047

Meyer and Parkinson, *Schnitzerei und Masken*, pl. 14, 3

## 17.18    PAIR OF CANOE PROW ORNAMENTS

Wood, paint
64 (25¼) high
New Ireland
Collected by Robert Parkinson, 1896-1898

Staatliches Museums für Völkerkunde, Dresden, 12079

Foy, *Tanzobjekte*, pl. 12, 6-7

## 17.19    CANOE AND FIGURES

Wood, paint
Canoe: 332 (131½) long
New Ireland, Tabar (Gardner) Island
Collected by Robert Parkinson, 1896-1898

Staatliches Museums für Völkerkunde, Dresden, 12080

Foy, *Tanzobjekte*, pl. 11

## 17.20    MASK

Bark cloth, cane, paint
48 (18⅞) high
New Ireland, Tanga Island
Collected by Robert Parkinson, 1896-1898

Staatliches Museums für Völkerkunde, Dresden, 12133

Foy, *Tanzobjekte*, pl. 15, 2

# 18 Admiralty Islands

## 18.1  FIGURE

Wood, paint
172 (67¾) high
Admiralty Islands: Matankor
Collected 1910-1912, probably by Dr. Ludwig
Cohn (1911), or by Captain Carl Nauer

Ubersee-Museum, Bremen, D 10 787

It is probable that this is one of a pair of
ancestral figures, male and female, set on
either side of a house door.

Guiart, *Arts of the South Pacific*, pl. 321

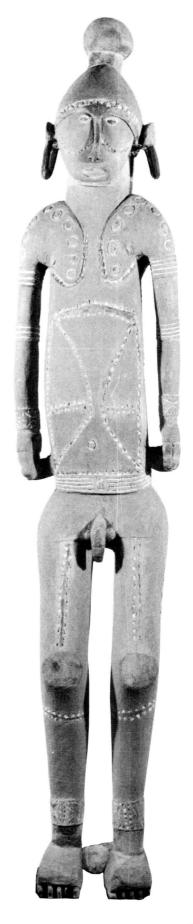

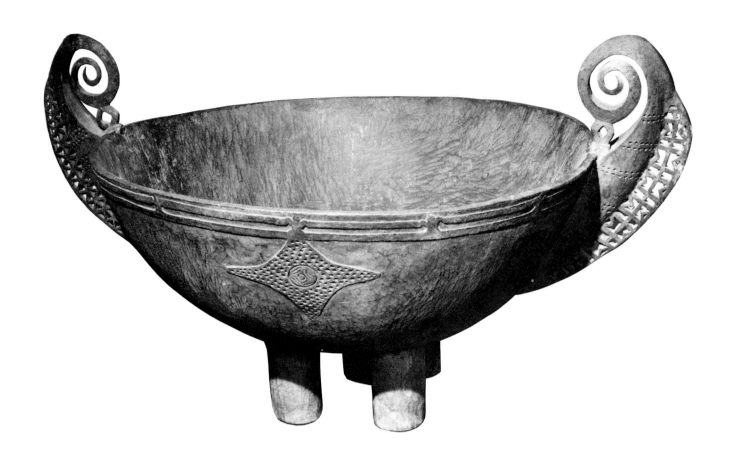

## 18.2  BOWL

Wood
129.5 (51) wide
Admiralty Islands: Matankor

The Metropolitan Museum of Art, New York, The Michael C. Rockefeller Memorial Collection of Primitive Art, Gift of Nelson A. Rockefeller P. 56.321

The manufacturing center for these bowls was Lou Island, from which they were traded through the area. They were used for large ceremonial feasts.

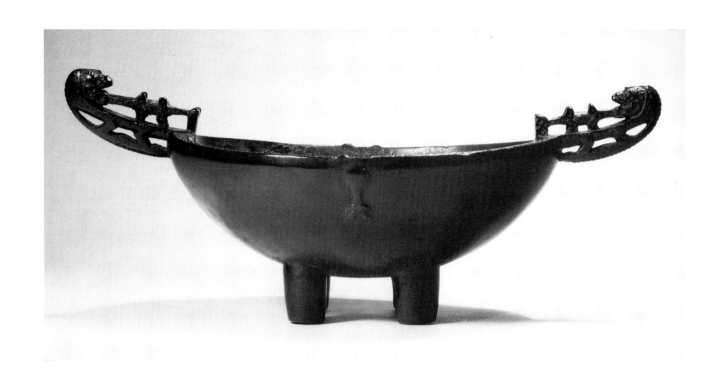

**18.3  BOWL** *(kiki)*

Wood
45.7 (18¾) wide
Admiralty Islands
Possibly collected by Count Festetics de Tolna,
about 1896
Formerly Dr. Stephan Chauvet Collection

George Ortiz Collection, Geneva

Portier and Poncetton, *Les Arts sauvages:
Océanie*, pl. 58

**18.4  LADLE**

Gourd, gum, wood, paint
22.9 (9) long
Admiralty Islands

University of East Anglia, Norwich, England,
Robert and Lisa Sainsbury Collection, 1971
UEA 171

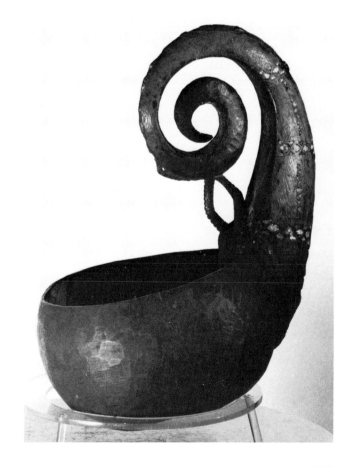

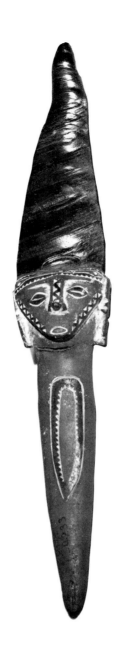

## 18.5 DAGGER

Wood, obsidian, parinarium paste, paint
31.5 (12⅜) long
Admiralty Islands: Matankor

Buffalo Museum of Science, New York,
C 10763

Obsidian was the main material used for
bladed weapons in the Admiralty Islands, ap-
parently following an ancient use and trade in
Melanesia. Like the bowls, these were mainly
the work of specialists on Lou Island.

Linton and Wingert, *Arts of the South Seas*, 173

## 18.6 WAR CHARM

Wood, feathers, cane, cloth, paint, gum
51.4 (20¼) long
Admiralty Islands

University of East Anglia, Norwich, England,
Robert and Lisa Sainsbury Collection, 1973
UEA 511

War charms of this kind were worn on the nape
of the neck, the feathers projecting out almost
horizontally.

## 18.7 LADDER

Wood, paint
171.5 (63½) high
Admiralty Islands: Matankor

Lent by the Trustees of the British Museum,
London, BM 1935-6

# MICRONESIA
## and the Melanesian and Polynesian Outliers

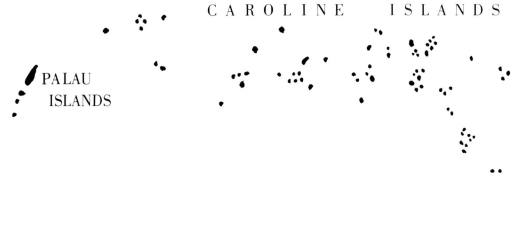

C A R O L I N E    I S L A N D S

PALAU
ISLANDS

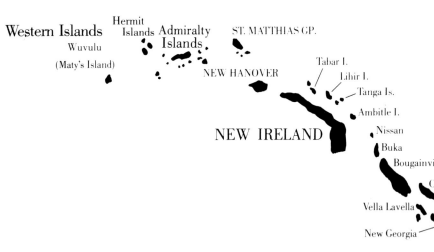

Western Islands

Wuvulu

(Maty's Island)

Hermit
Islands

Admiralty
Islands

ST. MATTHIAS GP.

NEW HANOVER

NEW IRELAND

Tabar I.

Lihir I.

Tanga Is.

Ambitle I.

Nissan

Buka

Bougainvi

Vella Lavella

New Georgia

MARSHALL ISLANDS

ELLICE ISLANDS

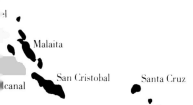

LOMON ISLANDS

el

Malaita

San Cristobal        Santa Cruz

canal

# 19 Micronesia and the Melanesian and Polynesian Outliers

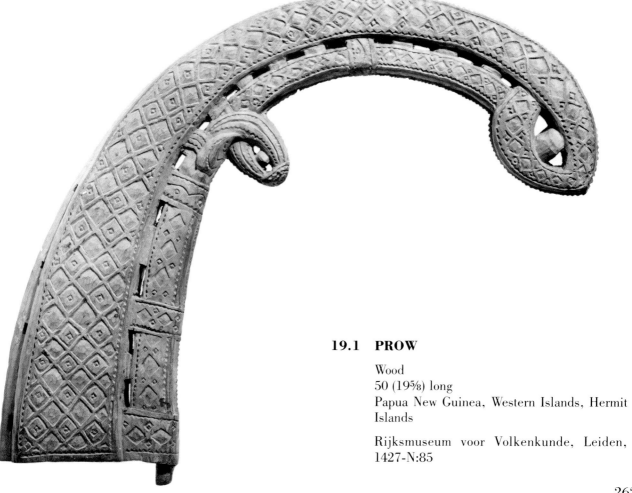

### 19.1  PROW

Wood
50 (19⅝) long
Papua New Guinea, Western Islands, Hermit
Islands

Rijksmuseum voor Volkenkunde, Leiden,
1427-N:85

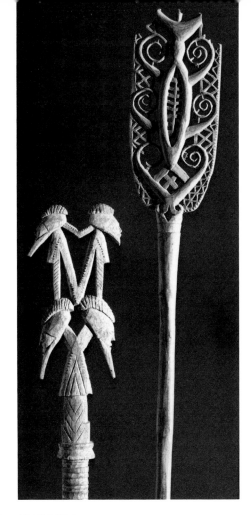

## 19.2  SPATULA

Wood
47.5 (18¾) long
Papua New Guinea, Western Islands, Hermit
Islands
Given by Dr. O. F. Mollendorf, 1883

Peabody Museum of Salem, Massachusetts,
E 735

## 19.3  SPATULA

Wood
41 (16⅛) long
Papua New Guinea, Western Islands, Hermit
Islands

Peabody Museum of Salem, Massachusetts,
E 5339

## 19.4  SPATULA

Wood
35.4 (15½) long
Papua New Guinea, Western Islands, Hermit
Islands

Lent by the Trustees of the British Museum,
London, 1913.5-24.16

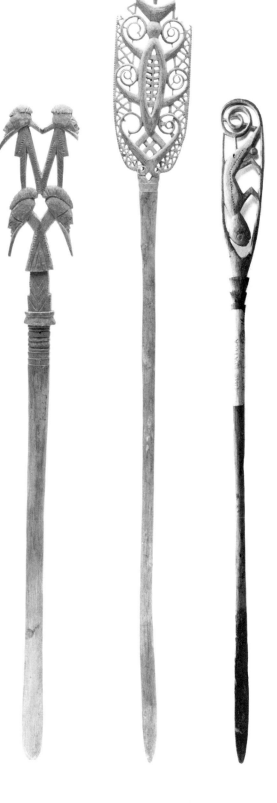

**19.5  DISH**

Wood
47 (18½) long
Papua New Guinea, Western Islands, Wuvulu
(Maty's Island)
Museum purchase from J. G. Umlauff

The University Museum, Philadelphia,
P 3482b

Linton and Wingert, *Arts of the South Seas*, 72

**19.6  DISH**

Wood
32 (12½) long
Papua New Guinea, Western Islands, Wuvulu
(Maty's Island)

Wayne Heathcote, New York

**19.7  DISH**

Wood
25 (9¾) long
Papua New Guinea, Western Islands, Wuvulu
(Maty's Island)

Wayne Heathcote, New York

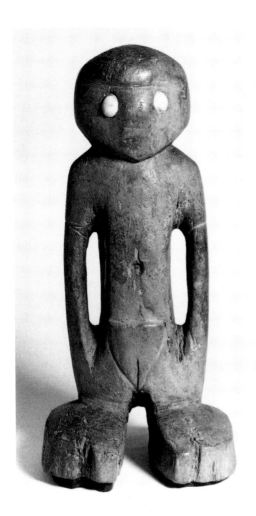

19.8

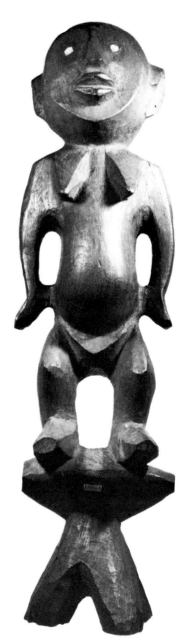

19.9

### 19.8  FEMALE FIGURE

Wood, shell
37.8 (14⅞) high
Probably Ellice Islands

Indiana University Art Museum, Bloomington,
Raymond and Laura Weilgus Collection,
68.214

### 19.9  FEMALE FIGURE

Wood, shell
53.3 (21½) high
Ellice Islands, Pleasant Island
Formerly the Cumberland Museum, Whiteha-
ven, before 1895

Faith and Martin Wright, New York

Edge-Partington, *Album*, 2:89,7

### 19.10  DOUBLE FIGURE

Wood
57 (22½) high
New Ireland, Enus (Tench) Island

Hamburgisches Museum für Völkerkunde,
Hamburg, 6426 I

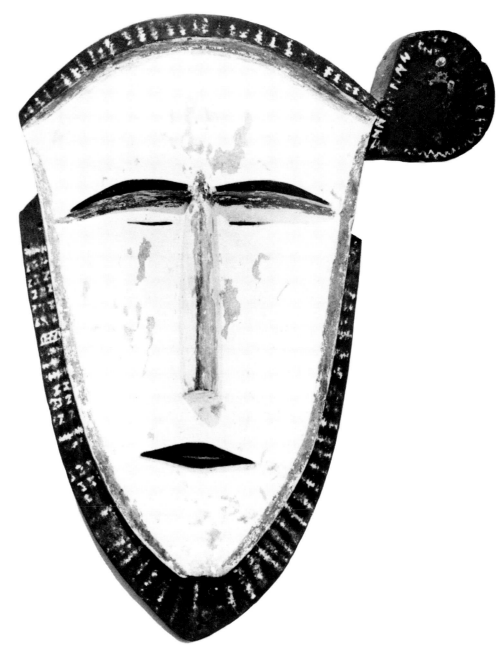

**19.11  HOUSE MASK**

Wood, paint
78.5 (31) high
Caroline Islands, Mortlock Island

Bernice Pauahi Bishop Museum, Honolulu,
5634

Masks of this type were said to be gable orna-
ments from men's houses. This example came
from the Hawaii National Museum (1872-
1891), the entire contents of which were trans-
ferred to Bishop Museum. It was probably col-
lected on one of the cruises of the *Morning
Star*, a ship which carried supplies to mission
stations in Micronesia during the nineteenth
century.

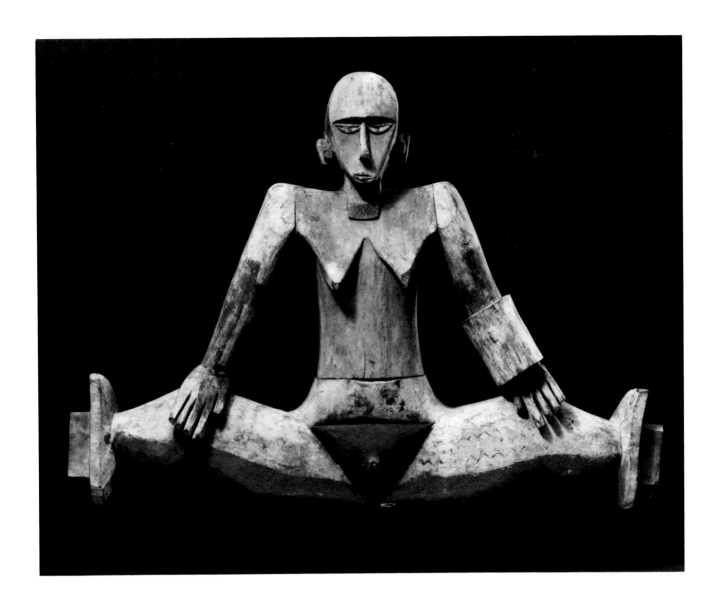

## 19.12 FEMALE GABLE FIGURE

Wood, paint
65.5 (25¾) high
Caroline Islands, Palau Islands
Collected by Augustin Krämer, 1908-1910
Formerly Linden-Museum, Stuttgart

The Metropolitan Museum of Art, New York,
The Michael C. Rockefeller Memorial Collec-
tion of Primitive Art, Gift of Nelson A. Rock-
efeller, 1970, P 70.32 a-d

A figure of this type was attached to the gables
of many Palau Islands men's houses, just above
the door. They represent a mythical woman,
Dilukai, who is said to have been tied in this
position to shame her unpopular husband and
thereby drive him away from their village.

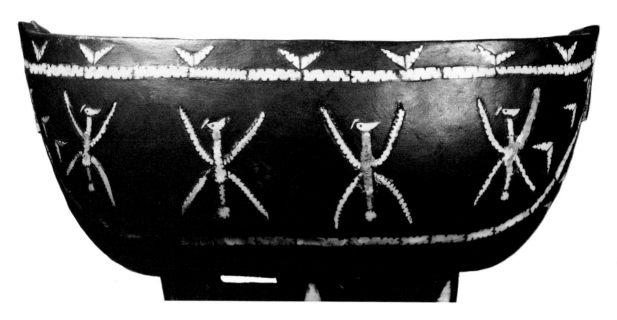

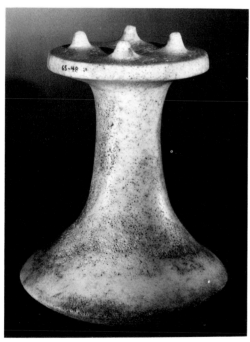

**19.13  POUNDER** *(wusuus)*

Coral
15 (5⅞)
Caroline Islands, Truk

The University Museum, Philadelphia,
65.48.11

**19.14  BOWL**

Wood, shell
58.5 (23) wide
Caroline Islands, Palau Islands

Faith and Martin Wright, New York

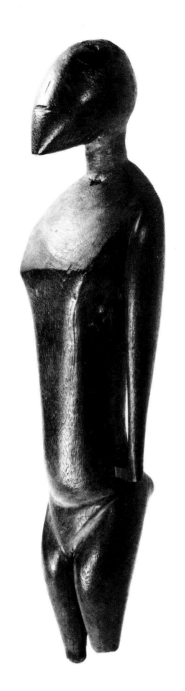

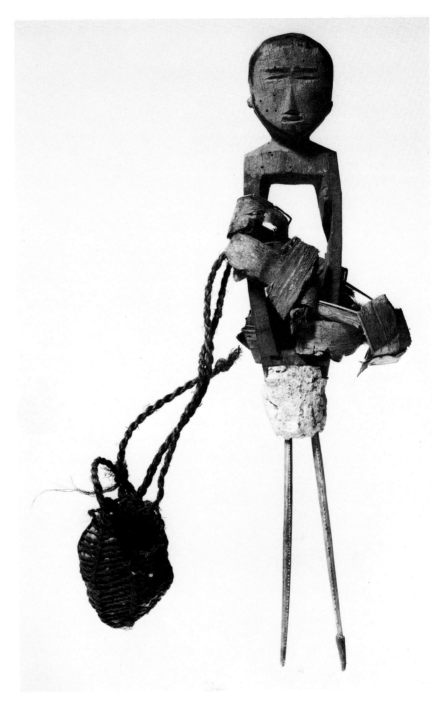

**19.15  FIGURE (tino)**

Wood
35 (13½) high
Caroline Islands, Nukuoro

Musée de l'Homme, Paris, 33.2.1

Guiart, *Arts of the South Pacific*, pl. 409

**19.16  WIND CHARM**

Wood, stingray spines, other materials
40.7 (16) high
Caroline Islands, Onoum

The Fine Arts Museums of San Francisco, Gift
of the Park Commission, 1905, 26168

Dwyer and Dwyer, *Traditional Arts, Oceania*,
39

**19.17 SKIRT**

Woven palm stripping
190 (74¾) long
Caroline Islands, Fais
Collected by George Nichols and given to the
East India Marine Society, 1801; original
number 603

Peabody Museum of Salem, Massachusetts,
E 5569

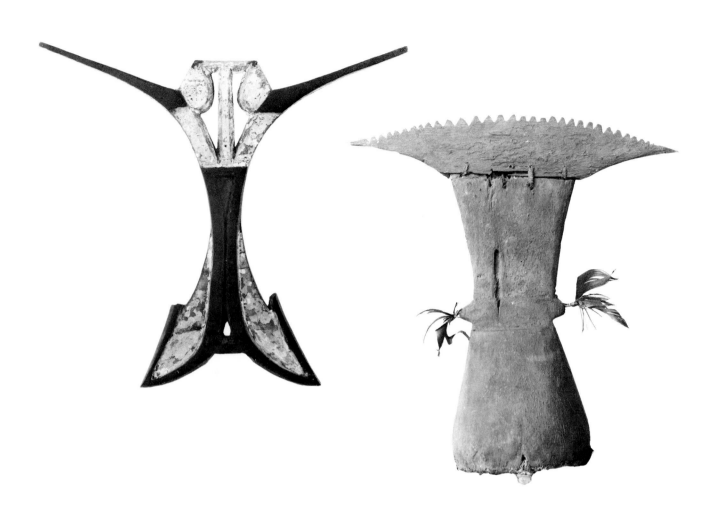

**19.18 CANOE ORNAMENT**

Wood, paint
42 (16½) high
Caroline Islands, Truk
Collected by H. F. Moore and Townsend, U.S.
Fish Commission cruise of S.S. *Albatross*,
1899-1900

National Museum of Natural History, Smithsonian Institution, Washington, 206261

This is one of a pair originally fastened at the prow and stern of a war canoe. The highly stylized forms at the top represent a pair of sea birds standing beak to beak.

Linton and Wingert, *Arts of the South Seas*, 69

**19.19 PAIR OF CANOE DECORATIONS**

Wood, paint, feathers
36.8 (14½), 39.4 (15½) high
Marshall Islands, Jaluit
Collected by H. F. Moore and Townsend, U.S.
Fish Commission cruise of S.S. *Albatross*,
1899-1900

National Museum of Natural History, Smithsonian Institution, Washington, 206161, 206162

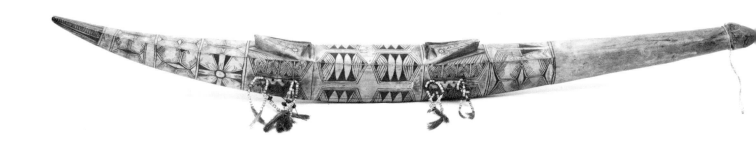

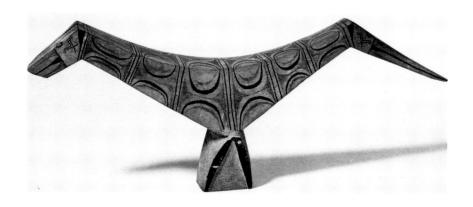

**19.20   DANCE CLUB**

Wood, paint
101 (39¾) long
Solomon Islands, Santa Cruz
Given by Dr. Charles Goddard Weld, 1910

Peabody Museum of Salem, Massachusetts,
E 14417

The significance of the dance clubs of Santa
Cruz is obscure, but it has been remarked that
this form resembles that of the area's canoes.

**19.21   HEADREST, BIRD FORM**

Wood
21.5 (8½) wide
Solomon Islands, Santa Cruz

University Museum of Archaeology and An-
thropology, Cambridge, Z 11022

## 19.22 SEATED FIGURE *(duka)*

Wood
39.5 (15⁹⁄₁₆) high
Solomon Islands, Santa Cruz

Otago Museum, Dunedin, New Zealand,
D.29.131

## 19.23 BREAST ORNAMENT *(tema)*

Turtleshell, tridacna shell
Solomon Islands, Santa Cruz

Dr. William Davenport, Philadelphia

These composite pectoral ornaments consist of
a disk of clamshell, symbol of the moon, on
which are mounted turtleshell silhouettes. The
turtleshell elements, which show many var-
iants in detail, depict a highly stylized frigate
bird at the bottom, with several fish above it.

## 19.24 EIGHT *TEMA* UNITS

Turtleshell
12 (5) high
Solomon Islands, Santa Cruz

Private collection, New York

# NEW GUINEA

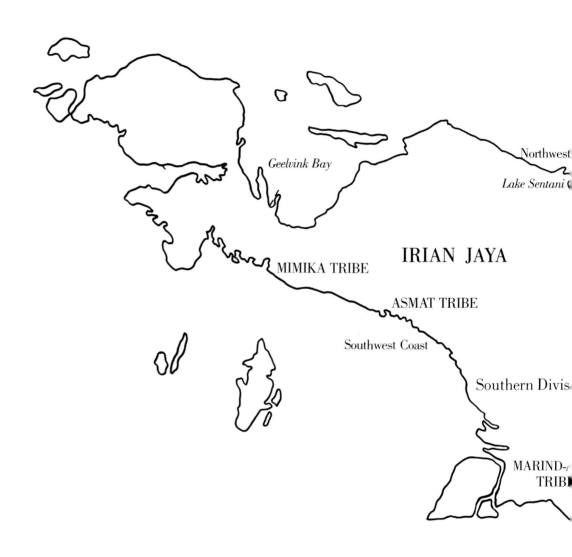

*Geelvink Bay*

Northwest

*Lake Sentani*

IRIAN JAYA

MIMIKA TRIBE

ASMAT TRIBE

Southwest Coast

Southern Divis

MARIND-*
TRIB*

*A R A F U R A     S E A*

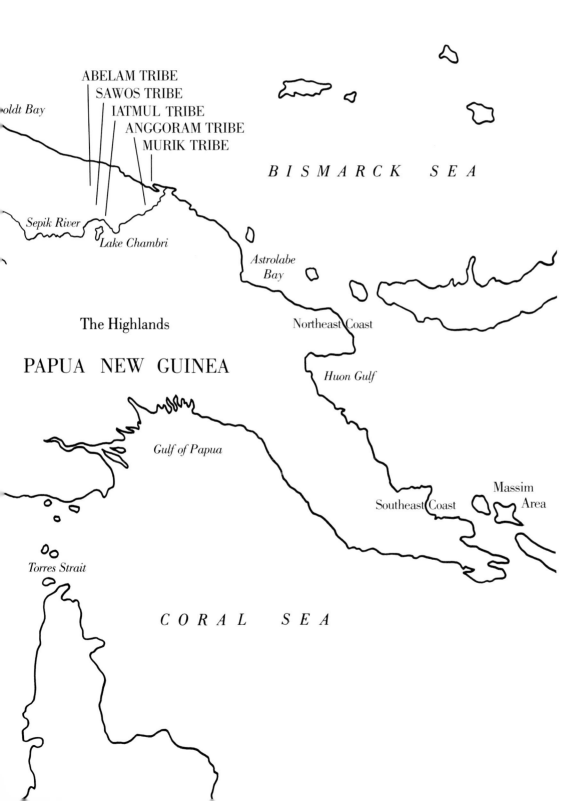

ABELAM TRIBE
SAWOS TRIBE
IATMUL TRIBE
ANGGORAM TRIBE
MURIK TRIBE

oldt Bay

*Sepik River*

*Lake Chambri*

*Astrolabe Bay*

*B I S M A R C K   S E A*

The Highlands

Northeast Coast

PAPUA NEW GUINEA

*Huon Gulf*

*Gulf of Papua*

Massim
Area

Southeast Coast

*Torres Strait*

*C O R A L   S E A*

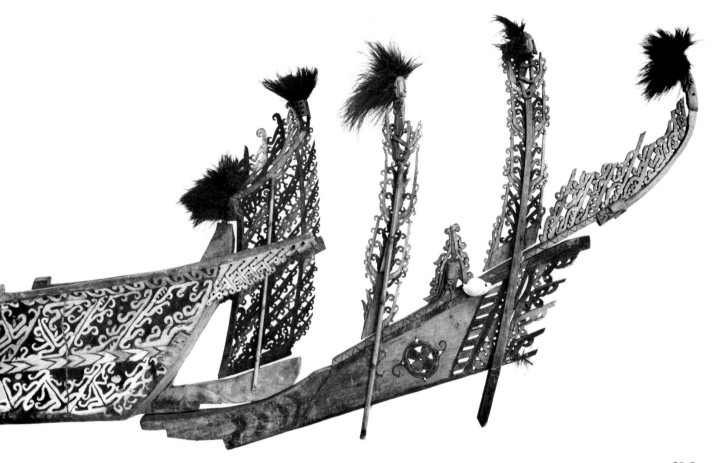

20.2

**20.1  FIGURE OF A GOD**  Color plate 10

Wood
71 (28) high
Irian Jaya, Sorong, Radja Ampat Islands,
Waigeo Island
Acquired 1930

Tropenmuseum, Amsterdam, 573-36

Van Baaren, *Korwars and Korwar Style*, pl. 66

**20.2  CANOE PROW**

Wood, paint, cassowary feathers
200 (78¾) long
Irian Jaya, Geelvink Bay, Doreh Bay ?
Collected by Paul Wirz, 1922

Museum für Völkerkunde, Basel, Vb 5980

Hoogerbrugge, *Irian Jaya Woodcarving*, pl. 15

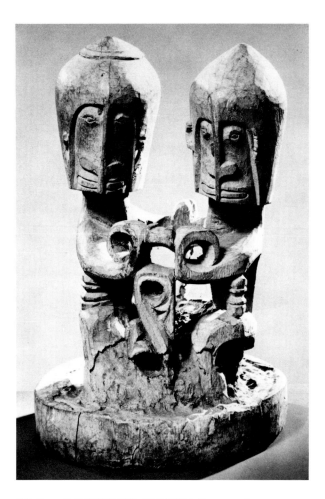

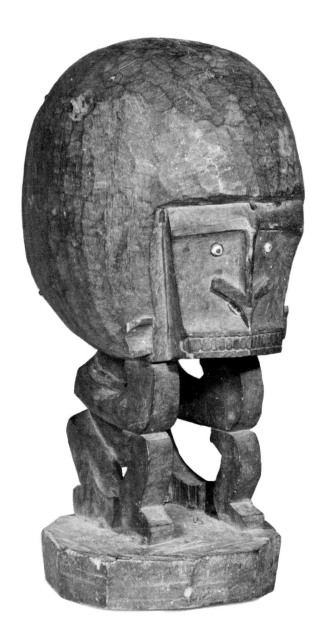

## 20.3  ANCESTOR GROUP *(korwar)*

Wood
23.5 (9¼) high
Irian Jaya, Geelvink Bay, Doreh Bay?

The Brooklyn Museum, New York, Frank L. Babbott Fund, 62.18.2

Figures by the generic name of *korwar* were carved in a number of styles by the groups inhabiting the Geelvink Bay area but apparently have not been made for ritual purposes since the first decade of this century. Sometimes they were used as containers for ancestral skulls (no. 20.4). They were considered mediating instruments between the spirits of the dead and the living descendants whom the spirits were expected to advise, by way of a shaman, and assist.

## 20.4  ANCESTOR FIGURE *(korwar)*

Wood, skull
44 (17¼) high
Irian Jaya, Manokwari, Geelvink Bay, Wandamen Bay, Windesi: Bentuni
Collected before 1902

Museum voor Land- en Volkenkunde, Rotterdam, 17624

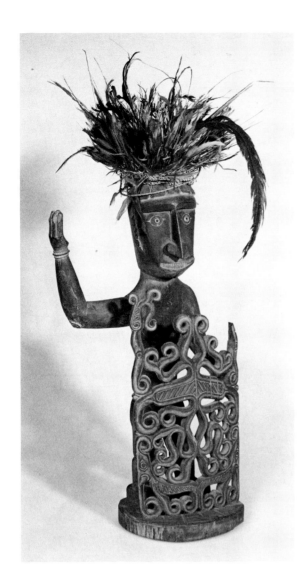

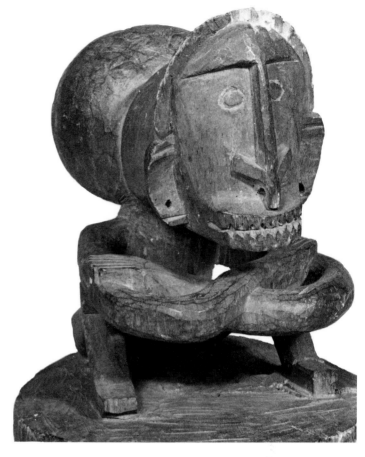

**20.5 ANCESTOR FIGURE (korwar)**

Wood, feathers
54 (21¼) high
Irian Jaya, Geelvink Bay, Doreh Bay
Collected before 1902

Museum voor Land- en Volkenkunde, Rotterdam, 11653

**20.6 ANCESTOR FIGURE (korwar)**

Wood
26 (10¼) high
Irian Jaya, Manokwari, Geelvink Bay, Wandamen Bay, Windesi: Bentuni
Collected about 1910-1912

Museum voor Land- en Volkenkunde, Rotterdam, 28861

Van Baaren, *Korwars and Korwar Style*, pl. 48

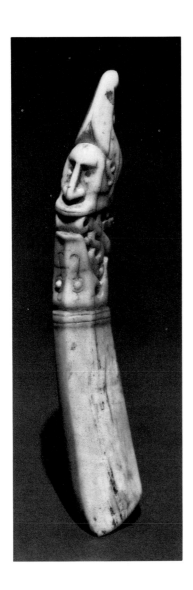

## 20.8 PROW ORNAMENT *(mani)*

Wood
35 (13¾) high
Irian Jaya, Sukarnapura, Walkenaers Bay,
Jamna Island
Collected by Prince Roland Bonaparte
Given to the Musée de l'Homme, 1888

Musée de l'Homme, Paris, 88.5.7

Laroche, "Notes sur quelques ornements de
Pirogue," pl. 3

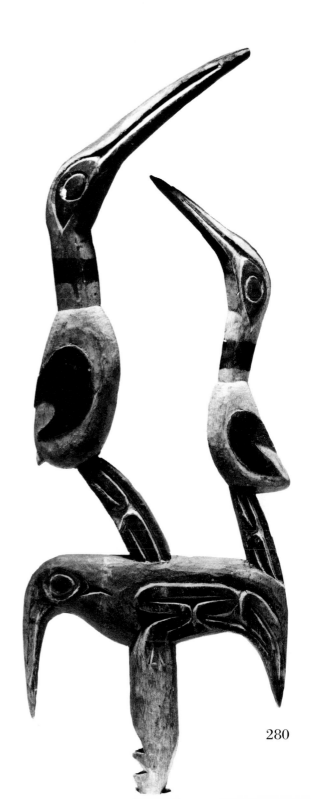

## 20.7 AMULET *(fanderi)*

Dugong ivory
14 (5½) high
Irian Jaya, Geelvink Bay

Herbert Baker, Los Angeles

Small personal amulets were usually carved
roughly in wood, occasionally with beads at-
tached. This example is most unusual for its
fine workmanship and exotic material. The
style is that of the *korwar* figures. Worn espe-
cially by men on raiding expeditions, they rep-
resent an ancestral being and possibly they
also the central post of the ceremonial house to
which head-hunting trophies were suspended.

Museum of Primitive Art, *Baker Collection*,
no. 168

## 20.9 PAIR OF CANOE PROW ORNAMENTS

Wood, paint
31 (12¼), 43.5 (17⅛) long
Irian Jaya, Sukarnapura, Walkenaers Bay,
Jamna Island
Collected by J.W.F.J. de Wal, 1911

Museum voor het Onderwijs, The Hague,
47852, 47853

Hoogerbrugge, *Irian Jaya Woodcarving*, pl. 13

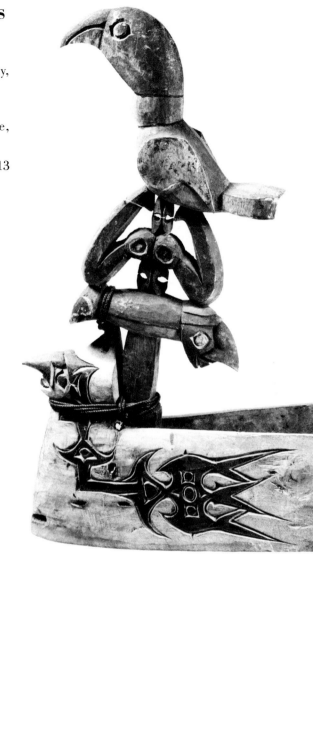

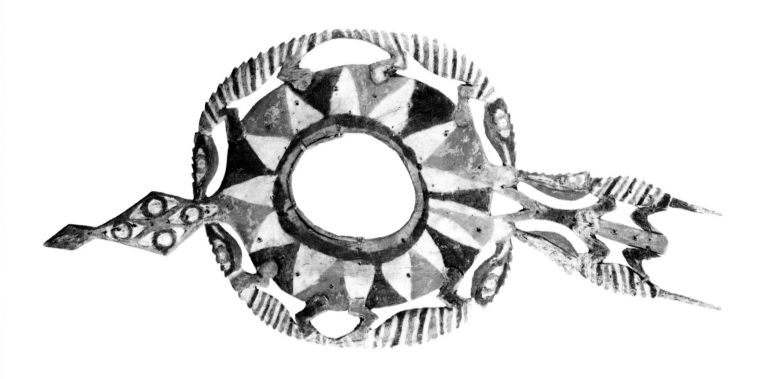

**20.10 HEADDRESS**

Wood, paint
105 (41⅜) long
Irian Jaya, Sukarnapura, Humboldt Bay
Collected by Captain Scherpbier, 1891

Rijksmuseum voor Volkenkunde, Leiden,
932-15

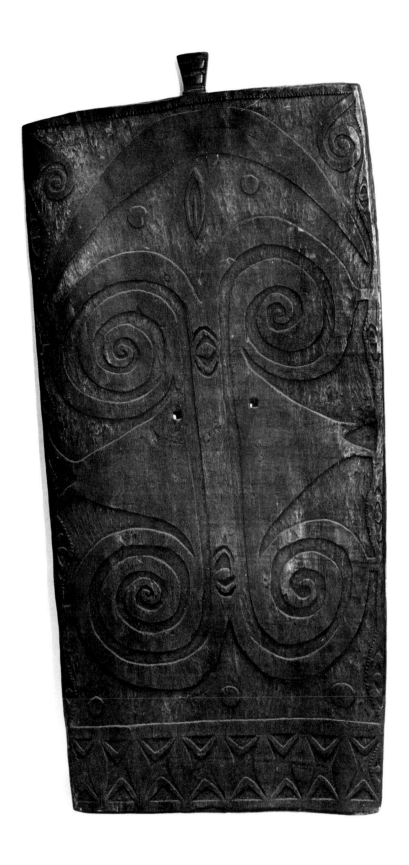

**20.11  SHIELD**

Wood
119 (46⅞) high
Irian Jaya, Sukarnapura, Humboldt Bay, Sika
Collected before 1900

Tropenmuseum, Amsterdam, A719

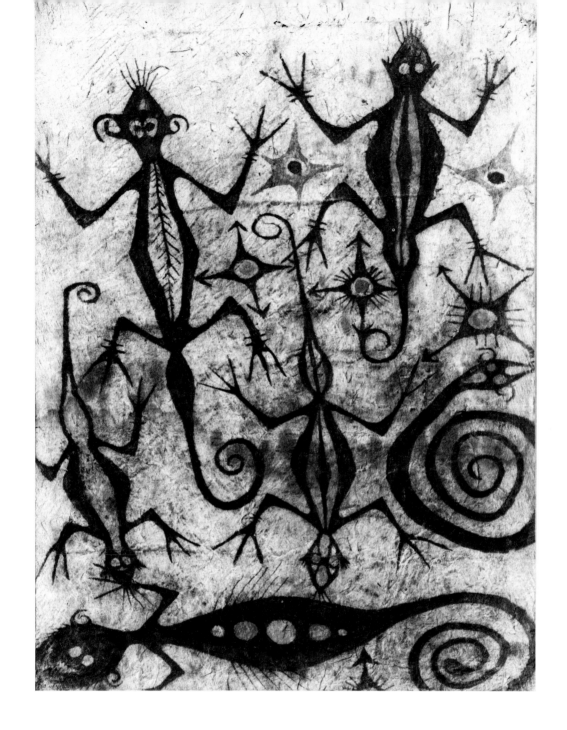

**20.12 LOIN CLOTH**

Tapa, paint
56 (22) long
Irian Jaya, Sukarnapura, Lake Sentani
Acquired 1931

Tropenmuseum, Amsterdam, 666-320

Kooijman, *Art of Lake Sentani*, fig. 98

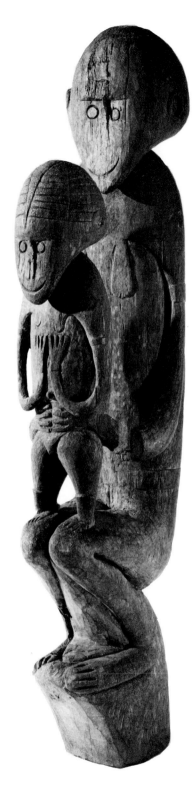

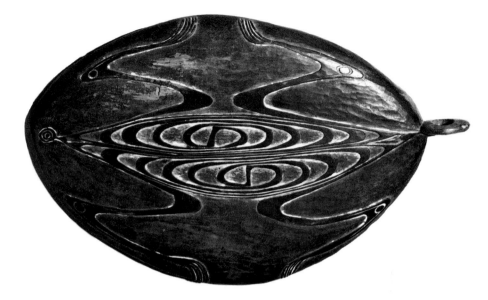

**20.13  WOMAN AND CHILD**

Wood
91 (36) high
Irian Jaya, Sukarnapura, Lake Sentani, Ifar
Collected by Paul Wirz, 1927

Museum für Völkerkunde, Basel, Vb 6659

Kooijman, *Art of Lake Sentani*, fig. 20

**20.14  BOWL**

Wood, paint
53 (20⅞) high
Irian Jaya, Sukarnapura, Lake Sentani
Acquired 1939

Tropenmuseum, Amsterdam, 1302-9

Kooijman, *Art of Lake Sentani*, fig. 25

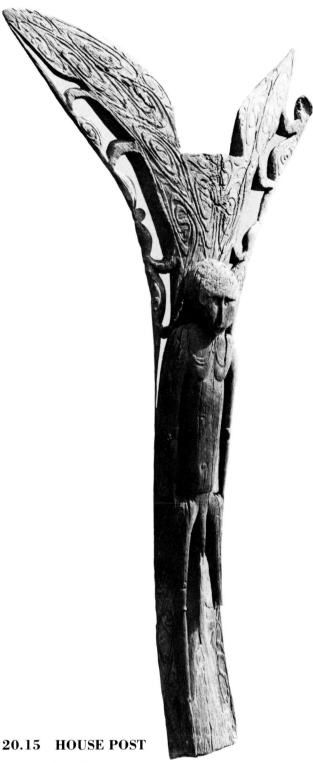

## 20.15  HOUSE POST

Wood
220 (86⅝) high
Irian Jaya, Sukarnapura, Lake Sentani
Acquired 1952

Tropenmuseum, Amsterdam, 2202-201

The Sentani people, like few other groups of
New Guinea, recognized hereditary chieftains.

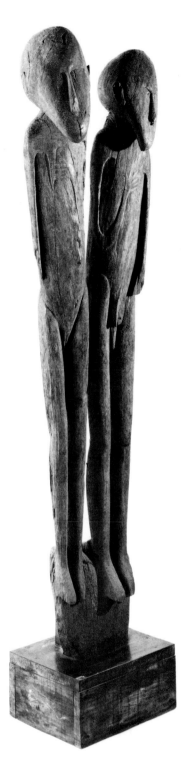

The houses of these notables, built like all
those of the villages over the waters of Lake
Sentani, were distinguished by a wealth of
carved decoration. This included house posts
worked from upended trees with buttress roots
and figures (nos. 20.13, 20.16), on the tops of
posts projecting through the floor.

Kooijman, *Art of Lake Sentani*, figs. 3, 28

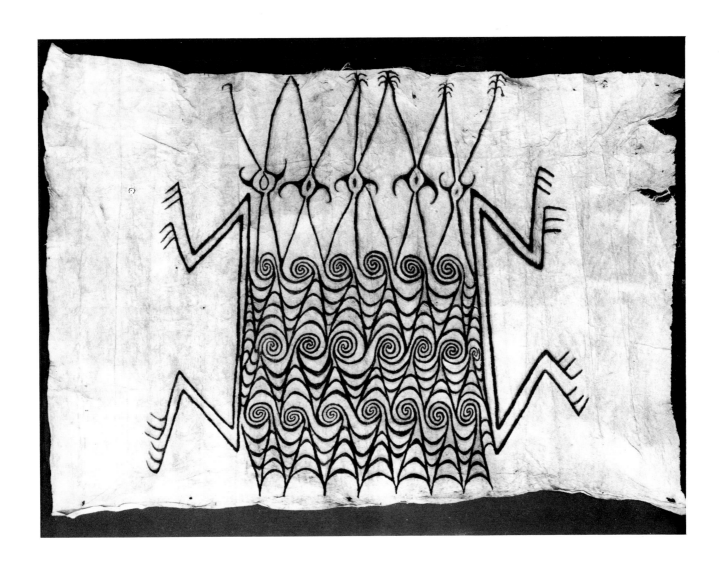

**20.17  LOIN CLOTH**

Tapa, paint
175 (69) long
Irian Jaya, Sukarnapura, Lake Sentani,
Saboiboi
Collected by Paul Wirz, 1927

Museum für Völkerkunde, Basel, Vb 6658

Painted sheets of bark cloth were used as
mourning garments by Sentani women and
hung above graves.

Wirz, "Beitrag zur Ethnologie du Sentanier,"
pl. 25, abb. 6; Kooijman, *Art of Lake Sentani*,
fig. 27

**20.16  DOUBLE FIGURE**

Wood
176 (69½) high
Irian Jaya, Sukarnapura, Lake Sentani
Collected by Jacques Viot, 1929
Formerly in the collections of Sir Jacob Epstein
and Mr. and Mrs. Gustave Schindler

Australian National Gallery, Canberra

Kooijman, *Art of Lake Sentani*, fig. 41; Schin-
dler, *Masks and Sculptures*, pl. 11; Australian
National Gallery, *Genesis of a Gallery*

# 21 The Southwest Coast

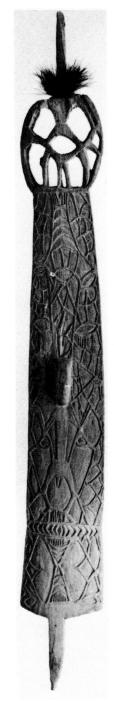

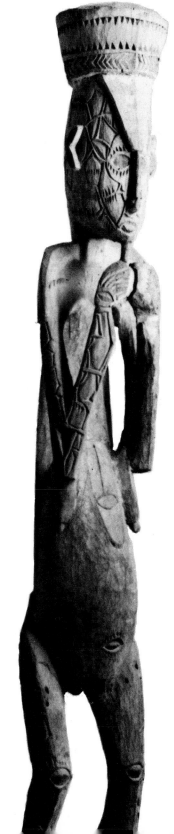

**21.1  CEREMONIAL SHIELD *(yamate)***

Wood, cassowary feathers
165 (65) high
Irian Jaya, Southern Division: Mimika

Rijksmuseum voor Volkenkunde, Leiden,
1416-12

**21.2  FIGURE**

Wood, paint
266 (104¾) high
Irian Jaya, Southern Division, Inabuka River,
Wajeri: Mimika
Collected 1914

Rijksmuseum voor Volkenkunde, Leiden,
1889-247

## 21.3 FEMALE FIGURE

Wood, paint
183 (62) high
Irian Jaya, Southern Division, Utakwa River:
Mimika
Collected by the A. F. R. Wollaston Expedition, 1910-1913

University Museum of Archaeology and Anthropology, Cambridge, 1914.231.254

Haddon and Layard, *Wollaston Expedition*, pl.
6, 7

## 21.4 SHIELD

Wood, paint
116 (45⅝) high
Irian Jaya, Southern Division, Northwest
River: Asmat
Collected 1909

Rijksmuseum voor Volkenkunde, Leiden,
1698.115

## 21.5 FIGURE

Wood
128 (50⅜) high
Irian Jaya, Unir River: Asmat
Collected during an army expedition, 1919

Rijksmuseum voor Volkenkunde, Leiden,
1971-981

Hoogerbrugge, *Asmat Art*, pl. 9

## 21.6 MEMORIAL POLE *(mbis)*

Wood, skulls
375 (147) high
Irian Jaya, Southern Division, Eilanden River:
Asmat
Collected by Paul Wirz, 1923

Museum für Völkerkunde, Basel, Vb 6316

The Asmat erected large carved poles to commemorate the victims of head-hunting raids and as reminders that their deaths must be avenged. Small versions are used as architectural elements in men's ceremonial houses, while large ones are erected outside as the focus of ceremonies. The projecting element at the top has phallic significance, and the *mbis* have also a function in promoting fertility.

Schmitz, *Oceanic Art*, pl. 152

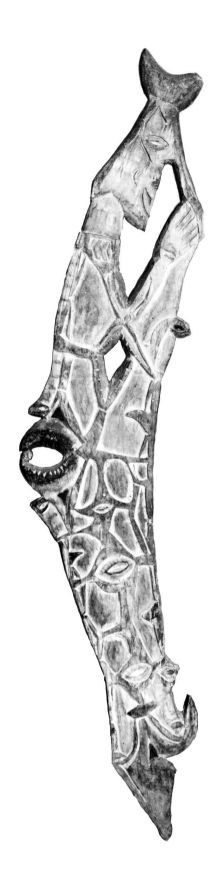

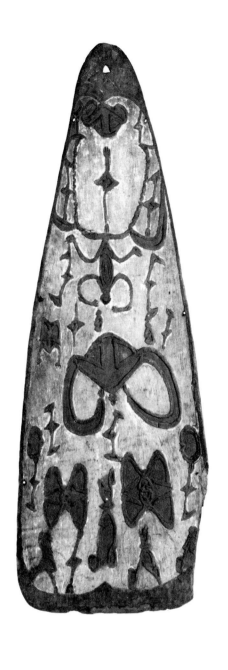
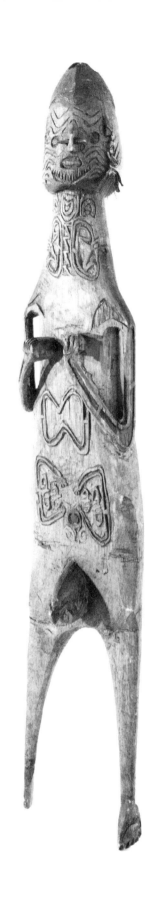
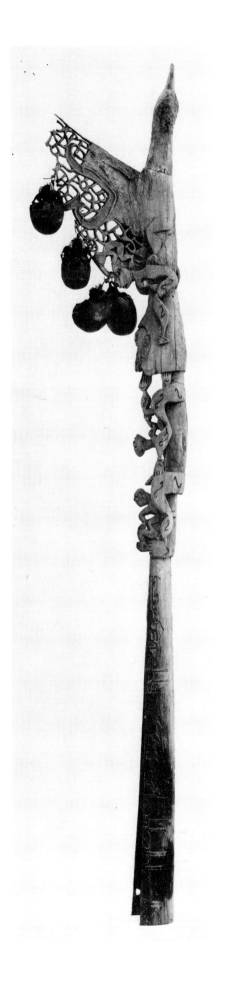

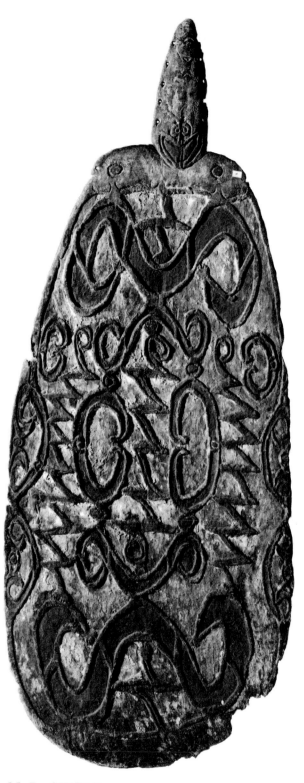

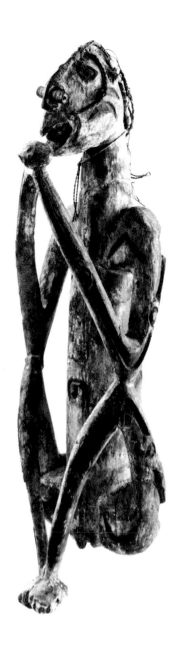

**21.8 FIGURE**

Wood, paint, seeds, fiber
57 (22⅜) high
Irian Jaya, Southern Division, Northwest
River: Asmat
Collected by Captain A. J. Gooszen, 1907-
1908

Raymond and Laura Wielgus Collection, Tucson, 61-232

Arts Club of Chicago, *Wielgus Collection*, no.
36

**21.7 SHIELD**

Wood, paint
157 (49¾) high
Irian Jaya, Southern Division, Northwest
River: Asmat
Museum acquisition, 1919

Rijksmuseum voor Volkenkunde, Leiden,
1971-976

# Papua New Guinea

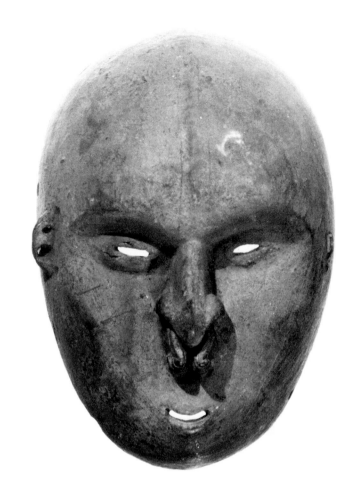

## 22.1 HOUSE CARVING

Wood
260 (102⅜) long
Papua New Guinea, East Sepik Province,
Seleo: Ali
Collected by Dr. Ludwig Cohn, 1912

Ubersee-Museum, Bremen, D 4721

This carving was one of a pair placed diagonally from veranda to ground on a men's ceremonial house.

Tischner and Hewicker, *Oceanic Art*, pl. 13;
Nevermann, *Masken und Geheimbunde*, 14

## 22.2 MASK OF MALE SPIRIT *(lewa)* Color plate 8

Wood
49 (19¼) high
Papua New Guinea, East Sepik Province,
Schouten Islands: Wogeo
Collected by H. Ian Hogbin, 1934

The St. Louis Art Museum, Gift of Mr. and
Mrs. Morton D. May, 170:1975

*Lewa* were spirits ceremonially called upon to enforce various edicts of headmen, such as tabus on growing crops. They manifested themselves as masked dancers who performed during the period that the tabu lasted.

Hogbin, *Island of Menstruating Men*, 60; Parsons, *Ritual Arts*, pl. 128

## 22.3 BAG CONTAINING SEVEN AMULETIC FIGURES

Basketry, wood, paint
Bag 30.5 (12) high; figures 12.5 (5) high
Papua New Guinea, East Sepik Province,
Murik Lakes: Murik

Kathleen Haven, New York

Men frequently owned collections of small carvings, kept in special bags and used for various types of magic. Some of the figures in this group were designed for magic in connection with hunting dogs, canoes, and (the flying fox) sexual adventure. As a whole the group shows the range of major types of figure sculpture made in this area.

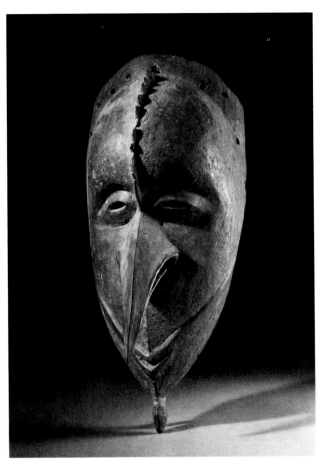

22.4

## 22.4  MASK

Wood
23 (9⅛) high
Papua New Guinea, East Sepik Province,
Boroi: Gamei
Collected by A. B. Lewis, 1909-1913

Field Museum of Natural History, Chicago,
140370

The masks of the lower Sepik River area are
carved in a bewildering variety of styles, rang-
ing from naturalistic to extremely stylized. This
example, and the heads of no. 22.5, illustrate a
few of the possibilities in this range. A well-
known feature of the masks is the frequent
extreme prolongation of the nose, which has
often been assumed to relate to the beaks of
(presumably) totemic birds (see nos. 22.6,
22.8, 22.9). It also occurs on the masks of the
middle Sepik River people (nos. 22.41-44) and
finds an echo in some masks, and decorated
skulls, of the Gulf of Papua (nos. 25.13,
25.18).

## 22.5  POLE WITH FOUR SURMOUNTED HEADS

Wood, paint
110.5 (43½) high
Papua New Guinea, East Sepik Province

Faith and Martin Wright, New York

Rousseau, *L'Art océanien*, fig. 210

295

## 22.6  FIGURE

Wood, paint, fiber, net bag
203 (80) high
Papua New Guinea, East Sepik Province,
Singgarin: Kopar
Collected by Captain H. Voogdt; acquired by
A. B. Lewis, 1909-1913

Raymond and Laura Wielgus Collection, Tucson, 59-162

Museum of Primitive Art, *Wielgus Collection*,
pl. 26

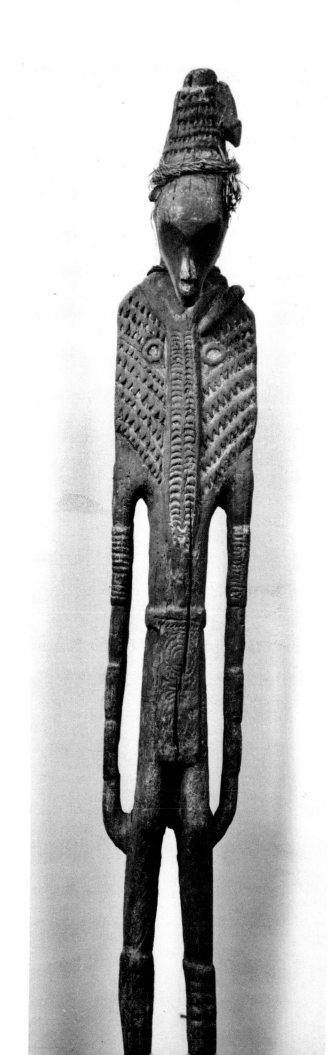

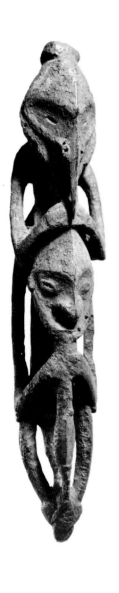
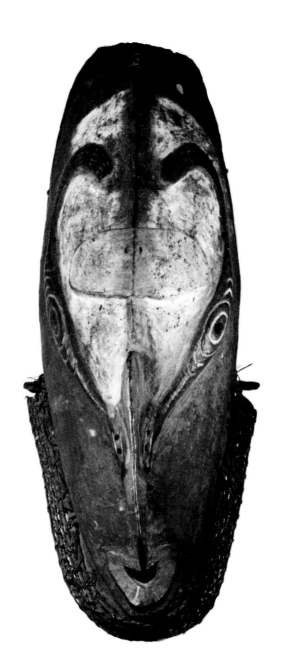
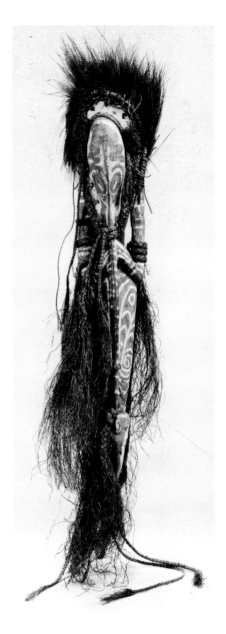

**22.7 RITUAL OBJECT**

Wood, paint
50 (19¾) high
Papua New Guinea, East Sepik Province:
Anggoram

Bruce Seaman, Tahiti

**22.9 FIGURE**

Wood, paint, fiber
60 (23⅝) high
Papua New Guinea, East Sepik Province;
Karawari River area, Kraimbit
Museum purchase from E. J. Wauchope, 1938

By courtesy of the Australian Museum Trust,
Sydney, E 46368

**22.8 MASK**

Wood, paint, cane
64.8 (25½) high
Papua New Guinea, East Sepik Province

Faith and Martin Wright, New York

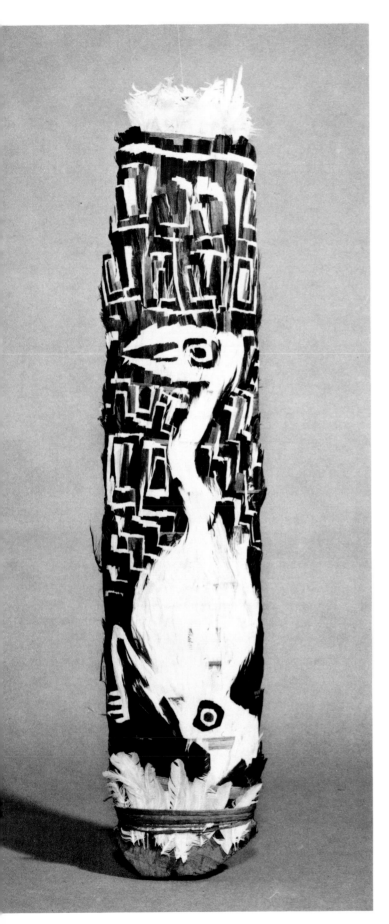

## 22.10   SEATED FIGURE

Wood, cane
94.6 (37¼) high
Papua New Guinea, East Sepik Province:
Anggoram or Kambot?

University of East Anglia, Norwich, England
Robert and Lisa Sainsbury Collection, 1954
UEA 157

University of East Anglia, *Sainsbury Collection*, pl. 221

## 22.11   FEATHER MOSAIC, CASSOWARY

Feathers, cane bands, board
110 (43¼) high
Papua New Guinea, East Sepik Province,
Keram River: Kambot
Collected by Gregory Bateson

University Museum of Archaeology and Anthropology, Cambridge, Z 9390

Featherwork in New Guinea mainly took the form of headgear, often impressive in both elaboration and scale. Only the Kambot made representative designs of feathers tied to boards, arrays of which were used to form huge murals inside ceremonial houses.

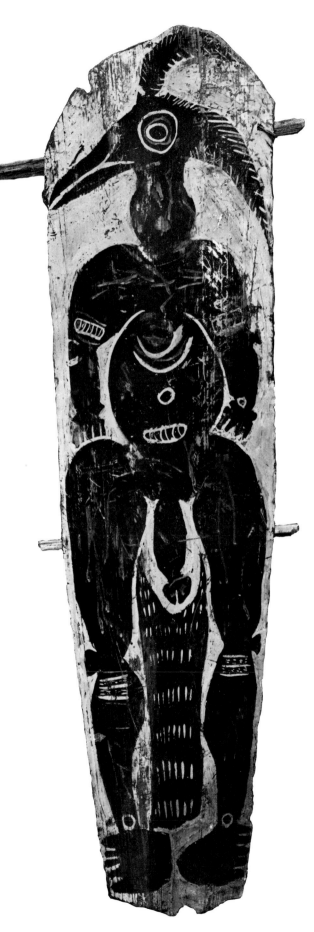

## 22.12 PAINTING, BIRD-HEADED MAN

Sago spathe, paint
131 (51⅝) high
Papua New Guinea, East Sepik Province,
Keram River, Raten: Kambot
Collected (probably) by E. J. Wauchope; ac-
quired 1938

By courtesy of the Australian Museum Trust,
Sydney, E 62596

The gables of Kambot ceremonial houses are
elongated triangles built almost parallel to the
ground. The undersides were covered with
paintings on sheets of bark, usually depicting
one major ancestral figure bordered by minor
groups of human and animal ancestral beings.

299

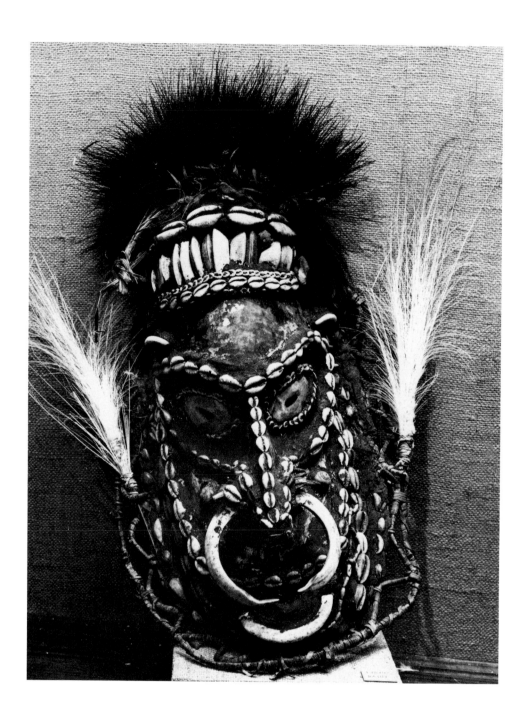

## 22.13  MASK, MALE SPIRIT

Basketry, shell, feathers, boar tusks
91 (35⅞) high
Papua New Guinea, East Sepik Province,
Keram River, Raten: Kambot
Museum purchase from E. J. Wauchope, 1938

By courtesy of the Australian Museum Trust,
Sydney, E 46404

Typically, masks and other objects of this tribe
show, to an unusual degree, the use of cumula-
tive elements, sometimes being almost entirely
constructed of shells, feathers, and boar tusks
applied over a human or animal skull.

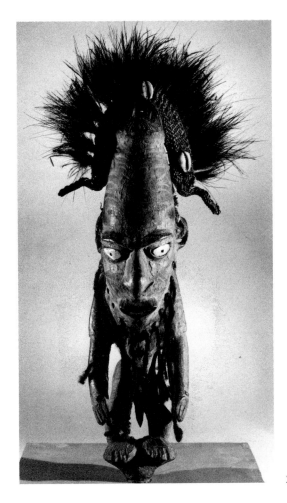

22.15

## 22.14  MASK

Wood, paint
34.3 (13½) high
Papua New Guinea, East Sepik Province, Yuat
River: Biwat

The Baltimore Museum of Art, The Janet and
Alan Wurtzburger Collection, 40

Baltimore Museum of Art, *Wurtzburger Collection*, fig. 40

## 22.15  FIGURE FOR SACRED FLUTE

Wood, paint, shell, hair
49.5 (19½) high
Papua New Guinea, East Sepik Province, Yuat
River: probably Biwat

The Baltimore Museum of Art, The Janet and
Alan Wurtzburger Collection, 55.251.36

Throughout New Guinea, flutes are highly sacred musical instruments. They figure largely in men's cults, usually being played not as solo instruments but in pairs or even larger ensembles. Their music represents the voices of spirits of the air, the forest, or the water.

Basically long bamboo tubes, the flutes are often richly ornamented, nowhere more so than in the area of the Sepik River, where they are often fitted with carved figures inserted at the upper end. The most striking of these, again, were made by the Biwat, among whom the flutes represented the children of an ancestral crocodile spirit.

Baltimore Museum of Art, *Wurtzburger Collection*, fig. 36

301

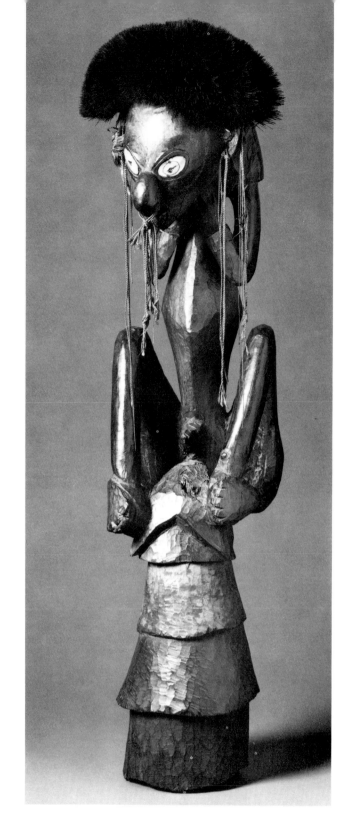

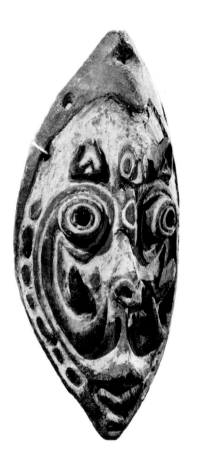

## 22.16   FIGURE

Wood, shell, cords, cassowary feathers
122 (48) high
Papua New Guinea, East Sepik Province, Yuat
River: Biwat

Barbier-Müller Collection, Geneva

## 22.17   MASK

Wood, paint
49 (19¼) high
Papua New Guinea, East Sepik Province, Yuat
River: Biwat
Collected by Margaret Mead, 1932

American Museum of Natural History, New
York, 80.0.8287

This remarkable mask, like the crocodile fig-
ure (no. 22.18), has its features enhanced by
projections which indicate a relationship with
the opposed-hook style of the Sepik Hills area
to the west (nos. 22.63,64).

Wardwell, *Art of the Sepik River*, 49

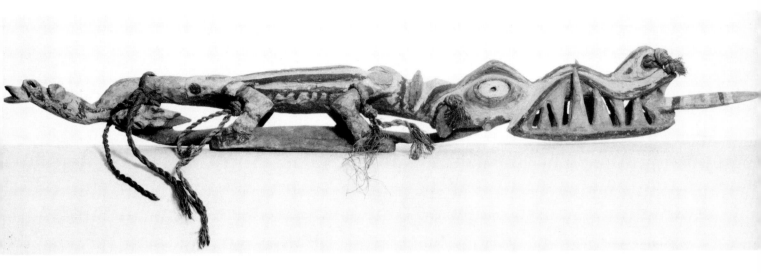

## 22.18 CROCODILE

Wood, paint, shell, fiber
85.2 (33½) long
Papua New Guinea, East Sepik Province, Yuat
River: Biwat
Collected by Margaret Mead, 1932

American Museum of Natural History, New
York, 80.0.8276

The Biwat of the Yuat River purchase carved
wooden figures of water creatures from the
bush people (Yaul and Dimiri), which are held
by the men between their legs in dances. This
crocodile figure is probably one such, though
in Biwat style. As malevolent magical objects
they are also hidden in fishing waters. There
would seem to be a possible functional analogy
between these *peleva* and the *garra* of the
Bahinemo (see no. 22.63).

## 22.19 THE GOD AMBOSSANGMAKAN

Wood
242 (95¼) high
Papua New Guinea, East Sepik Province, Yuat
River, Mansuat: Mekmek
Collected by Dadi Wirz, 1955

Museum für Völkerkunde, Basel, Vb 17683

This extraordinary figure is the finest of a group
collected from villages now situated in the bush
off the Yuat River, but probably they were
originally much nearer to it, as the river has
changed course in the last few generations. All
represent tutelary spirits, or "gods" of war,
hunting, and healing; they were apparently
kept in private houses (rather than ceremonial
houses) as the central objects of individual
cults. The figure of Ambossangmakan is in-
deed said to have been carved and bought as
decoration for a private house, and only later to
have revealed its true identity to its owner in a
dream. On the evidence of the lineage which
owned it, the figure appears to have been
carved about 150 years ago.

Laumann, "Geisterfiguren . . ."; Museum für
Völkerkunde, Basel, *Ethnographische
Kostbarkeiten*, 52-53

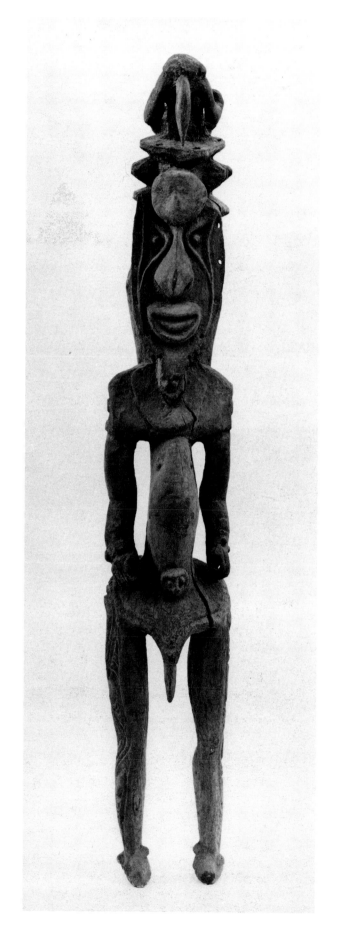

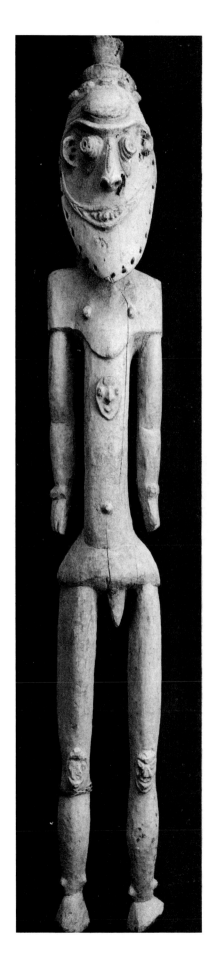

**22.20  FIGURE**

Wood, paint
221.5 (87¼) high
Papua New Guinea, East Sepik Province, Yuat
River: Yaul

The Museum of Fine Arts, Houston, 62-44

**22.21 FIGURE**

Wood
127 (50) high
Papua New Guinea, East Sepik Province,
Karawari River: Ewa

Museum für Völkerkunde, Basel, Vb 25416

The Ewa, formerly a large group, now reduced
by epidemics, carved figures in a style related
to, but richer and more elaborate than, those of
the "opposed-hook" style of the neighboring
Alamblak and Bahinemo. War and hunting
spirits are depicted. On the deaths of their
owners, the carvings were often deposited in
dry rock-shelters with the bones and other
relics.

Haberland, *Caves of Karawari*, pl. 51

**22.22 FIGURE**

Wood
130 (51¼) high
Papua New Guinea, East Sepik Province,
Karawari River: Ewa

Museum für Völkerkunde, Basel, Vb 25417

Haberland, *Caves of Karawari*, pl. 52

**22.23 FIGURE**

Wood
141 (53½) high
Papua New Guinea, East Sepik Province,
Karawari River: Ewa

The St. Louis Art Museum, Gift of Mr. and Mrs.
Morton D. May, 147:1975

Haberland, *Caves of Karawari*, pl. 19; Par-
sons, *Ritual Arts*, pl. 76

**22.24 FEMALE FIGURE**

Wood
192 (75¼) high
Papua New Guinea, East Sepik Province,
Karawari River: Ewa
Collected by Panzenböck, before 1963

Museum für Völkerkunde, Basel, Vb 19637

Schmitz, *Oceanic Art*, pl. 103

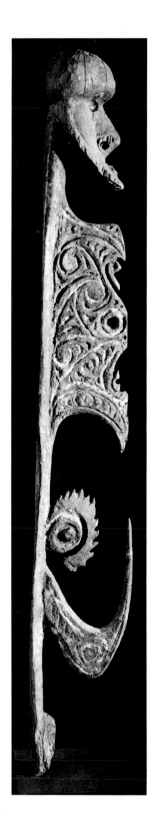

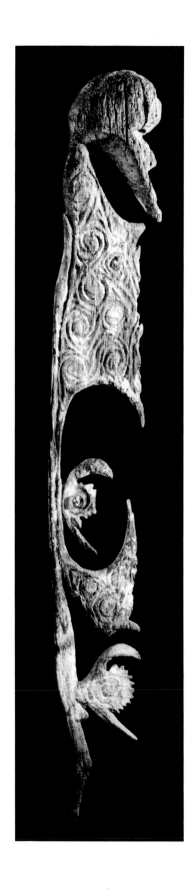
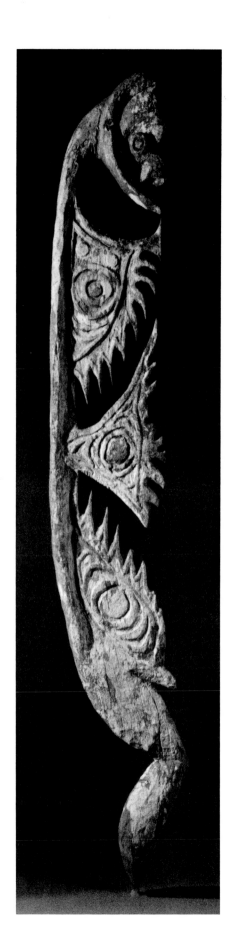
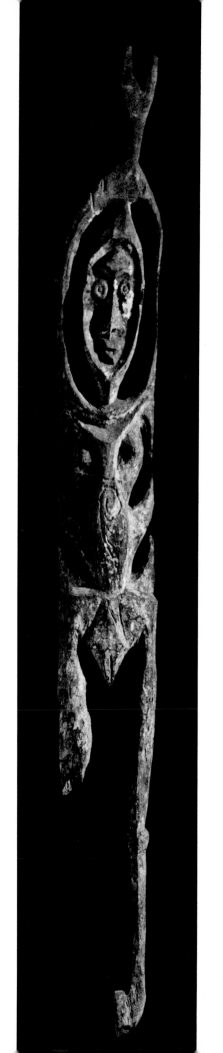

## 22.25 CROCODILE

Wood, paint
698.5 (275) long
Papua New Guinea, East Sepik Province,
Karawari River, Manjamei: Karawari
Collected by Alfred Bühler, 1959

The Museum of Fine Arts, Houston, Gift of
Houston Endowment, Inc., 61-46

Bühler, "Kultkrokodile vom Korewori"

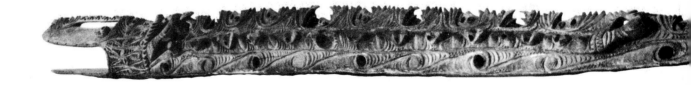

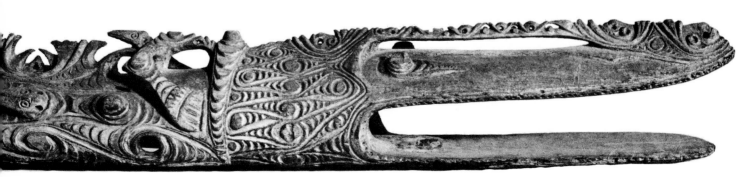

## 22.26 FIGURE *(tunegatsir)*

Wood
128 (50½) high
Papua New Guinea, East Sepik Province,
Karawari River, Baräbidyin: Alamblak
Collected by Eike Haberland, 1963

Museum für Völkerkunde, Frankfurt, NS
43349

Haberland and Seyfarth, *Die Yimar*, pl. 40,
3-4

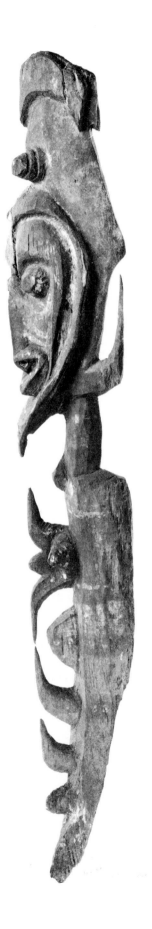

## 22.27 MASK *(morwinegar)*

Wood
58 (22⅞) high
Papua New Guinea, East Sepik Province,
Karawari River, Baräbidyin: Alamblak
Collected by Eike Haberland, 1963

Museum für Völkerkunde, Frankfurt, NS
41949

Haberland and Seyfarth, *Die Yimar*, pl. 15, 2

## 22.28 MALE SPIRIT MASK *(didagur)*

Basketry, paint
57 (22½) high
Papua New Guinea, East Sepik Province,
Karawari River, Wolpam: Alamblak
Collected by Eike Haberland, 1963

Museum für Völkerkunde, Frankfurt, NS
43202

*Didagur* masks appeared at initiation, in both
male and female form, the females having
shorter noses. The type is also found among the
Iatmul people of the Sepik River itself, from
whom the Karawari probably adopted it.

Haberland and Seyfarth, *Die Yimar*, pl. 17, 1

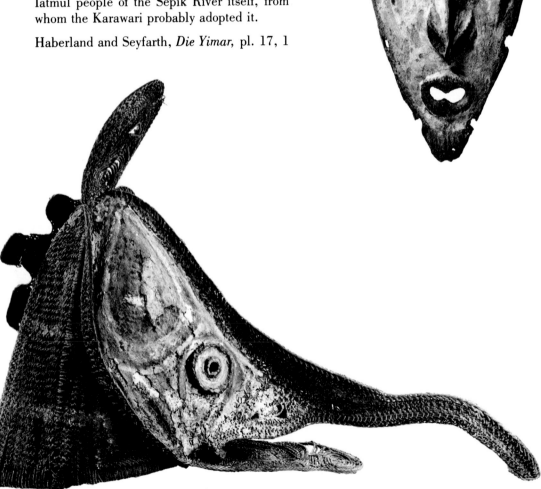

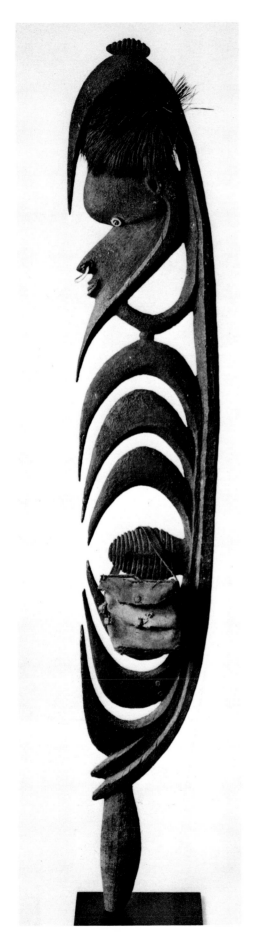

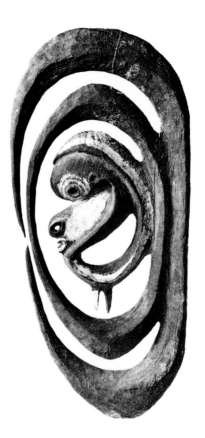

### 22.29  WAR AND HUNTING GOD *(yipwon)*

Wood, shell, cassowary feather headdress
205 (80¾) high
Papua New Guinea, East Sepik Province,
Karawari River: Alamblak

Private collection, New York

The *yipwon* figures of the Alamblak essentially
represent war and hunting spirits. The larger
ones are owned by clans and are kept in the
men's ceremonial houses, while small versions
(no. 22.30), patron spirits of individual men,
are carried in their net bags with other personal
property. The hook above the head is a bird's
beak; the other hooks are the spirits' ribs, while
the extension between them, in the middle, is
the heart.

### 22.30  WAR AND HUNTING AMULET
*(yipwon)*

Wood
40 (15½) high
Papua New Guinea, East Sepik Province,
Karawari River, Yanitobak: Alamblak
Collected by Eike Haberland, 1963

Museum für Völkerkunde, Frankfurt, NS
43299

Haberland and Seyfarth, *Die Yimar*, pl. 32, 2

22.29

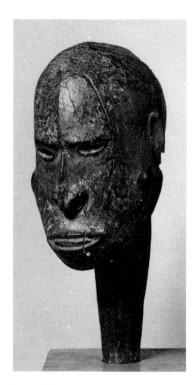

## 22.31 SUSPENSION HOOK

Wood
105 (41¼) high
Papua New Guinea, East Sepik Province, Blackwater River, Tunggambit: Kapriman
Collected by the *La Korrigane* expedition, 1934-1936

Musée de l'Homme, Paris, 61.103.305

The story associated with this hook illustrates the profound identification of such objects with individuals and their function as omen givers and as protective spirits. Representing the female ancestor of a particular family, it fell during an earthquake and was broken. Subsequently a child of the family died, and in consequence the figure was presumed to have lost its power.

Rousseau, *L'Art océanien*, figs. 85, 86

## 22.32 HEAD FOR SACRED FLUTE

Wood
32.5 (12¾) high
Papua New Guinea, East Sepik Province, Timbunke: Woliagwi Iatmul
Collected by Captain H., about 1914
Museum purchase, 1924

The University Museum, Philadelphia, 29.50.627

Linton and Wingert, *Arts of the South Seas*, 119

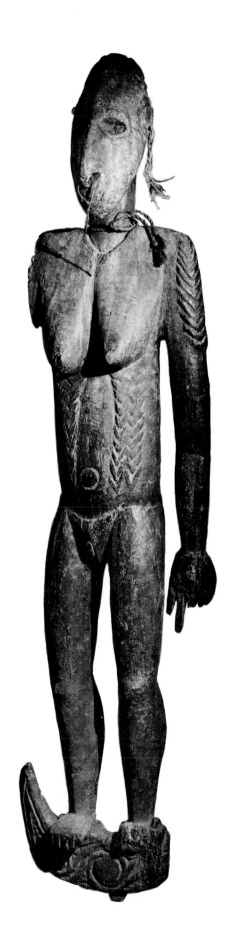

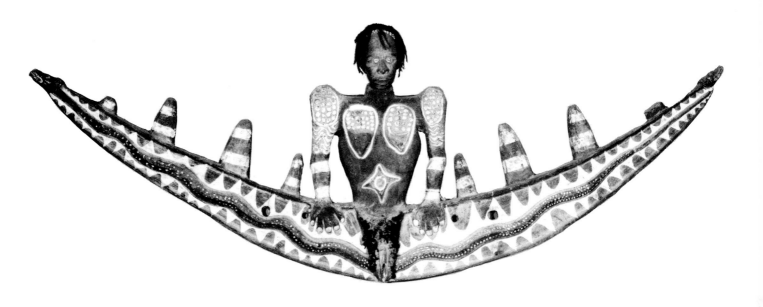

## 22.33  SKULL RACK

Wood, paint, overmodeled skull
277 (109⅛) wide
Papua New Guinea, East Sepik Province,
"Radja" (Angerman): Woliagwi Iatmul
Collected by Captain Haug in the *Siar,* 1909

Linden-Museum, Stuttgart, 61 611

The cult of the ancestral skull involved its
incorporation in a number of elaborate and
spectacular modes, from the erection of a form
of highly decorated puppets for mortuary rites

to the display of carvings with mythological
themes. The central figure in this example,
flanked as it is with snakes depicted on its
hook-bearing branches, is probably related to
the myth of a female ancestor who, with her
animal children, created the Sepik River itself.

Reche, *Die Kaiserin-Augusta-Fluss,* pl. 76, 3

## 22.34 SEATED FEMALE FIGURE

Wood, paint
112 (44⅛) high
Papua New Guinea, East Sepik Province,
"Radja" (Angerman): Woliagwi Iatmul
Collected by Captain Haug in the *Siar*, 1909

Linden-Museum, Stuttgart, 61 610

Female figures of this type were carved at the
bases of the poles which protruded above the
gables of ceremonial houses as supports of the
carved finials (no. 22.38). They represent
mythological ancestors, probably the
"mothers" of various plant and animal species.

Reche, *Die Kaiserin-Augusta-Fluss*, pl. 72, 3

## 22.35 MALE FIGURE

Wood, paint
148 (58½) high
Papua New Guinea, East Sepik Province,
"Radja" (Angerman): Woliagwi Iatmul
Collected by Captain Haug in the *Siar*, 1909

Linden-Museum, Stuttgart, 61 623

Reche, *Die Kaiserin-Augusta-Fluss*, pl. 72, 4
(note misnumbering)

## 22.36 CEREMONIAL FENCE ELEMENT

Wood, paint, shell
153.5 (60½) high
Papua New Guinea, East Sepik District, prob-
ably Kararau: Woliagwi Iatmul

The Metropolitan Museum of Art, New York,
The Michael C. Rockefeller Memorial Collec-
tion of Primitive Art, Gift of Nelson A. Rock-
efeller 1969, P 56.410

At either end of the big ceremonial houses of
the Iatmul was usually a small artificial hil-
lock, on which were grown totemic trees and
other plants. These mounds were surrounded
with fences including carved representations of
supernaturals.

Newton, *New Guinea Art*, pl. 68

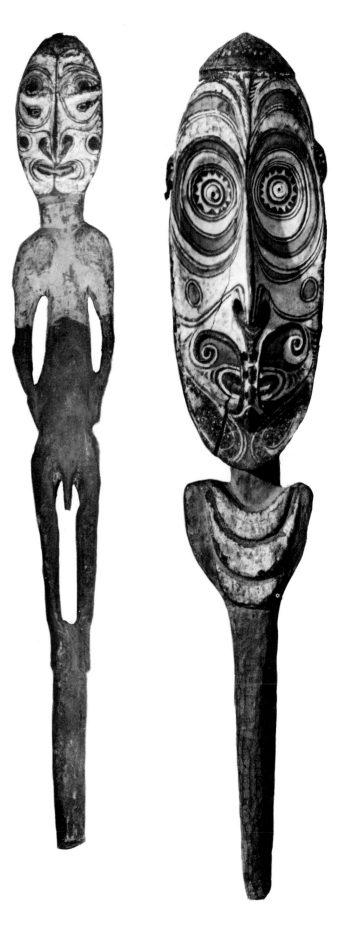

## 22.37 SUSPENSION HOOK

Wood, paint
161 (63⅜) high
Papua New Guinea, East Sepik Province:
(probably Woliagwi) Iatmul
Collected by Consul Thiel, about 1910
Formerly Hamburgisches Museum für Völkerkunde und Vorgeschichte, and Serge Brignoni Collection

Mr. and Mrs. Alvin Abrams, New York

Many hooks were hung from the beams of private houses as common articles of household furniture on which bags of food and valuables were hung to safeguard them from vermin. Some, however, were of a scale and elaboration which mark them clearly as cult objects abounding in symbols embodying mythological references. This example not only is of this type but shows an interesting relationship to the Ewa and Alamblak styles of the Karawari River, which connects with the Sepik River in this Iatmul area.

Reche, *Die Kaiserin-Augusta-Fluss*, pl. 40, 6

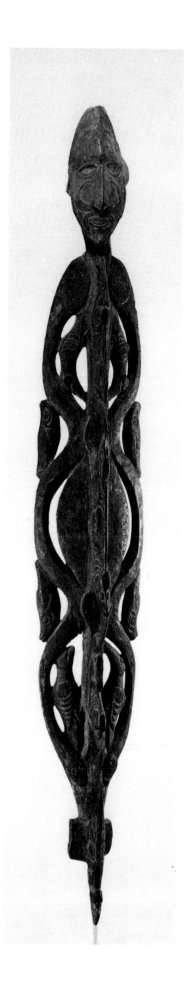

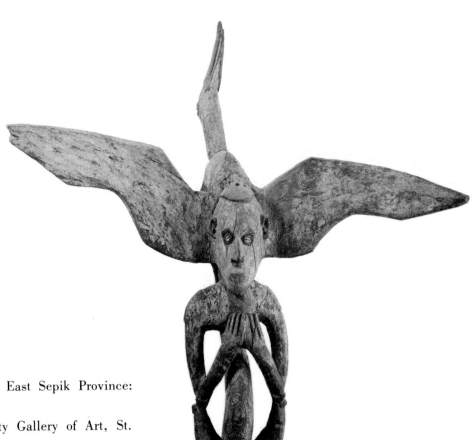

## 22.38  FINIAL

Wood, paint
122 (48) high
Papua New Guinea, East Sepik Province:
Iatmul

Washington University Gallery of Art, St.
Louis, WU 3767

Iatmul ceremonial houses had a gable at either
end, each capped with a finial figure of a man
(or woman), and bird. These are described as
enemies in the grip of eagles which symbolized
the aggressive force of the village. They may
also refer to bird-human spirits who gave
human beings the secrets of sacred musical
instruments.

Linton and Wingert, *Arts of the South Seas*,
frontis.; Parsons, *Ritual Arts*, pl. 84

## 22.39  GABLE FINIAL

Pottery, paint
33 (13) high
Papua New Guinea, East Sepik Province,
Aibom: Iatmul
Collected by William A. Robinson, 1930

Peabody Museum of Salem, Massachusetts,
E 24553

Ceramic analogues of the wooden finials
placed on ceremonial houses were made by the
villagers of Aibom, as part of their notable
pottery industry. Their main products were
utilitarian vessels for food storage and cooking
which were widely traded throughout the Sepik
River area.

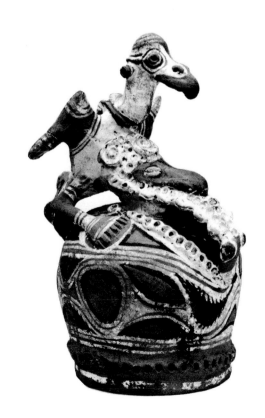

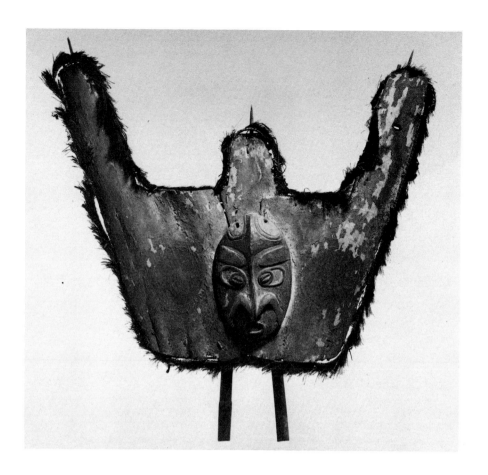
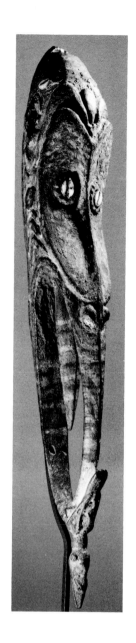

**22.40   CANOE PROW ORNAMENT** *(shabi)*

Wood, bark, cane, feathers
121.5 (35¼) high
Papua New Guinea, East Sepik Province,
Parimbai: Woliagwi Iatmul

Bruce Seaman, Tahiti

Ornaments of this type were set just behind the
prows of war canoes (the cane struts are set into
perforations). They embody protective spirits
which are also malevolent to the enemy.

**22.41   MASK** *(mei)*

Wood, paint, cowries
63.5 (25) high
Papua New Guinea, East Sepik Province:
(probably Niyaura) Iatmul
Formerly in the collection of Pierre Loeb

Raymond and Laura Wielgus Collection, Tucson, 56-28

This is probably a mask representing the
"mother" of the other *mei* masks, although the
more usual style is a flat silhouette.

Rousseau, *L'Art océanien*, fig. 52

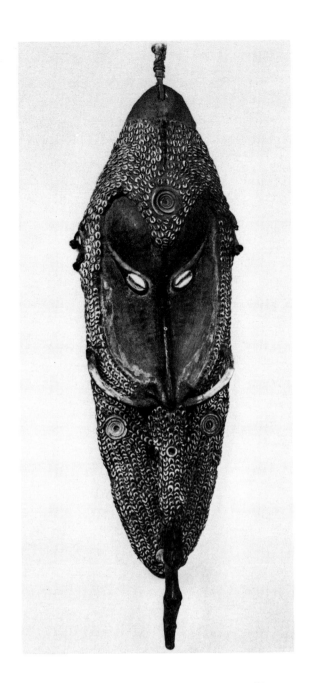

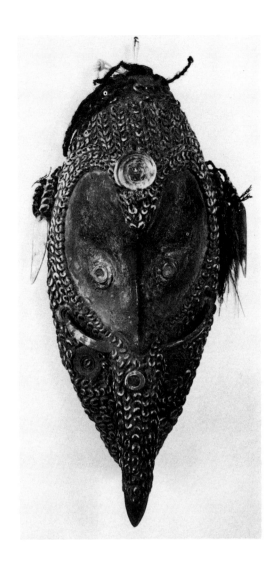

**22.42  MASK (*mei*: personal name *wolin-dambwi*)**

Wood, shells, boar tusks
68.6 (27) high
Papua New Guinea, East Sepik Province,
Kangganaman: Parimbai Iatmul

Bruce Seaman, Tahiti

*Mei*, the long-nosed masks of the Iatmul, ap-
peared in ceremonial parades in quartets of
paired "brothers" and "sisters." Here Wolin-
dambwi is the brother, Akimbaiwoli (no.
22.43) the sister, as is expressed by their dif-
ferent sizes. Both are mythical ancestors of the
Kangganaman village's Iatmul clan.

**22.43  MASK (*mei*: personal name *akimbaiwoli*)**

Wood, shells, human hair, cassowary feathers
35.5 (14) high
Papua New Guinea, East Sepik District,
Kangganaman: Parimbai Iatmul

Bruce Seaman, Tahiti

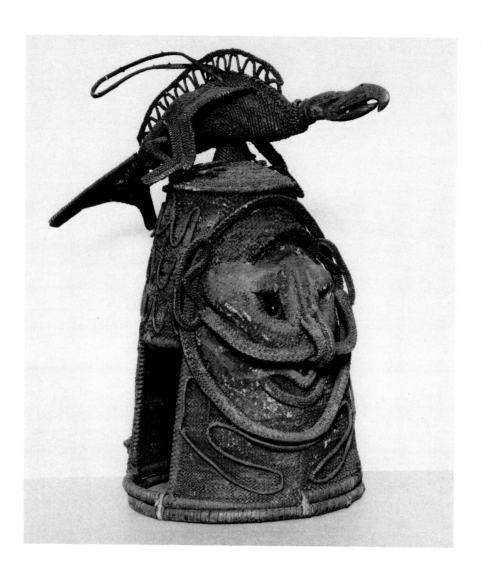

## 22.44 MASK (mei)

Wood, paint, shells, tusks, human hair
55 (21⅝) high
Papua New Guinea, East Sepik Province,
Sepanaut: Niyaura Iatmul

Private collection, New York

The flat-faced *mei* masks of the eastern Iatmul
(nos. 22.42, 22.43) differ markedly from the
narrower, heavy-browed masks of the western,
Niyaura Iatmul.

## 22.45 MASK WITH EAGLE

Basketry, wood
72.5 (28½) high
Papua New Guinea, East Sepik Province, Yen-
shamanggua: Niyaura Iatmul
Collected by Captain H., about 1914
Museum purchase, 1924

The University Museum, Philadelphia,
29.50.661

Masks of this type, surmounted by an eagle,
are comparatively rare, although several others
are known on which other totemic or mytholog-
ical birds are represented. It is recorded that
bodies of head-hunting victims were some-
times brought back to the raiders' village and
ceremonially speared by a man wearing the
mask of an eagle. Possibly this type of mask
was used.

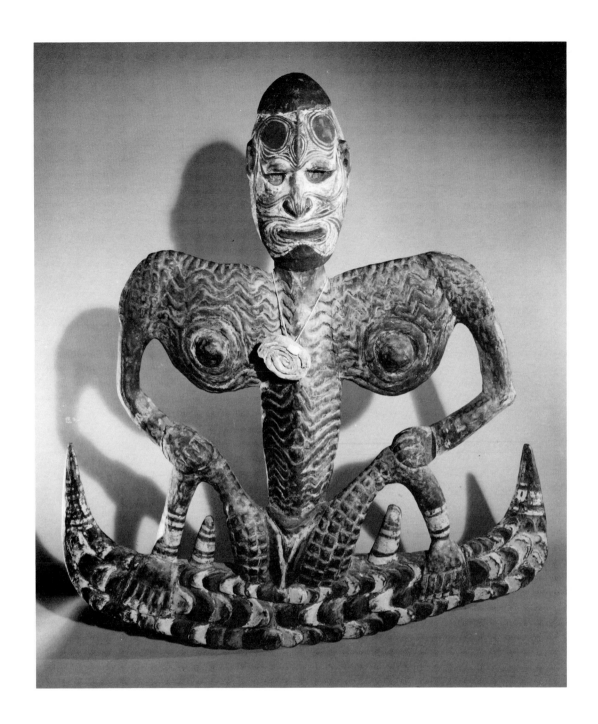

**22.46  SUSPENSION HOOK**

Wood, paint
97 (38½) high
Papua New Guinea, East Sepik Province, Yenshamanggua: Niyaura Iatmul
Collected by Captain H., about 1914
Museum purchase, 1924

The University Museum, Philadelphia, 29.50.334

321

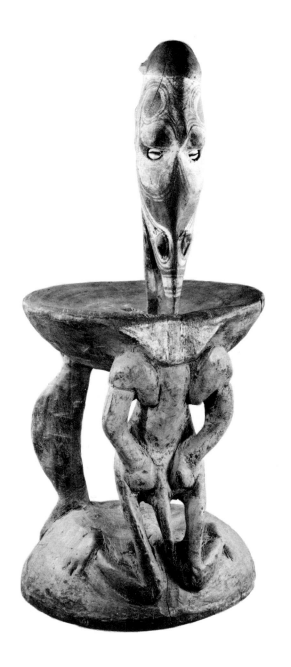

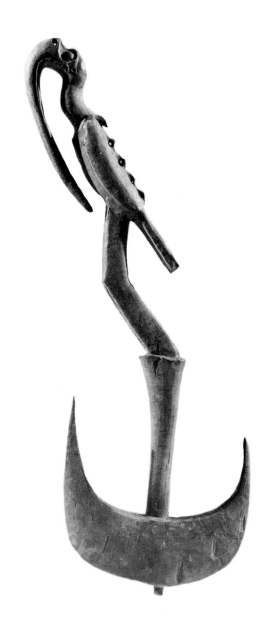

**22.47** **DEBATING STOOL**

Wood, paint, cowries
83 (32⅝) high
Papua New Guinea, East Sepik Province:
(probably Niyaura) Iatmul

Linden-Museum, Stuttgart, 120788

The Iatmul were much given to debate, con-
cerning, in particular, clan rights to mythologi-
cal names. The main accessory was a carving
which represents an ancestor kneeling or
standing beside his stool (rarely sitting on it).
The seat of the stool was beaten with leaf tallies
during the often violent discussions. The head
of the ancestor in this example clearly is a form
of *mei* mask.

**22.48** **SUSPENSION HOOK, BIRD FORM**

Wood
45.5 (17⅞) high
Papua New Guinea, East Sepik Province:
Chambri
Collected by Margaret Mead, 1933

American Museum of Natural History, New
York, 80.0.7464

Wingert, *South Pacific Islands*, pl. 35

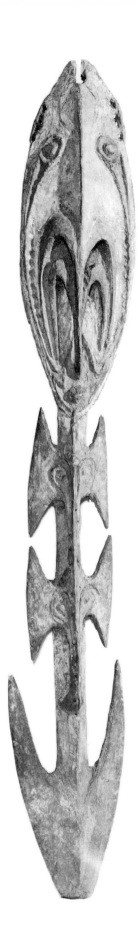

**22.49  SUSPENSION HOOK**

Wood
124.5 (49) high
Papua New Guinea, East Sepik Province:
Chambri
Collected by Margaret Mead, 1933

American Museum of Natural History, New
York, 80.0.8127

Wingert, *South Pacific Islands*, pl. 32

## 22.50  OPENWORK BOARD *(malu)*

Wood, paint
170 (67) high
Papua New Guinea, East Sepik Province,
Nggaigorevwi: Sawos

Jay C. Leff, Uniontown, Pennsylvania

These two boards (nos. 22.50, 22.51) are a
pair, and were so discovered in a man's private
house. They are remarkable for the fine preser-
vation of their paint, which has disappeared
from most examples.

Several types of these boards are known, but
little is recorded of their original purpose. One
explanation — that they were memorials to
those who succumbed to initiatory ordeals —
should probably be modified in view of their
obviously totemic iconography. Although they
were definitely carved by the Sawos, they were
widely traded to the Iatmul and perhaps even
the Anggoram.

Gilliard, "To the Land of the Headhunters,"
444; Newton, *Malu*

## 22.51  OPENWORK BOARD *(malu)*

Wood, paint
183 (72) high
Papua New Guinea, East Sepik Province,
Nggaigorevwi: Sawos

Katherine Coryton White Collection, Los
Angeles

## 22.52  OPENWORK CARVING

Wood, fiber skirt
113 (44½) high
Papua New Guinea, East Sepik Province, To-
rembi: Sawos

Bruce Seaman, Tahiti

There is a clear relationship among the form of
this carving and the *malu* boards and the
mythological theme of no. 22.33. In this case
the female ancestor is associated with catfish,
which in mythology are the canoes of the ances-
tors. The rigid attitude of the figure is typical of
Sawos sculpture.

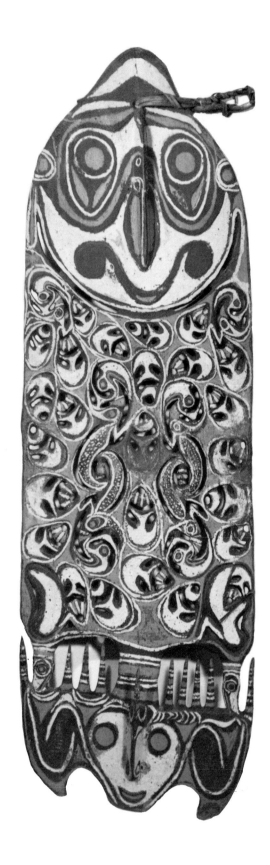

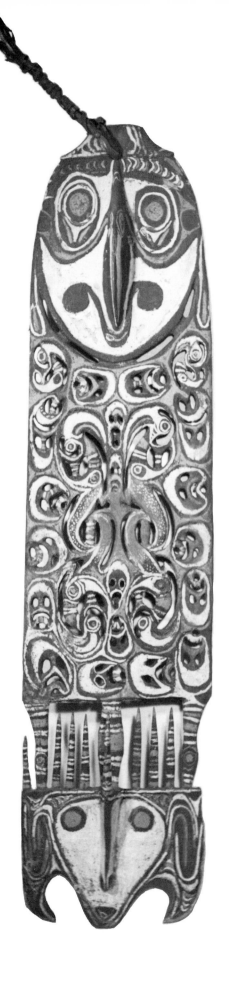

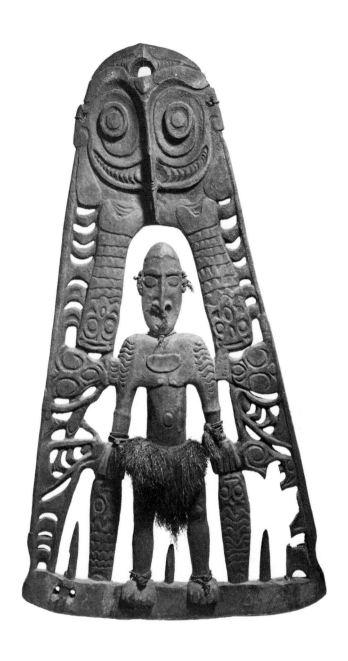

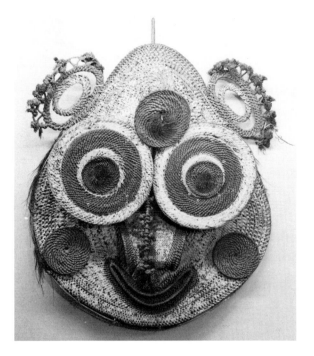

## 22.53 MASK

Basketry, paint
68.6 (27) high
Papua New Guinea, East Sepik Province:
probably Sawos

Mrs. Claire Zeisler, Chicago

This mask was probably originally fastened to
the façade of a ceremonial house; in such
positions large masks represented a female
spirit which the building as a whole per-
sonified.

Wingert, *South Pacific Islands*, pl. 28

## 22.54 BOWL

Pottery, paint
27.3 (10¾) diameter
Papua New Guinea, East Sepik Province:
Sawos

Dr. Ruth F. Lax and Dr. Leon A. Falik, New
York

Conical bowls for containing food are produced
in large numbers by the eastern Sawos villages
and are widely sold through the pottery trade
complex of the Sepik River area. They are
always decorated with engraved designs and
polychrome. The designs are usually com-
pletely stylized and symmetrical; this example
is rare in its use of figurative elements: human
figures and the cassowary, an important bird in
mythology.

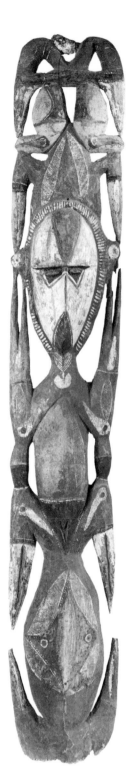

## 22.55 FIGURE

Wood, paint
174 (68½) high
Papua New Guinea, East Sepik Province,
Bobmagum: Wosera Abelam
Collected by Alfred Bühler, 1956

Museum für Völkerkunde, Basel, Vb 13857

Basel, *Ethnographische Kostbarkeiten*, 82-83

## 22.56 FIGURE

Wood, paint
305 (120) high
Papua New Guinea, East Sepik Province,
Prince Alexander Mountains: Abelam

Private collection, New York

This figure is an example of the major sacred
carvings of the Abelam people. The style, in
which groupings of birds' heads echo the op-
posed hooks of the groups south of the Sepik
River, is probably older than the more natu-
ralistic style.

## 22.57 FEMALE FIGURE

Wood
142 (55⅞) high
Papua New Guinea, East Sepik District:
Wosera Abelam

Linden-Museum, Stuttgart, S40 009

The reversed joints of the figure refer to the
actual physical appearance of the ancestors, as
described in myth.

Linden-Museum, *Melanesien,* abb. 98

## 22.58 CEREMONIAL HOUSE GABLE

Bark, paint, wood
366 (252) high
Papua New Guinea, East Sepik Province,
Prince Alexander Mountains: Abelam

Dr. D. Carleton Gajdusek

## 22.59 BOARD

Wood, paint
171 (67⅜) high
Papua New Guinea, East Sepik Province,
Prince Alexander Mountains: Abelam

The St. Louis Art Museum, Gift of Mr. and Mrs.
Morton D. May, 36.1977

Parsons, *Ritual Arts,* pl. 118

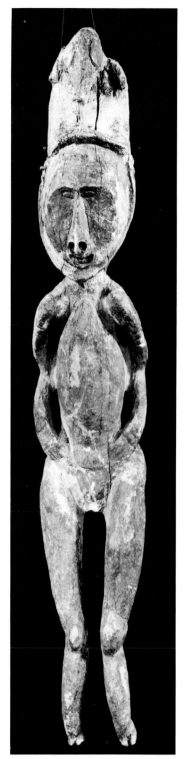

22.57

327

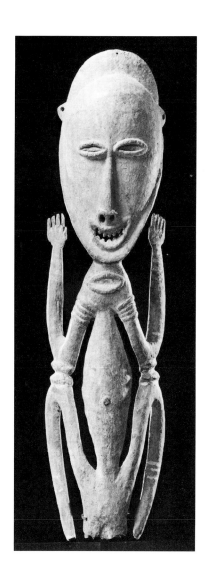

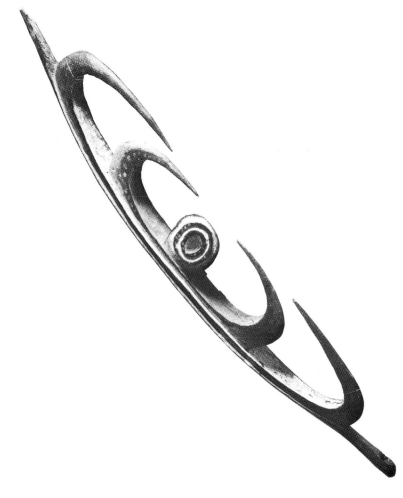

22.62

## 22.60 OPENWORK CARVING: LIZARD, SNAKE, BIRDS

Wood, paint
70 (27⅝) high
Papua New Guinea, East Sepik Province: Abelam
Collected by Reo Fortune, 1933

American Museum of Natural History, New York, 80.0.6645

## 22.61 FIGURE Color plate 2

Wood, paint
76 (29⅞) high
Papua New Guinea, East Sepik Province: Abelam or Boiken

S. and J. Onzea, Brussels

## 22.62 CULT CARVING (*garra: personal name tsindu*)

Wood, paint
108.3 (42⅝) long
Papua New Guinea, East Sepik Province, Hunstein Mountains: Bahinemo

Bruce Seaman, Tahiti

The two *garra* (nos. 22.62, 63) were used at an initiation ceremony in July 1967, which may well be the last to have been performed by the Bahinemo, who have since become Christians. As with some carvings of the Biwat (no. 22.18), they are held between dancers' legs. The style is a component of the range of the "opposed-hook" complex. The objects as a whole probably represent water spirits, though the hooks are said to represent birds' beaks and catfish antennae.

Newton, *Crocodile and Cassowary*, fig. 23, pp. 20-21

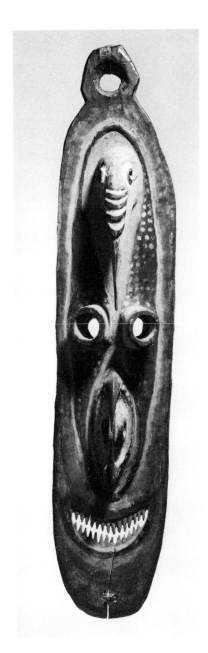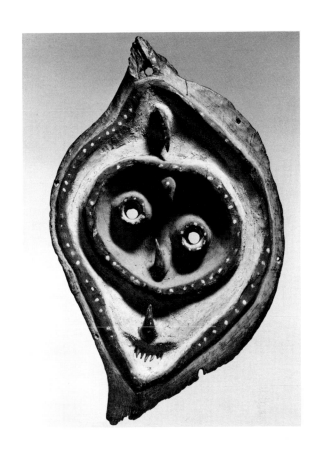

**22.63    MASK** *(garra:* **personal name** *kamamu)*

Wood, paint
102.2 (40¼) high
Papua New Guinea, East Sepik Province,
Hunstein Mountains: Bahinemo

Bruce Seaman, Tahiti

Newton, *Crocodile and Cassowary,* figs. 34, 35

**22.64    MASK** *(garra)*

Wood, paint
57.1 (22½) high
Papua New Guinea, East Sepik Province,
Hunstein Mountains, Gahom: Bahinemo

Bruce Seaman, Tahiti

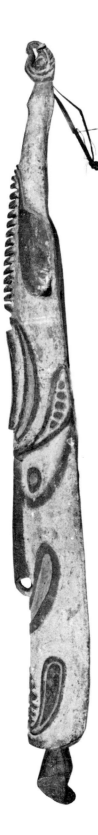
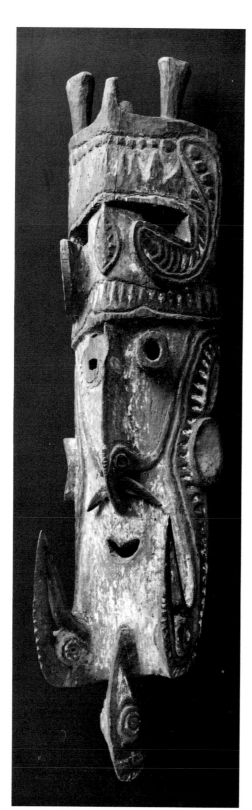

## 22.65 CANOE SHIELD MASK *(baal wulru)*

Wood, paint
82 (32¼) high
Papua New Guinea, East Sepik Province,
Kubkein: Wogumas
Collected by Alfred Bühler, 1959

Museum für Völkerkunde, Basel, Vb 15929

This mask from a canoe prow ornament is similar to no. 22.40. Among the upper Sepik River groups the whole construction represents a mythological female cassowary who bore the originator of head hunting. The cassowary's head is carved at the top of the extension above the head; in between, a vertical row of hooks represents the flowers of a vine much used in sorcery.

## 22.66 MASK *(lu milyawan)*

Wood, paint
148 (58¼) high
Papua New Guinea, East Sepik Province,
upper Sepik River: Nggala
Collected by Panzenböck, before 1962

Museum für Völkerkunde, Basel, Vb 21767

Representing male water spirits, such masks were displayed at a ceremony during which slit gongs were beaten in concert to stimulate the spirits' voices. The cult was restricted to men of the highest head-hunting grade.

Schmitz, *Oceanic Art,* pl. 111

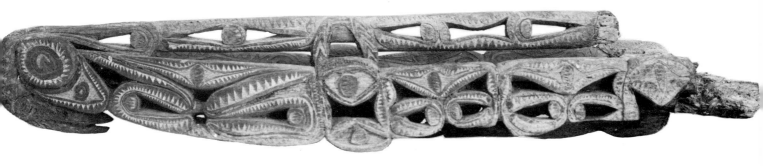

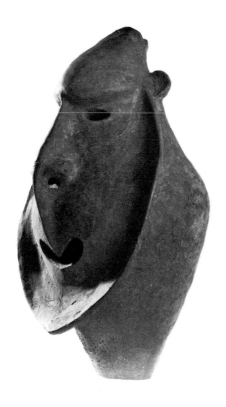

**22.67 CANOE PROW (i dap)**

Wood, paint
161.3 (63½) long
Papua New Guinea, East Sepik Province, May
River: Iwam
Collected by Stan Moriarty, about 1960

Private collection, New York

The canoe prows of the Iwam differ from those
of the middle Sepik River in showing not a
naturalistic image but a grouping of openwork,
apparently abstract designs. These are the
staples of Iwam art, also used as shields and
bark paintings. Each element, however, is at-
tributed a naturalistic significance (a bird's eye
or beak, crocodile teeth, animal tails, and so
on) and the combinations are apparently of
totemic significance.

**22.68 HEAD (yina)**

Clay
42 (16½) high
East Sepik Province, Ambunti Mountains:
Kwoma

Private collection, New York

Much pottery was made in New Guinea, but
relatively little ceramic sculpture. The greatest
practitioners of this art were the Kwoma and
Nukuma people, who made it for ritual use in
their yam-harvest cults. Pottery heads are in-
deed said to have been the original models for
the wooden ones also used today (see no.
22.70).

This head, with several others, was collected
from Yambun, a village of the river-dwelling
Manambu people, who maintained both trad-
ing and fighting relations with the Kwoma. It
was apparently brought back by a Manambu
boy who went to be initiated into Kwoma ritual
about the beginning of this century. Subse-
quently it was assimilated into the Manambu's
own cult of sacred skulls.

Newton, *Crocodile and Cassowary*, fig. 115

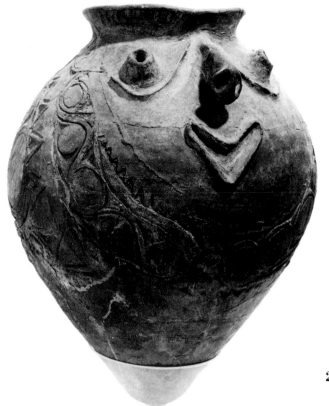

22.69

## 22.69 RESONATOR FOR SACRED FLUTE (*yanikariwai*)

Clay
45.7 (18) high
Papua New Guinea, East Sepik Province, Ambunti Mountains: Kwoma

Private collection, New York

This resonator is part of a wind instrument blown as the accompaniment to ritual performances.

## 22.70 YAM CULT HEAD (*yina*)

Wood, paint
109 (43) high
Papua New Guinea, East Sepik Province, Ambunti Mountains, Tongwindjamp: Kwoma
Collected about 1964

Private collection, New York

The Kwoma and Nukuma people have a series of yam-harvest rituals, at each of which a different type of carved wooden figure is displayed, called *yina, mindja,* and *nokwi*. A representative example of each type is shown here (nos. 22.70, 71, 72), though styles vary between the two tribes, and even among individual villages. The carvings were set up for ritual on containers of newly harvested yams, and their arrangement appears to express mythological and cosmological beliefs.

Kaufmann, "Uber Kunst und Kult";
Newton, *Crocodile and Cassowary*, 83-90

## 22.71 YAM CULT FIGURE (*mindja*)

Wood, paint
137.2 (54) high
Papua New Guinea, East Sepik Province, Mburr: Warasei

The Metropolitan Museum of Art, New York, The Michael C. Rockefeller Memorial Collection of Primitive Art, Gift of Nelson A. Rockefeller, 1965, P 65.30

*Mindja* figures represent sky and thunder spirits and are shown at ceremonies of the same name. The relief diamonds and loops represent a snake crawling along banana leaves.

## 22.72 YAM CULT FEMALE FIGURE (*nokwi*)

Wood, paint
117.5 (46¼) high
Papua New Guinea, East Sepik Province: Warasei

Bruce Seaman, Tahiti

## 22.73 PAIR OF HOUSEPOSTS

Wood
c. 304.8 (c. 120) high
Papua New Guinea, East Sepik Province, Torembi: Sawos

Private collection, New York

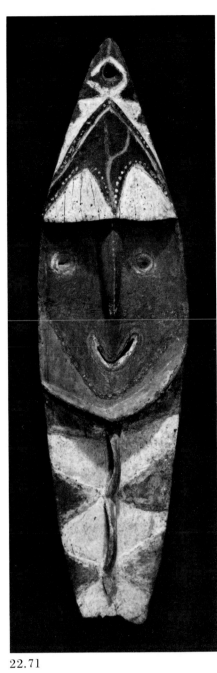

22.71

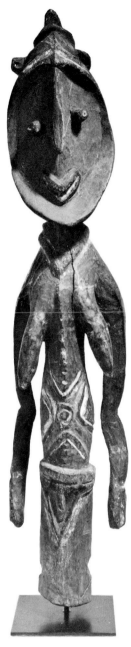

22.72

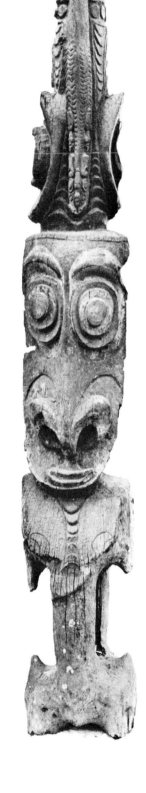

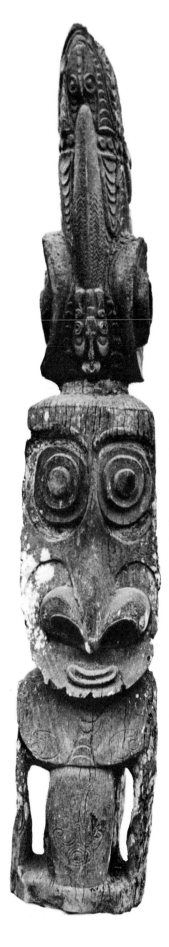

333

# 23 The Highlands

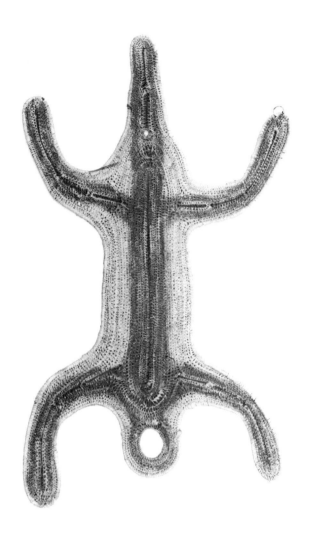

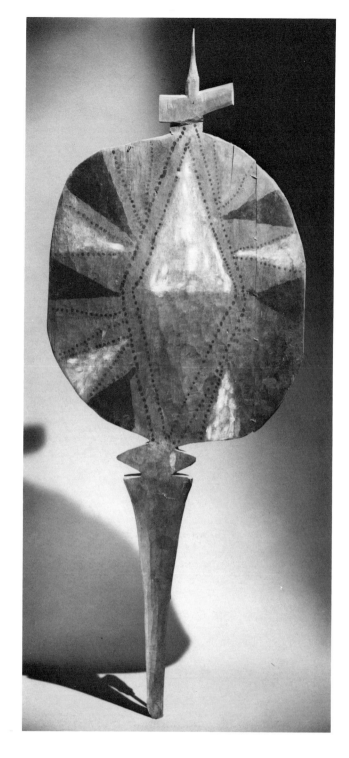

**23.1  CULT FIGURE**

Basketry
80 (31½) high
Papua New Guinea, Southern Highlands Province, Pangia
Collected by Dr. Roger B. Rodrigue, about 1960

Peabody Museum of Salem, Massachusetts, E 56766

**23.2  FIGURE** *(gerua)*

Wood, paint
141 (55½) high
Papua New Guinea, Eastern Highlands Province, Hegeturu: Gimi
Collected by Mr. and Mrs. Leonard B. Glick, 1961-1962

The University Museum, Philadelphia, 62.19.74

## 23.3  SHIELD

Wood, paint
153.8 (60½) high
Papua New Guinea, West Sepik Province,
Olsevip, Tobip-Bolangon Hamlet

Rhys Carpenter, Southampton, New York

Mr. Carpenter, who collected this shield, gives
the following information:

This shield was owned by Biraksok,
known as Biraksogem, son of Kavomnok,
grandson of Fakaelim. The shield was used
in the five Bolovip wars that could be re-
membered. (Bolovip was the largest hamlet
group in the area.) The shield would be
placed at the farthest extent of the "friendly"
land: at any point beyond the shield, a man
was liable to harm; at any point behind, he
was protected.

The magic stone (*moi'im*) in the bag hung
from the tip of an imbedded spear point near
the center of the shield is reported to be a
piece of stone held in Telefomin; the stone
fell into a river when the house where it was
kept was burned during a fight. It is reported
that pieces of this stone can still be found in
streams. The stone plays a central part in
two chants, one for curing internal ailments
and one for external sores and wounds.

The border of the central feature repre-
sents a waterfall, and the area enclosed is
water; the diamond is a navel. The serrated
edge is the long strands of the tail of a bird of
paradise.

# 24 The Northeast Coast

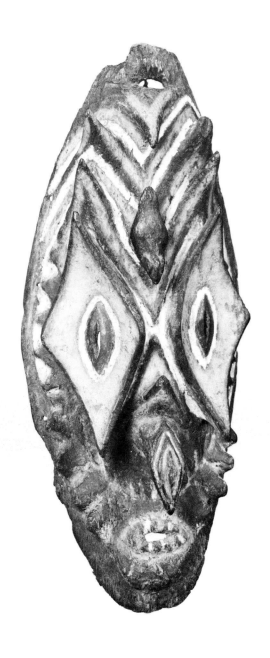

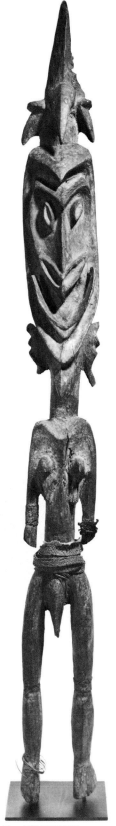

**24.1 MASK**

Wood, paint
65.4 (25¾) high
Papua New Guinea, Madang Province, Guam
River: Breri

Bruce Seaman, Tahiti

**24.2 FIGURE**

Wood, paint, cane belt, bark cloth
158.1 (62¼) high
Papua New Guinea, Madang Province, Ramu
River: Rao

Bruce Seaman, Tahiti

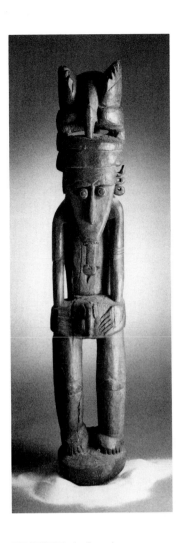

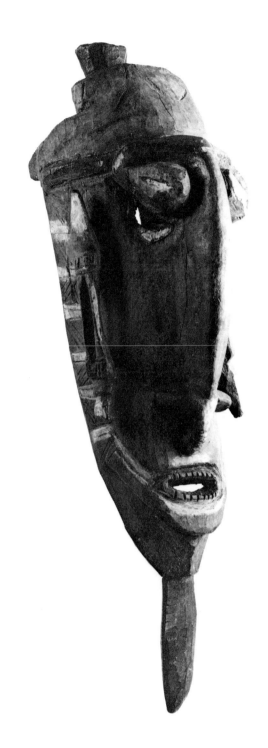

**24.3  FIGURE** *(telum)*

Wood
126 (49½) high
Papua New Guinea, Madang Province, Astrolabe Bay
Collected by Samuel Fénichel, 1891-1893
Formerly the Ethnographical Museum, Budapest

The St. Louis Art Museum, Gift of Mr. and Mrs. Morton D. May

*Telum* were figures of important ancestors, acting as media for their spirits when given offerings. They seem to have had a protective function. The protrusions from their mouths, as in this example, represent war-charms held in the teeth. Posture and the bird surmounting the head—although the style is distinctive—indicate a relationship between Astrolabe Bay and the upper Ramu River (no. 24.2) extending as far as the Yuat River (no. 22.19).

Bodrogi, "New Guinean Style Provinces," 39-99

**24.4  MASK**

Wood
66 (24) high
Papua New Guinea, Madang Province, Astrolabe Bay, Bongu
Collected by Samuel Fénichel, 1891-1893

The Ethnographical Museum, Budapest, 8932

Bodrogi, *Oceanian Art*, pl. 31

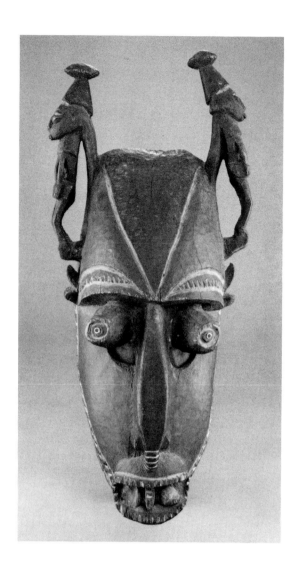

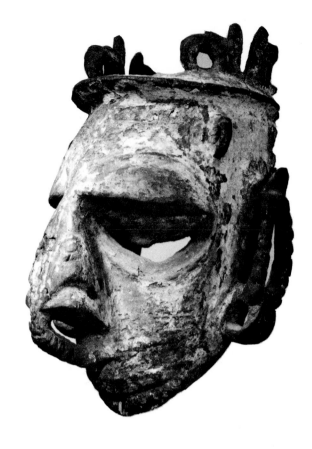

**24.5   MASK** *(asa kate)*

Wood
54.5 (21½) high
Papua New Guinea, Madang Province, Astrolabe Bay, Bongu?

The Minneapolis Institute of Arts, 78.8

Asa, a mythological monster, was personified by masks *(kate)* worn by dancers at initiation ceremonies, which formally declared the novices mature at their conclusion. This mask is probably unique in its use of a pair of figures on the head.

Bodrogi, "Some Notes," 91-184

**24.6   MASK**

Wood, paint
40.6 (16) high
Papua New Guinea, Madang Province, Astrolabe Bay
Collected by Reverend Tauber, 1925

Raymond and Laura Wielgus Collection, Tucson, 57-57

Museum of Primitive Art, *Wielgus Collection*, pl. 6

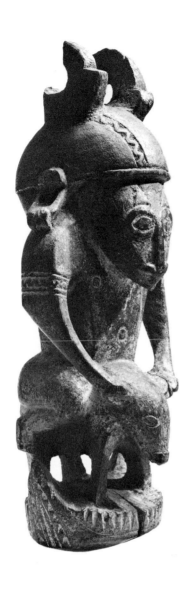

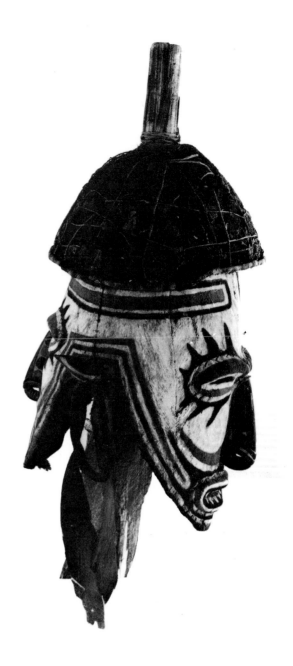

## 24.7 SUSPENSION HOOK, FIGURE ON PIG

Wood
36 (14⅛) high
Papua New Guinea, Morobe Province, Tami Islands

Museum Rietberg Zurich (Collection von der Heydt), Zurich, RME 135

Bühler, *Art of Oceania*, 152

## 24.8 HOUSE POST

Wood
183 (72) high
Papua New Guinea, Morobe Province, Tami Islands

Hamburgisches Museum für Völkerkunde, Hamburg, 1665 I

Tischner and Hewicker, *Oceanic Art*, pl. 31

## 24.9 MASK *(tago)*

Bark cloth on frame, paint
69 (27⅛) high
Papua New Guinea, Morobe Province, Tami Islands
Collected by Lajos Biró, 1899-1900

The Ethnographical Museum, Budapest, 64-277

Bodrogi, *Oceanian Art*, pl. 45

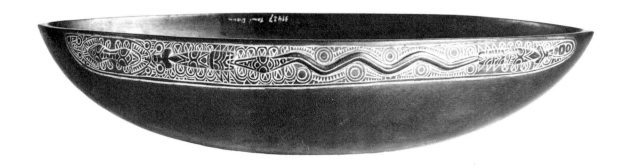

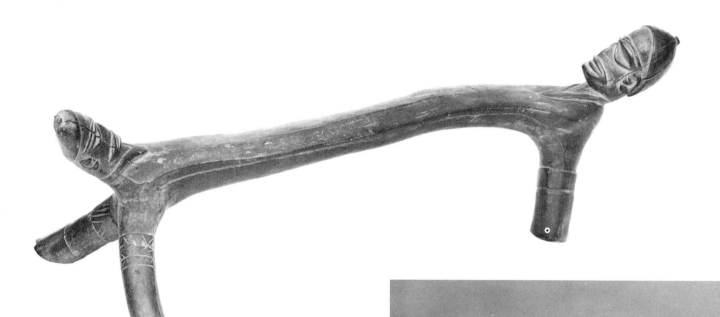

**24.10 BOWL**

Wood
54.5 (21½) long
Papua New Guinea, Morobe Province, Tami
Islands
Collected by C. Dann, 1916

Linden-Museum, Stuttgart, 91427

**24.11 HEADREST**

Wood
71 (28) long
Papua New Guinea, Morobe Province: Atsera
Collected by D. Carleton Gajdusek, 1974

Peabody Museum of Salem, Massachusetts,
E 54614

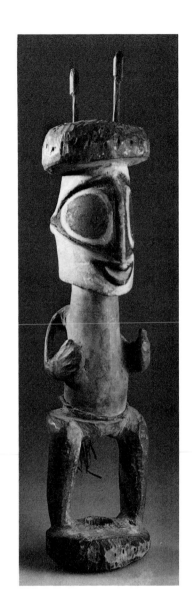

**24.12 FIGURE (jawik)**

Wood, paint
41.5 (16⅜) high
Papua New Guinea, Morobe Province, Rumu
River: Pasum

The St. Louis Art Museum, Gift of Mr. and Mrs.
Morton D. May, 56.1977

This figure has been attributed to the Sulka of
New Britain but is more probably from the
Pasum people. In this case it is a *jawik* figure,
attached to a large shieldlike construction on
the back of a male dancer and made to slide up
and down by the manipulation of strings.

Schmitz, *Wantoat*, 147-153

**24.13 HOUSE POST**

Wood
290 (114) long
Papua New Guinea, Morobe Province, Oertzen
Mountains, Balai
Collected by Eugen Werner, 1908

Historisches Museum, Bern, Pap. 234

Werner, *Kaiser-Wilhelms-Land*, 59; Rousseau,
*L'Art océanien*, fig. 128

# 25 The Gulf of Papua

### 25.1 MASK *(eharo)*

Bark cloth, paint, cane, fiber
158.5 (62⅜) high
Papua New Guinea, Gulf Province: Elema

The Museum of Cultural History, University of
California at Los Angeles, Gift of the Wellcome
Trust, X 65.4344

*Eharo* masks appeared to celebrate the accom-
plishment of prescribed stages of preparation
for the great Elema mask ceremony called
*hevehe*. They represent totemic creatures and
mythological beings; some are deliberately in-
tended to be comic.

### 25.2 ANCESTRAL BOARD *(hohao)*

Wood, paint
139.7 (55) high
Papua New Guinea, Gulf Province: Elema

Faith and Martin Wright, New York

### 25.3 BOARD *(kaiaimunu)*

Wood, paint
112 (44⅛) high
Papua New Guinea, Gulf Province, Paiya:
Kerewa
Collected by A. C. Haddon, 1914

University Museum of Archaeology and An-
thropology, Cambridge, 1916.143.41

Haddon, "The Agiba Cult"; Schmitz, *Oceanic
Art,* color pl. 26

### 25.4 BOARD *(gope)*

Wood
119 (46⅞) high
Papua New Guinea, Gulf Province, Goaribari:
Kerewa
Collected by A. B. Lewis, 1909-1913

Field Museum of Natural History, Chicago,
142703

Newton, *Papuan Gulf,* fig. 117

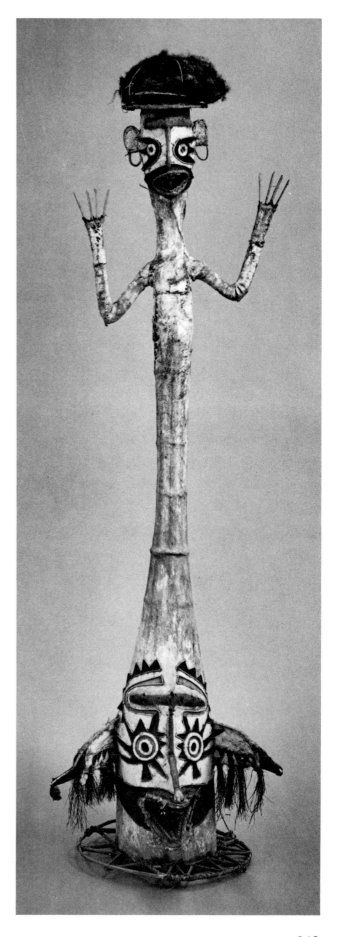

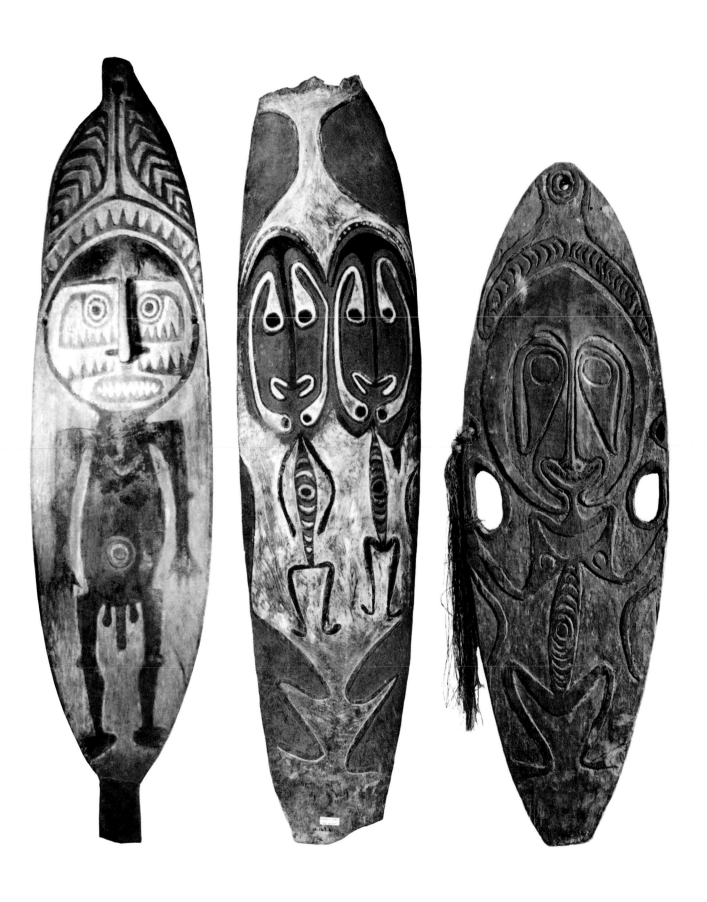

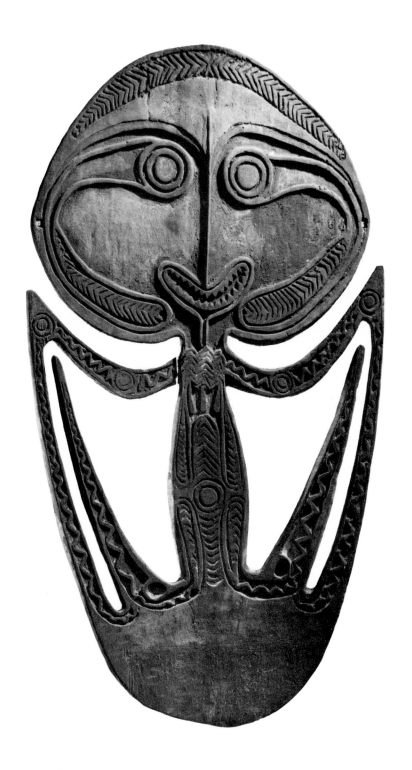

**25.5  SKULL RACK (*agibe*)**

Wood, paint
142 (55⅞) high
Papua New Guinea, Gulf Province, Omati
River, Paia'a: Kerewa

The Metropolitan Museum of Art, New York,
The Michael C. Rockefeller Memorial Collec-
tion of Primitive Art, Gift of Nelson A. Rocke-
feller, 1969, P. 62.88

A pair of *agibe*, one being male, the other
female, was owned by most clans. They were
set on small platforms in the men's houses;
ancestral skulls and head-hunting trophies
placed before them were attached to the up-
right prongs by cane loops. This is probably the
largest example known.

Newton, *New Guinea Art*, pl. 108

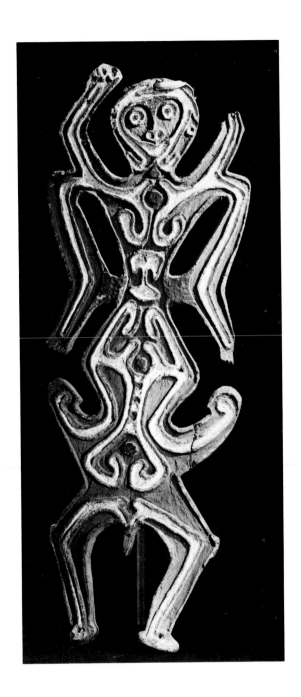

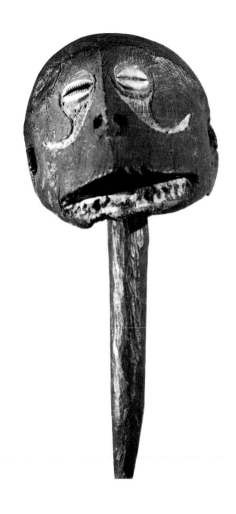

## 25.6 FIGURE *(bioma)*

Wood, paint
67.4 (26½) high
Papua New Guinea, Gulf Province, Era River, Koiravi
Collected by John W. Vandercook, 1929

The Brooklyn Museum, New York, gift of John W. Vandercook, 51.118.9

Each small figure of this kind was associated with a pig skull (an important hunting trophy), the legs being fitted into the eye sockets.

Newton, *Papuan Gulf*, fig. 168

## 25.7 HEAD

Wood, paint, cowrie shells
33 (13) high
Papua New Guinea, Gulf Province, probably Wapo Creek: Gope

University of East Anglia, Norwich, England, Robert and Lisa Sainsbury Collection, 1949 UEA 153

Trophy skulls, or carved equivalents of them such as this, were carried in dances in the Gulf of Papua area.

University of East Anglia, *Sainsbury Collection*, 145, no, 227

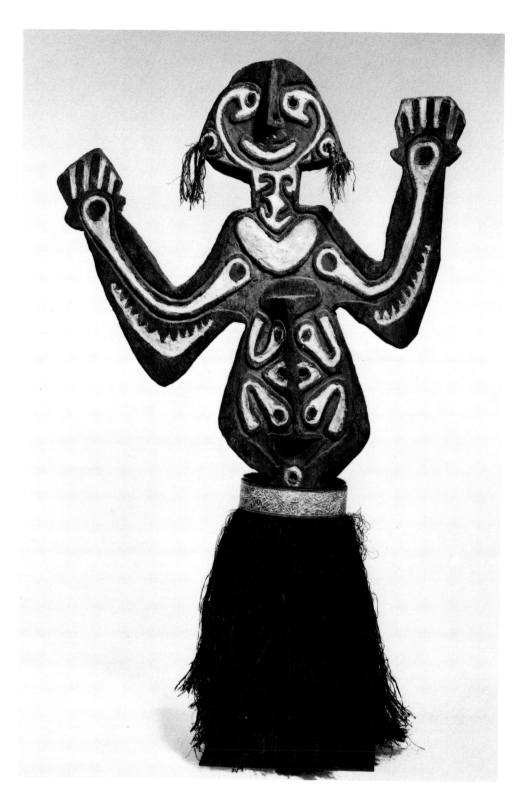

**25.8 FIGURE** *(ereveki)*

Wood, paint, fiber, bark belt, dagger, ornaments
147.3 (58) high
Papua New Guinea, Gulf Province, Urama Island, Kinomeri: Iwaino

Bruce Seaman, Tahiti

Ereveki, or Igovake, was a sky spirit who invented head hunting and was represented by such figures by several tribes.

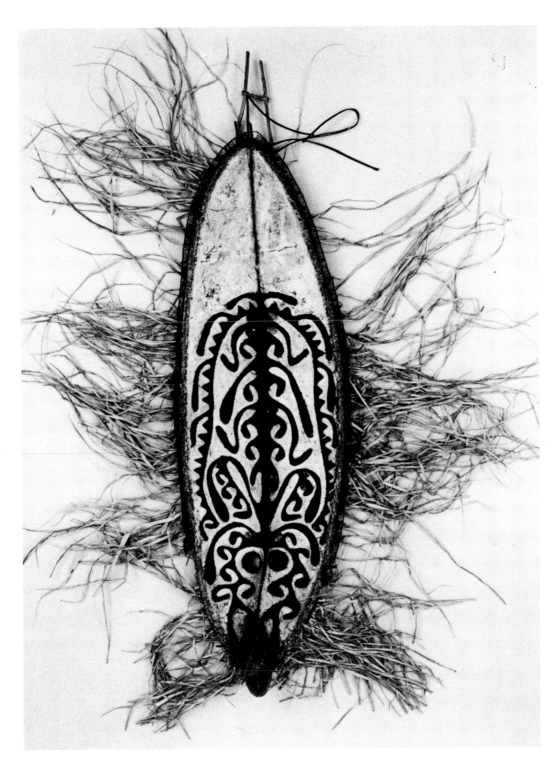

**25.9   MASK** *(keweke)*

Bark cloth, cane, paint
198 (78⅛) high
Papua New Guinea, Gulf Province, Urama Island: Iwaino
Collected by Frank Hurley, and A. R. McCulloch, 1922

By courtesy of the Australian Museum Trust, Sydney, E 27690

This large, oval mask form is typical of the gulf tribes and represents bush spirits among the western groups. The Elema use the same form, but there it represents spirits of the sea.

Hurley, *Pearls and Savages*, facing p. 210

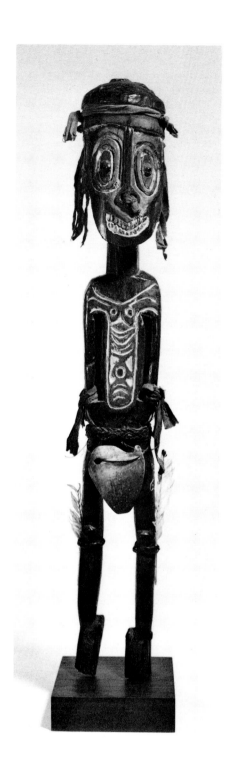

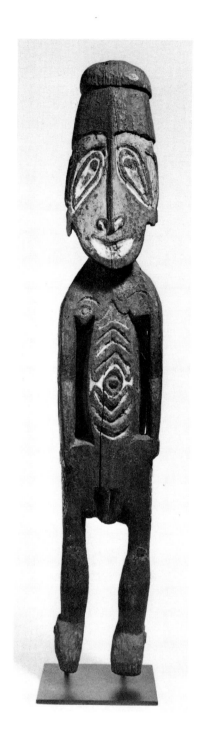

**25.10  MALE FIGURE**

Wood, paint, seeds, fiber, shell, feathers, cloth
108.6 (42¾) high
Papua New Guinea, Gulf Province: Tura-marubi

Bruce Seaman, Tahiti

**25.11  FIGURE**

Wood, paint, seeds, fiber, shell, cloth
101 (39¾) high
Papua New Guinea, Gulf Province, Turama River: Turamarubi

Bruce Seaman, Tahiti

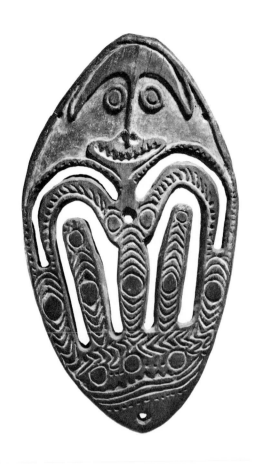

**25.12  SKULL RACK (*agibe*)**

Wood, paint
70 (27½) high
Papua New Guinea, Gulf Province, Bamu
River

Bruce Seaman, Tahiti

**25.13  DECORATED SKULL**

Skull, wood, seeds
23 (9½) long
Papua New Guinea, Gulf Province, Bamu
River
Collected by P. G. Black, before 1903

Buffalo Museum of Science, New York,
C11460

Linton and Wingert, *Arts of the South Seas*, 99

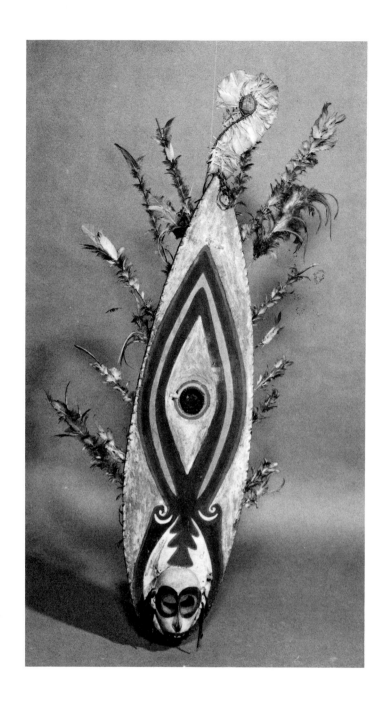

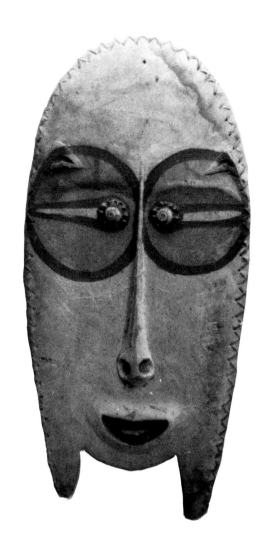

**25.14  MASK**

Wood, seeds, feathers, paint
116 (45⅝) high
Papua New Guinea, Gulf Province, Aramia
River, Kubu: Gogodala
Collected by G. Landtman, 1910-1912

University Museum of Archaeology and Anthropology, Cambridge, 1912.171.312

The Gogodala had a highly developed system of specific designs *(tao)* which were used heraldically on canoes, paddles, drums, and—as in this case—masks.

**25.15  HEAD ORNAMENT** *(ikewa)*  Color plate 13

Wood, paint, seeds
59 (23¼) high
Papua New Guinea, Gulf Province: Gogodala
Collected by Paul Wirz, 1931

Tropenmuseum, Amsterdam, 2670-381

Rijksmuseum Amsterdam, *Papoea-kunst*, 3

**25.16  FIGURE** *(mimia)*

Wood
127 (50) high
Papua New Guinea, Western Province, Fly
River area
Collected by the Major Cook Daniels expedition, 1904

Lent by the Trustees of the British Museum,
London, 1906.10-13.41

*Mimia* figures are displayed in the men's
houses at initiatory ceremonies and ordeals
and made to "dance" by the manipulation of
ropes. They are also carried in war canoes on
raids, to weaken, by their magic, the strength
of the enemy.

Newton, *Papuan Gulf*, fig. 66

**25.17  FEMALE FIGURE** *(mimia)*

Wood
111 (43¾) high
Papua New Guinea, Western Province, probably Kiwai Island
Collected from E. Baxter Riley by A. B. Lewis,
1909-1913

Field Museum of Natural History, Chicago,
142781

Newton, *Papuan Gulf*, fig. 71

351

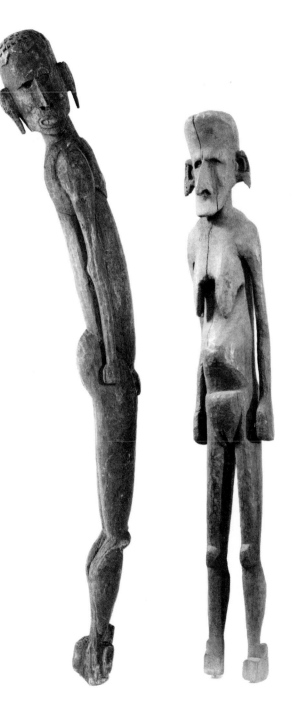

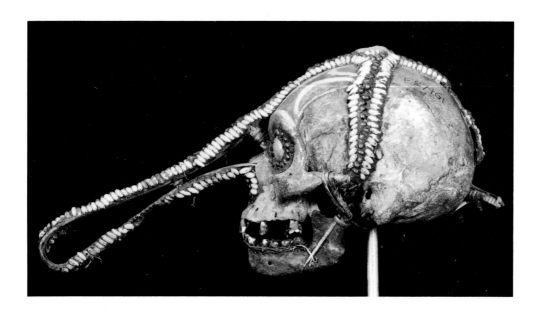

## 25.18  DECORATED SKULL

Human skull, cane, seeds, paint
39 (15⅜) long
Papua New Guinea, Western Province, Lake
Murray area
Acquired 1923

By courtesy of the Australian Museum Trust,
Sydney, E27461

Probably collected by Hurley and McCulloch;
see Hurley, *Pearls and Savages*, pls. opp.
pp. 18, 406

## 25.19  EMBLEM OF CROCODILE (*dema Ugu*)

Wood, paint, fiber, feathers
100 (39⅜) high
Irian Jaya, Southern Division: Marind-anim

Rijksmuseum voor Volkenkunde, Leiden,
2008-14

For the Marind-anim, the *dema* were the an-
cestors who had distributed to their descen-
dants the totemic things, including all animals
and plants. The reenactment of the myths
about them, by men in rich symbolic attire,
formed an important and spectacular feature of
the major cults. This emblem is part of the
costume of Ugu, a man-crocodile *dema* who
was the originator of sorcery.

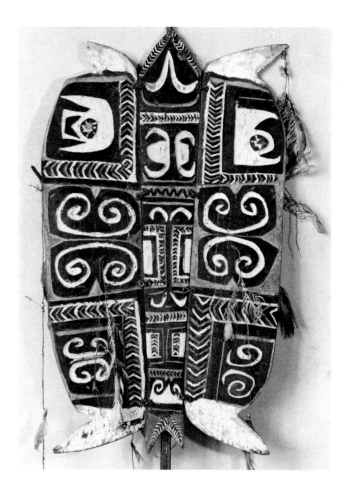

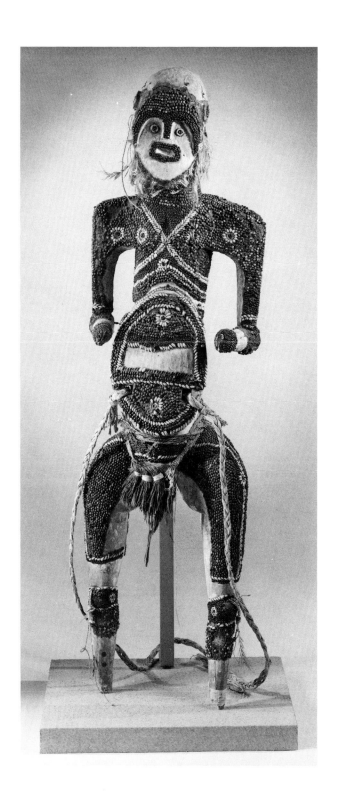

**25.20  MALE FIGURE *(koneim dema)***

Wood, seeds, paint
152.5 (60) high
Irian Jaya, Southern Division: Marind-Anim
Probably collected by Paul Wirz

Los Angeles County Museum of Natural History, A.1931.31-61

Koneim is the *dema* of coconut palms and is characterized by the grossly swollen belly full of the coconuts he has stolen. This figure was carried perched on the shoulders of a costumed *dema* dancer. It appears to be one which was photographed *in situ* by Paul Wirz, at which time it also had an enormous phallus and forearms with hands and extended fingers (Barry Craig, personal communication).

353

**25.21  MASK**

Turtleshell, seeds, paint
33 (13) high
Papua New Guinea, Torres Strait

Pitt Rivers Museum, University of Oxford,
England, 67-3316

**25.22  MASK**

Turtleshell, sennit, wood, human hair, casso-
wary feathers
51 (20) high
Papua New Guinea, Torres Strait

Raymond and Laura Wielgus Collection,
Tucson, 61-230

Rousseau, *L'Art océanien*, fig. 115; Arts Club
of Chicago, *Wielgus Collection*, no. 35

**25.23  MASK**

Turtleshell
117 (46) high
Papua New Guinea, Torres Strait, Mabuiag
Island
Collected and given by Mrs. Goodwin, April
1890

Peabody Museum of Salem, Massachusetts, E
2135

Linton and Wingert, *Arts of the South Seas*, 128

**25.24  MASK**

Wood, hair, paint
70 (27½) high
Papua New Guinea, Torres Strait, Saibai Island
Collected before 1900. Formerly in the Mel-
bourne Aquarium collection

Barbier-Müller Collection, Geneva, 4241

The wooden masks were worn for the *mawa*
ceremony, held about September to celebrate
the harvesting of a type of fruit. The masker
wore also a voluminous coconut-leaf costume
and appeared at night to inspire a state of mock
terror.

Haddon and others, *Reports*, 4:297-298,
5:348-349

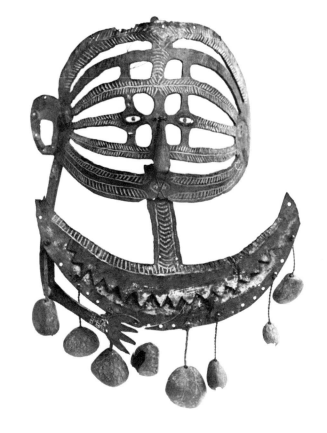

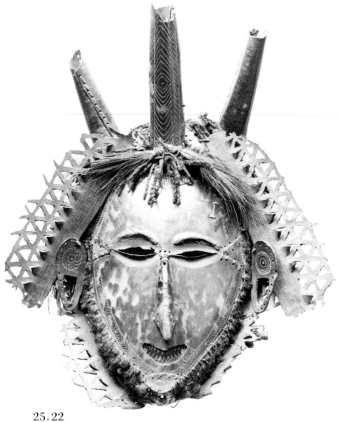

25.22

354

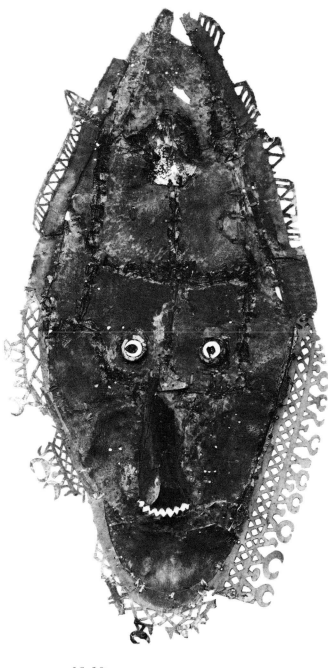

25.23

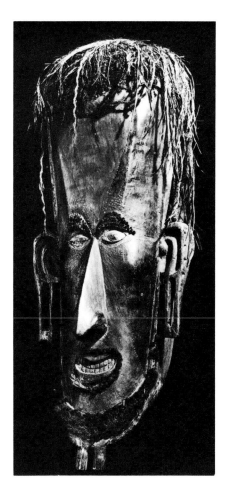

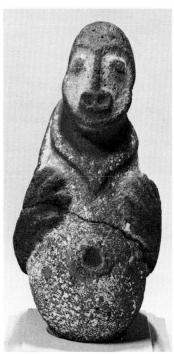

**25.25 FIGURE, RAIN CHARM (*doiom*)**

Lava, paint
19.5 (7⅝) high
Papua New Guinea, Torres Strait, Easter Island
Collected by A. C. Haddon

University Museum of Archaeology and Anthropology, Cambridge, Z 9659

*Doiom* represent male spirits invoked in rain-making magic.

Haddon and others, *Reports*, 6:194-201

# 26 The Southeast

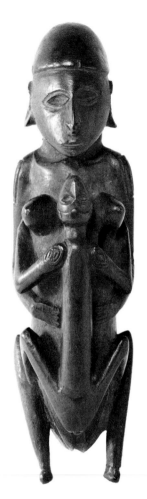

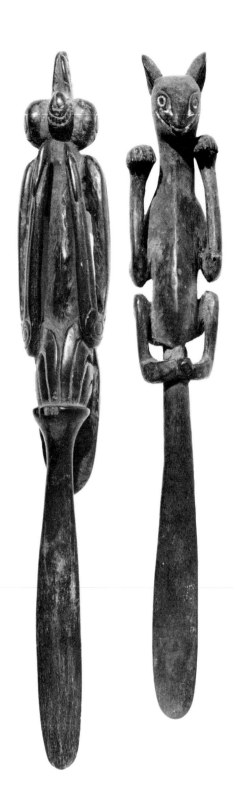

**26.1   COPULATION GROUP**

Wood
25.4 (10) high
Papua New Guinea, Milne Bay Province, East
Cape
Collected by Samuel MacFarlane, about 1875

Lent by the Trustees of the British Museum,
London, BM +2500

**26.2   LIME SPATULA WITH PRAYING
MANTIS**

Wood
38.4 (15⅛) long
Papua New Guinea, Milne Bay Province,
South Cape

Lent by the Trustees of the British Museum,
London, BM +3848

Edge-Partington, *Album*, part 1, pl. 281, no. 8

**26.3   LIME SPATULA WITH WALLABY**

Wood
34.2 (13½) long
Papua New Guinea, Milne Bay Province
Museum acquisition, 1886

Lent by the Trustees of the British Museum,
London, BM +3409

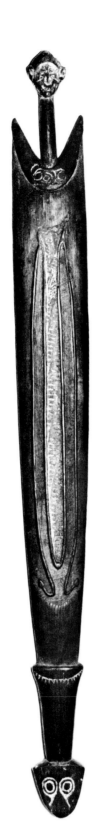

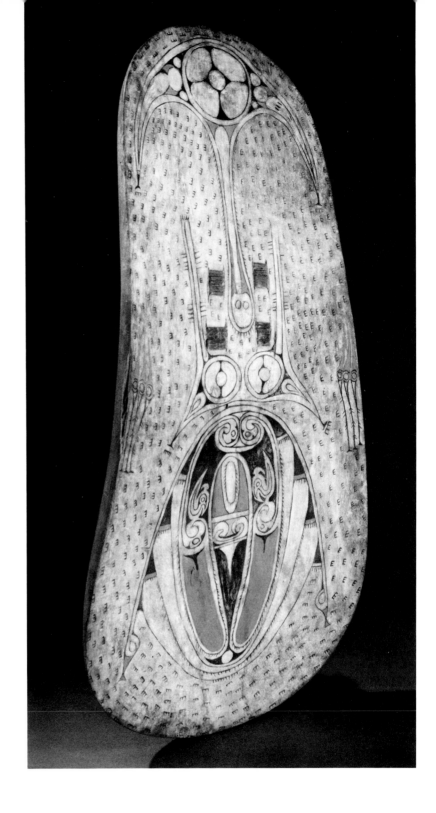

**26.4 CLUB**

Wood
78.5 (30⅞) long
Collected by Admiral John Erskine, on H.M.S.
*Havanna,* 1850
Papua New Guinea, Milne Bay Province

Otago Museum, Dunedin, New Zealand, W. O.
Oldman Collection 050.132

**26.5 SHIELD**

Wood, paint, cane
84 (33⅙) high
Papua New Guinea, Milne Bay Province, Tro-
briand Islands

The St. Louis Art Museum, Gift of Mr. and Mrs.
Morton D. May, 49.1977

Parsons, *Ritual Arts,* pl. 151

357

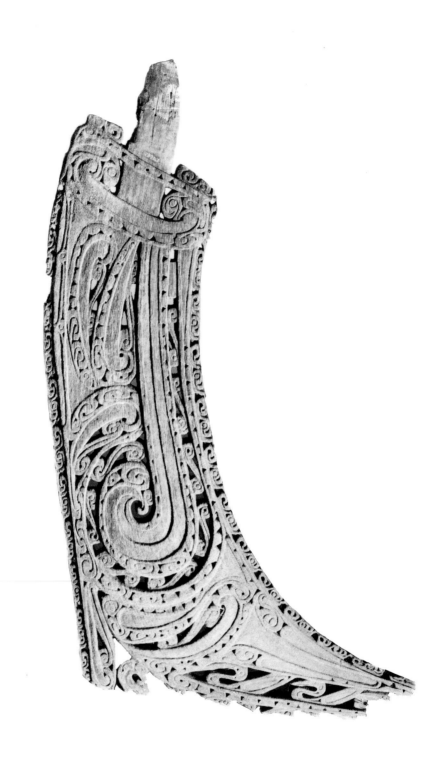

**26.6  CANOE PROW CARVING**

Wood
121 (47⅝) high
Papua New Guinea, Milne Bay Province
Collected by James Chalmers, before 1901

Field Museum of Natural History, Chicago,
275882

# References

All bibliographical references appearing in the catalogue are given in abbreviated form, by author and shortened title. The full references appear alphabetically by author below.

Amherst, Lord, and Thomson, Basil. *The Discovery of the Solomon Islands*. 2 vols. London, 1901.

Archey, Gilbert. *The Art Forms of Polynesia*. Auckland, 1965.

Arts Club of Chicago. *The Raymond and Laura Wielgus Collection*. Chicago, 1966.

Australian National Gallery. *Genesis of a Gallery. Part 2*. Canberra, 1978.

van Baaren, Th. P. *Korwars and Korwar Style*. Art in Its Context. Museum Series: vol. 2. Mouton, The Hague, Paris, 1968.

Badner, Mino. "Some Evidences of Dong-Son Derived Influence in the Art of the Admiralty Islands." In *Early Chinese Art and Its Possible Influence in the Pacific Basin*, edited by N. Barnard, *3*: 597-630. New York, 1972.

Baltimore Museum of Art. *The Wurtzburger Collection of Oceanic Art*. Baltimore, 1956.

Barbier, Jean-Paul. *Arts d'Afrique, d'Océanie, et d'Amérique*. Geneva, 1977.

————. *Indonésie et Mélanésie*. Geneva, 1977.

Barrow, T. T. *Art and Life in Polynesia*. London, 1971.

Barton, F. R. "Note on Stone Pestles from British New Guinea." *Man, 8* (1908): art. 1, pp. 1-2.

Bellwood, Peter. *Man's Conquest of the Pacific*. Oxford, 1979.

Bodrogi, Tibor. "New Guinea Style Provinces: the Style 'Astrolabe Bay'." *Opuscula Ethnologica Memoriae Ludovici Biro Sacra* (1959), 39-99.

————. *Oceanian Art*. Budapest, 1959.

————. "Some Notes on the Ethnography of New Guinea." *Acta Ethnologica, 3* (1953): 91-348.

————. "Zür Ethnographie der Vitu- (French-) Inseln." *Baessler-Archiv,* n.s. 19 (1971): 47-71.

Boltin, Lee, and Newton, Douglas. *Masterpieces of Primitive Art. The Nelson A. Rockefeller Collection*. New York, 1978.

Bowler, J. M.; Jones, R.; Allen, H.; and Thorne, A. G. "Pleistocene Man in Australia: A Living Site and Human Cremation from Mungo, Western New South Wales." *World Archaeology, 2* (1971): 39-60.

Bramall, Elsie. "Prehistoric Stone Objects from New Guinea." *Australian Museum Magazine, 7* (1939): 40-42.

Brigham, William P. *Additional Notes on Hawaiian Feather Work*. Bishop Museum Memoir, 1, No. 5. 1903

————. *Hawaiian Feather Work*. Bishop Museum Memoir 1, No. 1. 1899

Buck, Peter H. (Te Rangi Hiroa). *Arts and Crafts of Hawaii*. Honolulu, 1957.

Bühler, Alfred. *Heilige Bildwerke vom Neuguinea*. Basel, 1958.

————. "Kultkrokodile vom Korewori (Sepik Distrikt, Territorium Neuguinea)." *Zeitschrift für Ethnologie, 86* (1961): 183-207.

————. *Art of Oceania*. Zürich, 1969.

Cook, James. [*Atlas* of plates for] *A Voyage towards the South Pole, and round the World . . . in the Years 1772, 1773, 1774 and 1775*. 2 vols. London, 1777.

Corbin, George. *The Art of the Baining of New Britain*. Ann Arbor, 1976.

Cox, J. Halley, and Davenport, William H. *Hawaiian Sculpture*. Honolulu, 1974.

Cranstone, B. A. L. "A Unique Tahitian Figure." *The British Museum Quarterly, 26* (1963-1964).

————. *Melanesia. A Short Ethnography*. London, 1961.

Damm, Hans. "Sacrale Statuen aus dem Gebiet der Arawe (Arue) in Süd-Neubrittanien (Südsee)." *Annals of the Náprstek Museum, Prague, 1* (1962): 29-36.

Danielsson, B. *La Découverte de la Polynésie*. Paris, 1972.

Davenport, William H. "Sculpture from La Grande Terre." *Expedition, 7* (1964): 2-19.

Dodd, Edward. *Polynesian Art. The Ring of Fire*. Vol. 1. New York, 1967.

Duff, Roger. *No Sort of Iron*. Christchurch, New Zealand, 1969.

Dwyer, J. P. and Dwyer, E. B. *Traditional Art of Africa, Oceania and the Americas*. San Francisco, 1973.

Edge-Partington, James. *Album of the Weapons, Tools, Ornaments, Articles of Dress, etc., of the Natives of the Pacific Islands*. 3 vols. London, 1895-1898.

Egloff, B. *Archaeological Investigations in the coastal Madang Area and on Eloaue Island of the St. Matthias Group*. Records of the Papua New Guinea Museum No. 5. Port Moresby, 1975.

Emory, Kenneth E. *Archaeology of Nihoa and Necker Island*. Bernice P. Bishop Museum Bulletin 53. Honolulu, 1928.

————. "A Kaitaia Carving from South-east Polynesia?" *Journal of the Polynesian Society*, 1931, 253-254.

Errington, F. K. *Karavar, Masks and Power in a Melanesian Ritual*. Ithaca and London, 1974.

Ferrando Pérez, Roberto. "Zeichnungen von Südsee-Eingeborenen dem frühen 17. jahrhundert." *Zeitschrift für Ethnologie*, *79* (1954): 75-81.

Force, Roland W., and Force, Maryanne. *The Fuller Collection of Pacific Artifacts*. London, 1971.

Foy, W. *Tanzobjekte vom Bismarck Archipel, Nissan und Buka. Publikationen 13*. Dresden, 1900.

Freeman, J. D. "The Polynesian Collection of Trinity College, Dublin, and the National Museum of Ireland." *Journal of the Polynesian Society, 58* (1949): 1-18.

Garanger, J. *Archéologie des Nouvelles Hébrides*. Paris, 1972.

Gifford, Phillip C. "The Iconology of the Uli Figure of Central New Ireland." Ph.D. dissertation, Columbia University, 1974.

Gilliard, E. Thomas. "To the Land of the Headhunters." *National Geographic Magazine, 108* (1955): 437-486.

Glover, I. "Island Southeast Asia and the Settlement of Australia." In *Archaeological Theory and Practice*, edited by D. E. Strong. London, 1973.

Green, Roger C. "Lapita Pottery and the Origins of Polynesian Culture." *Australian Natural History*, June 1973, 332-337

————. *A First Culture History of the Solomon Islands*. Auckland, 1977.

Guiart, Jean, *L'Art autochtone de Nouvelle-Calédonie*. Noumea, 1953.

————. *The Arts of the South Pacific. The Arts of Mankind*. (New York, 1963.

————. "Les Effigies réligieuses des Nouvelles-Hébrides. Etude des collections du Musée de l'Homme." *Journal de la Societé des Océanistes, 5* (1949): 1-36.

————. *Mythologie du masque en Nouvelle Calédonie*. Paris, 1966.

Haberland, Eike. *The Caves of Karawari*. New York, 1968.

361

Haberland, Eike, and Seyfarth, S., *Die Yimar am Oberen Korowori (Neuguinea)*. Wiesbaden, 1974.

Haddon, A.C. "The Agiba Cult of the Kerewa Culture." *Man, 18* (1918): art. 99, pp. 177-183.

Haddon, A. C., and Layard, John. "*Ethnology.*" In *Reports . . . British Ornithologists' Union Expedition and the Wollaston Expedition in Dutch New Guinea, 1910-1913*. Vol 2, pt. 19.

Haddon, A. C. et al., *Reports of the Cambridge Anthropological Expedition to Torres Straits*. 6 vols. Cambridge, 1901-1935.

Harrisson, Tom. *Savage Civilization*. New York, 1937.

Heyerdahl, Thor. *The Art of Easter Island*. London, 1976.

Hogbin, Ian. *The Island of Menstruating Men. Religion in Wogeo, New Guinea*. London and Toronto, 1970.

Hoogerbrugge, J. *Asmat Art. 70 Years of Asmat Woodcarving*. Breda, 1977.

————. *The Art of Woodcarving in Irian Jaya*. Jayapura, New Guinea, 1977.

Hurley, Frank. *Pearls and Savages*. New York, 1924.

Idiens, Dale. "A Recently Discovered Figure from Rarotonga." *Journal of the Polynesian Society*, 1976, 359-366.

Kaeppler, Adrienne L. "*Artificial Curiosities*": Being an Exposition of Native Manufactures Collected on the Three Pacific Voyages of Captain James Cook, R.N. . . . Bishop Museum Special Publication 65. Honolulu, 1978.

————. "*L'Aigle* and H.M.S. *Blonde:* the Use of History in the Study of Ethnography." *Journal of the Hawaiian Historical Society, 12* (1978): 28-44.

————. *Eleven Gods Assembled: An Exhibition of Hawaiian Wooden Images*. Honolulu, 1979.

————. "Feather Cloaks, Ship Captains and Lords." *Bishop Museum Occasional Papers, 24* (1970).

Kaufmann, Christian. "Uber Kunst und Kult bei den Kwoma and Nukuma (Nord-Neuguinea)." *Bericht über das Basler Museum für Völkerkunde . . . für das Jahr 1967,* 63-111.

Kooijman, S. *The Art of Lake Sentani*. New York, 1959.

Krämer, O. *Die Málanggane von Tombára*. Munich, 1926.

Laroche, M. "Notes sur quelques Ornements de Pirogue." *Journal de la Société des Océanistes, 5* (1949): 105-115.

Larsson, Karl Erik. *Fijian Studies*. Göteberg, 1960.

Laumann, K. "Geisterfiguren am Mittleren Yuat River in Neuguinea." *Anthropos, 47* (1952): 27-57.

Linden-Museum, Stuttgart. *Mensch und Natur. Mythos und Kunst*. Stuttgart, 1978.

Linton, Ralph. *The Material Culture of the Marquesas Islands*. Honolulu, 1923.

Linton, Ralph, and Wingert, Paul S. *Arts of the South Seas*. New York, 1946.

London, Charmian K. *The Log of the Snark*. New York, 1925.

Mead, S. M., ed. *Exploring the Art of Oceania*. Honolulu, 1979.

Mead, S. M.; Birks, L.; Birks, H.; and Shaw, E. *The Lapita Pottery Style of Fiji and Its Associations*. Polynesian Society Memoir, No. 38. 1973.

Meyer, A., and Parkinson, R. *Schnitzerei und Masken vom Bismarck-Archipel. Publikationen 10*. Dresden, 1895.

Moschner, Irmgard. "Die Wiener Cook-Sammlung: Südsee-Teil." *Archiv für Völkerkunde, 10* (1955).

Museum für Völkerkunde, Basel. *Ethnographische Kostbarkeiten*. Basel, 1970.

Museum of Primitive Art, New York. *The Raymond Wielgus Collection*. New York, 1960.

——. *The Herbert Baker Collection*. New York, 1969.

Nevermann, H. *Masken und Geheimbunden in Melanesien*. Berlin, 1933.

Newton, Douglas. *Art Styles of the Papuan Gulf*. New York, 1961.

——. *Malu*. New York, 1963.

——. *New Guinea Art in the Collection of The Museum of Primitive Art*. New York, 1970.

——. *Crocodile and Cassowary*. New York, 1971.

Parsons, Lee. *Ritual Arts of the South Seas*. St. Louis, 1975.

Phelps, Steven. *Art and Artifacts of the Pacific, Africa and the Americas The James Hooper Collection*. London, 1976.

Poignant, Roslyn. *Oceanic Mythology*. London, 1967.

Portier, A., and Poncetton, F. *Les Arts sauvages: Océanie*. Paris, 1930.

Reche, O. *Der Kaiserin-Augusta-Fluss*. Hamburg, 1913.

Rijksmuseum, Amsterdam. *Papoea-Kunst*. Amsterdam, 1966.

Rousseau, Madeleine. *L'Art océanien. Sa Présence*. Paris, 1951.

Schindler, Gustave, and Schindler, Franyo. *Masks and Sculptures from the Collection of Gustave and Franyo Schindler*. New York, 1966.

Schmitz, Carl A. *Wantoat*. The Hague, 1963.

————. "Steinerner Schalenmörser, Pistille und Vogelfiguren aus Zentral Neuguinea." *Baessler-Archiv*, n.s. vol. 14 (1966): 1-60

————. *Oceanic Art. Myth, Man and Image in the South Seas*. New York, 1969.

Sarasin, F. *Ethnologie der Neu-Caladonier und Loyalty-Islander: Atlas* [of plates]. Munich, 1929.

Sharp, Andrew. *The Discovery of the Pacific Islands*. London, 1960.

Shutler, R. "Radiocarbon Dating and Oceanic Prehistory." *Archaeology and Physical Anthropology in Oceania*, 13 (1978): 215-228.

Simmons, D.R. *Craftsmanship in Polynesia*. Otago, New Zealand, 1963.

Skinner, H.D. *Comparatively Speaking*. Dunedin, New Zealand, 1974.

Sotheby Parke Bernet & Co. *The George Ortiz Collection of Primitive Works of Art*. London, 1978.

Stevens, H. N. *New Light on the Discovery of Australia*. London, 1930.

Tasman, A. J. *Tasman's Journal of his Discovery of Van Dieman's Land . . . translated by J. E. Heeres*. Amsterdam, 1898.

Tischner, H., and Hewicker, H. *Oceanic Art*. London, 1954.

UNESCO. *The Art of Oceania*. Paris, 1975.

University of East Anglia. *The Robert and Lisa Sainsbury Collection*. Norwich, England, 1978.

Watson, V. D., and Cole, J. D. *Prehistory of the Eastern Highlands of New Guinea*. Seattle and London, 1977.

Wardwell, Allen. *The Sculpture of Polynesia*. Chicago, 1976.

————. *Art of the Sepik River*. Chicago, 1971.

Werner, Eugen. *Kaiser-Wilhelms-Land*. Freiburg, 1911.

White, J. P. *Ol Tumbuna*. Canberra, Australia, 1972.

White, J. P.; Crook, K. A. W.; and Buxton, B. P. "Kosipe: a Late Pleistocene Site in the Papuan Highlands." *Proceedings of the Prehistoric Society*, 36 (1970): 152-170.

Wingert, Paul S. *Art of the South Pacific Islands*. New York, 1953.

Wirz, Paul. "Beitrag zur Ethnologie der Sentanier (Holländisch Neuguinea)." *Nova Guinea, 16* (1928): 251-370.

Photo Credits:

Save for those listed below, all photographs in this catalogue were provided by the lenders to the exhibition. For their assistance and cooperation we are most grateful.

Asselberghs, Brussels: 22.61; Hickey and Robertson: 22.29; Gideon R. Lewin: 3.2; Aida and Bob Mates: 12.2, 23.3; Peter Moore: 20.16, 22.69; Charles Reynolds: 22.41.